D1247051

To Infinity and Beyond!

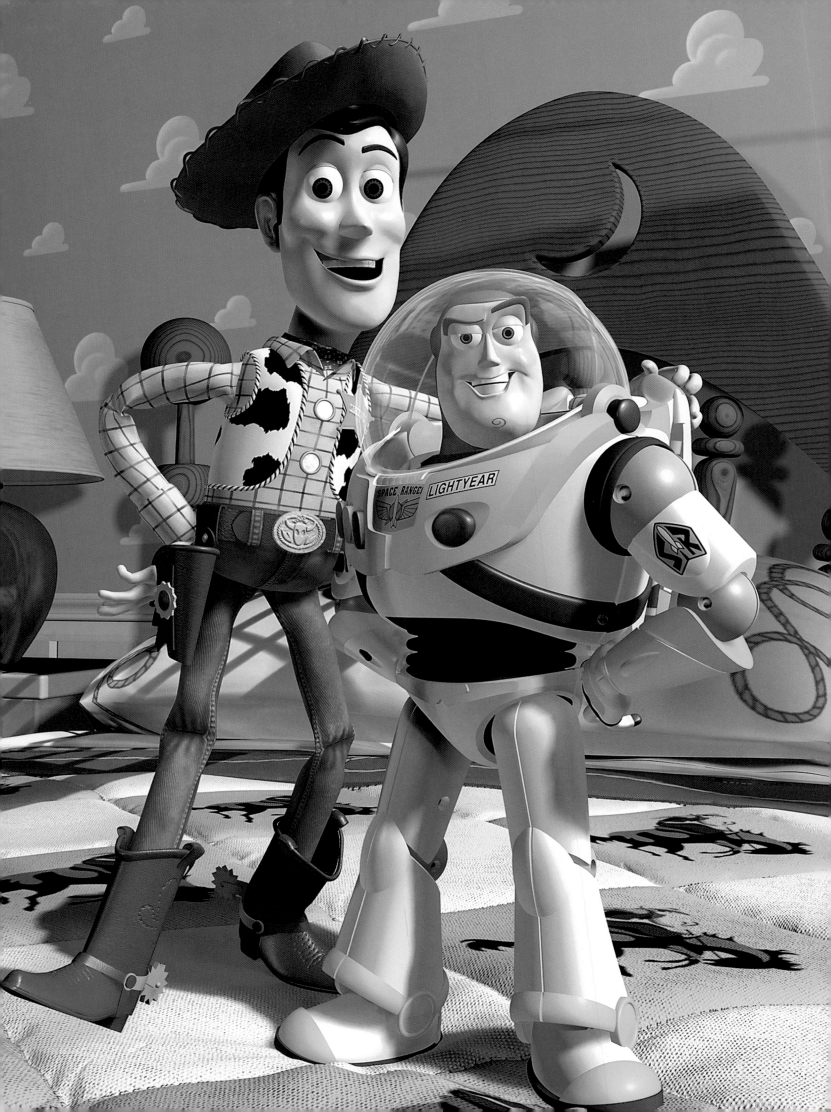

To Infinity and Beyond!

The Story of Pixar Animation Studios

By Karen Paik
Based on interviews and research by Leslie Iwerks
Foreword by John Lasseter, Steve Jobs, and Ed Catmull

CHRONICLE BOOKS

SAN FRANCISCO

Library of Congress Cataloging-in-Publication Data:

Paik, Karen.
 To infinity and beyond! : the story of Pixar Animation Studios / by Karen Paik;
based on interviews and research by Leslie Iwerks; foreword by John Lasseter, Steve
Jobs, and Ed Catmull.
 p. cm.
ISBN-10: 0-8118-5012-9
ISBN-13: 978-0-8118-5012-4
1. Pixar (Firm) 2. Animated films—United States. 3. Computer animation. I. Title.

NC1766.U52P5837 2007
791.430973—dc22
 2007028764

Manufactured in China

Designed by Tolleson Design

10 9 8 7 6 5 4 3 2 1

Chronicle Books LLC
680 Second Street
San Francisco, California 94107

www.chroniclebooks.com

Cover: Buzz Lightyear. Rendered character pose.
Page 2: Woody and Buzz. Rendered character pose.

Credits:
Page 28, Brent Schlender, "Pixar's Magic Man," Fortune, May 2006.
Page 48, Steve Jobs, excerpt from interview by Daniel Morrow, Smithsonian Instituion Oral and Video Histories, April 20, 1995.
Pages 48-49, Steve Jobs, excerpt from commencement address, Stanford University, June 12, 2005.

Contents

	Foreword	6
	Introduction	8
Chapter 1	Ed	12
Chapter 2	John	28
Chapter 3	Steve	48
Chapter 4	Pixar's Early Days	56
Spotlight	Sound	72
Spotlight	The Early Short Films	74
Chapter 5	Toy Story	80
Spotlight	Music	106
Chapter 6	Building a Studio	108
Chapter 7	A Bug's Life	116
Spotlight	"Geri's Game"	138
Chapter 8	Toy Story 2	142
Spotlight	Pixar University	162
Chapter 9	Pixar at Home	164
Spotlight	Voices	174
Chapter 10	Monsters, Inc.	178
Spotlight	"For the Birds"	200
Chapter 11	Finding Nemo	204
Spotlight	RenderMan	226
Chapter 12	The Incredibles	230
Spotlight	"Boundin'"	252
Chapter 13	Cars	256
Spotlight	"One Man Band"	278
Chapter 14	Pixar Joins with Disney	282
	Conclusion	294
	Academy of Motion Picture Arts and Sciences Awards	299
	Acknowledgments	300
	Index	301
	Author Biographies	304

Foreword

As we look back at Pixar's first twenty years, we are amazed by how this company has grown. It's a great gift to be able to support yourself doing work that you love, and all of us have been honored to see our characters and stories find a place in the world outside our studio.

The people who go to see our movies are trusting us with something very important—their time and their imagination. So in order to respect that trust, we have to keep changing; we have to challenge ourselves and try to surprise our audiences with something new every time.

The thing about doing something new, of course, is that you never know what's going to happen as a result. But that's never stopped anyone at the studio, and that spirit of adventure is the thing that makes us most proud to be part of the Pixar community.

It's been our privilege to work with the great people whose dedication, incredible range of talents, and uncompromising standards have made this studio what it is. They have surprised and inspired us every day for over twenty years.

—John Lasseter, Steve Jobs, and Ed Catmull

Introduction

"Pixar's seen by a lot of folks as an overnight success, but if you really look closely, most overnight successes took a long time." — *STEVE JOBS*

As the Pixar saying goes, "In the computer, nothing is free." A virtual world begins as the most purely blank slate one can imagine. There are no sets, no props, no actors, no weather, no boundaries, not even laws of physics. The computer is not unlike a recalcitrant genie, prepared to carry out any order you give it—but exactly and no more than that. So not only must every item be painstakingly designed and built and detailed from scratch, every physical "law" and property must be spelled out and applied. Otherwise, lamps fall through tables; rocks hover in midair; teeth shoot out of a superhero's head.

It took many years for even the most dedicated and able researchers to find their way in this environment, which requires one to denature and dissect one's intuitive grasp of the world. In 1972, when computer scientist Ed Catmull first started thinking about using computers to create animated feature films, the field of computer graphics was still so unsophisticated that one could only form images with straight lines. Not many people could look past those crude and clumsy pictures to see what the medium had the potential to be. In fact, to the casual observer, the idea of using such a laborious, unspontaneous tool to create animation—itself a medium in which there are never any happy accidents, only carefully planned results—probably seemed like an exercise in self-punishment. But Catmull persisted. He knew what could be achieved, and he was willing to work, build his team, and wait.

More than ten years later, that patience was rewarded with the perfect artistic partner. Like Catmull, John Lasseter, one of the first animators to take an interest in the medium, looked at the chunk of charcoal and saw a pencil. He, too, saw that while a computer could be demanding—sometimes maddening—to use, it also had the potential to be a tool of unbelievable delicacy, reach, and control. Lasseter calls computer animation "the mystical science": give the computer the right set of instructions to carry out, and you can create the impossible in a world with a physicality and seamlessness no other medium can match. And from their very first project together, it was clear that the warmth of Lasseter's

storytelling and the Lucasfilm Computer Division's technical wizardry was a transformative combination. But feature animation still represented a wildly ambitious use for a medium just finding its feet, one in which stories literally had to pull new technology into existence in order to be made. Not only was there no path to follow, there would be no destination unless they could figure out how to build it.

It was Steve Jobs who placed the long bet on that dream, buying the Lucasfilm Computer Division in 1986 and giving it a new life as Pixar. Pixar is known today as a successful movie studio. But its run of films from *Toy Story* in 1995 to *Cars* in 2006 is literally only half the company's story. For all the success of its second decade, Pixar spent much of its first decade struggling to survive, putting together a modest body of work in short films and commercials as it slowly built the technological and creative foundation necessary to achieve its goal of making the world's first computer-animated feature film.

As they grew Pixar from a 40-person hardware company into an animation company, and eventually the 900-person movie studio it is today, Catmull, Lasseter, and Jobs consistently found that what was true of their medium was true of their company: if they wanted it, they had to create it. The technology, the creative team, the filmmaking opportunity— none of these existed to be acquired.

Happily, their partnership proved to have the perfect combination of essential talents. Catmull's technical expertise helped attract many of the finest minds in computer graphics, people committed to constantly advancing the medium, to making it a tool that could offer something truly new to storytelling. Lasseter's discerning eye and collaborative spirit sought out artists capable of rolling with the punches in a medium that was essentially still a fron- tier town, and brought them together into a creative community the likes of which hadn't been seen in decades. And Jobs, the company's pathfinder and guardian angel, had the guts to back Pixar in the hard times and the savvy to guide it past pitfalls that would have swal- lowed it otherwise. Most important, all three shared an absolute dedication to quality above all else—a commitment that never wavered in the face of either success or failure.

Chapter 1

Ed

"For most of the time I was working on Toy Story *I didn't really* know *who Ed Catmull was. I mean, he was just Ed—Mr. jeans-wearing, flannel-shirt guy… just the nicest guy in the world. When we went to SIGGRAPH down in L.A. for* Toy Story, *I happened to share a cab from the hotel with him. When we walked through the doors of the convention center—into this hall filled with people—it was like the Red Sea parting. All these people are like, 'Can I get your autograph?' 'It's Ed Catmull!' He was like a rock star! It was great. I'll never forget that." —RALPH EGGLESTON*

Ed Catmull grew up in Salt Lake City, Utah, in suburban 1950s bliss. "My childhood was like the ideal of what it *should* be like to grow up in this country," Catmull recalled. "It was a very middle-class environment. There weren't the super-rich, and there weren't the very poor. There weren't bad problems. World War II had ended very recently, of course, but

Above: Ed Catmull. Teddy Newton, digital.
Right: Ed Catmull's 1968 University of Utah yearbook photo.
Previous spread: "The Road to Point Reyes" represented the cutting edge of computer graphics in 1983. Rob Cook, Loren Carpenter, Tom Porter, Bill Reeves, David Salesin, Alvy Ray Smith, digital.

for a kid it was something that happened forever ago. Parents who had gone through the Depression and World War II didn't talk about it. They were rebuilding the world. I was a child in that world, in a very safe place."

Catmull's mother was a secretary in a local elementary school, and his father was a high school math teacher, later a high school principal. Catmull and his four younger siblings grew up in a part of town bordered by open space, so they and the many kids in the neighborhood had their pick of diversions. If they didn't feel like staying in the neighborhood or riding their bikes downtown, they could play in the nearby creek or hills. Catmull, a Boy Scout, went camping every summer and skiing every winter in the Wasatch Mountains.

Catmull had two heroes as a child: Walt Disney and Albert Einstein. "I remember watching one of the *Wonderful World of Disney* programs where the animators were drawing on the desk, and right there, the characters came to life on the desk. I knew that it was an illusion, but there was just something magical about it. I couldn't imagine anything better than being an animator. I'd watch all the programs about it, and I bought art books and animation books and practiced drawing. At the same time, I really liked science and math, and back then, the image of the scientist was Albert Einstein. So here were these two idols, and I was drawn to both of them."

Catmull pursued both these interests through high school, where he was also the captain of the debate team and participated in school theater (playing the grandfather in *Flower Drum Song*). But as he neared college, he felt he needed to decide between the two: the arts or the sciences?

"I wanted to be the best in the world at something," he said. "And at that time, I couldn't see the path to become a great animator. I didn't have mentors or teachers to explain how you progress. So when I started at the University of Utah, I majored in physics."

University of Utah

Physics led Catmull to computer science, a field that was booming at the time thanks to a huge influx of research funding from the federal government's Advanced Research Projects Agency (ARPA). ARPA had been founded by the Department of Defense in 1958, when *Sputnik* was in the skies and the United States was in the throes of the Cold War. Many agencies with military roots focused on applied research related to specific goals, but ARPA, intended to serve as an incubator of cutting-edge technologies that would keep the U.S. ahead of its rivals, concentrated on pure research.

Left: Ed Catmull's first course in graduate school was on computer graphics.

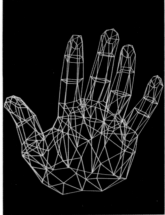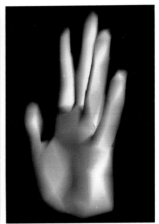

In 1973, the agency was prohibited from subsidizing projects that did not have direct military application. But through the 1960s and early 1970s, ARPA funding had helped push the boundaries of all aspects of computer science, touching off an extraordinary flowering of knowledge that catapulted us into the computer era. The University of Utah had been in the thick of the action; along with the University of California at Los Angeles, the Stanford Research Institute, and the University of California at Santa Barbara, it was one of the four institutions connected by the original ARPANET, the forerunner of the modern Internet.

Catmull eventually earned two bachelor's degrees, one in physics and one in computer science, and decided to stay at Utah to pursue graduate work in computer science. "I was intending at that time to work on computer languages. But my first grad course was a computer graphics course. As soon as I took the first class, I just fell in love with it. It blew everything else away. Here was a program in which there was art, science, and programming all together in one place in a new field, and it was wide open. It was like being at an Easter egg hunt where you're at the front of the line. You could just go out and discover things and explore."

At the time, Utah's computer science program, under the leadership of David Evans, Ivan Sutherland, and Tom Stockham, had become the world's preeminent center for computer graphics research. Evans, the chairman of the department, and Sutherland, the author of the seminal graphics program Sketchpad, had recently started the world's first computer graphics company, the Evans & Sutherland Computer Corporation. They cultivated an environment in which professors regarded grad students as peers in advancing the field.

Catmull, like many of his fellow students from that time, remembers the atmosphere with great affection. "We had ARPA funding, and it was an exciting field, so we just went nuts. We worked hard. We slept on the computer room floors." Malcolm Blanchard, one of his colleagues, recalled that "Ivan used to say he loved grad students because they didn't know what was impossible."

At the time, the brass ring for the field was photorealism—not as the ultimate goal, since "you could always just photograph reality"—but because reality was so complex that being able to match it would mean they had truly mastered the technology.

> "Tackling a hard problem brings energy into a group of people and gives you a sense of camaraderie. Here was a whole community of people trying to solve the problems of computer graphics, writing papers and exchanging ideas. This whole field was marching forward with great excitement. That sense of community was so strong that it inspired me to try to re-create it after I left." —ED CATMULL

Top left: This glass and bottle were among Catmull's early experiments with three-dimensional computer graphics. Top middle and right: Catmull's first piece of computer animation, which showed a hand opening and closing, was completed in 1972. It would become one of the first pieces of computer animation ever used in a feature film, apearing in the movie Futureworld *four years later.*

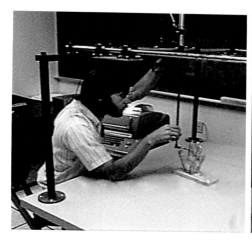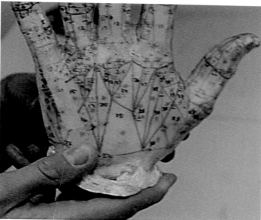

"Evans and Sutherland both had this gift for identifying students—often with very eclectic backgrounds—to bring into the graduate program," said Michael Young, the current president of the University of Utah. "They assembled a really remarkable group of people, many of whom then took that training and went out and helped to create some of the most central elements of what made computers so functional and possible to use in our lives."

Jim Clark, who was interested in what would eventually be known as virtual reality, helped start Silicon Graphics and Netscape. John Warnock, who was studying 3-D rendering, co-founded graphics arts company Adobe. Alan Kay, who was working with language paradigms and models of interactions with systems, went on to do important work in developing object-oriented programming and graphical user interfaces.

Ed Catmull, of course, wanted to use computer graphics for animation. "I knew that this was going to be a big, long, hard road to go down. But I could see the potential." The first step was to figure out how to make better-looking pictures. "All the images back then looked like they were made out of paper. They were polygonal and fairly crude, plus they had little staircase 'jaggies' around the edges." For his dissertation, he set himself the task of figuring out how to create smoothly curved surfaces.

In the course of solving this problem, Catmull came up with three concepts that became part of the foundation for today's sophisticated and elaborate computer graphics. The first was the idea of the "z-buffer," which allows a computer to assign a "depth" to an object in a three-dimensional space. This makes it possible for objects to correctly hide, or be hidden by, other objects in a picture. There is a z-buffer in every game and PC chip manufactured in the world today.

The second was the idea of "texture mapping," which allows you to easily add detail to a three-dimensional object by covering it with a two-dimensional image. For example, if you want to make a cube look like it is made out of wood, you can "wrap" the cube with a picture of wood grain, instead of programming the surface of the cube to have the actual irregularities of wood grain.

The third idea was a new type of mathematical surface called a "subdivision surface," which made it possible to build curved, irregular models with different geometric resolutions throughout the model.

These pioneering ideas, still fundamental to even the most recent developments in the field, marked the beginning of an illustrious career in computer graphics that would range from groundbreaking theoretical work to the development and application of CG in ways that would help create industries.

Top: To create the virtual hand, Catmull digitized a model made from a plaster cast of his left hand. Catmull, "Lesson learned—if you're going to make a plaster mold of your hand, shave your hand first."

In 1972, as part of a class project, Catmull digitized a plaster cast of his hand, and animated the computer model of it opening and closing. The animation was enthusiastically received (and was actually used in the 1976 movie *Futureworld*), but for Catmull it was only a first step. "I was completely in love with this notion of making things move and making them look good, and my goal was to develop the technology to the point where it could be used in feature films. I figured it would probably take ten years to solve the problems that were in the way of making computer graphics useful for films. I was off by a factor of two. It took twenty."

After receiving his PhD in 1974, Catmull interviewed at a number of companies and universities, but no one was interested in having him work on computer graphics—though Disney offered to hire him to work on the engineering crew for their new Space Mountain ride. "I wasn't so much discouraged by the lack of interest as I was a little miffed. I was disappointed the studios didn't see the potential. My view at the time was, they're not

Top: The NYIT graphics lab was housed in a two-story former garage. As in its former incarnation, the first floor was used for the machines, and the second floor was used by the people working with the machines.

willing to take the risk to get where they needed to be. But on the other hand, I'm just in my twenties," he said, laughing. "Nobody's going to listen to me at all."

"A lot of people were working on figuring out ways of making pictures with computers, and certainly a large number of them wound up at Pixar as a good place to do that and push it. Ed Catmull had the dream probably before anybody else did, that it was possible to do; it just took twenty years for the capabilities of the hardware and the cost of the hardware to come down to make that feasible." —JIM BLINN

New York Tech

At around that time, Dr. Alexander Schure, the founder of the New York Institute of Technology, decided to establish a computer graphics research lab at the school. Schure wanted to do something groundbreaking, and he felt that New York Tech, with its emphasis on career-minded education, was in a good position to accelerate the eventual convergence of computer graphics and filmmaking. After purchasing a large quantity of equipment from Evans & Sutherland, Schure asked David Evans if he knew of a suitable candidate to run the new lab. Evans recommended Ed Catmull as the perfect choice.

Catmull, who had by then settled for a job working at a small CAD (computer-aided design) software company, jumped at the chance. His first hire was Malcolm Blanchard, one of his co-workers and a fellow Utah alum. The second and third additions were Alvy Ray Smith, a former academic, and David DiFrancesco, a photographer. Both had recently left Xerox PARC (the company's now-legendary Palo Alto Research Center) after Xerox had decided there was no future in the area of graphics they had been researching: color.

These first few hires were just the beginning of what would eventually become a stream of luminaries at the New York Tech graphics lab: Garland Stern, Lance Williams, Ephraim Cohen, Jim Blinn, Pat Hanrahan, and Jim Clark, to name just a few. "We didn't know enough to make recommendations, but these were people obviously at the forefront of this technology," Schure explained. "We knew the secret was you had to have leaders who had the aspiration and drive to go! You just had to provide them the resources, let them know you had a commitment—and then get out of the way. We enabled a gathering of the best talent in the world."

The lab, housed in a converted two-story garage on New York Tech's Long Island campus, was filled with the best hardware money could buy—Schure had deep pockets, and he had stocked the lab generously. Anxious to put the equipment through its paces, the new team

Top: The lab at New York Tech contained the most sophisticated equipment money could buy, and lots of it. Alvy Ray Smith, "We didn't just have one frame buffer. We had thirty. We didn't have one RGV frame buffer. We had six." The lab contained tens of thousands of dollars' worth of equipment (in 1970s dollars!), but there was still room for a good old-fashioned animation pegboard.

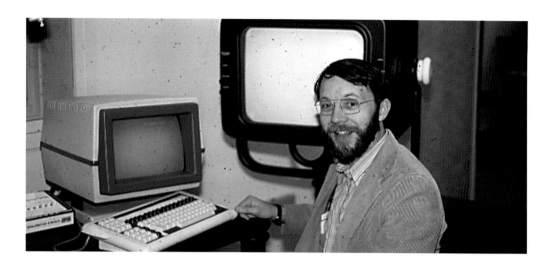

ran the facility more or less around the clock, just as they had at Utah. "We just started programming our brains out," said Catmull.

Because another New York Tech group was working on a traditionally animated film, *Tubby the Tuba*, the group's first efforts emphasized endeavors applicable to 2-D work. Catmull wrote a program called "Tween," which would allow computers to do the tedious labor of creating the drawings "in-between" an animator's key drawings. Smith extended his previous work with color to develop a full computer painting system. And Garland Stern came up with the idea of scanning hand-drawn images into the computer so that they could be digitally colored— now a standard practice in traditional animation. But the group also continued to work on simple 3-D animation programs, and Catmull began running experiments to see how computer graphics might be able to replicate motion blur—a signature effect of film.

Catmull was also quietly testing out his theories of how best to manage a creative group. "A lot of my theories were wrong," he laughed. "But I was trying to learn from the things that we were doing." And in fact, some of his theories turned out to work quite well indeed.

The most important one had to do with intellectual openness. Unlike many of their competitors at the time, the group was not secretive about its work. "There was a constant stream of people who would come and visit the lab, and we loved showing off our stuff," recalled Smith. Even more significantly, they made a point of engaging the academic community—then, as now, represented by the industry conference SIGGRAPH, the Association of Computing Machinery's Special Interest Group: Graphics.

"We wrote papers. We were on the panels. We gave tutorials," said Catmull. "And the cool thing about that was that it gave us such a great reputation that the very best people wanted to come and work with us." A practice they had adopted as a matter of survival— reaching out in order to stay involved with a geographically distant community—ended up being an evolutionary advantage.

> *"It was part of the learning process to realize that if we were going to get where we wanted to go, it wouldn't be because we thought of everything ourselves. We had to be able to attract really smart people who were thinking about things in different ways, or doing things that we couldn't do, and we had to be part of a larger community."* —ED CATMULL

"In the beginning I did feel insecure about hiring people who were smarter than I was," admitted Catmull. "To a certain extent that reaction is natural. But if you can't get past that attitude, it will only hold you back. You have to seek out the best talent if you want to excel."

Top: Ed Catmull in the Lucasfilm days.

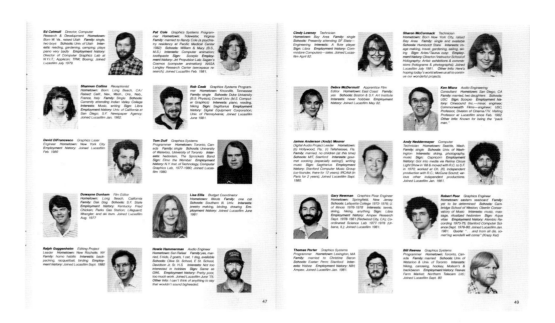

At the time, computer graphics was still a medium for scientists; to make art in the computer, one had to know how to write software. But the evolving field promised future artists the ability to control images down to the pixel, using the computer as both pencil and brush.

"In that lab, they established a new industry. They were not the new animators; they were the new makers of a technology that would change everything." —ALEXANDER SCHURE

The technology was making tremendous strides, and the enterprise was well-funded. But Catmull knew that New York Tech was not going to be the right place to make computer-animated movies. Though the group had attracted formidable technical talent, it did not have comparable story talent. "We had animators and artists. But we didn't have director-level creativity there. I could see that. I knew that we were missing something. But I didn't know how to get it."

Fortunately, it was about to come looking for him.

Lucasfilm

In 1977, *Star Wars* had adrenalized both American popular cinema and the film special-effects industry. Since the demise of the studio system, there had been few entities willing to support the expensive infrastructure necessary to do top-end effects work. George Lucas, knowing that his space fantasy would require effects that had never been done before, had put together his own optical- and visual-effects unit for the movie—the group that would become Industrial Light & Magic. The group's two major advances, a computer-controlled camera that allowed for dynamic special-effects shots, and an elaborate optical compositing system, gave the movie an unprecedented feeling of realism. That success led Lucas to believe that filmmaking would benefit even further from the development of more sophisticated technology.

"In all of Hollywood, George was the only person to actually invest in filmmaking technology in a serious way. The big studios were too risk averse, but George understood the value of technical change. He was the one that provided the support when nobody else did." —ED CATMULL

Before *Star Wars*, any shot involving a special effect not done "live" in the scene had to use a stationary camera; otherwise it was impossible to perfectly layer, or composite, the

JULY 4, 1982

Top: The Computer Division section of the 1982 Lucasfilm "yearbook" (cover shown above). Twenty-five years later, seven of the twenty people pictured are still with Pixar.

Top, clockwise from top left: The heads of the four major Lucasfilm Computer Division research endeavors, Alvy Ray Smith, graphics; David DiFrancesco, digital film scanning and printing; Ralph Guggenheim, digital video editing; and Andy Moorer, digital audio editing.

elements of the effect into the scene. A computer-controlled camera, which could perfectly replicate a particular series of movements over multiple takes, made it possible to use special effects in dynamic shots—for example, panning across an aerial dog fight before swooping in among the spaceships. Lucas's team also developed innovative optical compositing techniques to merge the dozens of separate elements involved in the complex scenes. But Lucas still chafed under the limitations of the existing technology. Optically composited scenes, which require the film to be re-exposed multiple times, inevitably suffer some degradation of image quality as the "layers" add up. Furthermore, celluloid itself is a fragile medium, and the developing process introduces yet another variable into the equation.

In 1979, Lucas decided to set up a computer division to develop the three items at the top of his wish list: a digital video editing system, a digital audio system, and a digital film printer—actually a combination scanner/printer for transferring images from film to the computer (where they could be manipulated without loss of image quality) and back. He also had more than a passing interest in computer graphics—he had seen some of the earliest examples of computer animation, and he was keen for it to get to the point where it could be used to produce visual effects.

In the search for someone to head this effort, Catmull was one of several candidates whom Lucas ended up personally interviewing. "I was very impressed with Ed as soon as I met him," Lucas remembered. "We immediately hit it off. He understood what I was trying to get to. In that time period, there were a lot of people who kind of BS-ed a lot. They just wanted to get a grant to get some money to kind of doodle. Ed was very concerned about actually making something that was going to be useful."

 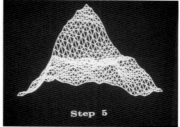

During the interview process, each candidate was asked who else Lucasfilm should be talking to for the position. "I gave them the names of all the people that they should talk to that might be qualified for the job," Catmull recalled. "It turns out I named all the people that they were talking to." Later, he found out that he had been the only candidate willing to refer the interviewers to his competitors.

He got the job.

To Catmull, the Lucasfilm offer immediately cleared up a heretofore immovable obstacle to his long-term goal—the missing creative piece of the moviemaking equation.

"When we were approached by Lucasfilm, it was fairly easy to say, well, this is the place where we can now take the next step forward," said Catmull. "They would bring to this grand endeavor the artistic side that we were missing."

However, Lucas, though serious about his new computer division, was not ready to hire more people just yet. *The Empire Strikes Back* was still in production, and Lucas could not afford to invest serious money in research until he found out whether or not the second movie in his trilogy would be a success.

Nevertheless, Alvy Ray Smith, David DiFrancesco, and colleague Tom Duff left New York Tech at around the same time Catmull did. They knew that they wanted to work together as a group, and they felt that leaving was the best way to acknowledge their long-term intent.

Schure had expected this might happen. "I was surprised we held Ed that long," he said. "His group had outgrown New York Tech at this point. They wanted to open an animation studio. They wanted to be in the commercial game, and we were a university. We wished them well; we were sorry to lose them. But we had great people in the laboratory, and the laboratory just went on."

The Lucasfilm Computer Division

Catmull's first month or so on the job was spent drawing up plans and making phone calls—all from Lucas's office, since the director was in London filming *Empire*. His first order of business was to find people to lead the research for each of the items on Lucas's wish list.

Alvy Ray Smith and David DiFrancesco, who had been working in Pasadena on Carl Sagan's *Cosmos*, came north to head up efforts in computer graphics and digital film printing, respectively. Ralph Guggenheim came out from New York Tech to take charge of the video editing system, which would eventually be known as EditDroid. Catmull recruited Andy Moorer from Stanford to do the same for the audio editing system, SoundDroid. Also rejoining the team were Malcolm Blanchard and Tom Duff. Duff referred Catmull to his friend Bill Reeves, who joined the team straight from grad school at the University of Toronto.

Top: A computer can create any shape desired using nothing but triangles—provided the triangles are small enough. These images show the process of making the fractal mountains in Loren Carpenter's short "Vol Libre."

Once it became clear *Empire* would be a success, the real funding turned on, and the group was able to start hiring in earnest. Again, Catmull was able to build a team of some of the very best people in the industry.

Loren Carpenter, who would become one of the key architects of Pixar's groundbreaking RenderMan software, recalled that when he heard Catmull was hiring, he immediately resolved to make the short film he was working on into the world's most compelling calling card.

"Ed had the highest respect of anybody in the computer graphics industry, in research and rendering and animation," Carpenter said. "I absolutely *had* to work for him. My plan was to overwhelm everyone at the SIGGRAPH conference with my film and paper and have T-shirts and everything to make it obvious that it would be a serious mistake for him not to hire me. I managed to pull that off."

Carpenter's short "Vol Libre"—a flight over a virtual landscape generated with pioneering fractal techniques—was the hit of 1980's SIGGRAPH, and Carpenter started work at Lucasfilm soon afterward. Tom Porter, whom Catmull brought in to build a digital paint system, came in at the same time, followed some months later by Rob Cook, who had been doing pioneering shading research at Cornell. (A "shader" is a program that indicates a CG object's color and texture.)

"There was a very strong spirit at Lucasfilm and within this extraordinary group of people," said Catmull. "We were allied with a superstar filmmaker, and we knew whatever we came up with was going to have an effect. That infused the whole group with this real excitement." Porter recalled that even seemingly mundane tasks like determining preferred data standards took on a unique energy, a feeling that the group was laying the foundation for truly significant work to come. As Carpenter put it, "We felt like we were on the tip of the spear."

"The only thing that was not perfect was that ILM at the time wasn't really interested in what we were doing," said Catmull. "Their view was that the resolution we were working at was too low, and the image quality was not good enough for what they were doing, so we were just this harebrained project that George had going on the side. They weren't antagonistic—this was a company with a lot of good spirit to it. It's just that we weren't highly relevant to what they were doing."

Top: Tom Porter with his early digital paint program.

The Empire Strikes Back, in addition to being a huge success at the box office, also incorporated a number of technical achievements and refinements, including marked improvements in the optical printer. "The ILM folks had a very clever and elaborate optical compositing system," Porter recalled. "They had really honed their skills and worked with this technology in order to achieve exactly what they needed, which was fine control over the lighting, focus, blurring, and effects. It was clear to me that we had to build the digital equivalent to that."

But in 1980, raster, or pixel-based, computer graphics, was only about five years old. While raster graphics made it possible to create infinitely more complex images than vector, or line-based graphics, it was also a much, much more complicated affair—similar to the way in which a mosaic is more complicated than a line drawing.

"Our images at the time were riddled with jaggies, really basic stuff," recalled Porter. "Developmentally speaking, we were just crawling at the time." As work progressed on EditDroid, SoundDroid, and the digital film printer, the graphics group threw themselves at the basic problems of creating realistic images. How many pixels do you need to have in a picture to reproduce the resolution of 35mm film? If every object you create is ultimately made out of lots of little polygons, how many polygons do you need to use and how small do they have to be? How much detail, and what sorts of detail, do you need to paint onto a surface in order to make it look real? How do you re-create the motion blur of film in a digital environment? And how do you write up all these instructions of "what" and "where" and "when" in a way that will guarantee that the computer generates the image you want?

In a brainstorming session, Cook, Carpenter, and Catmull estimated that they would need to be able to generate images containing 80 million polygons in order to compete with the level of detail offered by film. It was "an absurd number," Catmull recalled, but productively absurd. At the time, their software could not handle images of more than about 500,000 polygons. Setting the bar at 80 million encouraged an entirely different sort of ambition and long-term thinking. "It changed the whole mindset about the sort of problems we were trying to solve," said Tom Porter.

Computer graphics was still anything but a crowded field, but in recent years they had begun to see other companies spring up—some with the same goal of getting into 3-D animated filmmaking. Companies like III (Information International, Inc., also known as Triple-I) and later Whitney Demos had invested in powerful and expensive hardware, and their machine rooms were the envy of their peers.

While a $10 million Cray supercomputer could provoke a pang of covetousness in the most spartan of computer scientists, the Lucasfilm team reasoned that they would be better off waiting. "We did a calculation and we figured it would take a hundred Cray computers two years to render a feature film," Catmull said. "And therefore, we needed to keep developing. Because first of all, the computers kept getting faster every year, so if we kept doing the R&D, at some point the machinery would be more affordable. But even if we had $20 million to spend, which we didn't, we still wouldn't have been able to do a movie; it just wouldn't have been enough."

More importantly, no amount of hardware would compensate for the limitations of the current software. "At that time the technology was so new that we didn't have enough of the problems solved," said Catmull. "We needed a better renderer, but that was only one of the problems; the whole modeling and animation side of things was pretty crude too. I knew where we were trying to get, so the important thing was not to screw up along the way. There were too many places where you could fall off the track and be out of the game."

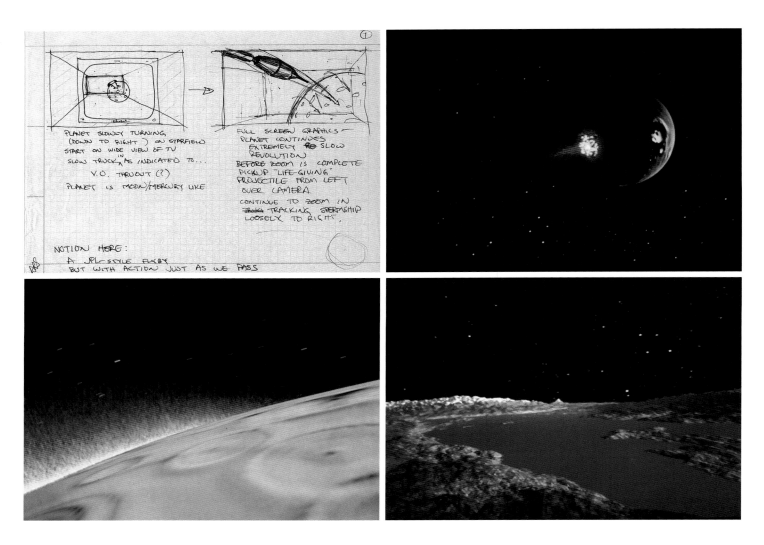

Top: Smith's reimagining of the Genesis Effect in Star Trek II *was inspired by his recent stint at the NASA Jet Propulsion Lab. "I'd just been working at JPL with Jim Blinn, so I had the* Voyager *fly-by mentality," he said.*

The ultimate finish line may have been 79.5 million polygons away, but the graphics group was still doing absolutely cutting-edge work, and they wanted a chance to show it off. Alvy Ray Smith convinced their colleagues at ILM, who had just been hired to do the visual effects for *Star Trek II: The Wrath of Khan*, to give the Computer Division a crack at one of them: a demonstration of the life-generating "Genesis Effect."

Smith's reimagination of the scene—originally intended to show a rock, encased in a glass shell, turning green with life—featured a rocket exploding on a barren planet, setting off a chain reaction that transforms the landscape into an oasis. The effort took advantage of all the latest developments in the graphics group. Bill Reeves' brand-new particle systems created the explosion and its attendant wave of restorative fire. Loren Carpenter's fractals created mountains and lush landscapes rising from the flames. ILM matte painter Chris Evans digitally applied the planet's textures using Tom Porter's paint program. Finally, all the elements were created with digital mattes and composited using Porter's new compositing software.

The scene still contained some digital artifacts, but since it was being presented in the movie as a computer simulation, there was fortunately no need to remove them. Even so, the finished images were gratifyingly realistic—nothing like the simple, rather crude digital pictures the public was used to.

"The reaction was—stunned," recalled Carpenter. "When people looked at these images they couldn't tell they were made on a computer. It was like people had just seen ten years into the future and had it dumped in their laps."

But Smith knew that the thing that would catch Lucas's eye was the camera move Carpenter had programmed: a spectacular, uninterrupted fly-over that followed the wave of life as it raced over the surface of the planet. "The shot was really a sixty-second commercial to George Lucas. It made perfect narrative sense, it wasn't some gratuitous computer graphics shot, but it was clearly impossible for a gravity-bound camera." Sure enough, after *Star Trek II* screened at Lucasfilm, Lucas stopped by Smith's office: "He said, 'Great camera shot.' And he was out of there. But from then on, he asked us to be in the movies and told his buddy Steven Spielberg about us."

"Not many people had seen computer paint programs by 1982. This was before 1984, when MacPaint popularized the idea of paint programs. It was an odd thing to take a pen in hand and sit at a tablet and look at a screen, but Ed Catmull walked in with Steven Spielberg, and they wanted a demonstration. So, here we go. I sat down at my monitor and was explaining how to apply paint to the picture. Within thirty seconds, Spielberg kind of pushes me out of the way and sits down. He took a few strokes and looked up—he was beaming! He paints away, and after a minute he looks up at me and the ILM folks and says, 'What a great time to be alive!'" —TOM PORTER

Looking forward to the 80-million-polygon future, the team knew it would need to build a renderer of unprecedented power and complexity. A renderer is a piece of software that can take all the instructions specifying the look and location of every item in a proposed picture and then "fill the order" to produce the final image. The more parts there are to a picture, the more sophisticated the renderer must be in order to handle all the details of surfaces, lights, textures, and materials.

Loren Carpenter and Rob Cook had collaborated to write REYES (Renders Everything You Ever Saw), an algorithm, or set of rules, for how to render a scene. REYES would eventually evolve into RenderMan, the dominant standard for digital work in Hollywood ever since its introduction (see page 226). Beyond the renderer itself, RenderMan provides digital artists with an interface that helps them translate the effects they're trying to achieve—for example, "when the door opens, light from inside shines onto the sidewalk and the car in front of the building"—into levels of instructions that are simple for the computer to follow. On the most general level, the instructions would require the artist to be able to specify details like, "The light is coming from a 40-watt bulb in a light fixture six inches below the center of the ceiling." It goes down through levels that specify things like how light reflects off of concrete versus how it reflects off of metal-flake paint.

In March 1983, the group used REYES to generate their very first film-resolution image—a picture of a bend in the road on the way to, fittingly enough, Marin's Point Reyes. "It took us months, but this one picture brought together all the shading work I'd been doing, the fractal work Loren had been doing for making mountains, the simulation of plants that Bill Reeves and Alvy had been doing," Rob Cook explained. "No one had attempted anything like it before, and even though it was just one frame, looking at it made you want to keep driving down that road. It was a huge deal at the time, and I think it inspired us all to keep going."

But before they could even think of using such computer-generated images in film, they had to figure out how to mimic the signature look of film. The most significant component of this problem was motion blur. As Tom Porter described it, "When you film things with a normal camera, the camera shutter opens, the object in front of the camera moves, the shutter closes in less than a thirtieth of a second, and the film captures a natural blurring of moving objects. If you don't have that blur, you'll have a very stroboscopic effect as things lurch across the screen."

Creating this soft blurring effect first required solving the fundamental problem of jaggies. Rob Cook and Loren Carpenter had been engaged in a friendly race with Ed Catmull to find the answer, each taking a different approach. Cook's successful solution, random point sampling, was a riff on an idea originally proposed by their colleague Rodney Stock. Point sampling, though fast, was considered too crude for high-quality images, but Cook discovered that distributing samples from individual pixels in a particular non-regular pattern—as they later found out, the same pattern as the distribution of cells in the eye—eliminated the jaggy edging that was typical with the method.

A conversation between Cook and Porter, in turn, led to a breakthrough—the application of the idea to motion blur. Recalled Cook, "I'd been talking about random point sampling with Tom Porter, and one day he walked in the room and said, 'Have you thought about just assigning a random time to every point?' And that was the burning insight that made it all work." Sprinkling the pixel samples in time, not just space—causing them to appear at different moments during the time the virtual "shutter" was open—allowed them to create perfect motion-blurred images with just a few point calculations at each pixel.

Inspired, Cook realized the idea could be applied to other parts of the puzzle as well. "I was working late that night and was thinking about the other problems: depth of field, soft shadows, and blurry reflections. And I suddenly realized that you could start at random places on the lens and get depth of field. You could start at random points on the light to figure out the shadows and get soft shadows. You could take random reflection directions and get blurry reflections. So this random point-sampling idea solved five of the most difficult problems in computer graphics with one blow! It was incredibly exciting."

In January 1984, Porter rendered a scene of five billiard balls in motion. "Even technical people and animators saw that picture and knew something was happening," said Porter. "They said that it fooled them. They thought it was a real picture."

While the group was getting closer and closer to the point where computer graphics could be used to create cinematic art, they were still having a hard time convincing others of the merit of what they were doing—even within Lucasfilm.

Said Catmull, "I think, for a long time, most people at ILM thought of computer graphics as just another tool to add to their bag of special-effects tricks. Except for the few of us in the Computer Division at Lucasfilm, people didn't see beyond that. They didn't realize it wasn't another something to go into the bag—it would replace the bag altogether."

Jim Morris, Pixar's current executive VP of production, headed up Industrial Light & Magic from 1991 to 2004. "When those guys in the Lucasfilm Computer Division figured out how to do motion blur and depth of field," he observed, "that changed everything. Those tools made it possible to seamlessly incorporate computer-graphic characters into live-action films. It was the start of the digital revolution in filmmaking, and nothing has been the same since."

George Lucas affectionately remembered his Computer Division as the "rebel unit" of Lucasfilm in the early '80s. "ILM was saying they didn't need digital technology. But we were building a lot of things ILM didn't understand in the beginning but began to appreciate later. I had to bridge this gap by saying to them, 'We've spent this money and developed this technology, and now you have to start using it.' It was pushing them in that direction and getting them projects that would allow them to use computer technology. I had to get people who were used to working a certain way for twenty years to change."

For Catmull and Smith—who had for years made annual trips to Disney, hoping to interest the studio in making a computer-animated film—the only thing that chafed as much as not being taken seriously by their colleagues was being taken *too* seriously by the artists they were trying to sell on the new medium. As Smith recalled, "In those early days, animators were frightened of the computer. They felt it was going to take their jobs away. We spent a lot of time telling people, 'No, it's just a tool—it doesn't do the creativity!' That misconception was everywhere."

But they were finally about to meet an animator excited by the potential of working with the computer. His name was John Lasseter.

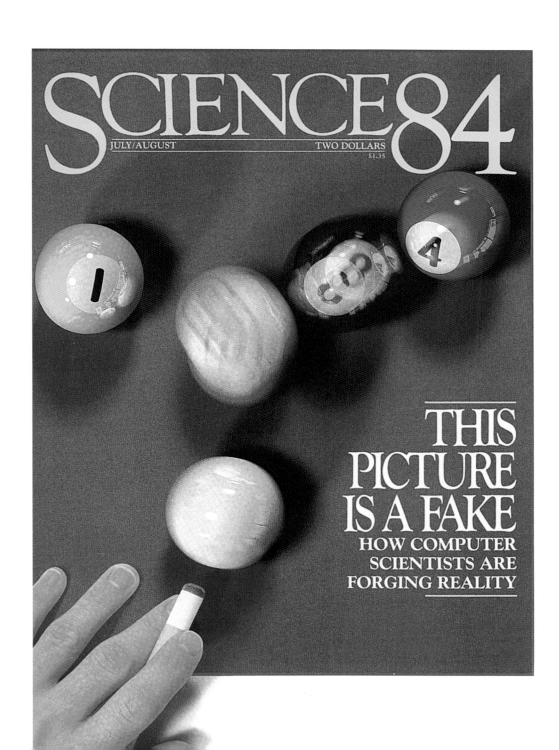

Left: Tom Porter's motion-blur study of five billiard balls appeared on the cover of Science *magazine in July 1984. The image is "dated" by the numbers on the billiard balls (1, 9, 8, 4).*

Chapter 2

John

Above: John Lasseter. Teddy Newton, digital.

"The thing about Ed was he loved movies more than writing software, I think. He basically used his knowledge of technology to promote his secret love, which is making movies. And John is one of those crazy animation people, brilliant and with a great sense of humor and story, and he was in love with the idea of doing a computer-animated film. It was sort of a marriage made in heaven." —GEORGE LUCAS

From the very beginning, John Lasseter demonstrated both an entertainer's instinct for a grand entrance and a knack for, as his father Paul put it, "being in the right place at the right time." His mother Jewell didn't know she was carrying twins—John's sister Johanna is six minutes older—until the week before they arrived, leading Paul Lasseter to dub his second son "the bonus baby."

Lasseter grew up in Whittier, California. His dad was the parts manager for the local Chevrolet dealership, and his mom was a high school art teacher who encouraged her children's artistic interests.

"She never formally taught us," Lasseter said, "but she always surrounded us with art supplies and showed us how to do different little projects—plaster casts, carvings, things like that." All three Lasseter children would go on to pursue creative careers; John's twin sister Johanna became a professional baker of elaborate wedding cakes, and their older brother Jim grew up to be an interior designer.

John took to drawing at an early age. At five, he won his first award when his picture of the Headless Horseman received the $15 first prize in a contest sponsored by the local grocery store. He recalled that his mother would bring pads of paper to keep him and his siblings quiet in church. "We'd sit down, and she'd immediately hand us the paper. I sat there and drew the whole time. I even did flip books in the corners of the songbooks."

Lasseter concocted a world that became a recurring subject of his drawings—a little boy's fantasy of treehouses and tunnels and secret caves and flying ships, populated by a gang of youthful adventurers. "As a kid I daydreamed a lot," Lasseter said. "I'm sure my teachers mentioned to my parents more than once that I needed to pay more attention in class.

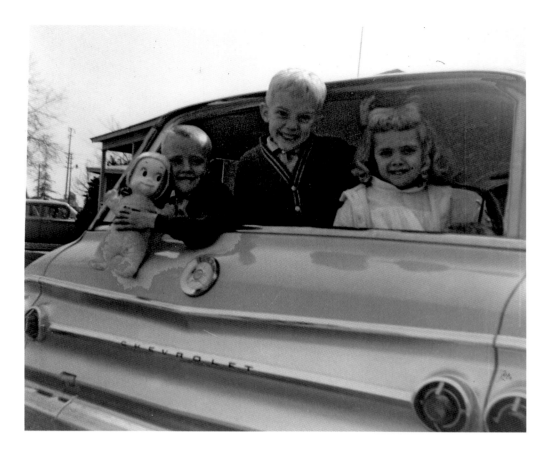

But I'd start seeing these stories in my head, and my mind would slip away and I'd lose track of time, or not hear things—stuff like that."

Lasseter loved comic strips—especially Peanuts and Dennis the Menace—but he absolutely adored cartoons. In the days before twenty-four-hour cartoon cable channels, before videotape and DVD, being an animation fanatic required extra dedication, and Lasseter had it in spades.

"I loved cartoons more than anything else. My parents could not get me out of bed on a school morning, but come Saturday morning, boy, 6:30, boom, I was out of bed, bowl of sugar-frosted flakes, six inches from the TV and waiting for the cartoons to start. I would watch the cartoons straight through until *Bowling for Dollars* would come on. It was just…my time." Even once he reached high school and joined the water polo team, Lasseter would hustle home after practice in order to catch the afternoon cartoons.

In ninth grade, Lasseter was searching the art section of the school library for a book to write a report on when he came across a battered old copy of *The Art of Animation*, Bob Thomas's history of the Disney Studios.

"There's a handful of little moments in my life that I could look back to and say were key to me following the path that I've ended up on," said Lasseter. "Finding that book was one of them. I read it cover to cover, and it dawned on me: People make cartoons for a living. They actually get paid to make cartoons! Right then, right there, I knew that was what I wanted to do."

Soon afterward, Lasseter's mother was driving him home from the 49-cent theater where he had just seen the re-release of *The Sword in the Stone* when he announced that he wanted to work for Walt Disney Studios. "She said, 'That's a great goal to have.' Later on

Top: John Lasseter as a child with his brother, sister, and beloved Casper doll. Casper's pull-string voice inspired a similar feature in Woody from Toy Story. *Lasseter, "My mother used to say she'd know when I fell asleep at night because Casper would stop talking."*

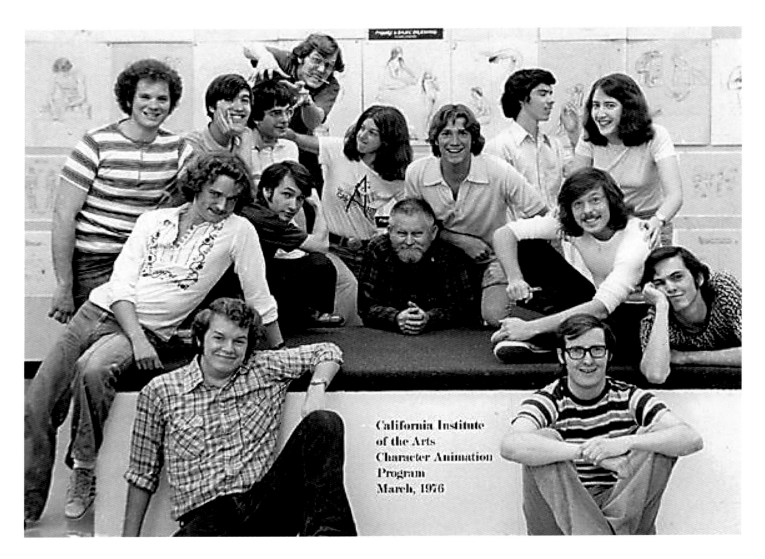

California Institute
of the Arts
Character Animation
Program
March, 1976

in life, after talking to people at CalArts and at the Disney Studios, I realized how rare that is to get that kind of support early on from a parent. But my mother always felt strongly that pursuing the arts is a noble profession."

Lasseter began writing to the Disney Studios, corresponding with Ed Hansen, the manager of the animation department, who invited Lasseter over for a tour of the studio. Since Disney had its own animation training program, Hansen encouraged Lasseter to focus on building a strong basic art foundation in college.

CalArts

At the beginning of Lasseter's senior year in high school, he received a letter from the Disney Studios announcing that CalArts, the art school founded by Walt Disney, was starting a program in character animation. Lasseter remembers shaking as he read it. He sent in a portfolio and was the second person accepted. In fact, Jack Hannah, the head of the program and the director of most of Disney's Donald Duck cartoons, invited Lasseter to be his student assistant for the summer, to help prepare materials for the fall.

As Hannah's assistant, Lasseter's job was to comb the "morgue," the basement archive that held all the animation drawings, backgrounds, and layouts from all the Disney films, choose great film scenes, and make photocopies of the animation drawings that students could

Top: The first class of character animation students at CalArts. John Lasseter is at top, with pencil in teeth. Brad Bird is seated in the middle row with right elbow resting on his knee. John Musker is seated at front right.

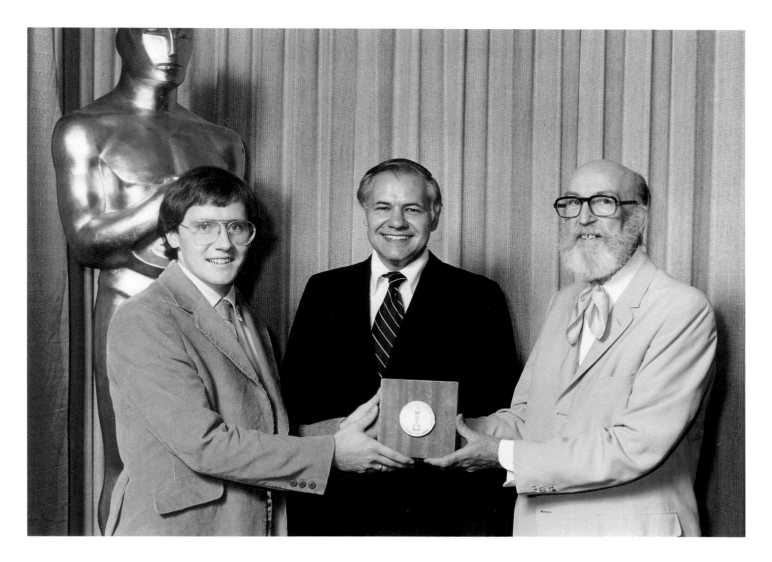

use for study. The job allowed him free access to much of the studio, and Lasseter met and became friends with several of the young artists in the animation training program—in particular, a young animator named Glen Keane.

Keane, who is now recognized as one of the greats of Disney animation, recalled, "John then wasn't any different than he is now. He was like a duck in water when he was dealing with animation—completely comfortable. This was his element; he knew everything about it."

For an animation fan, having the run of the Disney archives for a summer was an experience that was difficult to beat. But, amazingly, the school year was even better. "When classes started, it dawned on me pretty quickly how special this was," said Lasseter. The CalArts faculty included great artists from Disney's Golden Age, as well as the people who had taught them: art director and storyboard artist Elmer Plummer, layout artist Ken O'Connor, director Jack Hannah, and animator/director T. Hee. The students also had the benefit of design instruction from Bill Moore, a veteran instructor from one of CalArts' predecessor institutions, Chouinard Art Institute.

Lasseter's fellow students were as inspiring as his teachers. Most of the students in the inaugural years of the character animation program were, like Lasseter, longtime animation fans who had been writing to the Disney Studios for years. They included John Musker, who would co-direct such Disney features as *The Little Mermaid*, *Aladdin*, and *Hercules*; Tim Burton, whose animation experience would figure heavily in his work with *Batman* and

Top: John Lasseter receiving his Student Academy Award for "Lady and the Lamp." (The presenter at right is animator/director T. Hee.) Lasseter also won the following year for his short film "Nitemare." To this day, he is still the only two-time winner of the award.

The Nightmare Before Christmas (directed by Henry Selick, another classmate); Chris Buck, who would co-direct Disney's *Tarzan*; and Brad Bird, who would direct the animated feature *The Iron Giant* and, eventually, the Pixar film *The Incredibles*.

"Everyone was on fire about animation, and we didn't want to leave at the end of the day," Bird recalled. At night, they would check out beat-up 16mm prints of Disney classics like *Dumbo* and watch them on the school projectors, studying them meticulously, analyzing them frame by frame. "We probably learned as much from each other as we did from the teachers, just because we were all so into it, and spent so much time together," said Lasseter.

Lasseter said that the collaborative spirit was so inspiring that, years later, it made him determined to encourage the same openness at Pixar. "We worked really hard, but we also had so much fun, and it showed up in our work. We'd goof off, we'd laugh, we'd work together, and we'd look at and give feedback on each other's stuff. And the creativity just sort of overflowed."

> *"The first thing I saw of CalArts were the films that the students made. I saw John Musker's film, and I saw Brad Bird's film, and I saw John Lasseter's first film. There was a sense that there was a huge amount of talent at CalArts, and even at that early stage, I think we knew it was going to have a big impact on the studio."* —RON CLEMENTS

In the spring of his sophomore year, Lasseter and a group of classmates drove to the Chinese Theatre in Los Angeles to see the year's most anticipated movie: *Star Wars*. It proved to be another galvanizing moment in Lasseter's career. "Our expectations were high, but it had the goods. No one had ever seen anything like it before. The crowd just went nuts. You were having so much fun and were so into this film, you were just shaking by the end of it."

After seeing *Star Wars*, many of Lasseter's friends began thinking about going into live-action filmmaking with special effects. But for Lasseter, the experience only reaffirmed his commitment to his chosen medium. "I remember sitting there, looking around, and thinking, animation can entertain audiences like this. It made me rededicate myself to animation. I wanted to show it was possible to make something that could reach everyone, not just kids."

That summer Lasseter got a job at Disneyland. "I started off as a sweeper in Tomorrowland. People think that would be a lousy job, but it's actually one of the best jobs at Disneyland, because you're always out talking to the guests. It was especially exciting that summer because Space Mountain had just opened, and the park was so crowded and so fun. Everyone was having such a good time." After a few months, though, Lasseter was curious to see more of the park. Anticipating further work over the winter holidays, he applied to be a

Top left: Disney's Nine Old Men in 1972, from left to right, Woolie Reitherman, Milt Kahl, Les Clark, Marc Davis, Ward Kimball, Eric Larson, John Lounsbery (seated), Frank Thomas (standing), and Ollie Johnston. Top right: John Lasseter at work on The Fox and the Hound.

ride operator and was transferred to the Jungle Cruise. Unlike most Disneyland rides, the Jungle Cruise makes its ride operators, as the cruise "river guides," into part of the show.

"People don't believe this," said the famously gregarious Lasseter, "but it's the truth— before I worked on the Jungle Cruise, I was kind of shy. Even at CalArts, I basically just stayed in our small group. I was as nervous as could be the first time they loaded the boat with passengers—but suddenly something inside me clicked. Everything that I had trouble memorizing just came out. I started really having fun with it, doing voices and everything. By the end of the ride, people were clapping."

As an animator, Lasseter was used to performing in slow motion—one frame at a time. Working on the Jungle Cruise, he said, taught him things about comic timing that would have been much harder to learn through animation alone. He played with pacing and delivery, learning to tweak the material to its best effect. He learned how to read an audience's mood and roll with the punches when things weren't going well. Delivering the same routine hundreds of times also taught Lasseter that one's relationship to the material can make all the difference in the world.

"In animation, you work on your material for such a long time," he said. "You come to know it inside out. By the time you're done making the movie, you will have seen that joke, that line, that drawing, a thousand times, and it will no longer be funny. And a lot of times people will say, it's not funny anymore, let's try to make it funny, and in trying to 'fix' it, they break it. So I always tell people never to forget the first time something made you laugh."

At CalArts, students spent the first two years concentrating on a classic art education, and the last two years taking studio classes and producing short films. Lasseter's junior-year film, "Lady and the Lamp," was his first project to display what would become one of his signature talents—the ability to bring inanimate objects to life in a sympathetic and entertaining way.

"When I'm thinking about a story I literally see it happening in my head," Lasseter said. "Every new idea I get changes the picture in my head, and lets me see how the story might play differently. So I'm always thinking about how to 'plus' stuff, how to make something better and more entertaining. That's part of why I've always loved animation more than any other art form—because it gives you such incredible control over the way you tell

Top: The Walt Disney animation building in the 1980s.

your story. You can fine tune every last aspect—the characters, the performance, the look, the world, the details."

Brad Bird noted that Lasseter knew how to use that control from very early on. "As well as being talented and having his own great ideas, John was very talented at provoking ideas from other people, then picking and choosing which suggestions to use and how to use them. Directing isn't only about being able to pick out the good stuff; it's about knowing *which* good things to use and which good things *not* to use and how to assemble them to make the best whole. John always seems to make the right choice."

At the urging of his teacher T. Hee, who also happened to be one of the governors of the Academy of Motion Picture Arts and Sciences, Lasseter submitted "Lady and the Lamp" for the Student Academy Award—and won. Because of the timing of the awards cycle, Lasseter received the good news just as he was graduating from CalArts in 1979. It was a wonderful boost to receive as he prepared to begin the job he'd dreamed of for years—animating at the Walt Disney Studios.

Disney

> "We heard things about John from the very beginning. I remember when he was graduating, Bob Fitzpatrick, the president of CalArts, said to my husband, Ron [Miller, then the head of the Disney Studios], 'John Lasseter is something very special and you better let him have something to do there, because he wants it and [otherwise] maybe he won't stay.' I remember that. Very perceptive on Bob Fitzpatrick's part." —DIANE DISNEY MILLER

Though he wouldn't realize its significance until later, Lasseter arrived at Disney in the wake of a major upheaval. The week before he started work, roughly half of the animation department—mainly animators in their late twenties and early thirties—quit the company to form an independent studio under the leadership of animator Don Bluth (who would go on to direct *An American Tail* and *The Land Before Time*, among other films). In retrospect, the scale of the departure was an ominous sign.

But Lasseter was too thrilled to be working at Disney to give much thought to a walkout of the younger animators. After all, he and his CalArts classmates had come to the studio for the opportunity to work with its legends—the famous Nine Old Men, who had mastered the secrets of the form and transformed the frontier of animation into a citadel.

"I remember what it was like, walking through D wing in the animation building at that time," said Disney producer Don Hahn. "The first room was Henry Selick, Bill Kroyer, Dan Haskett, and John Musker. The second room was Brad Bird and Jerry Rees. Farther down the hall was Tim Burton, and Glen Keane was at the end of the hall. I was the guy running around with the clipboard, making sure everybody got their scenes done. Everybody was twenty-five and under, and they were all taking their drawings up to Frank and Ollie or to Milt and Eric. It blew up after that, and people like John Lasseter and Tim Burton and Brad Bird and Henry Selick all kind of blew to the winds. But there was that moment of contact, when the masters touched the students, and that affected everybody's lives."

Lasseter was now working with and learning from his idols—in particular, Frank Thomas and Ollie Johnston. "Their work had so much heart," Lasseter said. "They were actors, and they did these incredible moments that were always there for the story and the character." Lasseter, like many others, spent many afternoons in Frank and Ollie's office.

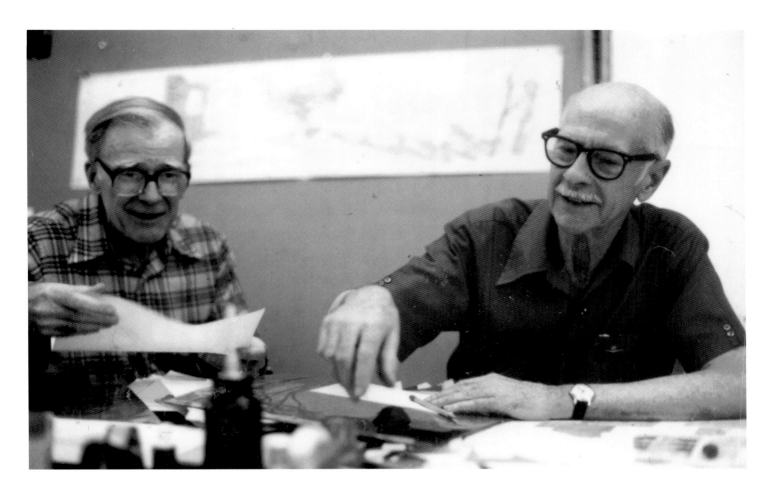

"Their door was always open. I would show them my scenes, and they'd give notes, and we'd just talk. They were starting to work on *The Illusion of Life* at the time, and so much of what would later go into that book was stuff I was able to get firsthand from them. It was unbelievable."

There was an instant connection between the still-green newcomers and the seasoned veterans, recalled Brad Bird. "The old masters still at the studio had been carrying the torch for quality animation all these years, and they recognized a similar passion in the young people coming in," he said. "We were believers, and these guys were like the apostles."

If these defining artists of Disney's Golden Era had still been calling the shots at the studio when this younger generation arrived, things might have turned out very differently. But by the fall of 1979, the Nine Old Men—the youngest of whom was already 65—had retreated from the studio's filmmaking life. Ward Kimball had retired. Les Clark and John Lounsbery had passed away. Those who remained at the studio—Ollie Johnston, Marc Davis, Eric Larson, Woolie Reitherman, and Frank Thomas—were focused primarily on mentoring the younger animators.

Meanwhile, the studio's leadership roles had fallen to people who showed little interest in what the new recruits had to offer. "All these new people were coming in, and we're all young and on fire with love for animation," recalled Lasseter. "We wanted to do *Star Wars*-level entertainment with animation! We were so excited, but the creative leadership didn't know how to handle us and worked really hard to keep us under control." In this restrictive atmosphere, the luster of working for Disney soon wore off. "I'll be honest, my bubble burst pretty quickly," Lasseter said ruefully.

Top: Frank Thomas and Ollie Johnston.

"We had come from a system at CalArts where we all looked at each other's work, we were each other's critics and supporters, we drew ideas from each other. We were all full of passion and enthusiasm. But at the time we came to Disney, that collegial spirit was not quite encouraged."—JOHN MUSKER

At the time, the studio was working on *The Fox and the Hound*. When Lasseter and his friend Glen Keane pitched some changes to the finale in order to create more tension and excitement, they were met with stubborn resistance—though their suggestions eventually ended up in the film.

One conversation in particular remained vivid in Lasseter's memory over thirty years later. "This guy said to me, 'So, you want to be creatively in charge here? I'll tell you how to be in charge. You sit down and do in-betweens for twenty years, *then* you can be in charge.' I remember walking away and deciding right then that if I was ever creatively in charge of anything, I'd *never* say to a young artist what that guy had just said to me. In that one exchange he killed all the enthusiasm I had to help make the project better."

Top: John Lasseter and Glen Keane, after working together on a new ending for The Fox and the Hound, *would continue to experiment, collaborating on an innovative animation test for "Where the Wild Things Are."*

"Almost no one entered animation between the mid-'50s and the early to mid-'70s. Even after Walt died, the Disney studio didn't go after new artists, and I've yet to find anyone who could explain why. They had the best animators in the world, and they seemed to think these people would just go on making films forever. But then as their artists began to retire and die, it eventually dawned on them that they'd better start getting some new people. Frank and Ollie and Eric Larson and Milt Kahl and Marc Davis and a few of the others were still around, and could help with the training somewhat. But the recruitment effort was

long overdue. So when that whole generation of young artists came into the business, there was a huge learning curve they had to repeat. Now, they had teachers who had done it, so they knew it could be done, they had the films to look at. But there hadn't been the kind of continuity in the art form there should have been, so there was still an enormous amount of ramping up that they shouldn't have had to do. They kind of had to go from a dead start and be coaxed along until their talents began to mature and develop, and their real potential could be realized." —CHARLES SOLOMON

For Lasseter, what made the rigidly hierarchical working environment even worse was the feeling that animation at the studio had hit a plateau. Walt Disney had been famous for his obsession with "plussing" (improving on) every project he touched, and under his leadership, the studio had acquired a reputation for innovation. From the multiplane camera invented for *Snow White and the Seven Dwarfs* through the animatronic squid developed for *20,000 Leagues Under the Sea*, Disney-supervised films were constantly experimenting with new filmmaking techniques and equipment. Lasseter, always interested in ways to improve his own work, greatly admired Disney's willingness to search out and test new technologies that might help tell a story more effectively.

But there had been no significant advances made in animation since 1961's *101 Dalmatians*, for which longtime Disney collaborator Ub Iwerks had invented the Xerox technique of photocopying drawings directly to cels. "The story of *101 Dalmatians* could not have been done without this technology," said Lasseter. "I mean, repeat animation for 101 dogs? Forget it—you wouldn't want to do that. But the Xerox made it possible. Some people worried about the loss of the hand-inked look, but they took the graphic quality of this new technique and designed a whole film to fit that, and it just worked beautifully. After that, there were still great, brilliant moments in their films, but the films as a whole were not up to what they used to be. I kept thinking, what's going to be the new thing that takes animation to the next level?"

As it turned out, Disney did have something innovative in the works—but not in animation.

Tron

"There was tremendous buzz and anticipation for *Tron* in the filmmaking and film-going community because it was breaking new ground," recalled film historian Leonard Maltin. "It represented Disney's willingness to try something *very* new that would put them on

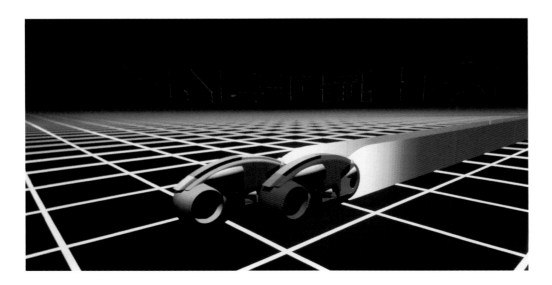

Left: An early version of the famous "lightcycle" sequence from Tron *was John Lasseter's first exposure to computer animation.*

the cutting edge." Though *Star Trek II*, with its Lucasfilm-produced Genesis Effect, would precede the movie to theatres, *Tron*, a story set inside a video game, was the first film to make integral use of computer graphics.

The film's effects were being done by three different companies: MAGI/Synthavision of Elmsford, New York, Digital Effects of New York City, and III (Triple-I) of Los Angeles. Jerry Rees, one of Lasseter's old CalArts buddies, and Bill Kroyer, a Disney pal, were working in a trailer on the Disney back lot doing storyboards and choreography for the computer graphics for the film. Knowing Lasseter had an interest in new technology, they invited him over to take a look at some of the first special-effects dailies they had received.

As it happened, they showed him the beginning of what would prove to be one of the film's iconic scenes—a MAGI/Synthavision sequence of two "light cycles" racing across a virtual landscape. "They threaded this film made with a computer through this old Moviola from the 1930s, which, in hindsight, is funny and ironic," Lasseter recalled. "I was immediately blown away by the potential of the images. Hand-drawn animation was always two-dimensional. Even the multiplane camera that allowed you to layer 2-D images only gave the appearance of three dimensions—sort of two-and-a-half-D. But what I was seeing was a true, three-dimensional world you could move around in."

Of course, animation had always offered true three-dimensionality in the form of stop-motion animation. But stop-motion lacked cel animation's ability to iterate—a deal-breaker for an inveterate reviser and fine-tuner like Lasseter. A series of drawings can be individually tweaked and rearranged, even repositioned, if necessary. But stop-motion is "straight ahead" animation; like live action, it captures its performances linearly. When each frame of a scene is photographed in sequence, it's impossible to change or refine details of timing, performance, or appearance without redoing the entire shot.

Computer animation, Lasseter immediately realized, promised to combine the dimensionality of stop-motion or live action with the iterative control of cel animation. The prospect of literally having a whole new dimension to play with—in an infinitely tweakable medium—was irresistible.

Glen Keane shared his excitement. "Our feeling was, 'Why can't *we* do that!?' Your imagination starts to take hold. And we started thinking, 'Wouldn't it be cool if we had

Top: One of Lasseter's designs for
The Brave Little Toaster. *John Lasseter, pencil.*

Disney-like characters moving against a dimensional background like they had in *Tron?*'"
The two approached Tom Wilhite, the studio executive overseeing *Tron*, about producing
a thirty-second test featuring hand-drawn characters moving around a three-dimensional
set. Wilhite, who had a development arrangement with Maurice Sendak, approved their
proposal and suggested that they base the test on characters from Sendak's book *Where the
Wild Things Are*.

Lasseter worked with MAGI/Synthavision's Chris Wedge (who would go on to direct
the films *Ice Age* and *Robots*) to model the environment and block out the scene with
geometric placeholders for Max and his dog, which Keane then used as a guide to
hand-animate the characters.

Lasseter and Keane saw the computer as the logical successor to the multiplane camera—
an advance in technology that held the potential to be as freeing for animation as the
Steadicam had been for live action. But when a screening of *Tron* met with a chilly
reception at Disney animation, the two sensed that the studio would not know what
to do with their experiment.

Frank Thomas was one of the few veteran animators excited about the project. "I'd say
95 percent of the fellows at the studio were saying, 'You'll never get me to do any com-
puter animation,'" Thomas recalled. "I think there were two or three people besides me
who felt there was a future for this. I said, 'Gee, if you can get that much imagination
and types of movement in there by a computer, not a pencil, you'll be ahead of the game.'
The potential was there, but at the time nobody wanted to do it except for Lasseter and
the people he was working with."

Hoping that their work would be greeted more favorably if they showed the executives
exactly how it could be put to use, Lasseter suggested to Keane that they develop an idea
for a feature in the same style, which they could present along with the completed test.
Lasseter's friend composer John Debney knew Lasseter's fondness for animating the
inanimate and had passed along a Thomas Disch novella called *The Brave Little Toaster*
that seemed the perfect fit.

Tom Wilhite, who remained supportive of their work, optioned the book, and Lasseter,
while continuing work with Keane on the *Wild Things* test, began developing *The
Brave Little Toaster* with his friends Brian McEntee and Joe Ranft. In a truly unfortunate
example of miscasting, Ranft—whom Lasseter considers one of the all-time greats of
animation story—had before then been assigned to in-betweening the effects in *Mickey's
Christmas Carol*, painstakingly animating the chains on the ghost of Jacob Marley. "John
saved me," Ranft said, laughing. "I don't think I would've survived much longer as an
in-betweener."

As with the *Wild Things* test, the plan was for the feature to be done with hand-animated
characters on computer-generated backgrounds. Lasseter began scouting companies to
see which one might be the best fit for the project. One of the companies he and Wilhite
visited was Lucasfilm.

For Ed Catmull and Alvy Ray Smith, having a Disney employee try to sell *them* on using
the computer for animation was unusual, to say the least. But the *Wild Things* work Lasseter
shared with them was one of the most novel uses of computer graphics they'd ever seen.
Lasseter, in turn, was dazzled by their newly completed image "The Road to Point Reyes,"
and he floated the idea of having Lucasfilm do the backgrounds for *The Brave Little Toaster*.
Regretfully, Catmull declined—their interests didn't quite line up, and he wasn't in a position

to contract out the Computer Division's services anyway. But the rapport between the two parties was clear.

Shortly after Lasseter returned from Lucasfilm, he was notified that *The Brave Little Toaster* had to be pitched to Ron Miller, the head of the studio, and Ed Hansen, the manager of the animation department, immediately. This made Lasseter uneasy—he believed in the project, but he had also perceived some coolness in Hansen's manner after Wilhite had given Lasseter's experiments the go-ahead. When Miller walked into the pitch looking grim, Hansen by his side, Lasseter knew it was going to be a tough sell. After the pitch, Miller stood up and asked how much the project would cost. When Lasseter said it would cost no more than a regular film, Miller replied that there was no point in using computer animation unless it would make things "faster or cheaper." With that, he walked out of the room. At first, Lasseter was almost too perplexed by what had happened for his disappointment to fully register. But there was more to come.

"About five minutes later," Lasseter said, "I got a call from Ed Hansen. I went down to his office, and he said, 'Well, John, your project is now complete, so your employment with the Disney Studios is now terminated.'

"I couldn't believe it. I had just been fired."

> *"There was a political battle going on at that time between the management that was here then and some of the younger management John worked for that was trying to sort of bring Disney into the modern era. But some of the old-school managers didn't like their turf being invaded, so John got caught in the crossfire, completely aside from any creative issues."*
> —JOHN MUSKER

Wilhite arranged to keep Lasseter on in the live-action department until the *Wild Things* test was completed, but there would be no further work for Lasseter at Disney Animation—a crushing prospect for someone who had never considered working anywhere else. It was as *Wild Things* wound down that fall that Lasseter, feeling numb and depressed, ran into Ed Catmull at a computer graphics conference on board the *Queen Mary* in Long Beach, California.

Catmull, a speaker at the conference, was happy to see Lasseter again and inquired after *Toaster*'s progress. He was disappointed to hear the project had been shelved, and sorry to hear Lasseter had been let go…but not *too* sorry.

"About an hour later," Lasseter remembered, "I was sitting in the grand ballroom listening to this boring speaker and thinking about how I wasn't going to do *Toaster*. All of a sudden I hear this whisper coming from off to the side: 'Pssst. John. John!' I looked over and there's Ed, standing behind a column. Ed doesn't normally do that kind of thing, so I got up and walked over.

"'John,' he goes, 'I was just talking to Alvy. Since you're not really doing anything, do you want to come up and do a little freelance job? We're thinking about doing something with character animation with the computer.' It seemed a little weird to me at the time—I had always thought the computer would do backgrounds, and the character animation would be done by hand—but yeah, why not? Frankly, I didn't have anything else going on."

A power reconfiguration at Disney had resulted in Wilhite's departure from the studio, so after clearing matters with his interim supervisor, Lasseter headed north to meet with the Lucasfilm team.

"I've always thought that if Walt Disney had still been alive, there never would've been a Pixar. Because Walt Disney would've had the first CG animation studio in the world; he would have understood that CG was an innovation. And John never would have left."
—CHRIS WEDGE

Lucasfilm

Lasseter made two trips to the Lucasfilm Computer Division in late 1983, to find out more about the work they were doing and get the lay of the land. After the *Wild Things* test was completed in January 1984 and Lasseter was officially shown the door at Disney, he promptly moved up to the Bay Area and began freelancing full-time at Lucasfilm.

Lasseter had spent the previous two years collecting examples of the best-looking computer-generated images he could find, and he soon realized that all of the people whose work he had most admired were at Lucasfilm.

"I was floored," Lasseter recalled. "I asked Ed, 'How did you get all these people? These guys are the best in the world.' And he said, 'Well, I try to hire people that are smarter than myself.' I laughed, but that statement really hit me, because Ed is really smart himself. It showed how secure he was in his own ability, to let great people shine. It was so opposite to what I had left behind at Disney, where all the young talent and enthusiasm was being kept down. It was amazing. I just started blossoming there."

Lasseter admits that at first, despite Catmull's good example, he was intimidated by his colleagues. At the time, pretty much any company or university working in computer graphics was using proprietary software, and he was worried that he would need to learn to program in order to work with Lucasfilm's system.

"I mean, there I was, surrounded by all these PhDs who had basically invented computer animation," he said. "I knew I was never going to be able to learn how to program like they could. But then I realized they couldn't bring a character to life with personality and emotion through pure movement like I could. So I thought, okay, I'm not going to worry about the programming. That's what they do. I'm just going to sit right next to them, and we're going to collaborate."

The Lucasfilm team had always intended for their technology to eventually be used to create art, and this was their first real opportunity to develop their tools with an artist's concerns in mind. Lasseter began by teaching his new colleagues how to think like artists themselves. "John taught us a lot about how to look at filmmaking and how to look at character animation and design," said Eben Ostby. Bill Reeves was inspired by Lasseter's early concept pastels for the short they were planning, which explored how particular scenes might be lit and shadowed. In his words, "they opened my eyes to what I wanted to start thinking about beyond just basic shapes—the sort of things an image needed to make it look good, to make it look interesting." A field trip to a Maxfield Parrish exhibit in San Francisco was for others an object lesson in color use, showing that a "green" tree is sometimes more effectively rendered in blue and orange and purple.

But what made Lasseter a uniquely catalytic addition to the Computer Division was his enthusiasm for the medium itself and the energy he derived from and brought to collaborative work.

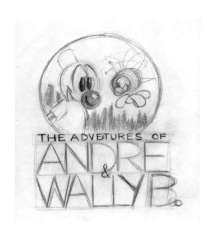

Top: Concept art for "The Adventures of André & Wally B." John Lasseter, pencil. Above: Lasseter's design for the team's "André & Wally B." T-shirt.

André & Wally B

Lasseter had been hired by Lucasfilm to design and animate the lead (and at that time, only) character in a one-minute short film that had been dubbed "My Breakfast with André," after the popular art-house film *My Dinner with Andre*. The short, as conceived by Smith, was to depict an android named André waking up and surveying the beautiful landscape around him. The character choice had been made with the computer's limitations in mind—since their modeling system could only handle geometric shapes (spheres, ellipsoids, cylinders, cones, and so on), a robot seemed the safest choice.

Lasseter soon realized that there was no reason to do a robot just because his shape palette was restricted. After all, the early versions of Mickey Mouse, as designed by Disney's earliest animator Ub Iwerks, had been made almost entirely of geometric forms. Taking those early Mickey Mouse designs as inspiration, Lasseter built a cartoony, soft-looking character, with ellipsoid fingers, tube arms, a spherical head, and a cylindrical hat. The one thing he was dissatisfied with was the body—the inverted ice-cream-cone shape he had fashioned out of a cone and a sphere just didn't have the right expressiveness. What he really needed, he told Catmull, was a shape that could bend, so that the character could express emotion and attitude through his posture. Catmull took on the assignment himself, eventually returning

with a teardrop shape whose top and bottom halves could be scaled and rotated to create a flexible, water balloon–like form. This not only addressed the problem of the main character's torso design, but provided the inspiration for a second character and a basic storyline.

"I was playing with the teardrop shape," Lasseter recalled, "and I just started envisioning this big fat bumblebee with these gigantic water balloon–like feet hanging from him—with no visible legs—and a big stainless-steel stinger."

There's the story, Lasseter thought, the motivation for André to move. The bee—which would have to be named Wally, of course, after the other character in *My Dinner with Andre*—would chase and sting André. It was a simple bit of business, but the character interaction gave the short some oomph.

To everyone's delight, this symbiotic back-and-forth continued throughout the project. "I loved working with these guys, and I kept challenging them, asking for new things," said Lasseter. "And then, seeing the work they were doing—not just the solutions, but the things that went 'wrong' in a neat way—made me come up with ideas I otherwise would never have thought of in a million years." This working relationship—which Lasseter neatly described as "the art challenges the technology, and the technology inspires the art"—would ultimately become the foundation of Pixar's approach to filmmaking.

Part of what helped Lasseter thrive in this environment was his ability to visualize the whole from the parts. Though the Lucasfilm Computer Division was working with some of the fastest computers available at the time, they still took hours to generate a single image element. For example, the components of "The Road to Point Reyes" had been developed separately, and then composited into the final image. But Lasseter could look at the different parts of an image individually—sometimes days apart—and hold all the elements in his mind's eye to see through to the finished product.

"The Adventures of André & Wally B.," which the team planned to unveil at that year's SIGGRAPH, would feature the skills of a real Disney-trained animator, set against the stylized, almost pointillist-like backgrounds generated by Bill Reeves' particle systems, and enhanced by the group's marquee breakthrough, motion blur.

Meanwhile, the hardware side of the Computer Division was making great strides toward Lucas's equipment goals. Ralph Guggenheim and his team were nearing completion on the EditDroid nonlinear video editing system, and Andy Moorer and his team were working on a second, lower-cost version of their digital audio signal processor (ASP), also known as SoundDroid.

Top: Concept art for André (left and middle) and Wally B. (right). John Lasseter, pastel. The teardrop shape Catmull created for André's body inspired Lasseter to create the character of Wally B.

The digital optical printer was actually being developed in two parts. David DiFrancesco had been working on the "printer" part—the laser scanner that would actually record the image to film. But the laser printer also needed a "brain"— a computer specially equipped to handle the complicated task of manipulating and assembling the picture components into a print-ready image. That "brain" was the Pixar Image Computer, being developed by Adam Levinthal, Rodney Stock, and Tom Porter. It was being designed to handle not only digital compositing, but any and all techniques necessary to re-create analog photographic effects in digital form.

The name "Pixar" had itself been a joint effort. "We always had a terrible history of naming things," Alvy Ray Smith admitted. "We could never name ourselves—we were always the 'Computer Division.' But it came time to name the image computer we'd made. And one night Loren Carpenter, Rodney Stock, and I were at this greasy spoon in Ignacio, a town in Marin County. I grew up in New Mexico, where Spanish is the second language, and the infinitive form of the verb always ends in 'er,' 'ir,' or 'ar.' I suggested 'Pixer,' an invented Spanish verb that means 'to make pictures.' I think it was Loren who said, 'Well, radar ends in 'ar,' and it's got a kind of high-tech feel to it. Why don't we use 'ar' instead of 'er'? And that's where 'Pixar' came from."

The word also had nice overtones of other felicitous combinations: "pixel" and "art" and "pixel arranger."

"The Pixar Image Computer was a good seven, eight years ahead of everybody else," Loren Carpenter explained. "It was 11.8 megahertz, which is nothing—my computer today is 3.2 gigahertz. But it still did a whole lot in one click. We could do painting, real-time rotation. It was this way of working with images and pixels that became the basis of the multimedia instructions in all modern processors."

SIGGRAPH 1984 was a milestone for the Lucasfilm Computer Division. Catmull had continued to encourage his researchers to publish their work, and that year the group had a record seven papers accepted to the conference. The hotel suite displaying the prototype Pixar Image Computer was continually swamped. And George Lucas himself flew out to Minneapolis for the debut of "The Adventures of André & Wally B." at the conference's film show.

Top: In the early days of CG, images were captured on film by setting up a camera to take a picture of each individual frame as it was finished and displayed on the computer's monitor (left). "The Adventures of André & Wally B." featured a number of technical innovations, but the most notable by far was motion blur (middle and right). Above: Wireframe model of Wally B. Edwin E. Catmull, John Lasseter, Eben Ostby, Alvy Ray Smith, digital.

Though part of the short was still unfinished—they had been loaned the use of several Crays, but rendering the motion blur had slowed even the supercomputers to a crawl— it was a hit with the audience. Later, Catmull recalled, many would not even remember that the piece had been incomplete. Lasseter's whimsical creations were something entirely different from the research images, flying logos, commercials, and demo reels that had become standard fare for SIGGRAPH exhibitions. "'That's the only thing I saw that looked like a movie to me,'" Lasseter remembered Lucas saying.

"The 1984 film show was actually the first time that I was embarrassed about computer graphics. I'd gone to SIGGRAPH every year since 1978 with such love, as someone who was part of this industry praying that we would grow and show the world what we could do. But for the first time, I watched it through George Lucas's eyes and saw that there wasn't a lot of filmmaking going on. There were a lot of images, but the creative element, the artistry, was missing. There wasn't enough that was good enough, in my estimation, to impress a major filmmaker. There was no comparison between what the computer industry was able to showcase and what George was able to put up on the screen with Return of the Jedi.*"*
—TOM PORTER

Lasseter returned to Los Angeles after SIGGRAPH. He was reluctant to leave the idyllic work environment at Lucasfilm, but he couldn't pass up the opportunity to direct *The Brave Little Toaster*, which Tom Wilhite, who had since left Disney, was planning to set up as an independent feature. In L.A., however, no one was returning his calls, and Lasseter soon learned that the funding had fallen through and the project was off. Stunned, he recalled, "I was so upset because I'd left probably the greatest experience I'd ever had, working with the Lucasfilm Computer Division.

Lasseter phoned Catmull to report the bad news about *Toaster,* and within the hour, Catmull called back with a full-time job offer. Lasseter returned north, becoming a full-time Lucasfilm employee in October 1984.

Lasseter rejoined the Computer Division just as it was being given another chance to show off its work in a feature film, this time in a period adventure directed by Barry Levinson called *Young Sherlock Holmes*. Dennis Muren, the film's visual-effects supervisor, was one of the few higher-ups at ILM truly interested in computer graphics, and he felt that the film's stained-glass knight sequence was the perfect opportunity to put the technology through its paces. As the first computer effect meant to blend seamlessly into a live-action scene, the project was an opportunity for the graphics group to prove it had been worth Lucas's investment—that computer graphics was a viable option for film effects. The group passed this test with flying colors—*Young Sherlock Holmes* was nominated for an Academy Award for Best Visual Effects—but for Lasseter, the experience was most memorable as a lasting lesson in management.

Top left: To create the stained-glass knight for Young Sherlock Holmes, *the effects team built a real-life model that was then digitized for manipulation in the computer. Here, Bill Reeves (left) and John Lasseter (right) digitize the cut-out knight.*
Top right: The finished effect, as seen in the film.

At ILM, the entire *Young Sherlock Holmes* team gathered for mandatory dailies every morning. Muren provided clear guidance, giving feedback on everyone's footage and carefully explaining why he was asking for any changes, but, as Lasseter recalled, the atmosphere was one of collective problem-solving. "The room was always open for discussion, and Dennis really listened to everybody. I was amazed by that. It was so different from anything I had experienced before. It molded me as a director in all the good ways, more than anything my past experiences had taught me not to do." This open-dailies model would eventually become an important feature of Pixar's creative culture.

> *"Doing the stained-glass knight for* Young Sherlock Holmes *was really painful, because I was used to being able to grab something and physically alter it when I needed to change its look. And in this case, you couldn't do any of that—you had to wait until tomorrow, or three days from now. But the stuff really stands up today, and the potential of it was just phenomenal. You could design the thing exactly the way that your mind conceived it, not only shape-wise, but also lighting-wise or anything. It was really great being there, working on it with the pioneers of that whole process."*
> —*DENNIS MUREN*

How to Start a Business

Ironically, the Computer Division's success was accompanied by increasing uncertainty about the group's future. Once philosophical questions about how an advanced technology group like the Computer Division would fit in at Lucasfilm were being superseded by practical questions of how to keep the group alive.

Over time, several projects that had originally begun as part of the Computer Division—EditDroid, SoundDroid, and a new computer games effort later called DroidWorks—had effectively been spun off from the main group. As this happened, the term "Computer Division" came to refer less to the group that handled all of the development of Lucasfilm's technical tools, and more to the group doing work on the graphics portion of the original set of goals. And while their effects work was impressive, it represented only the tiniest fraction of Lucasfilm's overall effects load. The Computer Division was for all practical purposes a pure research group, and as such, it was a tempting target for company executives looking to cut costs. (Lasseter had been smuggled into the company as an "interface designer"; the group would never have been permitted to hire something so "frivolous" as an animator.)

"Ed and I had to suffer a lot of attacks on our people, attempts to have them fired," remembered Smith. The executives then running Lucasfilm, he said, didn't seem to realize that the true value of the Computer Division was the talent that had produced the technology, not the technology itself.

Catmull and Smith decided to take matters into their own hands before their group was irreparably downsized. "We actually went to a local bookstore and bought one of those 'How to Start a Business' books," Smith recalled. "I can't believe we were that naïve, but that's what we did."

Catmull and Smith drew up a business plan for a forty-person company. Their ultimate dream was, of course, to create a computer-animated film, but the medium was too new to serve as the foundation for a self-supporting company. Instead, they based their proposal on the group's most promising piece of technology—the Pixar Image Computer, which

had generated interest in fields ranging from medical imaging to satellite surveillance. Animation was justified in their plan as a form of training. Catmull admits that while it made no sense from a business point of view, there was never any thought of cutting animation from the agenda. "It was ingrained into who we were," he said simply.

Lucas had always been supportive of the group and its groundbreaking work, but a diverging of paths seemed inevitable. While he had not hesitated to develop technology he could not acquire otherwise, he didn't want to run a computer company; it would require considerable investment to pursue the business opportunities for the group's technologies. And though he was sympathetic to their ambition to pursue computer animation, as he put it, "I couldn't really start another film company—I was already in the middle of one. We just didn't have the resources to try to put together an operation like that."

So it was agreed—the Computer Division would strike out on its own. Catmull and Smith began looking for an investor.

Top: In planning to spin off the Lucasfilm Computer Division into its own company, Ed Catmull (left) and Alvy Ray Smith (right) based the prospective company's business plan on the Pixar Image Computer.

Chapter 3

Steve

Steve Jobs grew up in what is now called Silicon Valley, at a time when the area was still largely fruit orchards. Back then, as he recalled in a 1995 interview with the Smithsonian Institution, the air was so clear you could see from one end of the valley to the other. His father, Paul, was a machinist and "kind of a genius with his hands," said Jobs. He gave his son an early education in what would become the language of the valley—the language of invention and construction.

"When I was about five or six, he sectioned off a little piece of [his workbench in the garage] and said, 'Steve, this is your workbench now.' And he gave me some of his smaller tools and showed me how to use a hammer and saw and how to build things. It really was very good for me. He spent a lot of time with me…teaching me how to build things, how to take things apart, [how to] put things back together."

Larry Lang, a Hewlett-Packard engineer and ham radio enthusiast who lived down the street, taught Jobs about electronics. It was through Lang that Jobs discovered Heathkits— do-it-yourself kits for assembling audio equipment and other electronic products. "Heathkits were really great," said Jobs. "You looked at a television set [and thought,] 'I haven't built one of those, but I could. There's one of those in the Heathkit catalog, and I've built two other Heathkits, so I could build that.' Things became much more clear that they were the results of human creation, not these magical things that just appeared in one's environment. [They gave you] a tremendous sense of self-confidence, that through exploration and learning one could understand seemingly very complex things in one's environment."

Reed

After graduating from high school, Jobs enrolled at Reed College in Oregon. His parents, who had adopted him at birth, had promised his biological mother that he would receive a college education. However, Jobs quickly became worried about the heavy financial burden the tuition was placing on them, and he dropped out after six months.

As he put it in his 2005 commencement address to Stanford University, "I had no idea what I wanted to do with my life and no idea how college was going to help me figure

it out. And here I was spending all of the money my parents had saved their entire life. So I decided to drop out and trust that it would all work out okay."

Though no longer an enrolled student, Jobs remained on campus, sleeping on his friends' floors, scraping together food money by collecting bottles for the nickel deposits, and dropping in on the classes he found truly engaging. One of these was a class on calligraphy—a discipline in which Reed had developed a national reputation. Jobs had always been attracted to the visual, but the calligraphy class was his first sustained study of the visual elements of design.

"I learned about serif and sans serif typefaces," Jobs said, "about varying the amount of space between different letter combinations, about what makes great typography great. It was beautiful, historical, artistically subtle in a way that science can't capture, and I found it fascinating." Typography, or the design of the appearance of text, is a medium in which the quiet but powerful influence of the visual can be immediately and viscerally sensed. There are few simpler ways to show that form always has an effect on function or content than to look at the same piece of text in two wildly different fonts. If Jobs' early interactions with the mechanical world had instilled in him the conviction that technical innovations were meant to be understood and put to use, his study of typography high-lighted the ways in which design can influence experience.

Apple

Of course, Jobs would go on to dedicate his career to making sophisticated technology widely used and widely accessible. Apple Computer, the company he founded in 1976 with his friend Steve Wozniak, introduced the American public to the notion of the "personal computer" with the Apple II, the first computer meant for a broad market of home users.

From the beginning, Apple focused on improving the quality of its users' experience through the use of thoughtful design and the incorporation of cutting-edge developments in visual technology. The Apple II was the first personal computer to employ color graph-ics, and the company cemented its reputation as an innovator with the 1984 debut of the Macintosh, the first mass-market computer to employ bitmap graphics and a graphical user

Top: Steve Jobs
Above: Apple's Macintosh computer.

interface. Options like multiple typefaces and proportionally spaced fonts allowed its users, in turn, to exercise greater control over the visual presentation of *their* results.

Almost immediately after the company became a success, Jobs began campaigning to put computers in schools, to make computer literacy part of the educational curriculum. Apple ultimately donated a computer to every public school in the state of California, with software developer partners making a matching donation of software—the first ever mass deployment of computers to schools.

In short, Apple was unquestionably the most graphically-oriented, consumer-friendly computer company of its era. So when Utah alum and recent Apple hire Alan Kay heard that the graphics folks at the Lucasfilm Computer Division were looking for an investor, an introduction seemed in order.

"I think one of the strongest positive things you can say about Steve is he has a real feeling for quality. And he's quite willing, in the manner of anybody who's interested in art, to pay extra for the quality. It's like, you can get about 95 percent of the sound of even a good pipe organ digitally these days, and it is an unbelievable multiplier to get those last few percent to 'perfect,' but if you care, you will do it. And that group is typical of what I think of this old-guard group being like—they're tremendously loyal, they stick around, they're willing to work on hard problems, and they're willing to just gut it out for as long as it takes to get quality. So I was pretty sure that he would absolutely appreciate what these guys were trying to do." —ALAN KAY

Putting a Deal Together

"Apple had been doing stuff with graphics at some level for ten years," recalled Jobs, "but it was all 2-D. The 3-D stuff that Ed and his team were doing was way beyond what anybody else was doing. It was very exciting, and I recommended to Apple that we acquire their team. But at the time, I was basically in the process of getting fired from Apple, and they weren't interested in it anyway."

Shortly thereafter Jobs made his own offer for the Computer Division, proposing to incorporate the group's talents into a new computer company. "It was a remarkable idea," said Catmull—one that would eventually lead to NeXT, and later back to Apple and the OSX operating system—but it was not what Catmull and Smith were looking for, and they politely declined. They wanted to stay focused on pure graphics, and eventually expand into animation.

Catmull and Smith continued their search for an investor. "It was an awful process, just grueling," said Catmull. "It nearly tore us apart. One of Alvy's friends, who had just formed a company, emphasized over and over that it was the hardest thing you could ever do in your life. So we were warned—but it didn't make things any easier. It was painful largely because the businesspeople at Lucasfilm at the time—who are no longer there—were not very good and were making life hell for us."

Though there had been a fair amount of interest in the Computer Division, many investors were deterred by the asking price Lucasfilm had set: $15 million for partial ownership of the new company, plus $15 million in guaranteed funding.

Catmull and Smith spent much of the year trying to pull together a deal with the Computer Division's two most serious suitors, Philips and General Motors. The Dutch

Above: The Wall Street Journal's *coverage of the sale of the Lucasfilm Computer Division.*

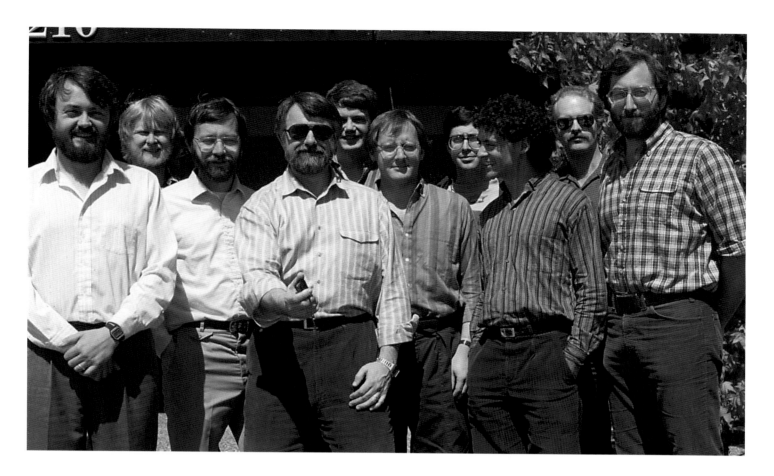

electronics giant was interested in using the Pixar Image Computer for medical imaging purposes, and the American car manufacturer wanted to use the Pixar for computer-assisted automotive design. Philips, GM, and Lucasfilm would become the new company's majority owners, with the employees getting a piece as well, and the big corporations would provide the working capital. But the deal fell apart at the last minute in November 1985 due to internecine conflict between GM and Ross Perot's company EDS, then a GM subsidiary.

After making his original offer to Catmull and Smith, Jobs had gone on to start NeXT Computer, Inc., which would offer its customers a graphically sophisticated computing environment running on a machine of workstation-like power and performance. With his new computer company up and running—the one for which he had originally been interested in acquiring the Lucasfilm team—there was theoretically no more reason for Jobs to be interested in their group.

For someone whose expertise was in making computers for the consumer market, the attraction of a specialized graphics company filled with computer science PhDs who, actually, *really* wanted to make movies wasn't necessarily obvious. But Jobs had kept an eye on the Computer Division, waiting for the right time to make a move, and after the GM/Philips deal fell through, he promptly put in an offer to Lucasfilm.

As Jobs saw it, buying Pixar was a natural extension of the interests that had governed his career. "I truly believed that computer graphics—and I had some experience with that in a 2-D form—could be used to make products that would be extremely mainstream. Not tangible, manufactured products, but something more like software—intellectual products. It just made sense to me. And what I saw at Pixar was some *amazing* computer science and the possibility of that being used in an even more artistic fashion than I'd ever been involved in. So I was very excited.

Top: Some of the key members of the Lucasfilm Computer Division. From left to right, Loren Carpenter, Bill Reeves, Ed Catmull, Alvy Ray Smith, Rob Cook, John Lasseter, Eben Ostby, David Salesin, Craig Good, and Sam Leffler.

"What's more, I could see computing power exploding exponentially over the next decade. But hardly anyone I knew had any idea of exactly what they were going to do with all that power. And I saw Pixar was a black hole for computing power." Jobs smiled. "So I liked that too."

Pixar

On February 3, 1986, Jobs acquired Lucasfilm's Computer Division for $10 million—$5 million to Lucasfilm and $5 million in guaranteed funding for the new company, which would be named Pixar, after its most well-known product. Pixar would take all the graphics hardware and software technology it had developed, but Lucasfilm would retain a stake in the advances the Computer Division had developed before the sale.

> *"We lost a ton of money on the Computer Division, even after selling it, but in the end it paid off. Because it put us ahead of everybody else in the special-effects business and ultimately got me where I wanted to go, which was to be able to tell the* Star Wars *story the way I wanted to tell it."* —GEORGE LUCAS

The filmmaking innovations envisioned by Lucas, and brought to fruition by the various offshoots of the original Computer Division, made Lucasfilm by far the most technically advanced studio of the time. Although the bulk of the computer graphics group departed as Pixar, Lucasfilm would continue to develop the use of CG in special effects under George Joblove and Doug Kay, whom Catmull had helped recruit to ILM.

Lucasfilm's interest in the Computer Division research was later translated into a perpetual license to future versions of RenderMan software. As Catmull observes, the value of this license has, over the years, turned out to be worth far more to Lucasfilm than the original sale price of the division.

Though Lucasfilm was not, in the end, the place for Pixar to grow, the two companies would maintain a warm relationship. "Years later, when *Toy Story* came out," Lasseter remembered, "George came over and we toured him around the studio. He was so proud and happy for us. I'll never forget it."

"There are a hundred different ways George could have reacted to Pixar's success," said Jobs. "But the way he's always felt about Pixar is as a proud papa. He's been supportive every step of the way—both because of his personal connection with us, and because he is a huge champion of Bay Area filmmaking. And I've always admired him for that."

It had taken over ten years for Catmull to assemble a team with the right skills to produce the computer animation he'd imagined. Lucasfilm had been the staging ground, where a

Top: As part of the Pixar purchase agreement, Steve Jobs provided $5 million in guaranteed funding for the new company.

world-class team of computer scientists and a world-class creative talent who understood and loved the medium had finally come together. As a group, they had developed ground-breaking tools for a field whose potential was only starting to be grasped. But it was Steve Jobs' willingness to bet on that team as an end in and of itself—to support its ambitions to use those tools in realizing its own creative vision—that would enable the group to fulfill its dream of becoming a movie company.

Lucas recalled that, as the negotiations for the sale began, "I had one meeting with Steve, and it was basically a friendly kind of, 'Well, good luck.' I did say, 'You know, these guys are hell-bent on animation.' I did warn him that was basically Ed and John's agenda, and said, 'You know, if you think you're going to make products, I don't think that's what their idea is.' He didn't really say much about it one way or the other. But I think in his heart he bought the company because that was his agenda, too."

Indeed, Jobs had already bought into that dream "both spiritually and financially," he said with a laugh. As Lasseter recalled, "It was the level of talent he saw in the room that he believed in. Steve has always said that computers are the doorstops of the future; they're going to become sediment some day. It's what people *do* with computers that matters, and what he believed in was our ability to create amazing images that could live forever. I think that from the beginning Steve believed in Ed's dream of doing a feature film using computer animation."

Top: Steve Jobs.

Chapter 4

Pixar's Early Days

Pixar's original plan of supporting itself with the Pixar Image Computer seemed promising at first. The system's impressive power meant there was no shortage of interest—even though it was so far ahead of the curve that in some cases Pixar had to show its customers how it could be put to use.

"We started off with customers in the medical industry, the graphic arts industry, and the intelligence industry," Jobs recalled. "We invented software to do volumetric rendering for medical imaging. We'd take CAT scan data and rebuild the volume computationally, and use the Pixar Image Computer to do that and display it. You could actually rotate the image and cut it in various ways—nobody had ever seen anything like this. Now it's fairly commonplace, but most people don't know Pixar invented that."

The Pixar was an obvious attraction for companies working on computer-aided design, and while intelligence agencies kept their uses of the Pixar secret—"They would always buy our machines as 'Mr. Brown,'" Smith remembered—the Image Computer's ability to work with large satellite images was undoubtedly a selling point.

But one of the new company's most important contracts—certainly the most important in retrospect—was with Disney, for a hardware and software system called CAPS (Computer Animation Production System). Though the deal was finalized in the spring of 1986, it had actually been a year and a half in the making.

CAPS

In 1984, Disney had been taken over by new management. Roy Disney had led a shareholder revolt, bringing Michael Eisner and Frank Wells over from Paramount to head up the company, which he felt had become stagnant since his Uncle Walt's death. Though Eisner lieutenant Jeffrey Katzenberg was given responsibility for the overall Walt Disney Studios, Roy Disney, at his own request, was made chairman of Feature Animation.

Above: Luxo Jr. Rendered character pose.
Previous spread: Luxo and Luxo Jr.
Rendered film image.

"Animation had been sort of dying a slow, strangulated death over the ten years before that," he recalled. "Longer than that, really, because it sort of began to tail off when Walt

died. There was more talent there than was being utilized." Though creative renewal was his overriding concern, Roy Disney knew that such change had to be supported by operational improvements. Part of the ensuing reexamination of the studio's production methods was the decision to pursue a system that would allow animation drawings to be inked and painted in the computer instead of doing the work by hand on cels (an idea that had its roots in Garland Stern's work at New York Tech). Since the Pixar Image Computer was the fastest and most powerful image-processing machine in the industry, the Disney group came to the team in Marin.

The resulting system was a collaboration between Disney Feature Animation and Pixar, with Lem Davis and Mark Kimball of Disney developing the program that managed the thousands of images, and Tom Hahn, Michael Shantzis, and Peter Nye of Pixar developing the software that handled the "cel painting" image manipulation and filmmaking. The entire system ran on 21 Pixar Image Computers. Digital inking and painting—which gave artists a much broader and more finely varied palette than traditional methods— was actually only part of the CAPS package, which aimed to match and surpass any and all hand-created effects. Removing the physical cel from the equation meant images could be composed of many layers, with no fear of degradation, and could incorporate computer effects and sets. Multiplane effects, once prohibitively expensive, could now be used freely.

After experimenting with the system on the final scene in *The Little Mermaid*, Disney implemented it in full on *The Rescuers Down Under*—the first film ever to be completely processed through a computer. Said Kathleen Gavin, the film's associate producer, "In the beginning we thought of it as a paint system, but ultimately CAPS was a camera system. It gave us the live-action ability to use the camera to help tell the story, and that allowed us to be far more filmic than we would have ever dreamed."

"It catapulted the look of the films into an entirely new dimension," explained Sarah McArthur, the film's production manager. "The eagle flying sequence in *The Rescuers Down Under* was spectacular, because the characters could literally fly through the clouds in a way that they'd never been able to do before. And then every film thereafter just leapt up one notch after the other. And then every film thereafter just leapt up one notch after the other. There were directors who were hesitant at first, saying, 'Oh, I don't want to; what's wrong with the way we've always done it?' But the minute they saw the results, they were clamoring for it. CAPS was totally a godsend to the industry."

It was the following year's *Beauty and the Beast*, the first animated feature to be nominated for the Best Picture Academy Award, that would give the system's capabilities their widest exposure. One of the clips of choice whenever the film was referred to on television was a scene that could never have been done without CAPS: Belle and Beast, tracked by a swooping camera, waltzing in a computer-generated ballroom. Interestingly, the scene's

Above: The Pixar Image Computer. The look John Lasseter designed for the machine, referred to as the "BSD" (beveled square with dent), also served as the company's logo for several years.
Left: One of the Pixar Image Computer's most innovative uses was developed for medical imaging. Data from two-dimensional CAT scan "slices" of a human body was used to create a rotatable 3-D image.

use of animated characters set against a CG background, "filmed" with a moving camera, recalled work that Glen Keane and John Lasseter had done over fifteen years earlier with their *Wild Things* test.

Luxo Jr.

The initial core of Pixar's animation group was composed of four people—John Lasseter, Bill Reeves, Eben Ostby, and Sam Leffler (formerly of the Unix/BSD group at UC Berkeley)—sharing an office in one of the company's back hallways. Like mammals in the age of dinosaurs, they were strictly a side project compared to the main hardware business. "It was tough in the early days," Bill Reeves noted. "You wondered how much growth potential there was in that kind of stuff. But it was a blast—you're just creating stuff. It was fun, until it came time to think about where the paycheck was coming from."

But Catmull was determined to keep animation an integral part of the company's identity, and he had asked Lasseter to begin work on another short film. "'Let's do a little film for SIGGRAPH,'" Lasseter recalled him saying, "'something that says who we are.'"

In a technology-inspires-art story perfectly befitting Pixar's first project, the idea for the short came from the computer modeling lessons Lasseter had been receiving from Reeves and Eben Ostby. Shortly after Catmull proposed the new project, Lasseter was working on a digital model of the Luxo lamp on his drawing table. Once the model was finished and articulated, he began playing with it, moving it around as if it were alive. "Hmm," he remembered thinking. "Maybe there's something we can do with this."

Lasseter prepared some Luxo motion studies and brought them along to an animation festival in Belgium, where he gave a short presentation. There, Belgian animator Raoul Servais complimented Lasseter on the studies and asked him about the project's story. Oh, there wasn't really a story, Lasseter answered; it was just a simple character study.

Servais advised, "No matter how short a film it is, it can and should have a story—a beginning, middle, and an end." As soon as he heard this, Lasseter knew Servais was right. The film would be short—they couldn't afford anything big—but it had to have a story. Indeed, it would be the last time anyone would ever need to remind Lasseter of the importance of storytelling.

Top: "'Luxo Jr.' was a revelation," said CG researcher Jim Blinn. "I saw that thing and was blown off my chair." From left, photograph of Luxo lamp; concept pastel by John Lasseter, wireframe model of Luxo, Luxo motion study, and rendered film images.

Back at Pixar, an office visit from Tom Porter's young son inspired the creation of a second character—a Luxo Jr. "Spencer was about one and a half," Lasseter recalled, "and seeing him hold his arms up over his head made me laugh, because he couldn't really touch the top of his head yet. After he left, I started thinking, what would a baby lamp look like?"

Once Lasseter designed the child-scaled lamp, the relationship between the two characters was clear—a parent lamp and its boisterous, energetic child.

The computer was allowing Lasseter to truly come into his own as an animator. "My drawing skills were always weaker than my sense of timing and the movement I saw in my head," he explained. "When I was able to simply move an existing model, I stopped thinking about individual frames and started thinking of time as a whole."

Lasseter always did his best work at night, and since the animation group had to share time on their single interactive animation workstation, he generally took the midnight shift. "I'd get started around 9:30 or 10:00 at night, crank the music up, and get in the zone, me and the scene I was working on. And time would just stop. There were no windows in the first graphics room we had, so I would never have any idea what time it was unless people started coming to work."

Deirdre Warin, the receptionist at the time, often came to work to find a note from Lasseter asking her to wake him up when she arrived—a practice that would become routine over the next few projects. "I'd have to bang on the door because John would be asleep," she remembered. "He used to bring in a futon and sleep under his desk. And then he would get up, get a cup of coffee, and start animating again. He'd do this for weeks toward the end of each short film. It was nerve-wracking, but he always came through."

Bill Reeves, former Lucasfilm researcher David Salesin, and Rob Cook had come up with the technical advance showcased in "Luxo Jr."—self-shadowing. Previously, CG shadows had been created by "flattening" a darkened version of the shadowed object. "Those cast shadows looked fake but gave the look of a shadow," Lasseter explained. "Bill came up with the idea of this kind of depth map that was an image rendered from the point of view of the light source. Instead of storing information on the color of the objects in its view, it stored information on the distance to other objects. If one object appeared in the depth map before another, you knew that the former should cast a shadow on the latter. If nothing in the depth map appeared before an object, it was not in shadow and would be fully illuminated. You could even indicate what color you wanted the shadow to be. The animation of a lamp whose head is a light source, moving around and self-shadowing the world around him, was a perfect matching of technology and subject matter."

Because the group couldn't afford the computer time necessary to create backgrounds, their "set" was a plain wood-grain tabletop set against a black background. But, as Lasseter later concluded, the simple environment helped viewers focus on the characters and the animation. Even the computationally inexpensive black background served an artistic function, helping show off the contrast of light and shadow.

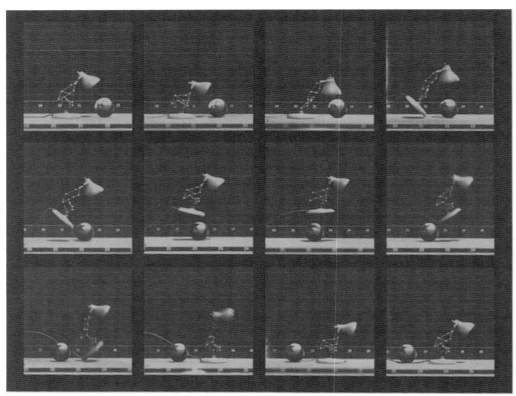

Plate 1292. *Child Lamp Hopping* *Eadweard Muybridge ca. 1889*

"Luxo Jr." made its debut as the next-to-last item in the 1986 SIGGRAPH film show, held in a huge arena in Dallas. Lasseter was nervous as he waited for the film to be screened. The program was heavy with flashy flying logos and rotating 3-D objects, and he worried that Pixar's offering—a minute and a half of animation on a simple set, filmed with a stationary camera—would be boring after all the "glitz and chrome." But before "Luxo Jr." had even finished, the huge crowd rose in a thunderous standing ovation. No one had ever seen anything like this before. Animation had always created the "illusion of life," but these utterly believable characters fairly leapt off the screen.

Jim Blinn, a former Utah classmate of Ed Catmull's who was himself doing pioneering work in CG, came up to Lasseter immediately after the screening. Lasseter braced himself for a question about self-shadowing or some other technology that he wouldn't know how to answer.

"John," Blinn asked, "was the parent lamp a mother or a father?"

"I knew, at that moment, we'd done it," Lasseter said with a smile. "For the first time, the story and characters were more important than the computer technology."

> *"Luxo Jr." to me was very John Lasseter in the sense that the lamps were very simple, seemingly mechanical, emotionless things, but he got a tremendous amount of expression out of them. So many animated films have tremendous skill on display, but don't look like anyone had any fun making them. One of the things I love about John's work is there's absolute joy in it!" —BRAD BIRD*

"Luxo Jr." proved that the medium of computer animation had advanced to the point where it could not only unobtrusively support a story but enhance it. It would become the first 3-D computer-animated film ever to be nominated for an Academy Award, and the little bouncing lamp eventually became a symbol of Pixar itself. As part of the studio's logo, Luxo Jr. would

Top: "Child Lamp Hopping," an homage to Eadweard Muybridge featuring Luxo Jr.

Computer Graphics, Volume 21, Number 4, July 1987

PRINCIPLES OF TRADITIONAL ANIMATION
APPLIED TO 3D COMPUTER ANIMATION

John Lasseter
Pixar
San Rafael
California

"There is no particular mystery in animation... it's really very simple, and like anything that is simple, it is about the hardest thing in the world to do." Bill Tytla at the Walt Disney Studio, June 28, 1937. [14]

ABSTRACT

This paper describes the basic principles of traditional 2D hand drawn animation and their application to 3D computer animation. After describing how these principles evolved, the individual principles are detailed, addressing their meanings in 2D hand drawn animation and their application to 3D computer animation. This should demonstrate the importance of these principles to quality 3D computer animation.

CR Categories and Subject Descriptors:

I.3.6 *Computer Graphics* : Methodology and Techniques - Interaction techniques;

I.3.7 *Computer Graphics* : Three-dimensional Graphics and Realism - Animation;

I.5 *Computer Applications* : Arts and Humanities - Arts, fine and performing.

General Terms: Design, Human Factors.

Additional Keywords and Phrases: Animation Principles, Keyframe Animation, Squash and Stretch, Luxo Jr.

1. INTRODUCTION

Early research in computer animation developed 2D animation techniques based on traditional animation. [7] Techniques such as storyboarding [11], keyframe animation, [4,5] inbetweening, [16,22] scan/paint, and multiplane backgrounds [17] attempted to apply the cel animation process to the computer. As 3D computer animation research matured, more resources were devoted to image rendering than to animation. Because 3D computer animation uses 3D models instead of 2D drawings, fewer techniques from traditional animation were applied. Early 3D animation systems were script based [6], followed by a few spline-interpolated keyframe systems. [22] But these systems were developed by companies for internal use, and so very few traditionally trained animators found their way into 3D computer animation.

"Luxo" is a trademark of Jac Jacobsen Industries AS.

The last two years have seen the appearance of reliable, user friendly, keyframe animation systems from such companies as Wavefront Technologies Inc. [29] Alias Research Inc., [2] Abel Image Research (RIP), [1] Vertigo Systems Inc., [28] Symbolics Inc., [25] and others. These systems will enable people to produce more high quality computer animation. Unfortunately, these systems will also enable people to produce more bad computer animation.

Much of this bad animation will be due to unfamiliarity with the fundamental principles that have been used for hand drawn character animation for over 50 years. Understanding these principles of traditional animation is essential to producing good computer animation. Such an understanding should also be important to the designers of the systems used by these animators.

In this paper, I will explain the fundamental principles of traditional animation and how they apply to 3D keyframe computer animation.

2. PRINCIPLES OF ANIMATION

Between the late 1920's and the late 1930's animation grew from a novelty to an art form at the Walt Disney Studio. With every picture, actions became more convincing, and characters were emerging as true personalities. Audiences were enthusiastic and many of the animators were satisfied, however it was clear to Walt Disney that the level of animation and existing characters were not adequate to pursue new story lines-- characters were limited to certain types of action and, audience acceptance notwithstanding, they were not appealing to the eye. It was apparent to Walt Disney that no one could successfully animate a humanized figure or a life-like animal; a new drawing approach was necessary to improve the level of animation exemplified by the *Three Little Pigs*. [10]

FIGURE 1. Luxo Jr.'s hop with overlapping action on cord. Flip pages from last page of paper to front. The top figures are frames 1-5, the bottom are frames 6-10.

SIGGRAPH '87, Anaheim, July 27-31, 1987

Disney set up drawing classes for his animators at the Chouinard Art Institute in Los Angeles under instructor Don Graham. When the classes were started, most of the animators were drawing using the old cartoon formula of standardized shapes, sizes, actions, and gestures, with little or no reference to nature. [12] Out of these classes grew a way of drawing moving human figures and animals. The students studied models in motion [20] as well as live action film, playing certain actions over and over. [13] The analysis of action became important to the development of animation.

Some of the animators began to apply the lessons of these classes to production animation, which became more sophisticated and realistic. The animators continually searched for better ways to communicate to one another the ideas learned from these lessons. Gradually, procedures were isolated and named, analyzed and perfected, and new artists were taught these practices as rules of the trade. [26] They became the fundamental principles of traditional animation:

1. *Squash and Stretch* -- Defining the rigidity and mass of an object by distorting its shape during an action.

2. *Timing* -- Spacing actions to define the weight and size of objects and the personality of characters.

3. *Anticipation* -- The preparation for an action.

4. *Staging* -- Presenting an idea so that it is unmistakably clear.

5. *Follow Through and Overlapping Action* -- The termination of an action and establishing its relationship to the next action.

6. *Straight Ahead Action and Pose-To-Pose Action* -- The two contrasting approaches to the creation of movement.

7. *Slow In and Out* -- The spacing of the inbetween frames to achieve subtlety of timing and movement.

8. *Arcs* -- The visual path of action for natural movement.

9. *Exaggeration* -- Accentuating the essence of an idea via the design and the action.

10. *Secondary Action* -- The action of an object resulting from another action.

11. *Appeal* -- Creating a design or an action that the audience enjoys watching.

The application of some of these principles mean the same regardless of the medium of animation. 2D hand drawn animation deals with a sequence of two dimensional drawings that simulate motion. 3D computer animation involves creating a three dimensional model in the computer. Motion is achieved by setting keyframe poses and having the computer generate the inbetween frames. Timing, anticipation, staging, follow through, overlap, exaggeration, and secondary action apply in the same way for both types of animation. While the meanings of squash and stretch, slow in and out, arcs, appeal, straight ahead action, and pose-to-pose action remain the same, their application changes due to the difference in medium.

2.1 SQUASH AND STRETCH

The most important principle is called *squash and stretch*. When an object is moved, the movement emphasizes any rigidity in the object. In real life, only the most rigid shapes (such as chairs, dishes and pans) remain so during motion. Anything composed of living flesh, no matter how bony, will show considerable movement in its shape during an action. For example, when a bent arm with swelling biceps straightens out, only the long sinews are apparent. A face, whether chewing, smiling, talking, or just showing a change of expression, is alive with changing shapes in the cheeks, the lips, and the eyes. [26]

The squashed position depicts the form either flattened out by an external pressure or constricted by its own power. The stretched position always shows the same form in a very extended condition. [26]

The most important rule to squash and stretch is that, no matter how squashed or stretched out a particular object gets, its volume remains constant. If an object squashed down without its sides stretching, it would appear to shrink; if it stretched up without its sides squeezing in it would appear to grow. Consider the shape and volume of a half filled flour sack: when dropped on the floor, it is squashed out to its fullest shape. If picked up by the top corners, it is stretched out to its longest shape. It never changes volume. [26]

The standard animation test for all beginners is drawing a bouncing ball. The assignment is to represent the ball by a simple circle, and have it drop, hit the ground, and bounce back into the air. A simple test, but it teaches the basic mechanics of animating a scene, introducing timing as well as squash and stretch. If the bottom drawing is flattened, it gives the appearance of bouncing. Elongating the drawings before and after the bounce increases the sense of speed, makes it easier to follow and gives more snap to the action. [26,3] (figure 2)

FIGURE 2. Squash & stretch in bouncing ball.

Squash and stretch also defines the rigidity of the material making up an object. When an object is squashed flat and stretches out drastically, it gives the sense that the object is made out of a soft, pliable material and vice versa. When the parts of an object are of different materials, they should respond differently: flexible parts should squash more and rigid parts less.

An object need not deform in order to squash and stretch. For instance, a hinged object like Luxo Jr. (from the film, *Luxo Jr.* [21]), squashes by folding over on itself, and stretches by extending out fully. (figure 3)

FIGURE 3. Squash & stretch in Luxo Jr.'s hop.

Squash and stretch is very important in facial animation, not only for showing the flexibility of the flesh and muscle, but also for showing the relationship of between the parts of the face. When a face smiles broadly, the corners of the mouth push up into the cheeks. The cheeks squash and push up into the eyes, making the eyes squint, which brings down the eyebrows and stretches the forehead. When the face adopts a surprised expression, the mouth opens, stretching down the cheeks. The wide open eyes push the eyebrows up, squashing and wrinkling the forehead.

Computer Graphics, Volume 21, Number 4, July 1987

Another use of squash and stretch is to help relieve the disturbing effect of strobing that happens when very fast motion because sequential positions of an object become spaced far apart. When the action is slow enough, the object's positions overlap, and the eye smooths the motion out. (figure 4a) However, as the speed of the action increases, so does the distance between positions. When the distance becomes far enough that the object does not overlap from frame to frame, the eye then begins to perceive separate images. (figure 4b) Accurate motion blur is the most realistic solution to this problem of strobing, [8,9] but when motion blur is not available, squash and stretch is an alternative: the object should be stretched enough so that its positions do overlap from frame to frame (or nearly so), and the eye will smooth the action out again. (figure 4c)

FIGURE 4a. In slow action, an object's position overlaps from frame to frame which gives the action a smooth appearance to the eye.

FIGURE 4b. Strobing occurs in a faster action when the object's positions do not overlap and the eye perceives seperate images.

FIGURE 4c. Stretching the object so that it's positions overlap again will relieve the strobing effect.

In 3D keyframe computer animation, the scale transformation can be used for squash and stretch. When scaling up in Z, the object should be scaled down in X and Y to keep the volume the same. Since the direction of the stretch should be along the path of action, a rotational transformation may be required to align the object along an appropriate axis.

2.2 TIMING

Timing , or the speed of an action, is an important principle because it gives meaning to movement-- the speed of an action defines how well the idea behind the action will read to an audience. It reflects the weight and size of an object, and can even carry emotional meaning.

Proper timing is critical to making ideas readable. It is important to spend enough time (but no more) preparing the audience for: the anticipation of an action; the action itself; and the reaction to the action. If too much time is spent on any of these, the audience's attention will wander. If too little time is spent, the movement may be finished before the audience notices it, thus wasting the idea. [30]

The faster the movement, the more important it is to make sure the audience can follow what is happening. The action must not be so fast that the audience cannot read it and understand the meaning of it. [30]

More than any other principle, timing defines the weight of an object. Two objects, identical in size and shape, can appear to be two vastly different weights by manipulating timing alone. The heavier an object is, the greater its mass, and the more force is required to change its motion. A heavy body is slower to accelerate and decelerate than a light one. It takes a large force to get a cannonball moving, but once moving, it tends to keep moving at the same speed and requires some force to stop it. When dealing with heavy objects, one must allow plenty of time and force to start, stop or change their movements, in order to make their weight look convincing.

Light objects have much less resistance to change of movement and so need much less time to start moving. The flick of a finger is enough to make a balloon accelerate quickly away. When moving, it has little momentum and, due to the friction of the air quickly slows it up. [30]

Timing can also contribute greatly to the feeling of size or scale of an object or character. A giant has much more weight, more mass, more inertia than a normal man; therefore he moves more slowly. Like the cannonball, he takes more time to get started and, once moving, takes more time to stop. Any changes of movement take place more slowly. Conversely, a tiny character has less inertia than normal, so his movements tend to be quicker. [30]

The way an object behaves on the screen, the effect of weight that it gives, depend entirely on the spacing of the poses and not on the poses themselves. No matter how well rendered a cannonball may be, it does not look like a cannonball if it does not behave like one when animated. The same applies to any object or character. [30]

The emotional state of a character can also be defined more by its movement than by its appearance, and the varying speed of those movements indicates whether the character is lethargic, excited, nervous or relaxed. Thomas and Johnston [26] describe how changing the timing of an action gives it new meaning:

Just two drawings of a head, the first showing it leaning toward the right shoulder and the second with it over on the left and its chin slightly raised, can be made to communicate a multitude of ideas, depending entirely on the Timing used. Each inbetween drawing added between these two "extremes" gives a new meaning to the action.

NO inbetweens........ The Character has been hit by a tremendous force. His head is nearly snapped off.

ONE inbetween......... The Character has been hit by a brick, rolling pin, frying pan.

TWO inbetweens........ The Character has a nervous tic, a muscle spasm, an uncontrollable twitch.

THREE inbetweens..... The Character is dodging a brick, rolling pin, frying pan.

FOUR inbetweens........... The Character is giving a crisp order, "Get going!" "Move it!"

FIVE inbetweens........... The Character is more friendly, "Over here." "Come on-hurry!"

SIX inbetweens........... The Character sees a good looking girl, or the sports car he has always wanted.

SEVEN inbetweens........... The Character tries to get a better look at something.

SIGGRAPH '87, Anaheim, July 27-31, 1987

EIGHT inbetweens........... The Character searches for the peanut butter on the kitchen shelf.

NINE inbetweens...........The Character appraises, considering thoughtfully.

TEN inbetweens........... The Character stretches a sore muscle.

FIGURE 5. Wally B.'s zip off shows use of squash and stretch, anticipation, follow through, overlapping action, and secondary action.

2.3 ANTICIPATION

An action occurs in three parts: the preparation for the action, the action proper, and the termination of the action. *Anticipation* is the preparation for the action; the latter two are discussed in the next sections.

There are several facets to Anticipation. In one sense, it is the anatomical provision for an action. Since muscles in the body function through contraction, each must be first be extended before it can contract. A foot must be pulled back before it can be swung forward to kick a ball. [12] Without anticipation many actions are abrupt, stiff and unnatural.

Anticipation is also a device to catch the audience's eye, to prepare them for the next movement and lead them to expect it before it actually occurs. Anticipation is often used to explain what the following action is going to be. Before a character reaches to grab an object, he first raises his arms as he stares at the article, broadcasting the fact that he is going to do something with that particular object. The anticipatory moves may not show why he is doing something, but there is no question about what he is going to do next. [26]

Anticipation is also used to direct the attention of the audience to the right part of the screen at the right moment. This is essential for preventing the audience from missing some vital action. In the very beginning of *Luxo Jr.*, Dad is on screen alone looking offstage. He then reacts, anticipating something happening there. When Jr. does hop in, the audience is prepared for the action.

The amount of anticipation used considerably affects the speed of the action which follows it. If the audience expects something to happen, then it can be much faster without losing them. If they are not properly prepared for a very fast action, they may miss it completely; the anticipation must be made larger or the action slower. [30] In a slow action the anticipation is often minimized and the meaning carried in the action proper. [12] In one shot in *The Adventures of Andre and Wally B.* , Wally B. zips off to the right. The actual action of the zip off is only 3 or 4 frames long, but he anticipates the zip long enough for the audience to know exactly what is coming next. (figure 5)

Anticipation can also emphasize heavy weight, as for a character picking up an object that is very heavy. An exaggerated anticipation, like bending way down before picking up the object, helps the momentum of the character to lift the heavy weight. Likewise for a fat character getting up from a seated position: he will bend his upper body forward, with his hands on the armrests of the chair, before pushing up with his arms and using the momentum of his body. [31]

2.4 STAGING

Staging is the presentation of an idea so it is completely and unmistakably clear; this principle translates directly from 2-D hand drawn animation. An action is staged so that it is understood; a personality is staged so that it is recognizable; an expression so that it can be seen; a mood so that it will affect the audience. [26]

To stage an idea clearly, the audience's eye must be led to exactly where it needs to be at the right moment, so that they will not miss the idea. Staging, anticipation and timing are all integral to directing the eye. A well-timed anticipation will be wasted if it is not staged clearly.

It is important, when staging an action, that only one idea be seen by the audience at a time. If a lot of action is happening at once, the eye does not know where to look and the main idea of the action will be "upstaged" and overlooked. The object of interest should contrast from the rest of the scene. In a still scene, the eye will be attracted to movement. In a very busy scene, the eye will be attracted to something that is still. Each idea or action must be staged in the strongest and the simplest way before going on to the next idea or action. The animator is saying, in effect, "Look at this, now look at this, and now look at this." [26]

Above: Excerpts from John Lasseter's 1987 SIGGRAPH paper "Principles of Traditional Animation Applied to 3D Computer Animation."

"host" every short film and feature from *Toy Story* on, hopping into view before the opening credits and turning out the light after the closing credits. Said film critic Leonard Maltin, "I like the fact that Luxo still has significance to the people at Pixar, because that's their Mickey Mouse, essentially. That lamp that they brought to life started the ball rolling for them. And I think there's a wonderful sense of continuity that is expressed when they use that as their symbol."

"Luxo Jr." would be followed by three more short films, one per year: "Red's Dream," "Tin Toy," and "Knick Knack." Each would demonstrate the group's increasing narrative and technical skill, as well as their increasing ambition. The animation team also refined its technology, learning how to depict more sophisticated objects and settings, further automating the animation process where possible, and field-testing Menv and RenderMan, the animation and rendering programs that would eventually be used to make its feature films.

Lasseter considers the experience invaluable. "In those early short films, from 'André & Wally B' through 'Knick Knack,' I grew so much as a storyteller and as a filmmaker," he recalled. "Bill Reeves and Eben Ostby grew tremendously as technical directors, and our technology grew from this research project made up of a bunch of programs kludged together into a fairly robust production program. So the experience was really, really valuable, both for artistic and professional development and for R&D."

Dark Days

Though Pixar's side project in animation was thriving, its actual business—selling Pixar Image Computers—was not. The company had expanded from 40 people to almost 140 at its peak, but by 1988, it had sold only 120 Pixar Image Computers; not nearly enough to cover its costs. The company was losing money. Lots of money. And it was all coming out of Steve Jobs' pocket.

"Steve put us through a lot of pain," said Smith. "He'd go to Ed and me and make us tighten the ship up. But, at the same time, he was unwilling to let the company go bankrupt. He put up with a lot—if we had been a real company, we would have died nine times over—but he always stepped forward to write a check."

Right: Pixar's first official company photo, taken in March 1987.

From a purely economic point of view, it would have made sense to shut down the animation group. "We were carrying this artistic team that really didn't have anything to do with the Pixar Image Computer business," Smith noted. "But we didn't want to lose that creative core from which the dream of a CG movie was going to come."

As painful as the mounting losses were, said Jobs, keeping the animation group going was never in question. "Pixar was a money pit for me," he said, laughing. "I kept putting more money into it, and the only bright spot was John's short films. He'd say, Can I have $300,000 to make a short film? And I'd say okay, go make it. That was the only thing that was fun. Everything else was not really working."

"Steve only ever told me one thing," remembered Lasseter. "And that was to 'make it great.'"

Between 1986 and 1991, Steve Jobs put almost $55 million into Pixar. Apple had been a phenomenal success, but this was still a considerable sum to put into a company whose prospects were uncertain at best. "If somebody had come to me and said, I want you to invest $55 million in this company, I would have said, 'No!'" he admitted. "But it was a little like putting a frog in a pot of water and turning up the heat a degree at a time."

"At the time, I couldn't figure it out," said Catmull. "This was a significant chunk of Steve's net worth, and it must have been very frustrating. But if you look at his career, you see that he has always had a very strong sense of loyalty. He's only ever been involved in three companies, Apple, NeXT, and Pixar, and he has never walked away from any of them. Even when NeXT and Pixar were both struggling, and it was not obvious that either of them were going to make it, he supported both of them until they flowered."

"I bought into Ed's vision of making the world's first computer-animated feature film," said Jobs, "but as time went on it did start to get scary. There were even a few times where I thought about selling it or getting another investor in. I got married, and my wife, Laurene, and I had started a family. When you're raising a family, you realize that at some point you've got to be sensible.

"But getting another investor in would have been more complicated than it was worth, and what was the alternative? The alternative was to throw in the towel and admit defeat—to go to your partners and say, 'I'm not putting any more money in it.' And I'm not that kind of person. Everyone working at Pixar could have walked out in the morning and by the afternoon gotten jobs somewhere else that paid three or four times the money they were making. But they didn't. They stuck it out. And when you have smart people around you that are that dedicated, that are devoting their lives to this, then you just want to keep on going and find a way to be successful. It just took a really, really long time."

> *"We went through some hard times, but everyone stuck together in the end. I think the thing that saved Pixar was that we'd all get depressed, but not all at once. One of us would get very forlorn about the situation and think about throwing in the towel, but others would shore that one up. So we never all got down at the same time." —STEVE JOBS*

"Steve was incredible at hanging in there, funding these guys," said Alan Kay, the go-between who had introduced Jobs to the Lucasfilm Computer Division. "They were ten years ahead of their time. And Steve just hung in there and hung in there and hung in there until they got into the sweet spot where everything that they knew suddenly was applicable in a way that made commercial sense. I remember feeling extremely good when I saw that Pixar had become such a success, because any funder like that should be rewarded. Ten years! That was an incredible thing. I hope he goes to heaven just for that alone."

Commercials

After finishing up "Knick Knack" in 1989, the animation group began thinking more seriously about how to take the next step toward their goal. If they were ever going to make a feature film, they had to start bringing in money—in the short term, to contribute to their upkeep, and in the long term, so that they could get more people and equipment into the group. The best way to do this, they decided, was to start making television commercials.

"John was the only animator here, and we could never have made it to a feature film with him alone, but by doing commercials we could bring in new talent," Catmull explained. "Commercials are like little short stories, and by doing them we would subject ourselves to the real-world deadlines and pressures that you'd have to deal with if you were going to make movies. Restrictions are part of art, and we had to bring that into our process."

Ralph Guggenheim, who had helped produce Pixar's short films, took charge of the production side of their commercial efforts. After an unpleasant early experience with an ad agency that forbade them to suggest new ideas in a client meeting, Pixar ended up forging a partnership with Colossal Pictures, a Bay Area commercial and effects house. Colossal already had an ad sales network in place, and agreed to act as Pixar's "agent," helping connect Pixar with clients in exchange for a commission.

Pixar's first assignment was a commercial for Tropicana orange juice featuring a straw in search of an orange. The distinctive look of Pixar's ads caught the attention of a public still largely unfamiliar with computer animation, and it soon became clear that the company would have no problem finding work. Within the year, Lasseter was able to hire two new animators to join him: Andrew Stanton and Pete Docter.

> *"Unlike some people, who in a similar position might have hired people who were non-threatening, John had the confidence to bring really top-notch people into the company to become part of the core creative group. He sought out the very best people he could find. The first person he hired was Andrew Stanton, the person who ended up writing most of our films. His next hire was Pete Docter, who I think is one of the best animators in the world. Needless to say John has something of a magic touch for finding great people."*
> —ED CATMULL

Andrew Stanton had first caught Lasseter's eye with his student films "A Story" and "Somewhere in the Arctic," which had played in Spike and Mike's Festival of Animation along with the Pixar shorts "Red's Dream" and "Tin Toy." When Lasseter's wife, Nancy Tague, a graphics researcher at Apple, needed a freelance story artist for a short film she was working on called "Pencil Test" (the first 3-D computer-animated short ever made on a Macintosh), Lasseter recommended Stanton. "John Lasseter and Brad Bird were already names when I first walked into CalArts, and they just got bigger over the years. So, to hit it off with John like that was so cool," Stanton remembered.

When Lasseter was given the green light to hire another animator at Pixar, Tague reminded him about Stanton and suggested he get in touch.

As it turned out, Lasseter couldn't have called at a better time. Stanton had been trying to find steady work as an animator, but found himself unable to break out of the in-betweening or assisting ranks. "I got turned down at Disney three times over the course of three years; never got in for any opening for any kind of job that I wanted. My friends would give me a call or recommend me if their companies had work, and I'd get in, but I'd never get in at their level; it was always a more junior position. My short films were

the one thing that gave me some sort of an identity, because outside of that I was just another penciler, a number in the industry, and not a great one at that." The realization that he was in danger of being permanently pigeonholed was slowly crushing his spirit, and he said, he had even begun to consider leaving animation altogether.

"When John hired me, I told him, 'I don't know how to use the computer.' But he told me that he wasn't hiring me for my technical skills. He said, 'I want you because you have something in your short films that really appeals to me.' He was hiring me for me, for my sensibilities. That has made me give 200 to 500 percent ever since I stepped into this door and made me faithful until the day I die. Because it not only saved my potential career, it invigorated me as an artist; it made me believe in myself. I don't know that I ever believed in myself to the level that I did once I got in here because of that opportunity."

"I said yes right on the phone," said Stanton, who arrived at Pixar in January 1990. "I packed up and headed straight to San Francisco and never looked back. It was the most serendipitous moment in my career and the best move I ever made."

For his second hire a few months later, Lasseter consulted his old friend Joe Ranft, who had been teaching storyboarding at their alma mater, CalArts. After parting ways, the two had made a pact to work together if and when Lasseter got to direct his first feature, and Ranft had frequently come up to visit or do freelance work for Pixar on the side, even as his star rose in the Disney story department.

"John was asking, 'Who's really great at CalArts?'" Ranft remembered. "And I told him he should meet Pete Docter, who was a student of mine. Their sensibilities were just an obvious match. Pete's animation had a joie de vivre that I knew would be right up John's alley."

"The Pixar shorts had totally hooked me," recalled Docter, "but working there never seemed like a possibility; everyone knew it was just John and a bunch of technical guys. When John called and offered me a job, it was a complete surprise. I didn't know what Pixar had planned or how I would fit in, but I wanted to be there. Plus," he added, laughing, "I knew being at a small company like Pixar meant I could be greedy—I wouldn't just *get* to do all different types of work, animation and story and design, I would *have* to!" Docter was so eager to start work that he actually skipped his own graduation, driving up to the Bay Area the day after classes ended.

At the time, computer graphics, especially in commercial work, was used primarily to create effects: flying logos, "gleams and glows," and especially morphing (the hot new use of CG). But Pixar carved out a different niche for itself. "We were the guys who *didn't* do morphing," said Guggenheim. "We were the guys who did character animation using computer animation, and there were very few other studios who really were doing that. We did some commercials that were effects-oriented, but the stuff that brought in much bigger dollars, because no one else could compete with us on it, was the character animation work. So why should we be caught in a bidding contest for morphing, when we could set our own price, without having to negotiate, on character animation?"

The introduction of two more classically trained animator-filmmakers to the group solidified Pixar's reputation as a studio that could not only execute an idea but act as a partner in improving a project. As Guggenheim described, "Certain ad agencies came back to us over and over again, and as we built relationships with them, we started contributing creative ideas." The Listerine campaign, for example, was one where the ad agency came up with a general idea—using old movies in the ads—and the Pixar team came up with specific variations, depicting the bottles as classic movie characters like Tarzan and General Patton.

Opposite page, top: Pete Docter's first assignment at Pixar was to animate on the Listerine "Boxer" commercial, directed by John Lasseter.
Opposite page, bottom: Lasseter won a Clio—the Oscar of the advertising world—for his work on "Conga," for Life Savers.

Guggenheim admitted that they had briefly been tempted to develop a secondary emphasis in effects-based work alongside their character animation work—the market was there, and the group had the technical expertise to do it. But, he said, Lasseter insisted on keeping their work focused on character animation. "If you look back at our commercial portfolio, probably 80 percent of it is character animation work. And we were doing it specifically because we felt this was our way to build up our ability to do a feature film. John believed very strongly that doing visual effects wasn't going to help us get to a feature film, but doing character animation was—and he was right."

The Fork in the Road

This rise in the fortunes of the animation group was the one bright spot for Pixar's finances, as its once-marquee hardware division continued to decline. Some early mistakes in pricing the Pixar Image Computer and its related services were coming back to haunt the company, and in the spring of 1990, the ongoing losses led to a major round of layoffs. Pixar had come to realize that in the long run the Image Computer would not be able to stay ahead of workstations, which were steadily increasing in performance and dropping in price. But the company was in a bind—Disney, their biggest customer, relied on the Image Computer to run the CAPS system, and they couldn't just abandon their hardware endeavor while Disney was still dependent on their machines. Pixar was in the process of rewriting the CAPS software to run on Silicon Graphics workstations, but the effort would take at least another year, and Catmull was worried that in the interim the cost of maintaining the hardware group would be fatal.

So later that year, when a local company named Vicom offered to buy Pixar's hardware business, Catmull barely paused long enough to utter a silent sigh of relief before agreeing. Though splitting the company in this way was an emotionally difficult decision to make, it was a necessary one—the two halves of Pixar would surely go under if they remained together, but they had a chance at survival if they split up.

In the end, the deal benefited everyone. Pixar was able to exit the hardware business gracefully, without jeopardizing its relationship with Disney. Disney enjoyed uninterrupted support for its existing CAPS setup until the system was ported over to workstations. And Vicom bought itself a better position in the market for the next few years.

"Looking in the rearview mirror," said Jobs, "it probably would have been better to take a more direct approach—to just fund the animation effort and not even try to pay the bills with products like the software and the Pixar Image Computer. But on the other hand, that might not have worked. We might not have been ready. John making those short films helped him get ready to direct a feature. Making all those commercials helped us develop our infrastructure and attract the additional talent we needed. And even then it was super-hard. So it's hard to go back and Monday-morning quarterback life."

Moving Toward a Feature

The success of Pixar's short films had not escaped the notice of Lasseter's former employer. Jeffrey Katzenberg, the head of the Walt Disney Studios, and Peter Schneider, the president of Disney Feature Animation, had been making overtures to Lasseter for years. "There was a whole group of very talented people that had been at Disney and had left prior to the takeover of the company in 1984," said Kathleen Gavin, who was a production executive at Disney in the late '80s. "And when the new administration came in, the people who were

still here, people like John Musker and Ron Clements, kept saying, 'You want to get these guys back.'"

Every time Pixar finished a short, it sent a copy to Disney to show the studio what it was up to. And every time, Lasseter would get a phone call in response—not at work, but at home—from Schneider or Katzenberg, trying to get him come back down to Los Angeles to be a director at Disney.

"It was tempting," said Lasseter, "especially since, like everyone else at Pixar, I hadn't had a raise in years, but I was having the time of my life in San Francisco. I was working with the premier computer-animation research group in the world, working for a guy whose dream was to do a feature film some day with this medium, and I had complete creative freedom. So I just couldn't."

Recalled Catmull, "John had the choice of returning to Disney as a director or staying with this little Northern California company that was losing money and bordering on collapse. But John kept telling them that if they wanted to do something with him, they should do it with Pixar. That says something about the spirit of our group, that we were onto something big if we could just pull together and make it happen."

Pixar had actually made its first serious attempt at a feature in 1989, when it tried to buy the film rights to Roald Dahl's book *James and the Giant Peach*. Lasseter was still the company's sole animator, but children's book author and friend Chris Van Allsburg had expressed interest in being the production designer for the project, and Colossal Pictures was a potential production partner. But Pixar's first preference was to produce any film themselves, so when Dahl declined their offer, they simply turned their full attention to commercial work, the better to build up their own production team.

After the release of "Knick Knack," Disney called Lasseter again, and again Lasseter proposed having Pixar make a film for Disney. In the past, said Lasseter, Disney had always told him that the studio would not release a movie under the Disney banner that was not made by the studio itself. But by 1990, Disney's animation renaissance was well under way. The year before, *The Little Mermaid* had been a critical and box-office success, and the buzz on the upcoming *Beauty and the Beast* was terrific. There was a renewed feeling of optimism and excitement around the medium.

Enter Tim Burton. Burton had left Disney for live-action in 1984, leaving behind a short film, "Vincent," and a feature idea, *The Nightmare Before Christmas*. After the huge success of *Batman*, Burton had gone to Disney to try to get *Nightmare* back so he could make it himself. Rather than lose either Burton or the idea, Disney offered to let him make it in the style he wanted, in stop-motion instead of traditional animation, as a project that they would then distribute. This project cleared the way for Disney to reconsider the idea of partnering with another studio to make a movie.

> *"When I was at the Disney Studios and I was working on the 'Wild Things' test, Tim Burton had an office literally across the hall from me, where he was working on 'Vincent,' his stop-motion short. Both of us had this idea to do our short projects and then develop a feature idea that would use the techniques we were interested in—I had* The Brave Little Toaster *as the story I wanted to do with the technology, and he developed* The Nightmare Before Christmas *for stop-motion. So for me, it's great that it was* Nightmare *that opened the door for* Toy Story—*it kind of brought that old Disney connection full circle."*
> —JOHN LASSETER

This time, when Lasseter proposed yet again that Disney consider a project with Pixar, Disney agreed, telling Lasseter to come back when they had a story.

They wouldn't have to wait long.

The inspiration for Pixar's first feature film can be traced back to the 1988 Holland Animation Film Festival, where Lasseter was screening "Tin Toy," and Ranft was scouting talent for Disney. Lasseter remembered, "Joe looked at 'Tin Toy' and said, 'You know, I just love this idea of toys being alive. It's such a big world. There are so many more stories you can tell with it.'"

Lasseter took the observation to heart. At first, he thought of expanding the Tin Toy world into a story for a Christmas TV special. Pixar's original plan had been to make commercials for two years, and then produce a half-hour computer-animated TV special that would convince Hollywood studios that the company could tell longer stories. Lasseter, Stanton, and Docter, with Ranft as a long-distance fourth, developed a story called *Tin Toy Christmas* and shopped the project around town, but they scrapped their plans when they realized that the form was not fiscally viable—the going rate per minute for a television special was a fraction of what they earned making commercials.

But the idea remained at the top of the toy box, and when Disney made its offer, Lasseter immediately remembered Ranft's words and returned to the concept.

"God, we were so lucky to be there at the right time and the right place," reflected Stanton. "Pete and I just happened to be the only other creatives working in-house with John, so when he got the go-ahead to come up with something bigger, we, just by default, were the lucky guys that got to sit in the room and bounce things back and forth with him." The quartet came up with a new story in which Tinny, the wind-up hero, gets separated from his owners and teams up with a ventriloquist's dummy to find his way home. Lasseter and Stanton went down to Disney to pitch the idea to Jeffrey Katzenberg, Peter Schneider, and senior vice president of development Tom Schumacher. In case this didn't go well, they brought along the books *James and the Giant Peach* by Roald Dahl and *Dinosaur Bob* by William Joyce as their backup.

Pixar had quietly started making contacts at other studios once they started developing their feature, feeling it wise to educate themselves and perhaps hedge their bets in case things with Disney didn't work out. As Ralph Guggenheim put it, "We were a tiny company of 50 people, of whom only half were doing animation, dealing with the biggest name in the animation business, a Fortune 500 company worth billions of dollars."

As it turned out, however, they had nothing to worry about. "Not a lot of that initial pitch remains," Schneider recalled, "but the idea of telling a tale from a toy's point of view was sensational."

Pixar had a deal.

> "I'll always be grateful to Joe for seeing the larger potential in 'Tin Toy.' Who knows
> if I would have looked at it as a door to a bigger world if it hadn't been for him?"
> —JOHN LASSETER

In the spring of 1991, Pixar and Disney signed a co-production agreement for three pictures. Pixar would produce the films; Disney would bankroll and distribute them. Guggenheim recalled that the process of hammering out the particulars had moved very slowly—until Steve Jobs flew down with them to meet directly with Jeffrey Katzenberg. Guggenheim credited Jobs with getting Pixar a much better deal than they could have negotiated on their

own. "At one end of the long conference table we have Steve and at the other end of the conference table we have Jeffrey, and it was like watching tennis at Wimbledon. They were volleying back and forth and laying out the terms of this deal. Well, tremendous progress was made."

Though the final terms weren't what they might have wished for—they were, after all, an unknown quantity teaming up with a cultural icon—Jobs still regards the deal as a landmark for Pixar. "It was the best thing that ever happened to the studio," he said. "That's the direction we wanted to go as a company, and there was no better partner to do it with, no one we could learn more from, than Disney."

Shortly before the deal was signed, Alvy Ray Smith, Catmull's comrade from the first days of New York Tech, left Pixar to start his own company. But Smith recalled seeing the attainment of Pixar's dream on the horizon as he departed. After one of the company's first meetings with Disney—an hours-long affair down at Disney headquarters in Burbank—the small group of Pixarians walked across the parking lot to their rental car.

Smith said, "I looked over at John Lasseter and said, 'What do you think?' He said, 'I can do it.'"

Top: The animation group outside Pixar's offices in Point Richmond, CA. From left to right, Bill Reeves, Eben Ostby, Yael Milo, Deirdre Warin, Flip Phillips, John Lasseter, Andrew Stanton, Ralph Guggenheim, Pete Docter, Don Conway, and Craig Good.

 / Spotlight

Sound

Thanks to the Lucasfilm Computer Division's relationship with Sprocket Systems, the Lucasfilm sound group, the sound for their first short, "André & Wally B," had been done by superstar sound designer Ben Burtt, of *Star Wars* and *Indiana Jones* fame.

"Ben had done an amazing job," Lasseter recalled. "His sound work on 'André & Wally B' was really cartoony and helped give the whole piece a classic cartoon feel. So of course when we were doing 'Luxo Jr.,' we called Sprockets to see if Ben could do the sound for this one, too. Ben was busy, so they offered us this new guy named Gary Rydstrom. I said, 'I don't want this Gary Rydstrom guy; I want Ben Burtt.' But they said, 'No, no, no, he's really good. You should give him a try.' So I said, 'Ohh, all right.' Of course, I ended up being thankful, because Gary became one of Pixar's most important collaborators."

Rydstrom would go on to do the sound for all of Lasseter's short films, as well as all of the studio's feature films up through *Finding Nemo*. Along the way, he would pick up seven Academy Awards for his work on films like *Jurassic Park*, *Terminator 2*, and *Saving Private Ryan*. But when he met with Lasseter that first time, both were just starting out in their careers.

Lasseter showed Rydstrom a clip of the short film. Rydstrom, impressed by its unique look, suggested that the sound aim for a similarly real-but-unreal effect, using real lamp sounds as the foundation for the sound work and tweaking them to create the appropriately caricatured effect, instead of going straight to a cartoony soundtrack. "It was clear to me that this form was a whole new thing that would require a whole new approach to sound," he said.

"I thought, yeah, that sounds pretty good," said Lasseter. But when he saw the short with Rydstrom's sound—complete with a "voice" for Luxo Jr. concocted from the squeak of a lightbulb being screwed in—he was absolutely "blown away."

"It was amazing," he recalled. "Gary's brilliant work made those lamps so real, so believable. It taught me that sound has an incredible ability to be a partner in the storytelling of a film, and ever since then Pixar has put a lot of emphasis on thinking of the sound as we develop our stories."

"John got so excited about what sound could bring to the movies that he would increasingly build that into the movie," said Rydstrom. "On 'Tin Toy,' it was almost insane. I think it's the most sound-intensive movie per square inch that I've ever done, because I was essentially both the sound and the music departments. The

Above, clockwise from left: Gary Rydstrom at the mixing board in Pixar's early short-film days; Ben Burtt, the sound designer for "The Adventures of André & Wally B."; Gary Rydstrom at Pixar today.

main character, Tinny, was a one-man band, and he made a sound every time he moved. I loved that. It was great. It was fun to feel like something I was doing was shaping the content of a film.

"I was working on a feature film at the same time I was doing 'Tin Toy,' and I would steal away a lot of the time I was supposed to be working on the feature to work on 'Tin Toy.' John mentioned this fact in several film festival interviews afterward, which made me worry that my career was going to be over—he was effectively saying, 'don't hire this guy—he won't work on your film!'"

Sound design, Rydstrom explained, is not just about finding the right sound effect for a particular moment, but about integrating every part of the film's aural landscape—sound effects, dialogue, and music—into a seamless whole. "In a live-action film there's a reality you have to build around to fit what's already been recorded during the filming," he said. "But in animation you have complete freedom because you're building everything up from scratch."

Like Pixar's visual artists, Rydstrom has often included allusions and in-jokes in his sound work for the studio. The Lucasfilm connection made it possible to use actual sound effects from Lucas productions in Pixar sequences that pay homage to the originals: the *Indiana Jones* "boulder roll" for the globe that

threatens to squash Buzz in *Toy Story*; *Star Wars* sounds for the Zurg-Buzz showdown in *Toy Story 2*. ("George was fine with it; he has a special love for Pixar," said Rydstrom.) There are even internal references between films in the Pixar universe: the Luxo lamp "voice" was used as a sound effect for an ordinary lamp in *Toy Story*, and a water effect from "Knick Knack" found new life in *Finding Nemo*.

"Walter Murch once compared sound design to art direction," said Rydstrom. "Just as someone was responsible for the use of color and visual designs, the use of sound could also be a singular vision. But working on Pixar movies has made me realize that sound design is also similar to animation, because of the importance it places on rhythm. You spend months building something up from the tiniest details to make it seem fluid and alive, but you play it on screen and it goes by in an instant."

One of Rydstrom's sound heroes is Treg Brown, who did the sound work for the classic Warner Bros. cartoons. "Treg Brown would use the most astounding array of different sounds—traffic jam noises, military sounds like blaring bugles. I once met Chuck Jones, and I asked him, 'What was Treg Brown's secret?' Jones replied, 'The Treg Brown secret was he never used an appropriate sound.' I knew exactly what he meant by that. I took that as my mantra. I don't think I've ever used an appropriate sound."

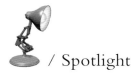 / Spotlight

The Early Short Films

Spike Decker and Mike Gribble, of Spike and Mike's Festival of Animation, were among Pixar's earliest champions, screening all of the company's shorts from "André & Wally B" on. "Long before John ever received his first Oscar, we dubbed him 'The King of All Animation,'" remembered Decker, laughing. "When we were programming the Classic show, we'd put the films in the show into different categories: A's, B's, and C's. We always knew if we could get something that John or Pixar was associated with, it would be an 'A' film."

Red's Dream

"Red's Dream," about the fantasies of a unicycle languishing in the sale corner of a bike shop, was a significant step up in complexity from "Luxo Jr." It featured rain, complicated mechanical and organic models, different sources of light (from a neon sign to a circus spotlight), and three different locations.

As Lasseter recalled, Eben Ostby was his tutor for all things technical and the point man for all his "hey, can't we just…" problems. Together, they worked on trying to eliminate the more tedious aspects of animation, using the computer to do grunt work like calculating the proper rotation of a moving ball, or automatically keeping the pedals of a unicycle flat as it moved.

"Basically, all our efforts would go into making the job of an animator be most focused on expressing the animation," said Ostby. "With each show we've done a little bit more of that. There's always more to do, but as we chip away at some of the various problems, the animators can interact with the models in higher-level ways."

Most people, however, remember the short for its melancholy ending—surely Pixar's most "controversial" to date. As Lasseter said on the director's commentary track to the short film, "Everybody said, 'Please don't let it have a sad ending! Have it have a happy ending! Have the clown come back and buy him!'" But Lasseter, proud of the story as it is, jokes that the film represents Pixar's "Blue Period."

Tin Toy

The animation group made its biggest technical jump between shorts with "Tin Toy," which told a much longer story with more complicated and difficult to create characters—a wind-up one-man band toy whose parts are in almost constant motion, and a human baby.

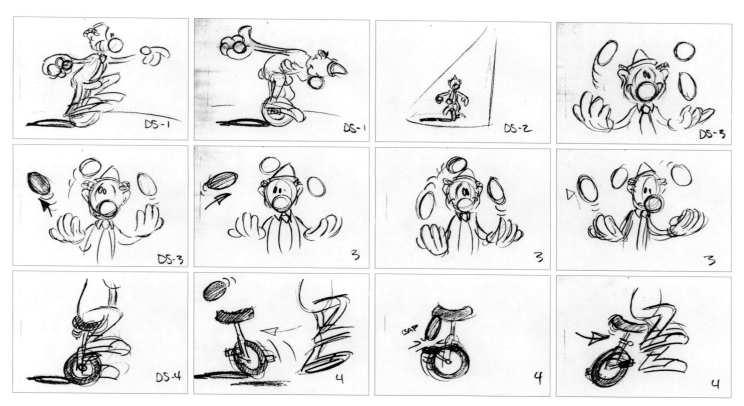

Above: Storyboards for "Red's Dream." John Lasseter, pencil.

"My sister had taken this great video of my nephew, Timmy. It was half an hour of him just sitting there, playing with his toys. As an animator I loved seeing the thought process of this four-month-old baby; everything he picked up went into his mouth, and he slobbered all over it. When he crawled toward my sister and started reaching up to the camera, pulling the lens toward his mouth, I thought, 'Ahh, imagine what it must be like to be a toy in the hands of a baby. That baby must seem like a monster.' And that idea is where 'Tin Toy' came from." —JOHN LASSETER

Fortunately, it was at this time that the group's new animation system, Menv (for "modeling environment") came on line. The first shorts had all been made with a program called Motion Doctor, which had been designed and built before Lasseter had even arrived at Lucasfilm. "We had thought it was pretty hot," said Bill Reeves, who had worked on the program alongside Tom Duff, "but we never understood what an animator would want to do; what kind of controls an animator would want, and how he would want to work it." Having a professional artist use and give feedback on the tools made all the difference, and Reeves, Ostby, and Sam Leffler immediately started thinking about building an entirely new animation system based on Lasseter's input.

Motion Doctor, like many animation systems today, functioned as one giant piece, with the program starting up every tool "whether you were using it or not," as Lasseter said. This made the program slow to start up and slow to use, even though the models they were working with were very simple and therefore computationally "light."

Because RenderMan, the other piece of Pixar software making its debut on the short, provided not only a renderer, but a shading language and a lighting mechanism, Menv focused on the other two parts of the pipeline: modeling and animation. Thinking with their long-term goal of making a feature in mind, the team had designed a system that allowed the user to bring up only the tools that were needed at the moment, a modular approach that made the system more nimble and made it easy to add and improve specialized tools. Menv also provided strong support for procedural and secondary animation—animation that could or should be done "automatically" (e.g., having the computer calculate the arc of a juggled ball based on where it lands.)

"I've worked at Pixar twenty-plus years now," said Reeves, "and the hardest I ever worked was on *Toy Story*. But 'Tin Toy' was the second hardest. We had two brand-new pieces of software, Menv and RenderMan, and we had this organic character, the baby, which we'd never done before. But hard

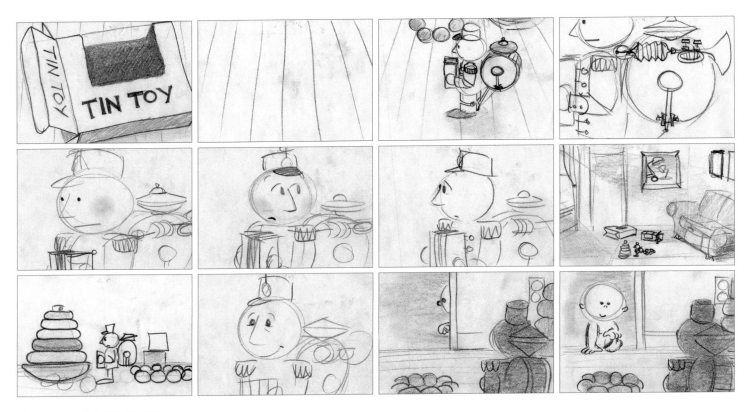

Above: Storyboards for "Tin Toy." John Lasseter, pencil.

work isn't bad when you're having fun, and that's what I love, just getting in there and making things happen—trying to get something done, and trying to make it look good and be good at the same time."

'Tin Toy' won the 1988 Academy Award for best animated short film—the first 3-D computer-animated film in history to win an Oscar.

Knick Knack

"Tin Toy was so difficult that for our next project we decided to do something simple and fun," said Lasseter. "We wanted to stick with what we knew the computer could already do really well—geometric shapes—with models that would be quick to build and animate."

Lasseter, taking Chuck Jones' Warner Bros. shorts as his tonal inspiration, and his wife's snow globe collection as his springboard, came up with "Knick Knack," the lighthearted tale of a frustrated snowman in a snow globe. The team couldn't resist pushing things just a *little*—they made the short in stereoscopic 3-D, and developed fluid simulation for the floating snow in the globe—but for the most part they took the technical aspect easy.

The animation group, which by then had more than tripled in size from its original four people, had developed a warm, familial feeling. Deirdre Warin, the department coordinator at the time, remembered it as "a kitchen table operation. It was very barebones, but it was enormous fun, and it was very focused." Because all the heavy-duty graphics equipment was kept in the same room, team members spent a lot of time together.

In the less pressurized atmosphere of the "Knick Knack" production, the group naturally moved to a more cooperative, experimental model than had been used on their previous shorts. "Everybody worked on a little bit of everything," Ostby recalled. Those who were interested were invited to create the other knickknacks in the room, designing them, modeling them, even helping to create some of the animation loop cycles.

Even the ending—in which Knick Knack momentarily breaks free of his snow globe, only to be "recaptured" in a fish bowl—was enhanced by a contribution from Warin, who suggested he discover a mermaid before being trapped again. "I was the only noncreative, nontechnical person there. But they thought my suggestion was a good idea, and John said, 'Yes, let's do it.' To me, it was a great indication of John's collaborative spirit, that he would ask for and listen to suggestions from anyone in the room, even someone who was not part of the creative team."

Above: Storyboards for "Knick Knack." John Lasseter, pencil.

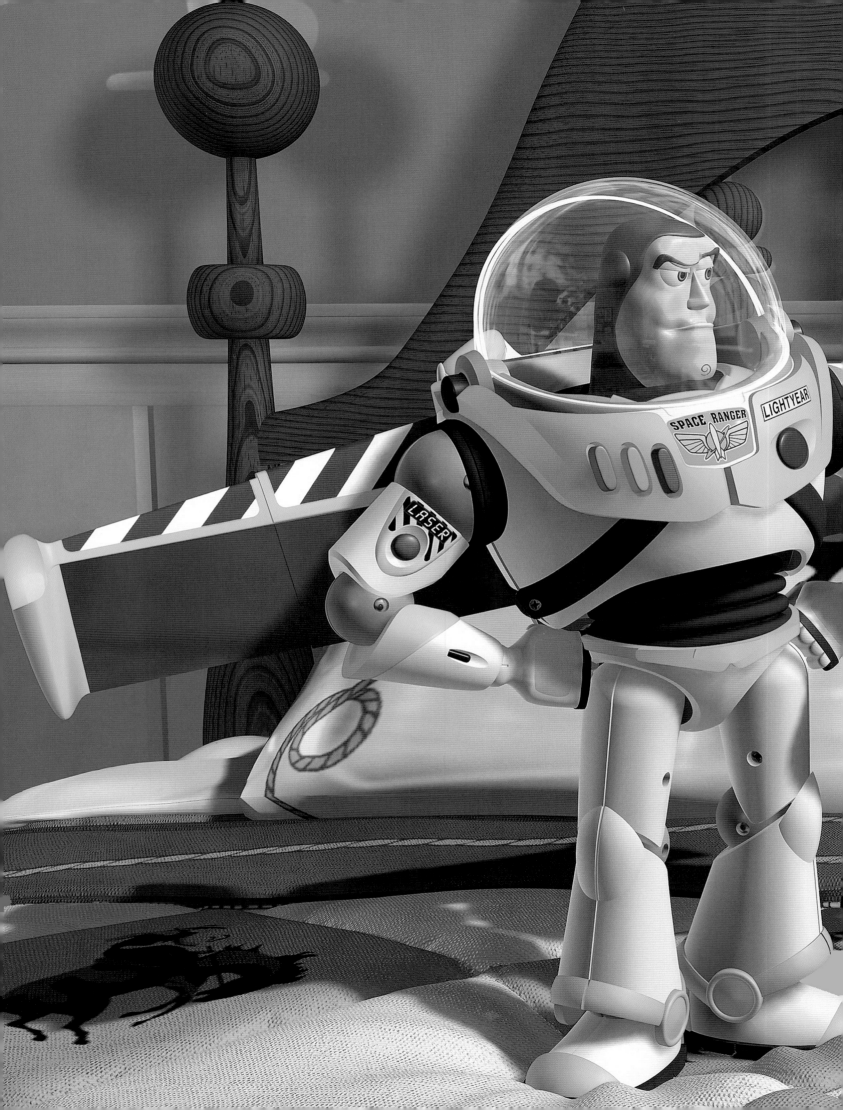

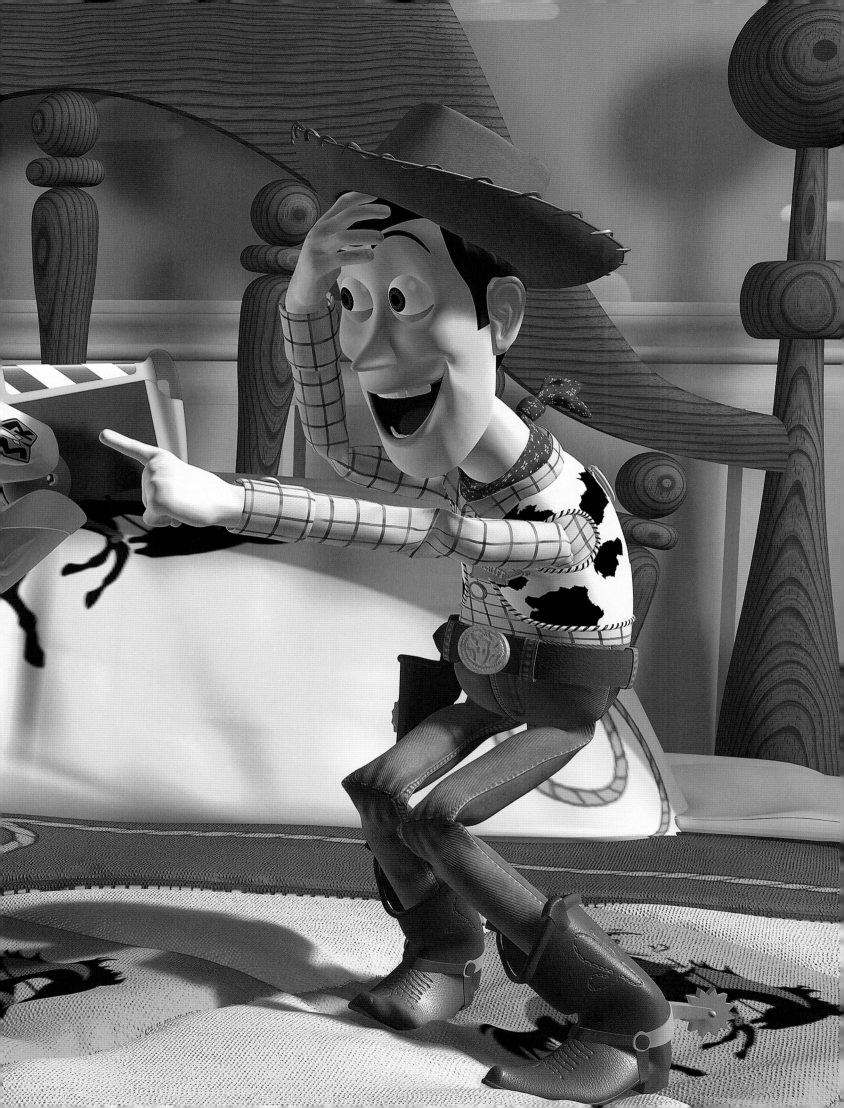

Chapter 5

Toy Story

Pixar signed the official contract to make the then tentatively titled *Toy Story* (along with an eventual "Picture 2" and "Picture 3") in July of 1991. Certain aspects of the film's production were prescribed by the terms of the contract. For example, Disney wanted someone riding herd on the project who would answer directly to them, so they required that the film have two producers, one from Pixar and one from Disney. Pixar chose Ralph Guggenheim, who had worked on their short films and produced their first commercials. Disney chose Bonnie Arnold, a live-action vet who had been the associate producer on *Dances With Wolves* and *The Addams Family*. Tom Schumacher, then senior vice president of Disney Feature Animation, would be the executive overseeing the project.

One of Pixar's first responsibilities was to deliver a thirty-second proof-of-concept test to Disney that would give the bigger studio an idea of the film's look and establish its "baseline of quality" (minimum standard). "This technology was all very new," explained Lasseter, "and not many people really knew what computer animation could look like."

"It was just a thirty-second gag," said Guggenheim, "but John was very clear about what he wanted to show, because he knew what hand-drawn animation could not do. So we included all these things that you could never have accomplished in hand-drawn animation: putting a plaid shirt on one of the characters, having highlights and reflections that move as the characters move around, having a venetian-blind lighting effect going across the room. We even put in some music from Randy Newman's score from *Avalon*, and some sound effects. It was a great little test.

"More than anybody else, John epitomized the desire we all shared to set the bar for the story quality and the image quality and everything else really high. We'd all been through these phases earlier in the history of computer graphics, particularly in the late '80s, when a lot of companies over-promised and under-delivered and people in Hollywood, in particular, began to believe that computer graphics was just a flash in the pan—something

Above: Woody. Rendered character pose.
Opposite page, top: Toy blocks. Tia W. Kratter, acrylic.
Opposite page, bottom: Andy's house. Tia W. Kratter, layout by Ralph Eggleston, acrylic.
Previous spread: Buzz and Woody. Rendered film image.

that existed only in the laboratory. We wanted to create a high standard of what people expected from computer animation."

Building the Team

> *"When we were starting out, the production people we'd brought in told us that when you made a movie, you formed a company within a company. There were legal reasons for it that I never understood, but at the time we were following their lead, trying to figure out how things worked. Stationery was prepared with 'Hi-Tech Toons' on it, logos were worked up. Basically the new production people were setting up a new identity for this group within our little company. I went to John and showed him the stationery, and he said, 'Oh, that's just a bad idea.' So, we put a stop to it. It was us—Pixar—that was going to make this film."*
> —ED CATMULL

Lasseter was just as excited about working with his team as he was at the prospect of finally directing his own feature. Lasseter had always loved talking shop and exchanging feedback with his colleagues, had always fed off of the energy of a group. And the exhilarating back-and-forth of making the short films had only whetted his appetite for more. "I love that working with other people can lead you to ideas that you'd never have thought of by yourself," he said, "so I love that animation practically *requires* you to work as a team to make the film. It's the most collaborative art form there is."

Top: Caricature of Joe Ranft. Kelly Asbury, color by Tia W. Kratter, marker and digital.

Lasseter didn't *want* to go off on his own into the mountains and return with a completed script—he wanted Stanton and Docter and Ranft (now that he could offer his friend a full-time story gig) right there with him, working out the story together.

This inclusive spirit helped set the tone not only for the production of *Toy Story* but for the studio Pixar would become. As Pete Docter observed, "A good director allows a film to be something that changes and grows and adapts to the strengths of people, the strengths of the technology, all the things you have available. I think John's a really great example of that because he can see the potential in everything that's offered to him. He has great instincts. He has a good time with everybody; he's curious about everything, and he's about living life big. That is great; it's opened the studio and the films up to all these amazing things that we would have never had otherwise, and I think that has rippled down and become a big part of what makes Pixar a good place. There's just an energizing joy of life, a receptiveness to inspiration from anything and anyone and anywhere."

It wasn't long ago that Stanton and Docter had been new hires, surprised to discover that Pixar's animation group was no more than ten people crammed into the back rooms of a computer hardware company. They had rolled up their sleeves and plunged with enthusiasm into the commercial work that was starting to roll in. But now they found themselves plucked from their work pitching gum and mouthwash and candy and deposited at one of the rarefied peaks of the animation mountain—in the room, developing the story for a feature film.

"It's pretty miraculous, whenever I think about it," said Stanton. "None of us had ever done a movie ourselves before, and a large portion of us had never worked on a movie at all, and here, suddenly, we were being given the option to make a movie for the first time and do whatever we wanted. We were like kids with their tree fort out in the woods that nobody else knows about. It's your world, so you can make your own rules."

Joe Ranft arrived at Pixar in October 1992, making good on his long-ago promise to head up the story department on Lasseter's first film. Ranft had actually been up in the Bay Area for about a year already, working as the story supervisor on Tim Burton and Henry Selick's *The Nightmare Before Christmas*. In the nearly ten years since he and Lasseter had worked together at Disney, Ranft had built up an impressive resume, including credits on *The Brave Little Toaster* (which Tom Wilhite had ended up producing independently in Taiwan), *Who Framed Roger Rabbit*, *Oliver & Company*, *The Rescuers Down Under*, *Beauty and the Beast*, and *The Lion King*.

Pixar in those early days had a terrific "mom and pop" studio feel, Ranft recalled, full of an infectious energy and a hunger to do something new.

"It was great," Ranft said. "Everyone was questioning, 'Do we have to do it the same way?' It wasn't about reinventing the wheel; it was that people didn't want to be complacent. Like in the first pitches of *Toy Story* that we flew down to Disney to do, Andrew Stanton and Pete Docter played music during the pitch as a 'score,' which made it really fine. No one did that sort of thing at Disney, but these guys here had great enthusiasm and their pitches were really something. Everyone was still pretty young, and there were lots of practical jokes and goofing around."

Lasseter had singled out his collaborators as talented individuals, but as the team settled into story development they soon discovered an amazing creative chemistry.

"When Joe finally came on board full-time, it seemed like everybody just complemented each other," said Stanton. "Being with each other made us come up with better ideas—or improve on the ones we had. You could almost physically see them evolve right in front

Above: Buzz Lightyear concept drawing. Bud Luckey, pencil.

of your eyes. Somebody would start a joke, somebody would come up with a punch line, somebody would come up with a middle, and then the whole thing would just kind of come out, almost effortlessly. I guess it's like finding the right performers in a band. Suddenly you're all psychic; you're finishing each other's sentences. Nobody planned for that or worked at it. It just kind of fell into that. We could even be good at arguing with each other! No one was distracted by ego, because you knew that everybody just wanted the best idea for the film."

Story

The story Lasseter had pitched to Disney was, as Andrew Stanton described it, "sort of a Rip Van Winkle story. This little tin toy gets left on the side of the road at a rest stop and goes on a road trip to find his owners, and he bumps into this hand-me-down ventriloquist's doll who tries to help him. It was very convoluted, but we thought it was great at the time."

The idea of a lost toy trying to find a home had its roots in the *Tin Toy Christmas* special. In that project, Tinny was one of a set of three musician toys that ended up being separated for sale. The idea of a toy being driven by a desire to find an owner felt intuitively right, but the story itself didn't feel right for a feature. Finally, Lasseter and Stanton came up with the idea of contrasting a new toy with an old toy, who was a child's favorite. "We looked at each other and we went, 'A buddy picture!'" recalled Lasseter. Once they hit on this, the rest of the story began to come together.

"In the beginning, we imagined the toys' personalities as a little bit more childlike, because they loved being played with so much," Lasseter said. "But then, all of a sudden, we realized that they should be adults. And that opened the door for a whole other level to this film."

Part of what made Lasseter's short films so compelling, what gave them their particular snap and vitality, was their grounding of the fantastic in the everyday. As he put it, "I always want to show the audience something they're familiar with, but then show it in a way they've never seen before." This was a lesson he had learned from his brother, Jim, a designer and architect—that preserving a familiar point of access for people helps them relate to and appreciate the new. Lasseter made inanimate objects do the impossible—live and move and feel—in a way that not only stayed true to their literal physical nature but felt intuitively correct.

Top: Buzz Lightyear concept drawings. From left to right, William Joyce, pencil; Jeff Pidgeon, pencil; Bud Luckey, pencil; Bud Luckey, marker and pencil.

"To me," he said, "the key is understanding that a man-made object is made for a reason. And therefore, if it were alive, it would want to serve that purpose more than anything else in the world. A glass is meant to hold liquid, so it's happiest when it's full. The more

you drink from it, the sadder it gets. When you get to the bottom and it's empty, its biggest hope is to be washed and filled again. The saddest thing in the world is a paper cup. What kind of life is that? It gets this moment of ecstasy—'I'm filled!'—and then it's drunk from and wadded up and thrown away. Life's done."

So once Lasseter and the rest of the team asked themselves a key question—"If a toy were alive, what would it want?"—the answers came flooding out. Toys are manufactured to be played with by children, they reasoned, so that is what they want more than anything else in the world. It followed, then, that toy anxieties must revolve around things that keep them from being played with by a child; things that take them out of the game. "Being broken means they won't be played with, so they're scared of that," said Lasseter. "Being lost, oh boy. Being stuck down at the bottom of the toy box and being forgotten, that's bad. But being shown up by the next new, big, shiny, fancy thing—that's a big one."

> *"We thought, you know what, the life of a toy is okay except for two times of the year: Christmas and a child's birthday. So that's where we got the idea of starting the story with the toys in the kid's room, with the anxiety and the stress of knowing that their owner's birthday party is going on downstairs." —JOHN LASSETER*

A relationship between a new toy and an old one would be unexpectedly complex emotional territory, fraught with undercurrents of jealousy, envy, pride, and insecurity.

They soon concluded that Tinny was miscast as the hero of this particular story. Tinny's blocky simplicity, toddler-friendly colors and sounds, and limited range of motion had been perfect for the short film—they emphasized his helplessness against the monstrous, drooling baby—but those limitations could eventually hamstring the storytellers in a longer story. More importantly, it was hard to believe that an old-fashioned wind-up doll would be a child's most cherished toy.

They decided to come up with a brand-new doll. Lasseter, combining his sons' love of action figures with his own childhood interest in NASA's missions of the '60s, suggested a spaceman action figure. The new character, a six-inch spaceman temporarily dubbed "Tempus from Morph," felt more believable as a contender for a child's favor; the team had gifted it with, as Stanton put it, "every possible idea we could ever come up with for the doll we always wished we could have."

But the change rippled outward, making Woody, the wooden ventriloquist's dummy, feel out of place. The Charlie McCarthy–style puppet was certainly the polar opposite of a futuristic action figure, but the difference was not harmonious.

Top: Buzz Lightyear concept drawings. From left to right, Bud Luckey, marker and pencil; Nilo Rodis, mixed media; Nilo Rodis, mixed media; Bob Pauley, pencil. Above: Buzz Lightyear. Rendered character pose.

It was sketch artist Bud Luckey who hit upon the solution. "Bud is originally from Montana," said Lasseter, "and he's got this wonderful Western kind of cowboy charm to him. And he came up to me one day and said, 'Have you ever considered making the ventriloquist dummy a cowboy?' As soon as he said that, I knew it was just perfect. First of all, the whole idea of a buddy picture is to pair up two characters who are as opposite as possible, and you can't get more opposite than a spaceman and a cowboy. They represent two different eras of cool toys, and for Woody, it makes him feel even more worried about being passé. But the other thing that's cool about it is that under their façades, they're very much the same; they're both classic American heroes exploring wild frontiers."

Woody the tuxedoed ventriloquist dummy became Woody the cowboy, and in Pixar's proof-of-concept test, it was the cowboy incarnation of the ventriloquist dummy who starred opposite the six-inch spaceman. But watching the test made the story team realize two things. First of all, said Lasseter, the size difference was too great. "You couldn't easily show them in the same frame," he said. "Woody's head was the same size as all of Tempus from Morph." Second, the ventriloquist dummy mouth not only looked, in Lasseter's words, "kind of creepy," its fixed lines limited the character's expressive potential.

They solved the first problem by changing the spaceman from an action figure to a twelve-inch doll, the same size as the GI Joe dolls Lasseter had loved as a child. This new, larger form was accompanied by a new and improved name, one that combined an homage to a real-life astronaut with some astronomical vocabulary: Buzz Lightyear.

The second problem was solved by changing the ventriloquist's dummy into a pull-string doll—which had the added bonus of allowing them to contrast the cowboy's scratchy pull-string recording with the spaceman's crisp digital voice.

At last, Buzz and Woody were born.

> "'To infinity and beyond!' came from a story session with Andrew, Joe, Pete, and myself. We had always thought of Buzz as being merchandising from a popular TV show, and we thought it would be great if he had a silly slogan. When we came up with 'To infinity and beyond!' we thought it was really funny, because, of course, there's nothing beyond infinity! To be honest, it was just meant to be a temporary thing at first. We thought, oh, we'll come up with something better later. But after a while, it just stuck." —JOHN LASSETER

Voices

One of the parts of making a feature that was completely brand-new for the studio was contracting with professional actors to provide voices for the animated characters; none of the short films had featured characters who talked.

The person Lasseter wanted most for Woody was actor Tom Hanks. Disney made the connection for them, and Pixar pitched Hanks on the project while *A League of Their Own* was in theaters, just after the actor had finished filming what would turn out to be an Oscar-winning performance in *Philadelphia*. To show Hanks what their project would look like, they had brought with them a short animation test of Woody, done to Hanks' "Don't eat the car!" line from *Turner and Hooch*.

"It was a perfect marriage of the line to Woody," Hanks recalled. "It was startling, actually—kind of hypnotic. It was like, 'Can I see that again?' I think I must have watched it three or four times. It didn't look like animation. It looked like plasticine come to life.

Above: Woody concept drawing. Bud Luckey, color by Ralph Eggleston; mixed media.

After that, they showed me the standard storyboards. But I couldn't explain, even to my friends, what it was like to see that animation. I just felt they were reinventing or inventing something, that this was going to be a whole new thing."

For Buzz Lightyear, Lasseter turned to stand-up comedian Tim Allen, who was just beginning what would be a star-making turn on the TV series *Home Improvement*. The choice ended up having an important effect on Buzz's character.

At first, the team had thought of Buzz as a toy who, aware of his own TV show, was kind of full of himself. But, Lasseter said, "Tim sounded like an everyday guy, which we realized would be much better for Buzz Lightyear. Instead of being aware of who he is, of his TV show and all that, Buzz should really think he's a space cop. He's crash landed on this planet, and the inhabitants don't have a clue; they keep telling him he's this toy. But Zurg's got this weapon that can destroy planets and he's the only one who knows the secret to stop him; he's got to get back up there! That's the passion that Buzz Lightyear has; he's a regular guy trying to save lives. Buzz Lightyear became a much better character because of that, and it all came from listening to Tim at that first recording session."

Tom Schumacher found it strange to remember a time when Lasseter wasn't an old hand at directing voice actors. "I don't know anybody in animation who is better at directing actors than John Lasseter," said Schumacher. "He's so comfortable, he's so fluid, and he's so fantastic in that room with them, but in fact, like everyone, he had to begin somewhere. In his experience directing shorts he'd already had great success, but now he was transforming that into the feature-length thing, and that made it all different. So I was with John the first time he did a recording session; it was with Tim Allen in Detroit for *Toy Story*. I sat in the booth with him, and showed him how this would normally work, and he just ran with it."

Jumping Hoops

The Pixar team went through iteration after iteration of their story, trying to make it better, going through all the usual trials of patching a story hole here, only to have another open up over there. They had successfully resisted pressure to make *Toy Story* into a musical, but they still felt like they were being kept on a relatively short leash. "The first year felt like it was mostly a lot of hoop jumping," Ranft recalled. "I think the unspoken thing with Disney was, 'Are these guys good enough to make a feature?'"

Pixar had developed a good working relationship with Tom Schumacher early on; as Lasseter recounted, he had helped smooth the way for their green light, and his story notes were always focused on improving the film they were making. But as the film was subjected to wider scrutiny, some Disney executives, Katzenberg in particular, felt that a film about toys

Top: Woody animation thumbnails by Glenn McQueen.

had to preempt any concern that it would be a story just for kids. It needed to assert a more clearly adult sensibility.

Recalled Schumacher, "Jeffrey would always be pushing for what he called 'edge,' which was, I think, code for 'snappy, adult, on the edge of inappropriate, and not too young.' A series of notes were given over a number of drafts and storyboard pitches that the film was too juvenile and that the film didn't have enough 'edge.'" Katzenberg even informed the Pixar team that they couldn't use the word "toy" in the movie's title, lest it scare away teenagers. (The title *Toy Story* went through without comment after Katzenberg left the studio in 1994.)

Because Katzenberg was the head of the studio, his notes carried the most weight by far, and the formidable Disney executive bureaucracy leaned heavily on Pixar to address every one, down to the smallest observation. Pixar, acutely aware of their inexperience and their lack of bargaining power in the relationship, reluctantly but dutifully complied.

The drill became as follows: Pixar would storyboard several sequences at a time, and after a couple of weeks Tom Schumacher and Peter Schneider would fly up to give their notes on the new material. The Pixar team would turn around the notes and fly down to L.A. with the revised sequences, showing their changes to Schumacher and Schneider in the evening so they could make any further tweaks overnight, before their 6 or 7 A.M. pitch the next morning to Jeffrey Katzenberg. Katzenberg would tear into the sequences in characteristically severe fashion, and the team would return north to reboard the material according to his notes—while also boarding a new set of sequences.

"It was the same process for about a year," Ranft said. "We were working our butts off, jumping through every hoop, addressing every note that was given to us, and just working really, really hard."

"We really went through boot camp to learn how to make Toy Story *under Katzenberg's regime, and in one way it was the best boot camp you could ever have. I mean, you were told, 'This is exactly how you do it,' and so we were basically thrown into the pool and forced to learn to swim. But the detriment was that every little decision was being forced on us, from the kinds of jokes we should tell and the manner in which something should happen all the way down to the nitty-gritty details. This was this whole new world of making a feature, so we deferred to the big boys, but in the process, we sort of let Woody's character slip past us." —ANDREW STANTON*

Black Day

Roughly a year into the process, Pixar put the first half of the film up on reels and took them down to Disney for a big screening to all of the studio's executives, as well as the film's composer, Randy Newman. Everyone had worked furiously to get the reels done, and it wasn't until the screening itself that the Pixar team had a chance to take a step back and look at the film with a more objective eye.

In order to give Woody an arc—if a somewhat simplistic one, Stanton admits—the plan had been to start him off as "a real selfish jerk" and make him a likable guy by the end. But as they went through round after round of notes, every iteration of the story made Woody more confrontational and belligerent, more "edgy."

"I remember being in some of the recording sessions with Tom Hanks," said Ranft. "Woody was being really mean to Slinky Dog, and Tom was like, 'Wow, I never get to play

Above: Woody concept drawing. Jeff Pidgeon, pencil.
Opposite page, top: From left, Joe Ranft, Pete Docter, John Lasseter, and Andrew Stanton on one of their regular trips down to Disney during the making of Toy Story.
Opposite page, bottom: Woody and Slinky Dog storyboard. Joe Ranft, pencil. The "edgy" Woody of the first version of Toy Story *was, the team ruefully agreed, a "jerk."*

characters like this. This guy's really a jerk!'" But it didn't register just *how* unlikable Woody had become until it was too late.

"I tell you, I sat there and I was pretty much embarrassed with what was on the screen," said Lasseter. "I had made it. I had directed everybody to do this. But it was a story filled with the most unhappy, mean characters that I've ever seen. Andrew and Pete and Joe and I, we looked at each other and knew, 'This is not the movie we wanted to make.'"

"After we screened the movie," recalled Tom Schumacher, "Jeffrey said, 'Well, why is this so terrible?' to me in the hallway. I said, 'Because it's not their movie anymore; it's completely not the movie that John set out to make.' They were following Jeffrey Katzenberg's notes, and the project had been driven completely off-track by trying to seek a voice that fundamentally wasn't the voice of Pixar or the voice of John Lasseter."

Disney, appalled, ordered Pixar to shut down production immediately. The Pixar team was instructed to lay off a big chunk of the crew and move the story team to Burbank, where they would reboard the film under Disney's watchful eye.

"Joe Ranft and I would have hallway discussions with people—'I'll quit before that happens, I won't go'—all that kind of talk," Stanton recalled.

Lasseter urged Disney to give them another chance. "Just give us two weeks," he said, "and we'll turn things around." Disney agreed to the momentary reprieve, and rather than lay off crew members just before the holidays, Pixar shifted people to the commercials division to keep everyone employed while they reworked the reels.

Before the screening, Lasseter said, he had been apprehensive about his lack of experience and thus had yielded to the advice of "the experts," even over his nagging feeling that such deference wasn't quite right. The failure of the reels, however, confirmed what his gut had been telling him. This was their big break, Lasseter realized, and they had effectively given it to someone else. They had made someone else's movie. If they were going to be evaluated by Disney, let them be evaluated on the results of their own instincts, not someone else's.

Lasseter said he told his team, "You know what? Let's just make the movie we want to make. We'll listen to their notes, but let's only take the ones we feel make the movie better and ignore the rest." They had nothing to lose—but precious little time in which to prove themselves.

Ranft, the grizzled veteran of the group, had worked on other films that had initially stumbled in the transition from boards to reels—films that later became huge hits, like *Beauty and the Beast* and *The Little Mermaid*—and the calm those experiences gave him buoyed the others. But even he recalled the *Toy Story* rewrite as one of the more harrowing experiences of his career: "All these people who had been working on the film were sitting around with nothing to do, being shifted to other projects, and there was huge pressure on us to make the story work. It was really very scary, and I think that's where Andrew, John, Pete, and I really bonded as a group. It was do or die time; the Grim Reaper was in the room, standing in the corner. It was like, 'Okay, you guys. If this story doesn't work, the whole project—this whole *place*—is dead!'

"So we worked night and day, and it was like the borders between us disappeared; we kind of melded into one. We just said, screw it, what do *we* want to do? What would be the funniest thing? We were brutally honest with each other about what we thought wasn't working. And we evolved a method of working I had never experienced anywhere else. We

Above: Slinky Dog. Kelly Asbury, pencil.

worked on each scene as a team. We became like one mind. And as things started to turn the corner, as we started to feel like things were really working, it just got more and more fun. It was like, well, if this doesn't work, who cares? We're having a blast."

The team came up with a new take on Woody that made him a much more sympathetic character: a well-intended, if selfish, favorite toy who didn't realize his self-serving tendencies until it was too late. In the scant few weeks they were eventually granted, the Pixar team completely remade the first third of the film. Their pass, though rough, showed that the new film would work—and finally showed the stamp of their own sensibilities.

"It was so refreshing because we were finally making the movie *we* wanted to make, with the kind of humor and emotion and action that *we* liked," said Lasseter. "And I tell you, from that point on, everything started working. We turned the reels around; we showed it to Disney. It wasn't great, but it was good. It showed the potential of what *Toy Story* would be."

Sarah McArthur, though not directly involved with the project, was the head of production at Disney Feature Animation at the time, and recalled her colleagues being struck by the speed and degree of the project's improvement. "The Disney management team was incredibly impressed by how quickly the *Toy Story* team turned it around—how they took the feedback they were given, and didn't necessarily respond to the notes specifically, but addressed the spirit of the notes, and turned the project around incredibly quickly in a way that was very unexpected."

There would be no layoffs; there would be no relocation to Burbank. Disney approved a couple of sequences for production, and the show was back in business.

Lasseter said the experience laid the foundation for the studio's creative process today. "There was something really magical about the way we worked together. To this day, there is something special when we all get together in a room. There was so much trust between us; we all had slightly different talents, and there was immense respect for what each person brought to the collaboration. It doesn't matter whose idea it is; we use the one that makes the movie better. Even though we're working on different movies now, we're all under the same roof, and we help each other all the time. We know that between us, we can solve any problem."

Putting Themselves into the Film

Once the immediate life-or-death threat to the project had passed, the group was able to take more pleasure in the actual process of filmmaking. As they went further and further into the story, overhauling, revising, and polishing, more and more of their own personalities infused the story and the characters.

"If you watch the film today, you can really see that combination of Andrew, me, Pete, and Joe," said Lasseter. "There are a lot of great people whose personalities found their way into the film, but *Toy Story* is very much a story that came out of that core four of us, out of the fun we had together, out of who we *are*."

> *"John always said that he was Andy, and Joe and I were Sid, and I think that's true. I think Sid is* normal. *He's the true representation of most American boys. I think Andy is the weird one, this boy who takes care of his toys, treats them all nicely, and always carefully puts them away!" —ANDREW STANTON*

Stanton, who proved to have a remarkable instinct for story, had never considered himself a writer. But on *Toy Story*, he said, "we had the great luck of having Joss Whedon work on

Above: Slinky Dog. Rendered character pose.

the film for a couple months before he went on to do his *Buffy the Vampire Slayer* TV series. Once we read his stuff, we realized how good a script could be. He wrote so visually—you could see what he'd written like an image in your head—and I just soaked up everything he did. Once I realized the power of what you could do if you wrote a script right, I wanted to be able to do that myself!"

A few weeks after Whedon left, the Pixar team needed a scene rewritten. "I said to Pete, 'Why don't we write it ourselves?'" Stanton recalled. "I just went into the office and typed up something and decided I was going to keep going until someone told me to stop. It was a hole that needed to be filled."

Their creative choices, Stanton went on, were governed by a very simple rule. "We all asked ourselves, 'If I were in a log cabin, and only making this thing for myself, what would I do? What would I want to see? What's the audience member in me not getting that I would like to get?' I think that's what gives our films their personal stamp, and I feel like that should always be a major ingredient of every movie we make. The minute we start making choices by guessing what we think other people want to see will be the day we start going on the decline."

> *"I think what John gets, and what Andrew gets, and what Pete gets, and what Joe and all those talents at Pixar get, is that to follow is profoundly uninteresting, though often safe. When you walk in the footsteps of those who come before you, if they're fresh enough, you're probably okay. But if it's way later, you don't know if they fell off a cliff; you're following these footsteps that kind of go nowhere. John and that team have been willing to do things because they liked them, and it's that willingness to just speak from their soul, as opposed to following in the footsteps of others, that has made them so successful."* —TOM SCHUMACHER

Production

While making a feature had been a long-cherished dream for Pixar, actually achieving that goal required the company to build—practically from scratch—a creative and operational infrastructure capable of producing eighty minutes of fully CG animation. This was no small task, considering that the longest project the company had produced to date was "Tin Toy," clocking in at a mere five minutes. Even *Jurassic Park*, the previous big dog of feature CG, had contained less than 10 minutes of computer-generated dinosaur animation composited into live-action scenes.

Fortunately—at least at the beginning—Pixar was blissfully unaware of exactly how intimidating their task was. Said Docter, "I remember we had an offsite meeting where everybody in the company—like thirty of us—talked about what it would take to make the film. I think we decided that we would need about twelve animators. And we honestly thought that one guy, Craig Good, could lay out the whole film, set up the cameras for every one of the shots. We figured that it might be a little bit of a stretch, but we could probably do it.

"Of course, we ended up with twenty-seven animators and a staff of seven or so layout people. And even then, *Toy Story* was a very small crew compared to the movies we make now. If we'd known how small our budget and our crew was, in terms of what it takes to make a feature, we probably would have been scared out of our gourds. But we didn't, so it just felt like we were having a good time."

"Pixar, for all its strengths, was still a rather academic kind of place," said co-producer Ralph Guggenheim. He recalled that Pixar had initially envisioned making a seventy-five-

Above: Andy. Steve Johnson, acrylic.

to eighty-five-minute feature film as being more or less like making 150 commercials—a comparison that didn't come close to capturing the additional complexity inherent in a project of such vastly increased scale.

"In producing a commercial, where there's fifteen, twenty shots, it's easy for a producer to walk around and keep everything in his or her head," he said. "But when you have 1,500 shots in a feature film, forget about it. You've got ten different departments all going at different speeds on different things; you need to really have an organized system to keep things together. Although we were in the TV commercial business and we were used to delivering on deadlines, we were a bit laid back. Bonnie Arnold really helped us understand how to shape our production team in a manner that would be effective and would work well on a large scale. In return, we taught her a lot about digital filmmaking, which was an area that she had never experienced before."

Disney, wanting to keep costs low, had given Pixar a budget that was no more than half the amount they usually spent on an animated film. As Guggenheim pointed out, this was to be expected. "From their point of view this was experimental filmmaking, and so while they knew that they had to be in on the experiment, they didn't want to risk a lot of capital on it. That's fair. Everybody knows Hollywood is very risk-averse; executives are always careful not to spend more money than they need to when they need to." Fortunately, he said, Pixar also sensed that if things went well and the movie was looking good, Disney would be likely to make more money available to them later on in order to improve the film.

But because the skills Pixar needed were so specialized and so new, they couldn't simply grow and shrink the crew with their budget. They would have to start cultivating the people they thought they would need well in advance, and once they were trained, they would have to be able to hold on to them. Guggenheim said, "This wasn't like live-action filmmaking in Hollywood, where you could decide tomorrow the fact the studio is willing to give you more money and you're just going to hire twenty more people who already know how to operate the cameras and the dollies and the lights and the sound system. You need to find people who can use Pixar's proprietary animation software that nobody else in the world uses, and train them and get them up to speed."

"It was daunting, and there were more than a few difficult conversations that we had among ourselves, and times we wondered whether we could really pull this off with our limited budget and limited resources. But the one thing that was really wonderful about the whole

Top: Colorscripts for (from top) Sid's Room, Andy's Room, and Woody and Buzz. Ralph Eggleston, pastel. When Ralph Eggleston, Toy Story's art director, came to Pixar, he brought with him the practice of producing colorscripts for each project. A colorscript is a series of images, each representing a different scene, that allows the filmmakers to see and plan the "flow" of color, lighting, and overall mood throughout the film.
Above: Andy. Bud Luckey, pencil.

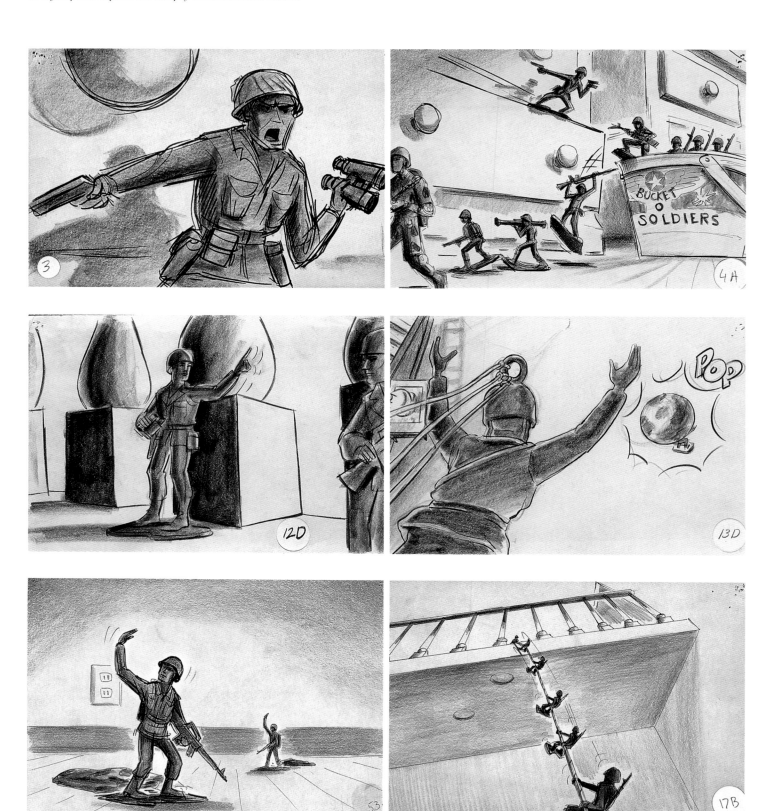

Crossover: Toy Story went through a number of story changes, but the one scene that remained virtually unchanged from the beginning was the Green Army Men sequence. Joe Ranft, pencil and ink; Bud Luckey (panels 12D and 13D), pencil and ink.

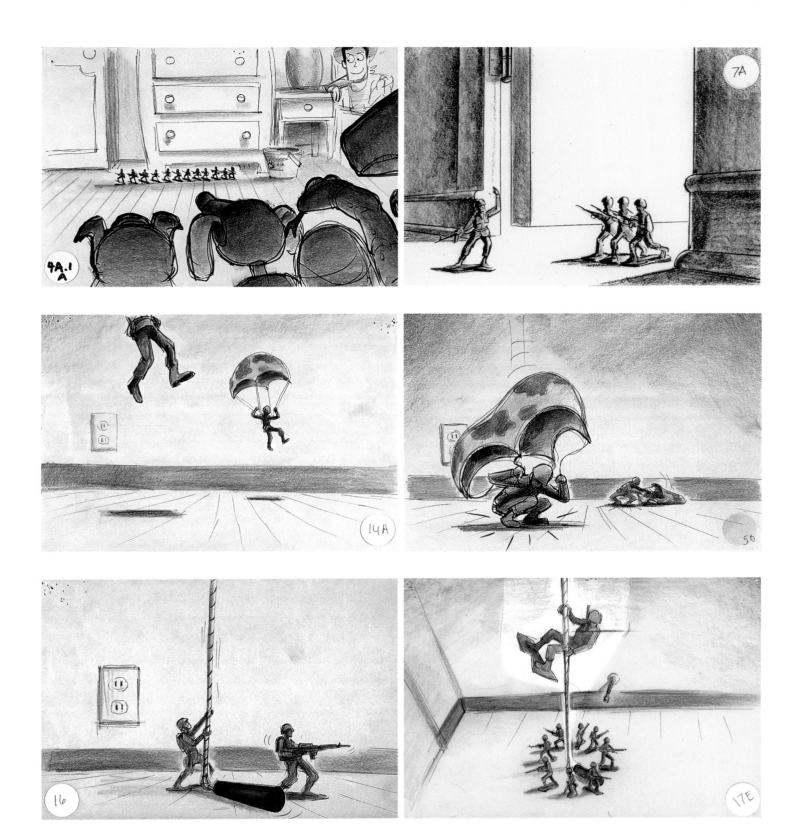

experience is that there was never a moment—from the time we started through the darkest of times when production stopped and we feared the worst—when we felt that we weren't going to make this film. We knew this was our sacred quest, we knew this was our holy grail, and nothing was going to get in the way of getting it done."
—RALPH GUGGENHEIM

Pixar's commercials department, now being supervised by future feature producer Darla Anderson, was thus an important shock absorber for the company, taking up employees when work on the feature was slow (as during the production suspension), and providing extra hands during crunch periods. Not only did the commercials division represent an outside source of income, a reminder of Pixar's ability to be independent, it allowed them to hire with an eye to the movie they wanted to make, without being absolutely constrained by their production budget at any given moment.

"Little by little," said Guggenheim, "the engine started gearing up and we built up the team necessary to make this film."

One of the new hires who would prove most influential on Pixar's future was an editor named Lee Unkrich.

Lee

Unkrich had joined *Toy Story* just as it entered full production. Trained as a live-action filmmaker at USC, he had never even thought of working in animation. But he'd seen "Luxo Jr." and "Tin Toy" at a festival where he was working as a student projectionist, and he had been so taken with the shorts that he actually bootlegged a copy of them so that he could show them to everyone he knew. A few years later, he heard that an animation gallery in Los Angeles was selling a tape containing all of the Pixar short films, and he immediately headed across town to buy a copy.

Right: Lee Unkrich, now an integral part of Pixar's creative team, had originally arrived at the studio expecting to stay no more than a few weeks.

"Literally the next day, I got a phone call from this guy, Bob Gordon, who was editing an animated film up in Northern California," Unkrich recalled. "He asked if I was interested in coming up for a few weeks to work on it. I thought, Northern California, animated feature—is this like some Care Bears movie or something? In my mind, all quality animation came out of Disney, which I knew was in L.A., so I was just trying to figure out how to gracefully get out of it when he mentioned the name John Lasseter. I said, 'Wait a minute, is this Pixar?'"

Yes, said Gordon; in fact, it was Pixar's first feature. Unkrich took the next plane to San Francisco.

Ranft vividly remembered the first time he saw a sequence Unkrich had cut. "The way he used sound, the way he made it play, was far beyond what I thought it could be, especially for a first pass. He had an amazing knack for making things work." The "temporary" gig was extended for a week, and then two, and then three; finally Unkrich was asked to stay on and finish the film.

Unkrich brought an invaluable live-action perspective to a medium that merged many aspects of both traditional animation and live-action. But most crucially, he immediately bonded with the core creative team. "There was a rhythm and a sense of collaboration that I had never experienced either in film school or professionally," Unkrich recalled. "We'd sit around a table, and it was like a creative feeding frenzy. We would take each other's ideas and heighten them, and then someone else would take them to a new level."

> *"One thing I discovered when I came up to Pixar is that editing for animation is much more participatory than editing for live action. The whole film is very elaborately storyboarded and cut together on reels ahead of time, and that process is as much a story development tool as a planning tool. Because you're involved at such an early phase, you get the opportunity to really help shape, not just the structure of the movie, but its tone and pacing. It's almost as if you're standing there alongside the director on location as they shoot the material and really letting them know what you need to make the best film possible, or even sitting alongside the screenwriter and talking about how to restructure scenes before they've even been shot." —LEE UNKRICH*

This match, at first glance a too-good-to-be-true coincidence, was actually an indirect example of how small the world of digital filmmaking was in 1994. Pixar was putting together *Toy Story* on the Avid nonlinear digital editing system—now an industry standard platform, but at the time still a relatively newfangled technology with only a small pool of expert users (*Toy Story* would be the first animated feature ever cut on the Avid). Pixar was among these early adopters because the company had extensive experience with the Lucasfilm EditDroid, a precursor system.

Unkrich had been one of the first students at USC to learn to use the school's brand-new Avid lab. "The reason I got the call from Pixar in the first place surely had to do with the fact that I knew the Avid well and I was on their manufacturer's list of experienced users." Pixar and Unkrich had made their own luck.

Animation

Computer animation was still a new medium, and it was no small proposition to assemble enough character animators for a complete feature crew. "The entire crew was green," remembered Docter. "Less than half had even used computers before. We were struggling—

often against the computer medium itself—to bring these characters to life in a way that felt natural and real. So many people rose to the occasion artistically, but Mark Oftedal and Doug Sweetland—both right out of school—did some truly groundbreaking stuff. I still remember seeing Mark's animation of Woody realizing he needs Buzz to be allowed back into Andy's room: Mark had these eye shifts Woody did—you could *see* Woody thinking! You could tell what was going on in his head! It made my spine tingle."

Glenn McQueen, one of the few experienced computer animators in the group, helped ballast the young crew as it found its footing. "A lot of us were really into the craftsman-ship of it all," recalled Docter, "but Glenn understood, more than we did, that the film wasn't about little pieces but the overall picture, and that we had to *finish* the movie. We'd have weekly quotas the whole department had to make. If we were five to ten feet off on Wednesday or Thursday, Glenn, who was really fast, would say, 'I'm done with my shot. Give me another one.' It was amazing. He would always go the extra mile for the group."

Making a feature also brought up, for the first time, the question of how to divide a project between multiple animators. Again, Pixar charted its own course. In hand-drawn animation, assigning animators to specific characters—a practice started at Disney—helps keep the characters "on model," maintaining a consistent look throughout the movie. But animat-ing in the computer means you don't have to worry about consistency of appearance—the computer model is always the same no matter who is moving it. Freed of this concern, Lasseter decided that the best approach would be to assign entire scenes to animators based on their dramatic strengths—their ability to convey a certain attitude or emotion. Rich Quade quickly showed a talent for the heartfelt; Glenn McQueen revealed himself the master of a particular strain of appealing insincerity. And, recalled Docter, "if a character had a scene where he totally flips out and goes bananas, we'd give it to Doug Sweetland."

Remembering how positive his *Young Sherlock Holmes* experience at ILM had been, Lasseter decided to adopt Dennis Muren's model of open dailies for his own animation reviews. Every morning the entire department gathered in the screening room to get Lasseter's feedback on their work and to offer suggestions and comments on their colleagues' work. The practice made it possible for everyone to learn from each other's mistakes and be inspired by each other's successes. Said Lasseter, "I found that when a really great shot came up, people would be like, 'Wow!' And then a week later you'd start seeing everybody's animation getting better." Having the reviews in the screening room also helped anima-tors understand what their work would look like once it was on the big screen. In the

Top: Woody and Bo Peep. Rendered film image.

afternoon, Lasseter would conduct "walk-throughs," visiting each animator at his or her workstation to discuss the shot in more detail.

The Top of the Mountain

For years, the people who made up Pixar's core technical team had bided their time, waiting for the opportunity to make the world's first computer-animated film. They waited to find the right place to develop the medium; the right creative talent to support. They waited until they had developed the right software to a sufficiently advanced stage; they waited until they had accumulated enough production experience, through shorts and commercials, to make the leap to a longer format. And, after taking their own stab at developing the right hardware, they had waited for computers to catch up to them, to become fast and powerful enough to create the images they envisioned.

On *Toy Story*, it all came together.

"In terms of technical impact," said Bill Taylor, co-founder of CG house Illusion Arts and one of the governors of the Academy of Motion Picture Arts and Sciences, "I think *Toy Story* was sort of a shattering experience for most of us in the visual-effects field. To see a whole CG movie animated that beautifully, rendered so beautifully, was just amazing. There was one effect where a raindrop runs down along a window in the foreground, refracting the background exactly as it should. They didn't have to put that in, but it's so good. That's emblematic of the kind of technical virtuosity that you now just normally expect in a Pixar movie. And to see all these characters operating at a level of expressivity that was fully the equal of what could be done with hand animation—it was staggering to see the technology come fully of age. Of course, everything Pixar has done since has been a step forward, but it doesn't have the shock value of the first one."

"To this day, *Toy Story* is the hardest, most exhausting, and still the most fun thing I've ever done at Pixar," said Bill Reeves, the film's supervising technical director. "It's the thing I'm proudest of in my career. To pull it off, we were essentially kick-starting an industry in terms of CG films."

For their first feature, Pixar had deliberately chosen to work within its range. They knew they could make the characters and environments of the toy world look believable, and Lasseter would warn the technical folks ahead of time about particular challenges that would require an early start—things like trees and the shrubs in Sid's backyard. Still, it was a formidable task, with tools and techniques being stretched to the outer limits. Woody and Buzz, for example, were much more complicated than any characters Pixar had done before—while Luxo had had only 18 "avars," or movable points of control, Woody had 1,500. Reeves had to rework the entire system for building model armatures and creating facial muscles.

Toy Story benefited from the cutting-edge custom work being done in-house by some of the finest minds in computer graphics. But a big part of what made the film look so good—for its day—was the skillful and subtle way in which these powerful tools were put to work—and *that* was the direct result of the close bond Lasseter had forged with the company's technical virtuosos.

Over the course of making their four short films, Lasseter had gained a deep understanding of the medium. He knew what it could do well, and he knew what it struggled with. Just as importantly, he knew where to grab hold of a problem in order to ask the right questions. At the same time, his collaborators—Bill Reeves, Eben Ostby, and Tom Porter in

particular—had developed a more discerning eye for the things that were important to an artist. They had begun to anticipate and incorporate the adaptability and fine control over appearance they knew Lasseter would want.

> *"I think we were blessed on* Toy Story *that John had been in this medium for ten years and knew what it was capable of, because it meant we could work hand in hand with him to make a doable leap beyond our capabilities at the time. We explained what we could and could not do, and where the bang for the buck was, and John was able to use that information to make educated decisions on what to prioritize. Sure, the humans didn't look great and there were other issues, but we were pretty much able to get the film that we all wanted."* —TOM PORTER

"The biggest challenge was just dealing with the length of the film," said Reeves. "We'd done short films, five minutes or so at most, and here was eighty-five minutes of characters and sets and all sorts of stuff. It was a challenge building a system that could deal with that level of complexity."

On the short films and commercials that Pixar had made before *Toy Story*, the technical needs of any individual project had been met by a handful of talented generalists, all of whom conferred daily and shaded or lit or modeled or programmed as necessary. But a feature required them to be able to parcel out—and scale—work that had until now been custom-designed for each problem as it arose. As Eben Ostby put it, "We were taking a process that was like handcraftsmanship in the computer and making it possible for twenty to a hundred people to work on parts of it at the same time."

When they made their short films, the core group had all worked in the same room. If a problem arose, recalled Reeves, "we could yell at each other. That doesn't work when you have 100 or 200 people working on a feature. You need a lot more infrastructure. And so we developed all sorts of database systems and rendering software systems that allowed you to render remotely on a farm of machines, that allowed you to centrally collect and share and save data."

These new programs didn't cover all the holes, of course. Later films would benefit from technology and software innovations that would make life easier and eliminate "brainless work" like making sure a character's foot made full contact with the ground, or moving a shot between animation and editorial via three-quarter-inch videotape. In the meantime, though, the crew accepted the hassles with equanimity, as the unavoidable cost of doing something that had never been done before.

As Lee Unkrich put it, "It was so absolutely Stone Age at the time—but we felt like we were on the top of our mountain."

> *"I certainly wasn't a computer expert at the time that* Toy Story *was made by any sense, but I remember there being a real uncertainty whether computers were ever going to be capable of doing feature-length films. There were a lot of people doubting that computers could actually be used for that duration of filmmaking. But then* Toy Story *came out and it just blew the world wide open. The fact that* Toy Story *used computers and had a complete three-dimensional world, that you were able to shoot coverage of the action just as you would if you were a live-action director, provided this incredible blend. It was the first time that I'd ever really had my eyes opened to what the possibilities of this new technology, animation, was—that you could be a live-action filmmaker and still show amazing animated visuals on the screen. You have this ability to create whatever you can imagine. It's very, very exciting because after seventy or eighty years of making films in largely the same way, suddenly there's technology existing and people making films that are raising the bar, pushing the boundaries. You feel like you're living in a pioneer filmmaking time again."* —PETER JACKSON

Opposite page, top: Hamm and Mr. Potato Head. Rendered film image. Opposite page, bottom: Woody leading the staff meeting. Rendered film image.

The Home Stretch

The first public test screening of *Toy Story*, held in Pixar's old home of San Rafael, raised eyebrows at Disney. As Tom Schumacher recalled, "It was one of the worst scoring previews we've ever had in the history of Disney Animation, and to that date, I think it was absolutely the worst one we'd ever had."

"But when the film got closer to being done, we had another preview screening," Lasseter recalled. "And never in the history of Disney previews had they seen numbers go from so low to so high for the same movie!"

The version screened for the first audience was admittedly not as polished, story-wise, as the finished film would be. But, Schumacher observed, that preview was probably also difficult for the audience to process because CG itself was such a new form.

In hand-drawn animation, a work-in-progress screening usually includes some finished footage and a lot of rough pencil animation and storyboards—all relatively familiar and viewer-friendly forms. But the intermediate stages of CG, with their gray, plasticky, and rigidly blocked-out models, are much less inherently appealing. The normal moviegoer had no frame of reference to "see" beyond these rough models to the final imagery. The first version of *Toy Story* contained everything from rough storyboards to early layout to finished animation, and as Schumacher put it, "It was like watching toilet paper tubes walking around, and then all of a sudden they were beautiful. The disparity between that was so great that I think the audience couldn't relate to them."

"With conventional animation, it's not that big a leap from a story sketch to the animated character," said Roy Disney. "You can say, okay, I can see what that'll look like in animation. But the leap in CG is really major. It's like stretching over the Grand Canyon. I remember the first time we saw the whole truck-chase sequence in there for real at the end. It was one of the last pieces that actually was animated. And when it was suddenly there in the flesh, it just transformed the movie. I remember going, 'Oh, I get it!'"

"That taught me something about *when* to show audiences a computer-animated film," said Lasseter. "Because if you don't know the medium, you won't know what you're looking at if you see it too early."

"To me, what's still one of the most amazing things about working in computer animation is that over the years and years of doing all these storyboard drawings, the drawings are always sort of a symbol of what the character is. Even if you draw the most beautiful drawing in the world, that's not what it's going to look like—and most of the time we're in kind of a hurry, so the drawings are not quite so beautiful. But when the finished shots start coming in, they're just amazing. I remember seeing the early stuff from Toy Story—

Top: Buzz and Aliens. Chris Sanders, pencil. It was during a Toy Story *gag session with some Disney colleagues that "The Claw" was born. Above: Alien. Bob Pauley, pencil.*

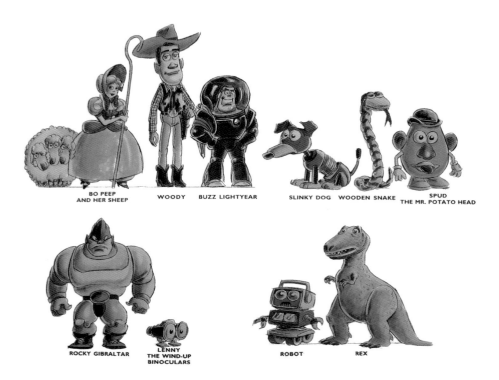

BO PEEP
AND HER SHEEP · WOODY · BUZZ LIGHTYEAR · SLINKY DOG · WOODEN SNAKE · SPUD
THE MR. POTATO HEAD

ROCKY GIBRALTAR · LENNY
THE WIND-UP
BINOCULARS · ROBOT · REX

everything felt like Wonkavision in Charlie and the Chocolate Factory, *where they talk about being able to take things right off the television set. It felt like you could do that, like you could reach into the screen and take the toy off and play with it. It was incredible. That feeling never goes away."* —JEFF PIDGEON

Back in the Lucasfilm days, Ed Catmull had estimated that they would need two years and a hundred Cray supercomputers to render the footage for a feature-length computer-animated film. The prohibitive cost of such an undertaking had kept them focused on software development, and they had spent over a decade practicing on smaller projects and positioning themselves, technically, to take advantage of the wave of faster, cheaper computers they knew was coming. By 1994, they were able to catch and ride that cresting wave. *Toy Story* was rendered in less than a year, using three hundred Sun workstations, each of which was as powerful and fast as a Cray had been.

"What that meant was our original projection of one hundred Cray computers was actually in the ballpark of what we ended up using!" Catmull said with a smile. "We'd called it right. We just did it several years later, when it was affordable."

Toys

For Lasseter, a notorious toy fiend, one of the things he was most looking forward to about the film was the prospect of having actual toys made of the characters he had developed. So it was a shock to hear that neither of Disney's major toy partners, Hasbro and Mattel, had been interested in producing toys for the film. Instead, Disney granted the worldwide master license to Thinkway Toys, a small Toronto-based manufacturer of talking coin banks.

Lasseter met with Albert Chan, the company's owner and toy designer, in January 1995, less than a year before the film's release. Chan had planned to produce a line of six-inch action figures—the type of toy judged to be the most likely seller. But Lasseter had based Buzz Lightyear on his memories of the twelve-inch G.I. Joe dolls of his childhood, and he wanted a twelve-inch Buzz Lightyear figure.

Top: Toy Story *character lineup. Bud Luckey, mixed media.*
Above: Alien. Rendered film image. The aliens are voiced by longtime Pixar story artist Jeff Pidgeon.

"Albert said, 'But there's no market for that. No one makes big, twelve-inch action figures anymore,'" Lasseter remembered. "And I said, 'Kids are going to want the toy they see in the movie, trust me.' He had a long look at me and he said, 'All right, I trust you. We'll make the twelve-inch action figure. We're still going to make six-inch ones, but I'll make a twelve-inch Buzz Lightyear and a fifteen-inch Woody doll, just like in the movie.'"

In early March, Chan arrived at Pixar to show Lasseter the prototype Buzz Lightyear. Companies usually needed a much longer head start to produce elaborate toys of this size, but Chan used innovative computer-controlled milling techniques to create molds directly from Pixar's computer models. Perfectly "on model," equipped with retractable wings and a recorded voice (*"To infinity… and beyond!"*), the toy *was* Buzz Lightyear. Suppressing his excitement, Lasseter asked Chan to follow him into the screening room, where a review was in progress.

"I walked in and didn't say a word—I just held up Buzz Lightyear," Lasseter explained. "And the place went *nuts!* Eben Ostby, who had modeled Buzz, leaped out of his chair and ran down and held it up. This was a character we had created for the screen—to actually be holding a Buzz Lightyear toy was so special."

Retailers did not share Pixar's excitement. When Chan shopped the toys around to stores, he was met with indifference. Wal-Mart passed, and Toys R Us and the Disney stores bought only a token amount. North American orders for Buzz Lightyear toys totaled 60,000 (45,000 for Woody dolls), a small number considering that blockbuster toy sales routinely averaged in the hundreds of thousands.

"Albert had seen the movie and believed in it," Lasseter said. "He put his own money into making another 250,000 Buzz dolls and 250,000 Woody dolls. Well, by a week before the movie even opened, every one of those toys had sold out, just from the movie trailers and commercials! Within the first week of the film's release, reorders for Buzz Lightyears were 1.6 million. Albert's factories just kept making Buzz Lightyears—to this day, he still makes Buzz Lightyears!"

To date, Thinkway has made over 25 million Buzz Lightyears.

> *"It's one of the most famous stories in retail mistakes, because, except for Albert with his fantastic talking Buzz and Woody dolls, nobody on any level got on board with the movie, nobody cared. The great irony, of course, is that* Toy Story *has become one of the greatest toy franchises in the history of modern films."—TOM SCHUMACHER*

Debut

"The wrap party for *Toy Story* was magical," remembered Darla Anderson. "It was like being on a first date, when everything is exciting and fresh. None of us had ever been through anything like this, and it was a huge achievement. We all got dressed up, which we never did then, and all 110 of us saw the film together. It was a big high and a pure experience in celebrating the achievement, without the world knowing what it was just yet. We were just congratulating ourselves on getting it out the door. And we danced all night."

"As naïve as it may sound," said Pete Docter, "making Toy Story felt like an extension of school, where we were just making the film we wanted to make for us and our friends to enjoy. So when it actually came out, it was pretty stunning. The fact that my parents in Minnesota had heard about it, that there were billboards and toys—that we were being reviewed by *Time* magazine!… It was overwhelming."

Toy Story was released on November 22, 1995. It became a phenomenon beyond anyone's wildest expectations, ultimately ending up as the top-grossing film of the year, as well as one of the best-reviewed. For Ed Catmull, the positive reviews were a tremendous source of satisfaction, as much for what they didn't say as for what they did. "In most of the reviews, the fact that *Toy Story* was a computer graphics film was only mentioned once. And I took some pride in this; it was actually important to us that it wasn't the focus of the review. Because that meant that they loved it as a movie, not as a piece of technology."

Similarly, while John Lasseter was floored to receive a special achievement Oscar recognizing *Toy Story* as the first feature-length computer-animated film, even more gratifying was the out-of-the-blue nomination the film received for Best Original Screenplay—the first ever for an animated film. "We didn't win, but to be nominated was an incredible honor. It validated the very core of what Pixar's about—story, story, story."

Neither Lasseter nor anyone else at Pixar was prepared for the degree of *Toy Story*'s critical and commercial success, which made 1995 a year of exhilarating surprises. But Lasseter's favorite memory of the film is from a perfectly ordinary day.

After *Toy Story*'s successful opening, Lasseter took his family on a vacation to Disney World. On their way home, as they were changing planes at the Dallas airport, Lasseter saw a little boy, about four years old, with his mother near a gate. The boy was clutching a Woody doll and had a huge smile on his face.

Lasseter said, "This was about five days after the movie came out. And my sons were going, 'Daddy, look! Go over and tell him who you are.' But I said, 'No, no.' I realized at that moment that Woody didn't belong to me anymore.

"That was a big moment for me. When you make these films, they become like your children. But at a certain point, they don't belong to you anymore; they belong to the world. And honestly, that is the whole point of why we do what we do. It's for that little boy; it's for our audience.

"Yes, we worry about what the critics say. Yes, we worry about what the opening box office is going to be. Yes, we worry about what the final box office is going to be. But really, the whole point of why we do what we do is to entertain our audiences. The greatest joy I get as a filmmaker is to slip into an audience for one of our movies anonymously, and watch people watch our film. Because people are 100 percent honest when they're watching a movie. And to see the joy on people's faces, to see people get really into one of our films…to me, that is the greatest reward I could possibly get."

Top left: John Lasseter receiving his Special Achievement Oscar for Toy Story.
Top right: Instead of a limousine, Pixar took the Oscar Mayer Weinermobile to the Academy Awards the year Toy Story *was nominated. It's been a company tradition ever since.*

 / Spotlight

Music

Before the Pixar team had ever settled on what sort of movie they *did* want to make, they knew the sort of movie they *didn't* want to make. "We didn't want to do the sort of animated movie that was popular at that time," said Lasseter. "We did not want to do a musical with seven songs, a princess as a love interest, a serious main character with funny sidekicks, and a bad guy that wants to take over the world. We wanted to be different; we wanted to do our own thing."

But the success of *The Little Mermaid* and *Beauty and the Beast* had led certain Disney executives to interpret the films' musical model as *the* recipe for success. So when, in an early note session, a Disney executive started talking about where to put the seven songs, Pixar stiffened. There aren't going to be any songs, they explained. This is a Disney animated film—there have to be songs, the executive shot back. Lasseter had been dreading this moment. "I thought maybe that was the end of *Toy Story*," he said. "Songs do allow you to get to an emotion quickly, but I just didn't want Woody and Buzz stopping in the middle of a scene to break out in song. That wasn't the movie we were making."

Chris Montan, Disney's executive music producer, pointed out that there were many different ways in which songs could

be incorporated into a film. He and the Pixar team worked together to come up with a list of movies that used songs in a way they felt could work with *Toy Story*. When Lasseter thought about films like *The Graduate*, indelibly associated with its Simon and Garfunkel songs, and *Harold and Maude*, with its songs by Cat Stevens, he decided he could see his way clear to a soundtrack in a similar vein, one in which songs would be an important part of the film's emotional mood, but not part of the story action. "The songs were written about a particular place in the story, or the emotion in a particular place in the story, but were not sung by the characters themselves," Lasseter explained.

The Disney execs were amenable to this approach, which Montan pitched as a "cohesive song score," although they were surprised at first by Lasseter's choice of composer. Randy Newman, the well-known singer, songwriter, and composer, hadn't been anywhere near the Broadway-influenced ballpark they had been thinking of. But Newman had written some of Lasseter's all-time favorite film scores (*The Natural* chief among them), and Lasseter loved the range of the composer's work, his ability to move easily between the deeply emotional and the sharply witty. "None of his scores sound like each other," said Lasseter. "Every score is unique and fits perfectly with its film;

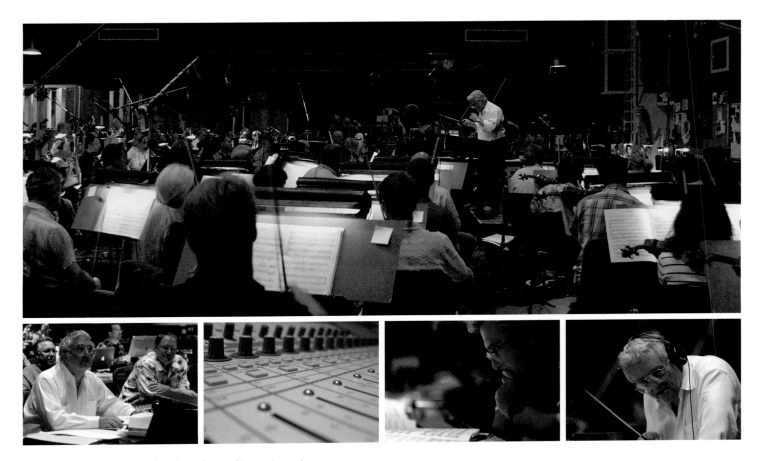

Top: Randy Newman conducting the orchestra during a Pixar scoring session.
Above: (left to right) Chris Montan, Randy Newman, and John Lasseter; the mixing board; Randy Newman; Randy Newman.

I just love the emotion in them. But wrapped up in the same package, you have the guy who wrote 'Short People' and 'I Love L.A.'—these satirical, hilarious songs."

After the initial thrill of meeting Newman subsided—"It's Randy Newman! I mean, here we are, these animation geeks from Northern California, and we're meeting with Randy Newman!"—Lasseter knew right away that the collaboration would be a good match. Indeed, Newman would end up scoring five of Pixar's first seven films.

"I believe there are two main things in our films that give audiences the underlying emotion of a scene: the lighting and the music," Lasseter explained. "Randy's music has added so much to *Toy Story*; *A Bug's Life*; *Toy Story 2*; *Monsters, Inc.*; and *Cars*."

"I find writing for movies very difficult," said Newman. "It's all day, every day, for ten weeks or I don't get it done, just over a piece of paper. But you know that the animators and the people working on this picture are working at least as hard as you are. They're clean, you know? They work hard for years and years and it shows. Best of all, they have respect for their audience. So many times you work with or for people that think you have to telegraph things to the audience and that,

you know, 'They won't get that.' They will. I mean, you see this movie with four-year-olds and five-year-olds as I did and they follow it like they were Shakespearean scholars seeing *Hamlet* for the eightieth time.

"The Pixar people have an affection for their audience that I've never seen betrayed. The movies have been successful. But irrespective of their success, they are good pictures, pictures that you would be proud to be associated with—and I am, very much so."

Chapter 6

Building a Studio

"Steve is a visionary. He saw the huge potential of what we could do at Pixar way before the rest of us, and way beyond what the rest of us imagined. He plays the game looking not three moves ahead, but three hundred moves ahead." —*JOHN LASSETER*

Ed Catmull observed that there were many other computer graphics companies that came up at the same time as Pixar and had similar ambitions. "Everyone turned out differently, of course," he said. "I think one of the biggest reasons Pixar turned out the way we did is because we had Steve. Hollywood, at least nowadays, is very focused on movies. It isn't about building studios, it's about making movies. And part of what Steve brought to Pixar was the entrepreneurial company-building spirit of Silicon Valley. He was focused on building a studio."

Even as the company moved into sight of the finish line on *Toy Story*, they were realizing that their current business model was, as Jobs put it, "unsustainable."

"Six to nine months before the movie came out, we started seeing final footage for the film," he remembered. "And we were blown away with it. We really felt strongly that the movie was going to be a success.

"But if all we could do was make one film every four years, we would not be relevant to our audiences. Financially, if one film did not do well, we would be wiped off the face of the earth. We had a major challenge on our hands, which was to grow Pixar from a production company, one that at best made one film every four years, to a studio that could turn out one film a year with no loss in quality."

To grow into a real studio and meet the goal of an annual feature release, Pixar had to invest in more talent and technology and build a production infrastructure that could handle several productions running parallel to one another. The problem was that it didn't have anything approaching the resources to do so. Pixar's software and television commercial endeavors had been successful in their respective fields, but they could not scale up to support the company as a whole.

Lawrence Levy, who joined Pixar as its first CFO in early 1995, had observed that even if *Toy Story* was a success, it wouldn't necessarily assure the company's future. "The original contract

PIXAR

INCORPORATED UNDER THE LAWS OF THE STATE OF CALIFORNIA

SEE REVERSE FOR STATEMENTS RELATING TO RIGHTS, PREFERENCES, PRIVILEGES AND RESTRICTIONS, IF ANY

THIS CERTIFIES THAT

IS THE RECORD HOLDER OF

CUSIP 725811 10 3

FULLY PAID AND NON-ASSESSABLE SHARES OF COMMON STOCK, OF

Pixar, transferable on the books of the Corporation in person or by duly authorized attorney on surrender of this Certificate properly endorsed. This Certificate shall not be valid until countersigned and registered by the Transfer Agent and Registrar. Witness the facsimile seal of the Corporation and the signatures of its duly authorized officers.

THIS CERTIFICATE IS TRANSFERABLE IN BOSTON, MA OR NEW YORK, NY

DATED: COUNTERSIGNED AND REGISTERED: THE FIRST NATIONAL BANK OF BOSTON TRANSFER AGENT AND REGISTRAR
BY:

AUTHORIZED SIGNATURE CHIEF FINANCIAL OFFICER CHAIRMAN OF THE BOARD

©PIXAR 1986–1995 ©THE WALT DISNEY COMPANY 1995

with Disney, from an economic point of view, was a disaster for Pixar," he said. "It was pretty onerous—the typical contract that a big studio would give to a fledgling little company on its first film—and it had all the issues of profit participations and deferrals and everything that would pretty much assure that you'd be very hard-pressed to make any money on it."

But Jobs had ambitious dreams for the company. "I think Steve chalked up our first deal with Disney to getting started, to getting the first film under our belt," said Lasseter. "But he did not want Pixar to be a production company or a commercial house. He did not believe Pixar should be getting paid for making movies that belonged to other people at the end of the day. He wanted Pixar to have a stake in its own future. And he saw the incredible importance of owning our stories and our characters."

To this end, Jobs decided that the time had come for Pixar to go public—to sell shares in the company on the open market.

The IPO

"When Steve suggested we take the company public, we all thought it was a nutty idea," Catmull recalled. "We felt it was too soon, that the right thing to do was have two films that would establish our track record. But Steve's logic was that when *Toy Story* came out, it was going to be successful, and Disney would want to extend their contract with us. If we were going to head into the future with a new contract with Disney, we would want to share 50 percent of the profits. And to do that we'd have to put up 50 percent of the production money for it to make sense to Disney. We needed money in the bank, and therefore, we needed to go public."

Top: One of the initial Pixar stock certificates, bearing the signatures of Pixar CFO Lawrence Levy and CEO Steve Jobs.

Lasseter understood the financial rationale, but he was deeply concerned by its possible implications. "When Steve first brought up the idea of going public, I told him I was worried we would start making creative decisions based on the need for profits in such and such a fiscal period," he said. "I didn't want Wall Street and the stock market driving what we did creatively, and I told him that the day that happened would be the day I left the company. Steve looked at me and said, 'I will never ask you to do that.' So, we made kind of a deal. It was a simple philosophy—just keep making the films, have fun doing it, and don't worry about the latest stock price."

The initial public offering (or IPO) was set for one week after the release of *Toy Story*—a risky proposition, in that it pegged the offering's outcome to the film's first week at the box office.

Jobs explained, "There was a certain amount of buzz before *Toy Story* came out. We actually could have gone public before the movie came out, before anyone knew how successful it was going to be, and we probably would have done very well. But we wanted to set a tone for our company, to show that we believed in our work and were willing to bet on the movie. We wanted people to see our movie before they invested in this company. And, of course, the film opened even bigger than any of us ever imagined. We ended up having the largest IPO of 1995, even bigger than Netscape. We raised about $140 million."

Mike McCaffrey, chairman and CEO of Robertson Stevens, the IPO's lead underwriter, recalled the thrill of being on the trading floor. "I think it's exciting when entrepreneurs see the market put a price on their vision. But what struck me about the Pixar management team was they didn't go overboard with that kind of feeling. There was also a sense of responsibility. Now that they had gone public, they had to deliver to their investors."

"These films are really, really hard to make," said Lasseter, "and all of a sudden I felt like I was carrying a lot of weight, having stockholders. But when I was able to step away from that a little bit, I recognized that the success of the IPO meant people really believed in us, and that was a good feeling. Most important, the money we raised let us be truly independent. It meant we could be an investor in our own films, and have a say in the quality of not only the movies themselves but everything that would be created from them. That's a luxury that not many little studios have."

Ed Catmull recalled that no sooner was the IPO money in the bank than Jobs' prediction of a contract renegotiation came true. "Disney came to us and asked to extend the contract, and Steve said that would be okay—if we could be fifty-fifty partners. And Disney agreed. I was in awe—Steve had called it exactly right."

Jobs knew that Pixar's future depended not only on its financial participation in its films, but on its ability to establish its own identity in the movie marketplace. So when hammering out the terms of the new deal, one of the conditions he had insisted on was that going forward, all films would be branded with both the Disney and Pixar names. "When *Toy Story* came out, most people didn't know that Pixar made the movie; they thought that Disney made it," he said. "So when we renegotiated our deal, one of our biggest concerns was to make sure people understood we were the ones making the films."

"It was exciting when they officially agreed to co-brand the films," said Lasseter. "It made us feel like we were real, like we were going to be around for a while. So often people come together to make a great movie and then just disband afterward. They might get people back together to do a sequel or something, but it's never quite the same. Our desire from the beginning was to build a studio. We wanted our people to be here for the long term, to be trained here and to feel secure about staying."

The Disney/Pixar deal would be extended to five feature-length pictures, and it would start with Pixar's sophomore effort, which was already in preproduction—a film about insects that would become known as *A Bug's Life*.

Looking Ahead

"We had been focused on making a movie for so long that when we finally got within sight of our goal, for a moment there was sort of a 'now what?' feeling," said Catmull, smiling. "But pretty quickly we realized that we had to systematically look at what we needed to do to become a real studio, to keep doing this for the long term."

Said Lasseter, "There are a lot of people in Hollywood who, after having a big success like *Toy Story*, would have started thinking, 'Well, we know how to do it; we've got it all figured out.' But what's great about Ed is that he was the first one to say, 'Hey, we really don't know what we're doing yet. Let's take a look at what worked and what didn't work, so we can make ourselves better in the future.' Ed's attitude has always been that we need to be constantly learning and constantly improving ourselves."

Catmull wanted the company to look not only at what they did right and wanted to repeat, and at what they did wrong and could learn from—but at what they did wrong and got away with. Postmortems on *Toy Story* uncovered serious communication problems that had been hidden during production by some of the project's greatest strengths—people's excitement for and dedication to the project.

Catmull said, "There are many companies that are very successful, but don't pay attention to the things that are going wrong until it's too late. So I was really shaken when I realized that we were starting to do a similar sort of thing. We resolved to never allow success to cover up our mistakes. We had to make it a priority to find and fix our problems early on."

Directors

When they stepped back to look at what they needed to do in order to grow the studio into one capable of releasing a film a year, Catmull and Lasseter realized almost immediately

Top: Pixar had been named for the product around which it had originally planned to build its business, the Pixar Image Computer. Its new logo made it clear that moving forward, animation would be the heart of the company.

that the limiting factor would be directorial talent. *Toy Story* had taken four years to make, about par for the course for animated features of its generation, so to release one film a year would require the studio to have at least three or four films in production at once. Who could lead all these projects?

The model in use at most other animation houses at the time was one patterned on the way Walt Disney had run his studio, with a single person—nowadays, usually an executive—calling the shots and setting the sensibility for the entire company. Indeed, it was common for most movie studios to come to be identified with their most senior executives.

But as Pixar grew, Catmull, Lasseter, and Jobs had refrained from consolidating the image of the studio in a single person. Each man brought a unique set of abilities to the task of running the company, and each of them appreciated and relied on the contributions of the others.

For instance, said Lasseter, "knowing Steve was there looking out for Pixar's long-term future made it possible for me to totally focus 100 percent on the creative side of things, and for Ed to totally focus on the day-to-day running and the technical development of the studio. We knew we were being taken care of. And Steve let us do our thing as well. He would give us his notes, and he always challenged us to figure out ways to do things better, but he really trusted us to make the movies and run the company from day to day."

It was natural, then, for Catmull and Jobs to defer to Lasseter on the question of how to structure the studio's creative side. Both felt very strongly that the studio's creative agenda should be set by a filmmaker, not an executive.

But Lasseter, in turn, while often called upon to be the "face" of the studio, had no desire to make Pixar into a one-man show. He knew what to do in the spotlight, but he never courted it; as often as not, his impulse was to bring others into the spotlight with him. "There are many people who want strong people working *for* them," said Catmull. "John wants strong people to work *with* him."

Top left: Pete Docter.
Top right: Andrew Stanton.

Lasseter wanted the name "Pixar" to be identified with the group of filmmakers at the studio and their shared attitude toward their craft. "I knew I couldn't possibly direct every movie Pixar made, and I didn't really want that either," he said. "Andrew and Pete were the second and third animators at Pixar after me, and I knew right away that these guys were good enough to make their own films. I was inspired by Ed Catmull's model of hiring great people and letting them shine, and I really wanted Pixar to be a place where these guys could have their time in the sun."

Top: Pixar's tenth anniversary company photo.

Chapter 7

A Bug's Life

"There's a classic thing in business, which is the second-product syndrome. Often companies that have a really successful first product don't quite understand why that product was so successful. And so with the second product, their ambitions grow and they get much more grandiose, and their second product fails. They fail to get it out, or it fails to resonate with the marketplace because they really didn't understand why their first product resonated with the marketplace. I lived through that at Apple—the Apple II was incredibly successful and the Apple III was a dud—and I've seen a lot of companies not make it through that. So, I was very concerned about our second product. My feeling was, if we got through our second film, we'd make it. The first one was the most risky, but after that, the second one was pretty close to it." —STEVE JOBS

Pixar had begun work on its second feature in 1994, about a year before the release of *Toy Story*. They were barely into principal animation on *Toy Story* and had no way of knowing whether or not Disney would pick up the remaining two movies in the original deal, but they knew they had to keep moving.

The initial brainstorming session for the project—a lunch meeting between John Lasseter, Andrew Stanton, Joe Ranft, and Pete Docter—had been an unusually fruitful one. Stanton mentioned that he thought an ocean movie could be great for CG, and Stanton and Docter got excited about the idea of a robot left alone on a garbage-choked Earth. But the idea that stuck was a twist on Aesop's fable "The Ant and the Grasshopper." The well-known story was a cautionary tale about a carefree grasshopper who plays all summer long instead of putting away food for the winter like his industrious neighbor the ant. But, Ranft and Stanton had wondered, what if the much bigger grasshopper simply *took* the food from the smaller ants when winter came?

Lasseter knew that one of them would have to leave *Toy Story* soon in order to begin work on this new project, which would eventually be known as *A Bug's Life*. The original plan for *Toy Story* had been for Stanton and Docter to jointly supervise animation once the project went into production. But, Docter recalled, over the course of *Toy Story*'s development Stanton had emerged as the writer of the studio. "It became really evident that his strong suit was story. He had something pretty amazing." So when it came time to begin principal animation, Lasseter decided to keep Docter on as sole supervising animator and

Above: Flik. Rendered character pose.
Opposite page, top: Grasshopper Attack.
Geefwee Boedoe, acrylic.
Opposite page, bottom: Grass study. Tia W.
Kratter, layout by Glenn Kim, acrylic.
Previous spread: Digital still from Leaf
Bridge animation test.

send Stanton off with a small crew to start developing the new project. By the time *Toy Story* was completed and the studio turned its attention to *A Bug's Life*, Stanton's team had put in about ten months on the story.

Stanton and Docter were obvious early candidates to direct their own films (for the moment, Ranft had little interest in directing, though Lasseter hoped to eventually change his mind), and Lasseter wanted to make sure that both went through the entire filmmaking process, from story development through production, before going off on their own.

In recognition of Stanton's expanded role on the new film, and to give him the essential production experience he had missed on *Toy Story*, Lasseter asked Stanton to be his co-director on *A Bug's Life*.

An Epic of Miniature Proportions

From the start, the creative team knew exactly the approach they wanted to take with the insect world. "We wanted it to be a big adventure," Lasseter recalled. "We called it 'an epic of miniature proportions.'"

But the unexpectedly meteoric success of *Toy Story* ratcheted up the pressure correspondingly. The grand ambition Pixar had always had for the movie was now multiplied by their drive to prove that *Toy Story*'s success was not a fluke.

"The executives here are great," said Darla Anderson, the commercials producer who was tapped to be Pixar's producer on the film. "We couldn't have a more truly supportive executive team. They never said, 'Hey, this one better be good.' But you didn't have to be a genius to know that everybody's looking at you and that the pressure's on. We really felt the future of the company and the weight of the world on us—could we do it again? Would our second movie be successful?"

Toy Story had done extraordinarily well, but Pixar's profit participation in the film had not been sufficient to give the studio much financial security. It needed *A Bug's Life*—its first film under the new "50-50" deal—to do well in order to shore up the studio's hopes for future films.

"I think *A Bug's Life* is the most difficult movie we've made," mused Lasseter. "It really was the classic sophomore effort, where you're like, 'Hey, let's make it even bigger this time!'"

Top: From left, A Bug's Life *director John Lasseter, producers Kevin Reher and Darla Anderson, and co-director Andrew Stanton. Above: Dot's Lookout. Tia W. Kratter, acrylic.*

Indeed, everything about their second project was bigger. They had chosen to make their epic in film's epic format—the widescreen aspect ratio of CinemaScope—so each frame had more in it. There was, literally, a cast of thousands—an ant colony, plus a troupe of circus bugs and a gang of grasshoppers. And they had jumped from the computer-friendly world of plastic toys and static interiors to an irregular, organic, constantly moving world of wind-blown grass, pebbly terrain, smoke, water, and fire. "If we'd wanted it to be easy we'd have done something smaller…but we didn't," grinned Kevin Reher, the *Toy Story* production accountant whom Disney chose to be their producer on *Bugs*.

But the biggest thing of all, Lasseter recalled, was the story. "It was just a giant story. Too many characters, too much going on—we were just drowning in this thing."

The group had—briefly—entertained thoughts of a smoother ride on their second go-round. "But when we started on *A Bug's Life* we realized we were back in kindergarten again," Ranft sighed. "Just because we figured out how to make Woody work didn't mean we could make this character work." Fitting an epic cast and story into ninety-five minutes turned out to be an epic struggle in itself, as they cut some characters and pared down others, trying to make the story play.

> "A Bug's Life *ended up being such a gargantuan opus that I probably worked harder on it than on any other movie. I twice worked thirty days at a stretch without a day off, and did countless all-nighters. Sharon Calahan, the director of photography, was living in her office for months. She'd only go home to do her laundry."* —LEE UNKRICH

Stanton, who once again assumed screenwriting duties, said, "It was such a Sisyphean job, more so than any other one, because for so long it never worked. Even when it was working, you never had the satisfaction of *feeling* like it was working."

Initially, the film's initial protagonist was a circus bug named Red, who offers his troupe's services to the beleaguered ant colony. But the story team kept having to invent patches to address a recurring question: why would this outsider put himself on the line for the colony? Then Stanton had the idea of making Red into Flik, a colony misfit who goes out to recruit help. To make absolutely sure it would work, he wrote an entirely new script on the side before introducing the idea to the group. It was the realignment the story needed—and with that block cleared, things flew. Stanton said, "We found the story solutions by such outside routes that by the

Top: Manny and Rosie sculpts. Jerome Ranft, cast urethane resin.

Above: Rosie. Rendered character pose.

Above: Ant Council. Rendered film image.

Top: *Sparrow Attack. Tia W. Kratter, layout by Bob Pauley, acrylic.*
Bottom: *Bungalow. Tia W. Kratter, acrylic. This early piece of concept art shows, at center, the original protagonist of A Bug's Life, Red the circus ant.*

time we applied them, it felt almost anticlimactic. But on the flip side, it made you feel like if the group could overcome a bad start like that, it could do anything. You knew you could walk through the fire with these guys. You lost your fear of the unknown."

The View from the Bug-Cam

The importance of research, of truly understanding their subject matter and chosen environment, was coded in Pixar's DNA. The creative team had conscientiously done their research for *Toy Story* in the form of company-funded field trips to Toys R Us, but ultimately the world of toys was very familiar to them. It was a world they'd grown up in, one whose rules they intuitively understood.

For *A Bug's Life*, they would need to study the insect world in order to figure out how to bring it to life. At first, Lasseter and company simply walked out the front door of the Pixar offices, stuck their heads into planters, and tried to figure out what plants looked like from underneath. Finding them awkwardly peering into the edges of the planters, hardware engineer Neftali Alvarez led an effort to rig up a tiny, wheeled "bug-cam" that allowed them to film things from half an inch above the ground. What they discovered with the bug-cam surprised them.

Top: Clover Canopy. Tia W. Kratter, acrylic.
Above: Transparent leaves, detail. Tia W. Kratter, acrylic.

"The one thing you noticed down at that level was how translucent everything was," Lasseter recalled. "To look up a stalk of a clover like it's a giant sequoia and see these huge clover leaves like giant stained-glass windows—it was stunning. The bugs have a beautiful view down there. We went under this curled-up fallen autumn leaf with the bug-cam and looked up, and it was breathtaking. It was like a gigantic auditorium made of a single, beautiful orange stained-glass window."

The idea of making an epic in miniature had at first simply been intended as a playful twist on their diminutive story world. But the bug-cam showed that that notion was actually right on the money. The realization that bugs really *did* live in a grand and beautiful world inspired everyone to try to capture that grandeur in their film.

At the time, Pixar's lighting tools could not capture what they were seeing—the translucency that lets one see a fly's silhouette from the other side of a sunlit leaf. Director of photography and lighting lead Sharon Calahan and shading supervisor Rick Sayre had to find ways of integrating the shading and lighting systems in order to get the right look. "The biggest challenge for us was to get the surfaces and the lights to talk to each other," said Calahan. "In order to make objects appear to be translucent or backlit, the lights and the shaders had to communicate." By allowing lighting to tweak the shaders as needed, they were able to achieve a final look that fulfilled the promise of those early bug-cam shots. "When you shine a light on something, how does it respond? Does it give you a nice rim light? Does it have translucency? We developed a lot of complexity that most people can't see, but they can feel," said Calahan.

"To this day I think A Bug's Life *is the most beautiful film we've made. It's gorgeous; it's like a painting come to life." —Lee Unkrich*

Hyper-Real Life

While Pixar wanted to make a world that felt real, they didn't want it to be a copy of the real world. They wanted a world that, consistent with the fundamental strength of animation, made things seem not photo-real, but hyper-real. They did their research in order to find out what was *essential* to the world and the characters they were creating; they learned the rules so they could break them intelligently.

There were rules to the rule-breaking, however. They were very willing to break rules of nature in service to the story, in order to make it easier for the audience to relate to and focus on the characters. But they never broke rules of nature that upheld the plausibility of the story and its world—even when it would have made things considerably easier. So while they gave the ants four limbs instead of six in order to make them more appealing, there was never any question that the ground the ants walked on would be uneven, that their antennae would always be moving, and that the background ants would have to move and behave just as realistically as those who were the focus of the scene.

Above: Manny and Gypsy, detail. Jason Katz, pencil.

Above: Glowing mushrooms. Tia W. Kratter,
layout by Geefwee Boedoe, acrylic.
Opposite page, top: The Offering Stone.
Tia W. Kratter, layout by Nat McLaughlin,
acrylic.
Opposite page, bottom: Grass variations.
Tia W. Kratter, acrylic.

Admittedly, the subject matter had been chosen with the strengths of the medium in mind; insects, with their hard and shiny exoskeletons, were thought to be a good match for the computer. The big problem was that many of the things that came *with* the idea of insects came less naturally to the computer. The main characters were hard and shiny, but they lived in an organic world of trees, leaves, rocks, water, fire, and uneven ground. Not only would the characters have to interact with all of these things, but many of these objects—not to mention the insects themselves—would be moving almost continually. Trees and grass sway in gentle breezes; antennae are in constant, subtle motion. To top it all off, you couldn't have just one or two ants—an ant colony called for hundreds of ants. If it was hard to storyboard such crowded scenes—to figure out the staging and choreography for so many characters—it was even harder figuring out how to make the crowds seem alive. These weren't simply props; the ants had to move and think and react in a credible way.

All these scenes of a living world, with their multitudes of moving, highly detailed parts, were very expensive to put together and to render. Fortunately, the show benefited from a huge upgrade in Menv, their modeling and animating software. Faced with scenes of a scale that simply could not be handled by the existing system, animation software development director Darwyn Peachey and his team came up with a new feature called "hooks" that allowed people to break up a scene into parts, turning elements "on" to work on them and "off" as they moved on to other parts.

And the technical crew consistently found ingenious solutions to their problems—even the complicated and relatively unglamorous problem of creating background crowds. As Anderson remembered, when Lasseter heard that the film would only be able to handle 50 crowd shots, with no more than 50 ants in each shot, "he said, 'I'm willing to accept that if that's all you can do, but I think you guys can do better.' He helped formulate this crowd team of animators and TDs and he believed in them, he pushed them." The group ended up developing such a successful and affordable solution that they were able to procedurally animate crowds in 430 shots, the largest of which featured 700 ants, all responding in a natural and convincing way. "At the end of the day the crowd team was such a bonded group and they were just so excited about what they accomplished. It was a great ending to something that could have gone horribly wrong," she said, laughing.

"John has a vision and he knows what he wants, but at the same time he's really inspired by his collaborators, which pulls the best out of anybody he's working with. He makes you feel good about the all-nighter you pulled to present him something." —DARLA ANDERSON

Ultimately, the technical staff met its challenges—from translucent plant life to an outdoor world in motion—with flying colors. "*A Bug's Life* was a technical nightmare, but Bill Reeves and his team pulled it off brilliantly," said Reher. "They managed to deliver all these effects that we had never tackled before in a very short amount of time. Technical doesn't always get its due in the outside world for being creative, but we have just as many artists in technical roles as nontechnical ones. It may be more efficient if technical is just a manufacturing line, but that doesn't necessarily make good movies, or beautiful movies. And *A Bug's Life* is a beautiful movie."

Growing Pains

What added the biggest layer of complication to the production of *A Bug's Life* was the fact that the *Bugs* crew was trying to do more with a smaller staff. The studio had maintained a separate commercial division during the production of *Toy Story*, but that division's workload

Above: Aphie. Tia W. Kratter, acrylic.
Opposite page, top: Oak tree. Tia W. Kratter, acrylic.
Opposite page, bottom: The Leaf Bridge. Tia W. Kratter, layout by Bill Cone, acrylic. This piece was one of the touchstone images in the planning of the film.

was managed in a way that allowed it to divert resources back to the feature whenever necessary—and by the end of production on *Toy Story* it was all hands on deck. In 1996, Pixar stopped doing commercial work altogether, splitting its resources into two parts— one team working on *A Bug's Life*, and another, smaller group working on a direct-to-video sequel, *Toy Story 2*.

Bill Reeves, one of the supervising technical directors on *A Bug's Life*, remembered it vividly. "Technically speaking, *Toy Story* wasn't necessarily a huge leap over some of the short films. It was just a lot longer. But *A Bug's Life* was a huge leap over *Toy Story*, both in terms of richness of set and lighting and effects—the ambitions were just huge. And, oh, by the way, we're taking away a third of your team to go do *Toy Story 2*. It was like, okay, let's light up the recruiting engine again and find some more people. Those were some trying times, just trying to figure out how we were going to repeat the success of *Toy Story* and grow."

This was an important question to answer, not just for the technical crew, but for the production staff. Sarah McArthur, a former vice president of production at Disney Feature Animation, joined Pixar to supervise overall studio production while *A Bug's Life* and *Toy Story 2* were already rolling. As she described it, her job was to figure out Pixar's existing production pipeline and streamline it in a way that would make it easier for Pixar to *keep* making movies. "We had to figure out how to make our movies in the healthiest way possible," she said, "one that would grow the production people we needed along with our artists."

As might be expected in a studio that had jumped from shorts to features in a single bound, McArthur found that the structure was rather homegrown and mysterious to all but the locals. "When I got here, I wanted to find out what was the Pixar way of making a movie. But every person I asked described the Pixar pipeline differently. It was as if it was a vining plant that grew back on itself and constantly iterated."

Upper top: Winter frost. Bill Cone, acrylic.
Lower top: Circle Leaf. Bill Cone, acrylic.
Above: Gypsy. Tia W. Kratter, acrylic.

One problem was the fragmented nature of the productions. "Everything was divided up between people," recalled McArthur. "There was nobody who had an oversight over the whole film. It didn't necessarily feel like that was something Pixar had chosen for itself. It felt like that was being driven from trying to apply too many different peoples' ideas. And it was also a little bit more in the vein of special effects perhaps, where work actually *would* be parceled out in chunks. I couldn't change it quickly, and it had to evolve in a Pixar fashion, but I thought it was important to try and get more oversight."

Paired producer teams were already in place on both *A Bug's Life* and *Toy Story 2*—on *Bugs*, for example, it had been decided that Anderson would focus on creative matters and Reher would ride herd on finances and logistics. But on subsequent films, McArthur put in place a production leadership structure that had worked well at Disney: one composed of a production manager responsible for production operations, an associate producer responsible for budget and scheduling matters, and a producer who supervised the overall project.

These adjustments and changes were a natural part of Pixar's attempts to grow as a studio. But for Pixar, the *Bugs* era of its history saw a less comfortable transition as well—the evolution of computer animation into a competitive business.

Antz

A Bug's Life was coming along during what felt like a very good time for computer animation. Pixar's Bay Area neighbor Pacific Data Images (PDI) had just signed a production deal with Jeffrey Katzenberg's brand-new company, DreamWorks SKG, and it was beginning to look like CG might be able to establish itself as an accepted medium, not just a novelty. The excitement wasn't just professional. Many Pixar employees had friends at PDI, and the computer graphics community in general had long been a tight-knit and collegial group.

Upper top: Circus interior. Tia W. Kratter, acrylic.
Lower top: Circus exterior. Tia W. Kratter, acrylic.
Above: Gypsy. Rendered character pose.

Top: Dot. Rendered film image.
Right: Flik. Rendered film image.

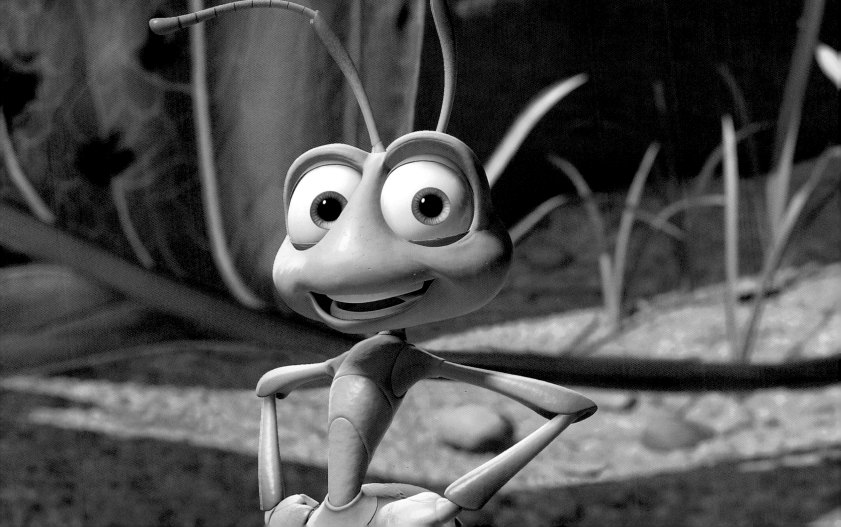

"It dates back to when we would all meet up at SIGGRAPH and everyone would share the development of their tools and their short films and all that," recalled Lasseter. "No one was making a lot of money at this; we were all just doing it for the love of it. So if someone had a success, you would celebrate it no matter what studio you were at, because it was something better for everybody."

People were accustomed to talking freely about their work, and as a result, it was common knowledge that Pixar's second movie was going to be set in the bug world, with ants as the main characters. It wasn't until production was in full swing that the *Bugs* team started to hear unsettling rumors that DreamWorks had instructed PDI to make an ant movie, which would be titled *Antz*. DreamWorks assured Pixar there was no need to worry because their movie would come out after Pixar's. But many Pixar employees had heard from their friends at PDI that *Antz* had two schedules, a publicly announced one that scheduled it for release after *A Bug's Life*, and an internal one that would land *Antz* in theaters first. Sure enough, DreamWorks ultimately announced that they were moving *Antz'* release forward from Spring 1999 to October 2, 1998, just seven weeks before *A Bug's Life*.

"What this did, besides really disappoint and hurt all of us at the studio," said Lasseter, "was fundamentally change computer animation from a community to an industry. Things suddenly became competitive in a way that forced you to keep everything secret. You couldn't tell people what you were doing anymore and share your work. It's sad, because it never needed to be that way."

Wrapping *Bugs*

"At Pixar, we always like to overdeliver," explained Lasseter. "We want the audience to be entertained from the very beginning to the very end." The studio had already produced a brand-new short film, "Geri's Game," to run in front of the feature.

But that wasn't all. As grueling as the production was, the crew was determined to finish in style—to dot every i and cross every t in making the film they had imagined. So after the last shots of the film were completed, the crew stayed on for another couple of weeks working on a surprise Lasseter had in mind since the end of *Toy Story*—a collection of fake "outtakes" to run over the end credits.

"When we were doing the outtakes, I did not realize how funny this was going to be to audiences," said Lasseter. "I should know, really, because we thought it was hilarious, and we always make these movies for ourselves anyway. But after *A Bug's Life* opened, we started hearing that people were staying through the credits just to see these. To this day, if you talk to people about the movie, it's something people always remember and mention."

A Bug's Life debuted nationally on November 25, 1998, and was cheered by both audiences and critics. The hard-won victory proved to Pixar, beyond a doubt, that they had what it

Top: Heimlich motion study. Dan Lee, pen. Above. Heimlich. Rendered character pose. Heimlich was voiced in the film by Joe Ranft, who had provided the scratch voice for the character in the film's reels. Said Lasseter, "We always set out to cast professional actors, but in the case of Heimlich, we just couldn't find anyone who was as good as Joe. His voice made the character so much more funny and appealing than anyone else's did." Opposite page, top: Berry Vine. Tia W. Kratter, layout by Geefwee Boedoe, acrylic. Opposite page, middle: Bunker. Tia W. Kratter, layout by Geefwee Boedoe, acrylic. Opposite page, bottom: Heroes' Welcome. Tia W. Kratter, layout by Geefwee Boedoe, acrylic.

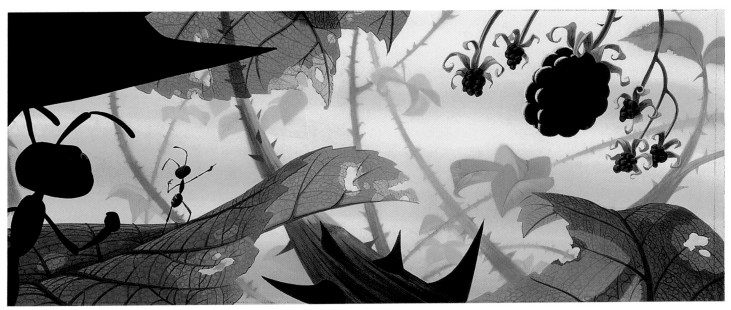

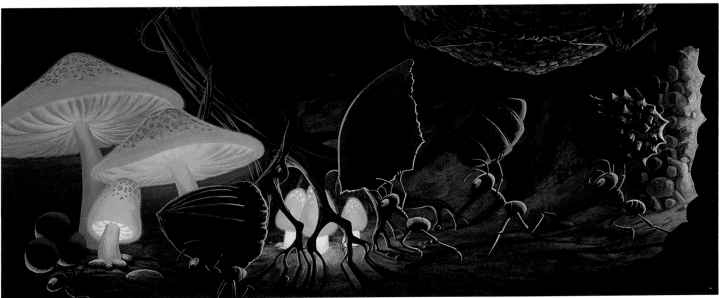

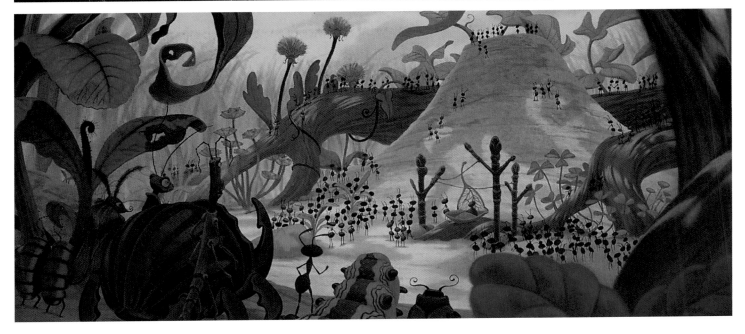

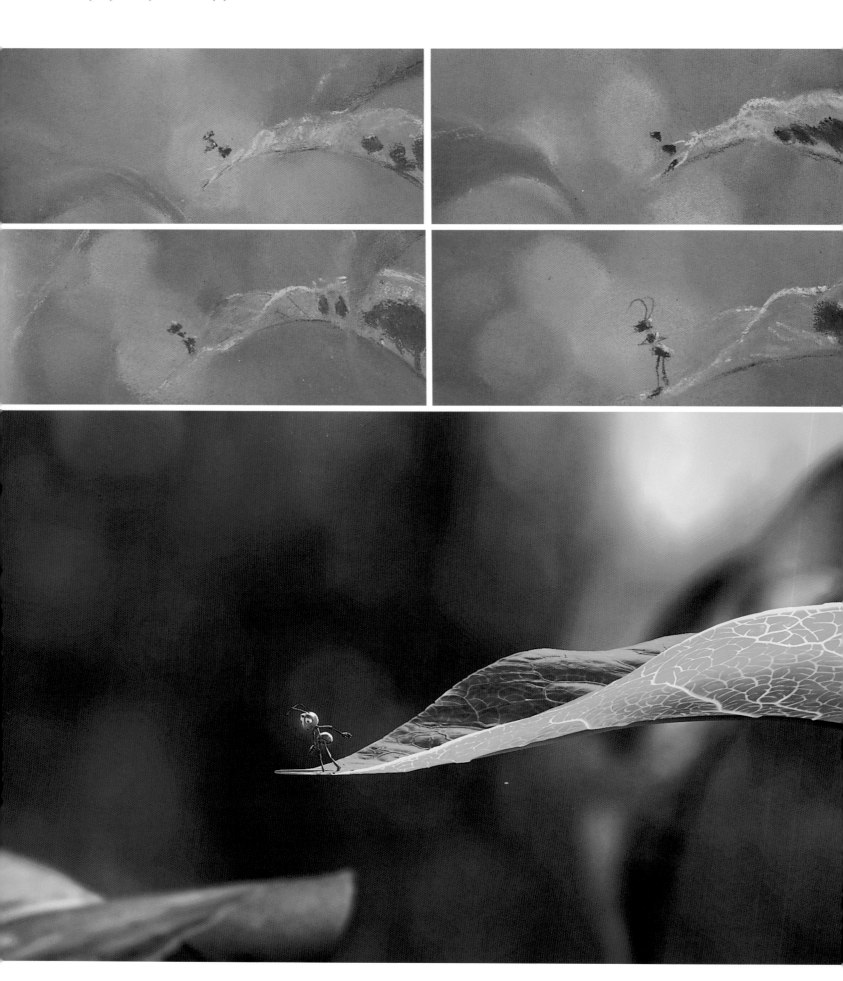

took, creatively, technically, and operationally, to be a real studio—that they could follow up and build on a successful movie.

Following Through

Pixar's ambition for *A Bug's Life* had extended beyond the film itself to every aspect of the audience's viewing experience. The *Bugs* team wanted to make sure that the image that would make it to viewers was truly the best and most accurate it could be, lovingly showcasing all the hard work that the technical crew had done to make the film beautiful, and allowing the audience to experience the film's world and story exactly as its creators had envisioned.

Because of the way analog films are edited, and the way analog film prints are created, the image actually seen in a theater is usually at least four or five generations removed from the original footage—a copy of a copy of a copy, with a corresponding decline in color and image quality. Before *A Bug's Life*, even digitally created films had to go through a generation or two on film in order to create the release prints that would be screened in theaters. But David DiFrancesco's new PixarVision laser film recorder (the successor to the digital film printer first developed at Lucasfilm) was able to handle an entire reel of film at a time. This made it possible to strike the release prints from a first-generation image, producing an exceptionally sharp picture that was absolutely faithful to the original data. The final result, Lasseter recalled, was "gorgeous. It was just so much brighter and clearer than anything that had been done before."

Pixar also took extra care to ensure that the film would look just as good—or even better—on video. DVDs had just started to become widespread, and all DVDs at the time contained a version of the film that had been digitized from the film negative. Since Pixar's computer-animated films were already digital, they decided to use their original digital data for *A Bug's Life* to produce the DVD—a first for the still-new format, and the first time home video had ever been able to offer viewers a picture cleaner than the one seen in theaters. The studio even established a "reframing team" in the middle of production to make sure that shots designed for the theatrical CinemaScope aspect ratio would still work when the frames were abridged for the full-screen video format.

"Everyone here is dedicated not only to making a good story, but to making our films look absolutely as good as we can," said Lasseter. "We really sweat the details to make sure that we can get great prints to every theater, and that our DVDs are as good as we can make them. It's all in service of creating a great motion picture experience."

"I always took it as a compliment to that work that, for about a year afterward, any time I went into a high-end video store, they were using *A Bug's Life* to show off their televisions," he said, smiling. "Success is measured in very funny ways sometimes."

Opposite page, top: Lighting studies. Bill Cone, pastel.
Opposite page, bottom: Flik on a leaf. Rendered film image.

 / Spotlight

"Geri's Game"

After the 1989 release of "Knick Knack," Pixar stopped making short films, turning instead to commercials, which would allow it to build up its staff in anticipation of making a feature film. But in 1996, John Lasseter and Ed Catmull decided it was time to start making shorts again. "Short films are part of Pixar's DNA," said Lasseter. "It's where we started, and as we grew we knew we wanted it to be a part of Pixar going forward. We love it as an art form, so we wanted to use the attention we got to create more awareness about the form, to help create more of an appetite for short films in the moviegoing experience."

But they also realized that making short films had been an excellent opportunity for training and experimentation. Any short would still primarily be a labor of love—as Catmull admitted, "you can't make money making shorts"—but they decided that if they could choose projects that would allow them to expand their technical reach, the R&D benefit would make it easier to justify the expense. Jan Pinkava, who had joined the Pixar commercials group in 1993, was chosen to direct the first of Pixar's second generation of shorts. An animator and short-film maker in his youth, Pinkava had earned an undergraduate degree in computer science and a PhD in theoretical robotics before returning to his first love through computer animation.

Pinkava had been lobbying hard for Pixar to begin making shorts again, so when Catmull came to commercials producer Darla Anderson after *Toy Story* and asked if she knew of anyone who wanted to make a short film, she pointed him in Pinkava's direction. As Pinkava recalled, "Ed came to me and said, 'Jan, maybe you can make a short film if you come up with a good idea. Oh, and by the way, it has to have a human character in it.'" Catmull knew that Pixar would eventually need to be able to have humans as main characters in its stories, and he thought that a short film would be a good way to put the studio's skills to the test.

Pinkava decided to try to come up with a story idea involving only one character—partly out of a desire to keep the film as simple as possible, and partly because he reasoned that if there were only one character, they would be able to put most of their resources into making that character look really great. He had already decided he wanted the character to be an old man: "From an animator's perspective, looking at the movements of an elderly person is fascinating. I thought, 'Why not go to the other end of the age spectrum from the baby in 'Tin Toy' and do something with an old person?'"

Almost immediately, Pinkava said, he thought of his maternal grandfather, a tenacious chess player. "His games could last all day because

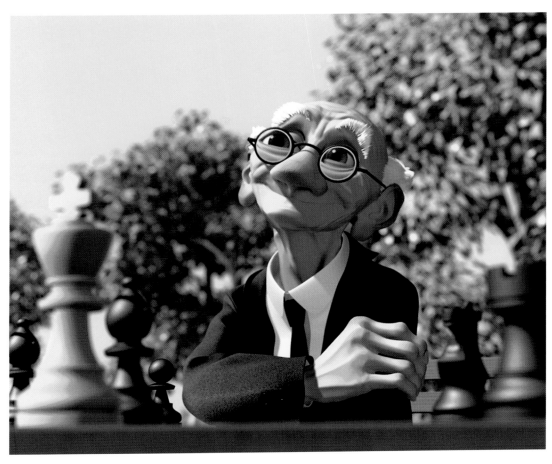
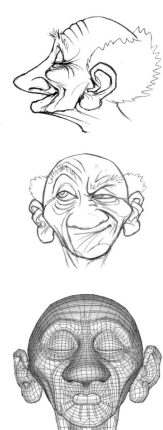

Above, clockwise from left: Geri, rendered film image; Geri concept drawings, Jan Pinkava, pencil; Geri wireframe model, Paul Aichele, digital.

he would just take as long as it took to make the right move. He wouldn't be hurried, he wouldn't be rushed, and he would fight to the bitter end." Remembering that his grandfather would, on occasion, even play games of chess with himself, "Geri's Game" was born.

In order to create human characters sufficiently detailed and expressive to "carry" a film, the short's technical team had to solve two major problems. First, they had to be able to create faces and hands whose smoothly irregular surfaces were flexible and finely articulated. Second, they had to be able to realistically simulate cloth, so that viewers would not be distracted from the characters' actions and emotions by their stiff and plasticky clothes. Both efforts (led, respectively, by former academics Tony DeRose and Michael Kass) were terrific successes. In fact, the subdivision surfaces technology employed to address the first problem worked so well that it was pressed into service on *A Bug's Life* before "Geri's Game" had even wrapped.

Now that Pixar has multiple films in parallel production—each with its own set of technical experts working on the film's specific problems—there are many more people doing research work at the studio, and the need to use short films as incubators for new technology has diminished. But shorts remain an important way for the company to develop both technical

and artistic talent. Working on short films provides essential opportunities for employees to develop leadership skills in a less high-pressure atmosphere and test their abilities in roles outside their area of expertise. "Work on a feature film is very focused," said Catmull, "almost like an assembly line. People do a wider range of work on a short, so it is a better training ground than a feature film to get a broad view of production."

Short films were no longer Pixar's "main event," but everyone was determined to make sure its efforts in the form would pick up where it left off—always reaching for the highest possible standard of filmmaking and storytelling. "I came to Pixar because I had been inspired by the wonderful short films John had made," said Pinkava, "and it was a privilege to make a new film that would hopefully be worthy of those, yet very different."

Indeed, "Geri's Game," which reflected Pinkava's affinity for smaller, more unconventional stories, received a flattering degree of recognition, winning an Oscar for Best Animated Short. "It was really cool to have them back," said Spike Decker of Spike and Mike's Festival of Animation. "John's films had been cornerstones of our Classic shows, and we were thrilled to get a Pixar short in the show again. You just come to expect a certain level of quality from them."

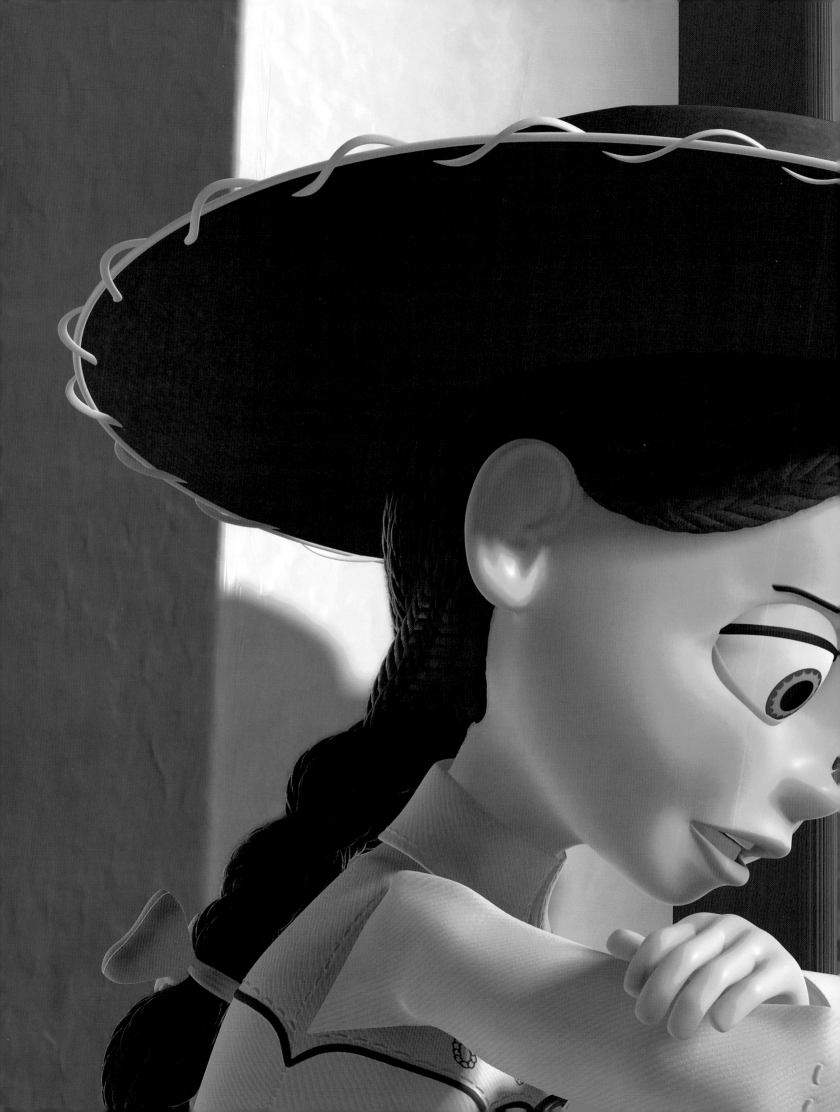

Chapter 8

Toy Story 2

Toy Story's success led almost immediately to talk of a sequel. Feature-length sequels were relatively uncommon in animation; while Walt Disney had toyed with the idea of doing follow-ups to some of his animated feature films, the only one actually produced in his lifetime was the 1942 live-action/animation mix *The Three Caballeros*, a follow-up to the similarly hybrid *Saludos Amigos*. The studio's first fully animated, feature-length theatrical sequel was the 1990 film *The Rescuers Down Under*.

But in 1994, the year before *Toy Story*'s release, Disney had experimented with a new format: the direct-to-video sequel. *The Return of Jafar*, a sequel to *Aladdin*, proved so profitable that the company decided such low-cost sequels would henceforth be an integral part of its animation business plan. The reasoning seemed sound enough to Pixar, and they were amenable to doing another *Toy Story* movie—but only if they could come up with a good idea.

Between Toy Heaven and Toy Hell

The idea for "Luxo Jr." had come from John Lasseter's desk, but the idea for *Toy Story 2* came from his office, which is filled with toys of every shape and description. One day, Lasseter and Pete Docter were discussing the proposed *Toy Story* sequel over lunch. Docter said, "John and I were talking about how *Toy Story* was interesting because it contained the heaven and hell of toys—Andy's room and Sid's room. And we were trying to figure out what purgatory would be. Then John started talking about his kids and the toys in his office."

Lasseter recalled, "I have five sons, and at that time four of them were quite little. And they just loved coming to Daddy's work, because they wanted to play with all of Daddy's toys. I loved to have them visit, but every time they came in here, I was a nervous wreck, because a lot of the stuff is one-of-a-kind or autographed or collectible. I would find myself telling them not to touch things. And that made me think, 'John, what did you learn from *Toy Story*? Toys are put on this Earth to be played with by a child!'"

> *"All of a sudden, just because a doll is signed by Tom Hanks, you've sentenced it to be set on a shelf for its entire life, never to be played with again. I thought, 'That's an interesting idea.'"* —JOHN LASSETER

Above: Jessie. Rendered character pose.
Opposite page, top: Woody in Al's display room. Randy Berrett, oil.
Opposite page, bottom: Al's display room. Randy Berrett, oil.
Previous spread: Jessie. Rendered film image.

Top: *Woody and Bullseye. Randy Berrett, pencil.*

Above: *Woody and Bullseye. Rendered character pose.*

"Following the logic of *Toy Story*," Docter explained, "being 'protected' like that would be awful for a toy. You're preserved perfectly—you don't get slobbered on or ripped or whatever. But you don't get to do what you were fundamentally meant to do. You don't get to be played with."

The bones of the story quickly followed. Woody, they decided, was the product of a famous 1950s cowboy TV show, *Woody's Roundup*, and a very valuable collectible. After being stolen by a toy collector, he would be given a choice. He could go back to be with his owner Andy, where he would be played with, but risk being broken and "dying," or he could go to a toy museum, where he would be cared for meticulously forever—but never be played with or loved again.

This, Lasseter felt, was an idea worth exploring in a sequel. Lasseter returned to *A Bug's Life*, and Docter, after writing the first treatment, returned to the project he had been developing—*Monsters, Inc.* Lasseter and the rest of the executive team gave *Toy Story 2* to a team of promising up-and-comers, supervised by a veteran producer, and let them run with it.

Trying to Do Two Things at Once

The core idea of *Toy Story 2* was so good, and the project was judged to have so much potential, that when its crew started pulling hard to have the movie upgraded to a theatrical release, the studio agreed. This promotion actually solved a moral dilemma for Pixar, which had been uneasy about having effectively created a caste system within the company—expensive, high-quality theatrical releases and low-budget, mediocre direct-to-video releases. "We came to believe that this division was bad for our souls; it wasn't the right way to think about things," said Catmull. "But even so, it still wasn't felt that *Toy Story 2* was going to be at the same level as *A Bug's Life*." It was still understood that the sequel would have a shorter schedule and a smaller budget.

Pixar wanted *Toy Story 2* to be more than the direct-to-video rush job that had originally been planned, but its status as the cheaper secondary effort was, to a certain extent, inescapable. As Galyn Susman, *Toy Story 2*'s supervising technical director, explained, "We went from not knowing what we were doing and barely getting one film done to now trying to put two things into production, and the only reason we were foolhardy enough to do that was because we believed that *Toy Story 2* was going to be direct-to-video. Even then, the whole notion that we would bifurcate our talent was very complicated. How do you decide who goes on the lesser project, *Toy Story 2*? Who stays on the main project? You need to seed that lesser project with enough talent so that it'll be successful, but you really don't want it to be a drain on the core resources that are there to build and to create *A Bug's Life*."

Pixar was having enough trouble just finding experienced story people and animators to staff *A Bug's Life*. At that time, animation was booming in what Ranft called "the post–*Lion King* gold rush. Kids straight out of school were getting signed to great deals and driving Humvees. It was the roaring late '90s." Between Disney, Warner Bros., Turner, and Jeffrey Katzenberg's new DreamWorks Animation, competition for the available talent was fierce—and in such a high-rolling job market, Pixar didn't have the money to hire all the people it needed.

The studio had come to accept that each movie would have its own idiosyncrasies, but as time went on, *Toy Story 2* seemed to accumulate more than its share of troubles. The creative and production teams were experiencing internal conflict, and the personnel changes made to address the problems seemed to have little effect. Most troublingly, the reels were not getting better with time. Slowly but inexorably, the executive team came to the conclusion that *Toy Story 2* would require drastic corrective action. But little could be done while the studio's primary creative talents were still busy getting *A Bug's Life* out the door.

Top: First lineup of the Roundup gang.
Pete Docter, marker.
Above: Bullseye. Ash Brannon, pencil.

"While we were working on *A Bug's Life*," Lee Unkrich remembered, "we would occasionally check in on *Toy Story 2*. Unfortunately, it was not shaping up to be at the level we knew it needed to be. The movie was going off course in a way that we had gone off course on the other movies. But the problem was, we were all so busy trying to get *A Bug's Life* made that we couldn't take the time to wrap our heads around the problems they were dealing with, and try to help them fix them."

It was only after the necessary publicity for *A Bug's Life* had concluded that Lasseter was able to turn himself to the project. "I had taken my family with me on the press trip to Asia," he recalled, "and the night we got back, we were all so jet lagged that no one was ready to go to sleep yet. So Nancy and I gathered all the kids into our bed and we put on *Toy Story*. I hadn't seen it for probably a year and a half. We watched it, and Nancy and I looked at each other and went, 'You know, this is really a good movie.' It was a great feeling to see the characters again and remember how proud we had been when we had finished that first movie. The next morning I went into the office and watched the reels for *Toy Story 2*. And it really wasn't very good. I felt like the wind had just been knocked out of me."

Lasseter and his team had been working more or less nonstop since *Toy Story* had been greenlit, almost seven years earlier. Everyone was exhausted and ready for a much-needed break while *Toy Story 2* took the spotlight. "We had all been working so damn hard on *A Bug's Life*," said Unkrich. "We were looking forward to not being behind the eight ball for a change." Lasseter had promised his family he'd take the summer off to be with them. But watching the reels, he knew he'd have to put off the big family trip another year. He had to step in to direct *Toy Story 2*. The movie needed fixing, and as he put it, "I couldn't ask anyone to do something I wasn't willing to do myself."

Stopping the Train

With less than a year to the movie's release date, Pixar made the emotionally and financially painful decision to stop the train and completely rework the story. The studio was no stranger to this sort of creative overhaul; it had happened on both of their previous movies. But unlike *Toy Story* and *A Bug's Life*, *Toy Story 2* was a movie already in full production. Many scenes had already been animated. What's more, the crew they were about to bring over had just come off of an exceptionally draining production on *A Bug's Life*. But the last thing anyone wanted was to put the studio's name on a movie—especially a *Toy Story* movie—that wasn't the best they could make it.

When the Pixar team told Disney that the movie wasn't good enough, and that they had to start over again, Disney told them that was impossible. The distribution machine had already been set in motion, and there was no way Pixar could restart the production process—which typically took at least two years—this late in the game. The promotional partners were all in place, the toys were being made, and there was too much money involved to move the release date. *Toy Story 2* had to be delivered in nine months, as scheduled—end of story.

Fair enough, Pixar said. If the release date was nonnegotiable, they would deliver the movie as promised. But they were absolutely unwilling to release the existing film. They were going to start over—and if nine months was all they had, they'd do it in nine months. The management team told everyone to go home and rest up over the holidays. When work started again in January, it was going to be all hands on deck.

Above: Prospector. Dan Lee, pencil.

"John and I were sitting at the table with some of my Disney colleagues, who said, 'Well, it's okay.' And I can't imagine anything being more crushing to John Lasseter than the expression, 'Well, it's okay.' It's just unacceptable to him, and it's one of his most endearing, most exasperating qualities, and probably the biggest reason for his success. That was just death to him, that these characters would end up in a movie that was 'just okay.' So nine months before it was supposed to come out, John threw the vast majority of the movie out and then started over. Which is unheard of." —TOM SCHUMACHER

One of the first changes they made to the production was physical. When Pixar had first decided to produce *A Bug's Life* and *Toy Story 2* in parallel, they had put each production team in its own building. At the time, Pixar's office space was already spread between two different complexes, so this "movie studio"–type arrangement had seemed both logical and convenient. But, they realized, by physically separating the two productions, they had unwittingly walked right into the problem they had seen and avoided on *Toy Story* with Hi-Tech Toons. They had fractured the company's sense of community and solidarity. "We said, we've got to make this place one studio again," recalled Lasseter. "It was Glenn McQueen's suggestion; he said, 'Let's just get all the animators together.'"

Though they couldn't take the time to reshuffle the entire company, they brought the two groups of animators together in the animation pit of Pixar's original building. "That experience changed our entire philosophy," said Lasseter. "We decided that from then on we wanted everybody in one building; we wanted all the departments, no matter what movie they were working on, to be together."

In addition, Pixar had to make sure the production pipeline would operate flawlessly. There was no room for error. Head of production Sarah McArthur took extra precautions, adapting her triangular production leadership template from a bi-level into a tri-level structure. She

Top: Woody and the Roundup gang value study. Jim Pearson, pencil.
Above: Prospector. Rendered character pose.

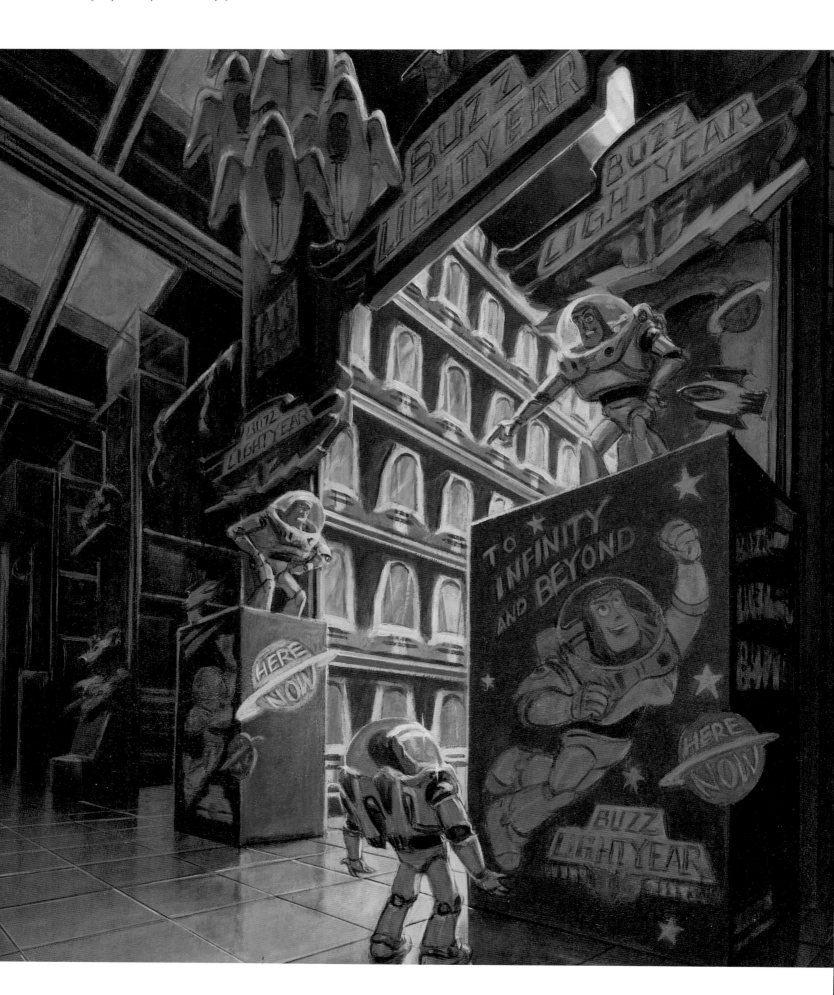

brought Graham Walters in as production manager below the show's existing producers, Karen Robert Jackson and Helene Plotkin, and came in herself to executive produce the show in an unusually hands-on way. "We had to have all the information we needed every moment, so we all sat very close to each other, and there was lots of checking in constantly," said McArthur.

Fortunately, the technical side of the movie was almost completely ready to go. The technical team would end up building two new characters, but most of the models and sets had already been built and field-tested in the first round of animation. The technical team had taken advantage of a recent Menv revamp to put in a lot of "under the hood" improvements, making the models simultaneously more sophisticated and easier to work with. Even the original *Toy Story* character models had been rebuilt—the old Buzz and Woody models would have looked outdated next to the better-looking models built for the new *Toy Story 2* characters.

With the production and technical crews poised and waiting for the gun, the creative team took a deep breath and plunged in.

"*Toy Story* was us"

"Steve Jobs gave me probably the greatest piece of advice," said Lasseter. "He said, 'In a time of crisis, you don't have time to figure out new people around you. Just bring all the people you know and trust around you.' And that's exactly what I did."

Lasseter enlisted the help of his core creative team almost immediately after deciding to take charge of *Toy Story 2*. He asked Lee Unkrich, who had edited *Toy Story* and *A Bug's Life* and who had become one of Lasseter's closest creative collaborators, to be his co-director (Ash Brannon, one of the original directors, also stayed on as a co-director). Andrew Stanton would write the new script. Joe Ranft signed on to co-supervise the story department, and Pete Docter came over from *Monsters* to help with story development.

> "Having John take the reins and say, 'I'm going to take this movie on' kind of freed us, in a weird way. We all cared so much, not only for John's sake, but nobody wanted to see the second Toy Story fail. And so that gave you the energy to get out of bed every day and give another 100 percent when you didn't think you had it. But being able to feel like you were just 'helping out' allowed you not to have to carry the pressure as much." —ANDREW STANTON

They all met for dinner one night to discuss the simple question of how they would all gear themselves up for such a massive task, but over the course of the evening, the conversation slowly changed from logistical to speculative.

"The existing version already had two Buzzes," recalled Unkrich. "Buzz had a little fight with another Buzz Lightyear in Al's Toy Barn, but that was it. Andrew came up with the whole idea of the real Buzz being switched with the other Buzz, and we thought, 'Yeah! We'd definitely want to see that movie.' We started throwing out these blue-sky ideas. Wouldn't it be cool if we could do this? Wouldn't it be cool if we could do that?"

As Stanton put it, "Getting together in the room again, thinking like *Toy Story* filmmakers, sort of unlocked all these ideas—things that used to be in iterations of the first movie—that would never have come up if we hadn't all worked and think-tanked together on the first one." They were suddenly energized by the prospect of what the movie could be, and were determined to do it right. Soon afterward, when the entire story crew came together for an emergency two-day story summit in Sonoma, they came in "on fire," Stanton recalled.

Above: Zurg. Randy Berrett, color by Laura Phillips, acrylic and pencil.
Opposite page: Buzz in Al's Toy Barn. Randy Berrett, oil.

Crossover: Storyboards for "The toys climb the shaft." Bob Peterson, pencil; Nate Stanton (panel 24452), pencil.

"I realized at that point that *Toy Story* was us," said Lasseter. "It's us sitting around that table. We made the first one, and Buzz and Woody come from us in so many ways; they're a part of our being. And we just got together and started laughing hysterically at all these ideas, building upon the foundation in the story."

> *"The Sonoma retreat came up with things like keeping the Prospector in his box and limiting his movement. That was really a genius idea, not only because it said a lot about his character, but also because it wasn't the best model in the world; he had short legs that were far apart, so he couldn't walk very well."* —ANGUS MacLANE

The foundation of the story, the basic structure and plot points, were all there. But Pixar had pulled the emergency brake because it needed *Toy Story 2* to have more than that. The movie needed that spark of life, the polish and verve and conviction that would make it into something the studio could be proud of, not just satisfied with.

As Catmull explained it, the movie's biggest problem was that it was predictable. "This film is coming out from Disney and Pixar. So you already know Woody's going to go back to his original family in the end. And if you know the end, there's no tension. You had to believe that Woody could choose to go to the museum."

To establish a real sense of mortality in the toy world, they brought Wheezy, the broken squeaky toy, forward in the story, and added new scenes like Woody's nightmare. Having the two Buzzes switch places added humor and gave the original Buzz a richer arc in his rescue of Woody. But perhaps the most significant change was adding "Jessie's Song."

"We had always had the scene where Jessie tells Woody how Emily was her Andy," said Lasseter. "And we knew it was the right thing; we knew it was a great story point. It had so much heart to it. But it just wasn't working. It just never worked in any situation. But that off-site story summit is where we came up with the idea to do it with a song."

Above: Wheezy. Nat McLaughlin, pencil. Wheezy was another character given voice by Joe Ranft.
Top: Storyboards for "Jessie's Song." Jill Culton, marker and pencil.
Opposite page: Scenes from "Jessie's Song." Rendered film images.

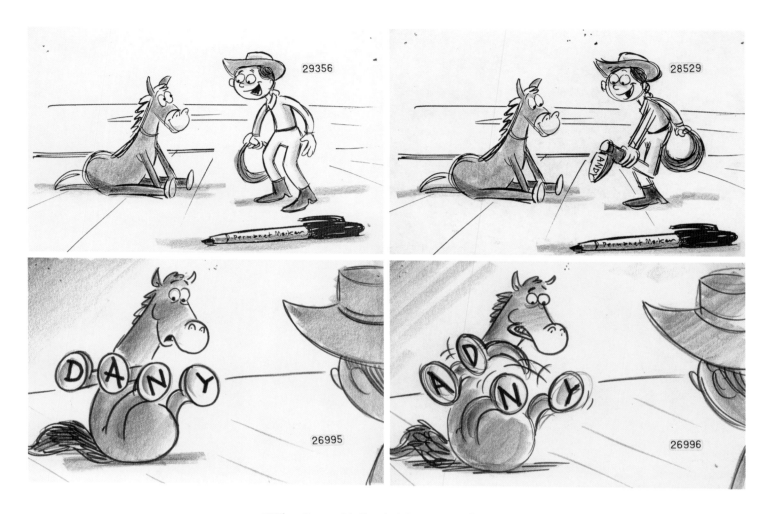

"When I met with Randy Newman to talk to him about the scene, I said, 'Randy, this song does not have a happy ending. This is about dearly loving someone. Your lives are so intertwined you can't imagine life without them. But they grow farther and farther and farther away from you to the point where they just discard you altogether.' And he wrote an amazing song. Being in Vancouver to hear him record it with Sarah McLachlan was one of the greatest moments in my entire career. It was just…magic." —JOHN LASSETER

"Jessie's Song" made Woody's decision meaningful because it separated in a visceral way the intuitive choice from the easy choice. Though Woody would still choose to return to Andy, he did so knowing that Andy, like Emily, might one day no longer love him back. Woody was given a thoroughly *human* dilemma—a complicated and difficult choice that would be laced with sadness no matter what the outcome. This made the decision interesting even though the outcome was not a surprise.

"Tim Allen and I actually saw *Toy Story 2* at the same time when it was all done," remembered Tom Hanks. "Like any actors, we were kind of sizing up how we did in the thing together—Tim's better in that one—and things like that: 'Oh, that's pretty,' 'Oh yeah, I like that.' But then when 'Jessie's Song' came up, we were just 40-year-old men crying our eyes out over this abandoned cowgirl doll. It was a knee-breaker."

Crossover: Storyboards for "Back at Andy's." Rob Gibbs, marker and pencil; Ken Mitchroney (panel 27950), pencil.
Above: Jessie. Jill Culton, pencil.

Go, Go, Go, Go

Days after coming back from the retreat, Lasseter pitched the new story to the entire crew. "I will never forget being in the room for that pitch," said Katherine Sarafian, who had

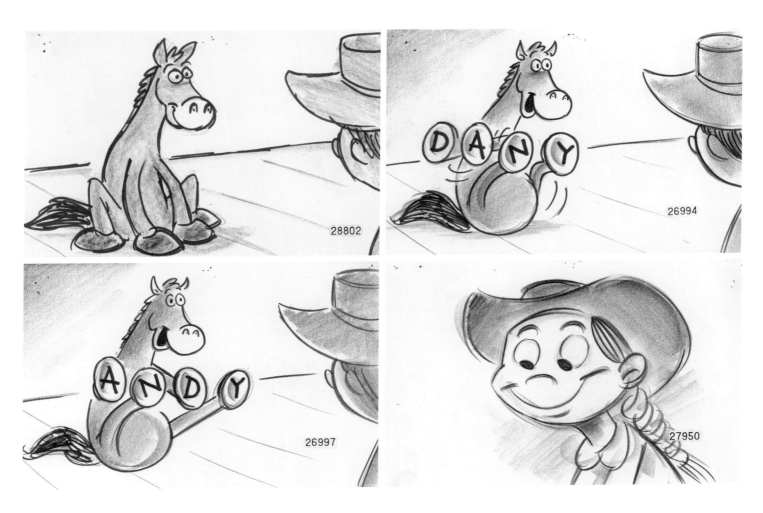

been a coordinator on *Toy Story*. "The energy of it was incredible." Animator Jim Murphy recalled, "He totally fired everyone up and inspired us to really do the impossible."

Tom Schumacher, who by then had risen to become the head of Disney Feature Animation, realized the film couldn't be held up in any way if it were to have any hope of meeting its due date, so he streamlined Disney's approval process. As Lasseter recalled, "Then, after a while he said, 'Guys, you know better than I do what it's going to take to make this. So just go. You have no time to wait for my approvals. Just go, go, go, go.'"

The *Toy Story 2* story crew rewrote and reboarded the entire movie in a month—an unprecedented feat. "I don't know if it could ever have been done again had it not been almost literally the same crew that had made the first one, so it was like a psychic situation," said Stanton. "We could just finish each other's sentences. We knew exactly how the characters thought. We knew what they ate for lunch and for dinner. That was the real eye-opener for me, from the writing standpoint—realizing that you can plot out a movie in a month and make it work if you already know who everybody is and how they think."

"Working on *Toy Story 2* was a delight," remembered Joe Ranft. "It was like being with a group of old friends. These characters were so fun to be with and draw, and just in terms of the physical boarding of the scenes, it was so much simpler than what we had been doing on *A Bug's Life*, where every shot had lots of ants and complex staging and complex choreography. The difficult part was how fast we had to do it. Dan Jeup and I had an army of people on it, like twenty story artists. It was really fun once we started seeing these scenes on reels and realizing, 'Hey, this is going to be pretty good.'"

Unkrich remembered meeting with Steve Jobs soon after joining *Toy Story 2*. "I said, 'Steve, I know we can make a good movie here, but I don't think we can get it out on time. I just don't know how we can do it. It's really intimidating.' And he said to me, 'Lee, you know, when I look back on my career, all of the best work that I've ever done was done under circumstances like this.' Looking back on it, he was absolutely right. *Toy Story 2* is arguably the best film we've made. It fired on all cylinders. But considering the circumstances under which it was made, it makes no sense that it should be as good as it is."

The general consensus at the studio is that *Toy Story 2*'s production was fueled by a nine-month-long adrenaline rush, induced alternately by panic and excitement. "*Toy Story 2* took a huge toll on people, an unbelievable toll, but it was also just incredibly exciting," said Galyn Susman. "Of all the projects I've worked on, it was by far the most exciting, because it was the most frightening. There was a palpable fear. Nobody knew if we were going to be able to finish."

Said Unkrich, "It was a daily, desperate battle to make sure the movie was of at least a certain quality. We set our bar really high because we weren't capable of compromise, but everything had to be figured out yesterday. Things were happening so fast that they almost felt out of control, yet somehow the stars aligned."

Stanton compared it to great improv. "There were a lot of choices that we never would have made if we hadn't been working under those tight circumstances. And a lot of those were better than choices we know we would've made had we been given more time. Having no room for error made us have this laser-beam focus."

"The amount of footage that was going through that studio was staggering," said Lasseter. "And it was all really good, too. There is not one bit of quality that was compromised during the making of *Toy Story 2*."

The Aftermath

"As a lifelong film buff, I am not happy when I hear a sequel is being made," said Leonard Maltin. "It does not warm the cockles of my heart. There are just a handful of sequels in

Top: Jessie, Woody, and Bullseye running on record. Rendered film image.
Above: Al McWhiggin in chicken suit.
Jim Pearson, watercolor.

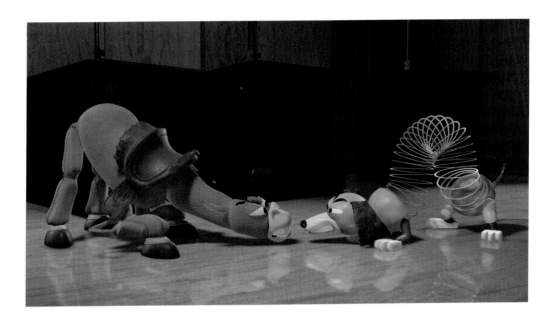

the history of movies that you can say with a clear conscience, 'Well, that was just as good as the original movie. Maybe even better.' One of them is *The Godfather, Part II*. Another example might be *The Empire Strikes Back*. And another is *Toy Story 2*. That's no small feat."

But that success came at a heavy price. "It was this brutal, brutal thing," Catmull recalled. "People were wearing down during the process of this. We have a lot of overachieving people working for overachieving managers, and they worked so hard that people began to really suffer from the stress." The toll was not just psychological but physical. After nine months of almost nonstop work with a keyboard and mouse, nearly one in three employees developed a repetitive-stress injury. One person was permanently disabled and had to leave the field altogether.

At the wrap party for the film, Lasseter took the stage at the Castro Theatre in San Francisco and looked out at the theater full of employees and their loved ones. "I am so sorry," he said, overwhelmed with both pride and regret. "We are never going to do this again."

> *"Everybody was so dedicated to it and loved* Toy Story *and those characters so much, and loved the new movie so much, that we killed ourselves to make it. It took some people a year to recover. It was tough—it was too tough, but we did it. Now enough time has passed that we can look back on that and we're glad we did it. But it was tough." —STEVE JOBS*

Sarah McArthur, the studio's head of production, said, "We learned that people at Pixar would literally give everything they had for a film. If we asked them, they would give and not hold anything back. And because they didn't hold back, people were hurt. We as a management group realized we had to really honor the commitment of our crew by protecting them. If we asked, they would give. So we had to never again allow ourselves to get in a position where we ever needed to ask."

"It was a failure of our management," Jobs said soberly. "We were not ready to do two things at once. We tried it for all the right reasons, but we failed at it, and we had to go rescue that. It made us even more cautious in doing that again, and from *Monsters, Inc.* onward it worked great. But with *Toy Story 2* we did it a few years before we were ready."

Top: Bullseye and Slinky Dog. Rendered film image.
Above: Al McWhiggin in chicken suit. Rendered character pose.

Pixar's Defining Moment

"Nobody—no company, no individual—does things without making mistakes," said visual-effects pioneer Ray Feeney, who has known Pixar since its Lucasfilm days. "The thing at Pixar is that the mistakes, when understood and found and dealt with, are replaced with something better."

Toy Story 2 taught the studio three key lessons, said Catmull. The first had to do with the physical health of the people working at the company. "At the end of this film we decided we could never have people work like that again," he said.

"So we instituted a program to prevent repetitive-stress injuries. We brought in a doctor and a nurse twice a week, and massage therapists every day, and a full-time ergonomist who went around to make sure everyone's workstations were set up right. We got new furniture that helped people work more comfortably. We trained people how to work correctly—how to

Above: Images from the film's colorscript, done in pastel by Bill Cone, as compared to the final film image.

maintain correct posture and take breaks. We made sure there was a gym in our new building, and offered yoga and tai chi classes. We got people to take it seriously, to take care of their bodies." Realizing that it also had to treat the problem's long-term causes, the company resolved not only to curb overtime, but to monitor pre-production story development much more closely.

The company's second lesson was the confirmation that people, not ideas, are what make the difference on any project.

"*Toy Story 2* made it clear to us that you have to find the right team," said Catmull. "Obviously ideas are important. But even the best story idea doesn't guarantee a great movie. When you make a movie, you are faced with an enormous number of creative decisions, on everything from the story elements to the designs of the characters to the color palette to the sounds. There are tens of thousands of possible ideas. So you need a special kind of creative leadership, one that can take all those thousands of ideas from everybody and

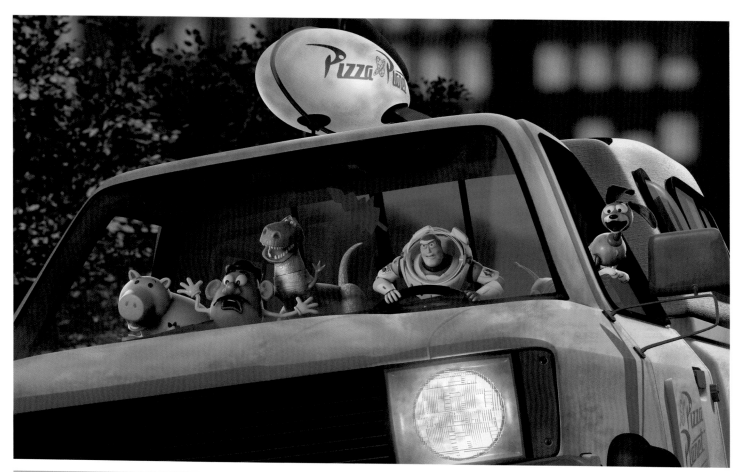

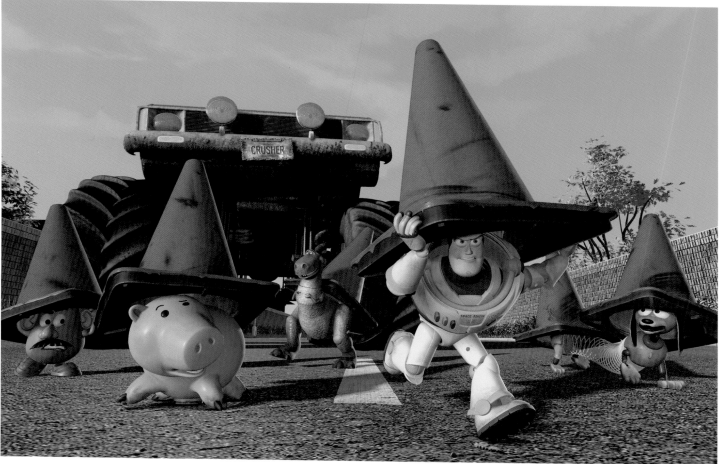

sort through them and select the ones that fit together. When you've got the right people working together, the ideas will follow. Even a mediocre idea won't be a problem. Because they'll either fix it or they'll throw it away and come up with something better."

Thirdly, said Catmull, Pixar had to wholly reembrace the philosophy that had guided it through its early days, and that had led them to shy away from the direct-to-video track to begin with—the philosophy that only the best would do.

"We realized it was dangerous for us to have introduced two tracks at the studio," Catmull said, "to be telling one group 'I want you to do a good job' and another 'I want you to do a mediocre job.' The right way to think about it was, we want everything we do to be great. This idea actually spread beyond our filmmaking and started to make us think differently about our entire business. We realized it was just a good way of thinking about everything. Once we got to that point, it made other things a lot clearer."

Perhaps part of what made the project so resonant to the people working on it was the fact that the choice its story offered to Woody—between, as Docter put it, "being alive but just surviving, or truly living and dying"—was also the choice that had been metaphorically posed to the studio. They had been given the choice between safely completing a "good enough" project and risking failure in the pursuit of a standard that had motivated them to make movies in the first place.

To this day, Catmull regards the making of *Toy Story 2* as Pixar's defining moment. "I was most proud of the studio when we decided that we were going to stop production and redo the film because it wasn't good enough. Until then, we were the neophyte. It took Disney on the original *Toy Story* to say 'this isn't good enough,' but this time we were the ones that did it. I felt like we had grown up some and proved ourselves."

Top: "Crossing the road" colorscript. Bill Cone, pastel.
Above: Rex. Rendered character pose. Wallace Shawn, the voice of Rex, starred as Wally in My Dinner with Andre—*the film that led John Lasseter, while working on Lucasfilm's first short, to match the main character, André, with a co-star named Wally B.*
Opposite page, top: Toys driving. Rendered film image.
Opposite page, bottom: Toys running with traffic cones. Rendered film image.

 / Spotlight

Pixar University

The idea for Pixar University ("we picked the name just for its initials: P.U.," said Lasseter) came out of the studio-building conversations John Lasseter and Ed Catmull had begun to have as *Toy Story* wrapped up. They realized that as the company grew, it would be important for it to offer continuing education to its employees—not only to teach new employees about the tools they would need to use, but to teach existing employees more about the work their colleagues were doing.

"Both Ed and I felt like you can never know enough," said Lasseter. "And, what's neat is that at Pixar you have both brilliant, traditionally trained artists and animators, and amazing technical minds that come from computer science departments. So you want the artists to learn more about the technology, and you want the technical artists to learn more about art and sculpting and acting and things like that."

To run the program, Catmull hired Randy Nelson, a former technical trainer at NeXT and one of the founding members of the juggling troupe the Flying Karamazov Brothers. "I interviewed people from various art schools, and frankly I thought they were not strong," Catmull said. "But when we met Randy, we liked him immediately. He also had an unusual combination of skills, which I felt was an asset. I figured I'd rather have a

world-class juggler running the program than a mediocre artist. People who have experience doing great work understand something that can be applied to other things. You want people who have the experience of doing something at the highest level."

Pixar University began at the Point Richmond facility in 1995. On Nelson's third day, Catmull handed him a copy of the 1935 note Walt Disney had written to Don Graham, an art instructor at the Chouinard Art Institute in downtown Los Angeles, assigning Graham the task of improving the quality of artists at Disney.

"The biggest difference in what Walt proposed to Don Graham was that their program trained the artists who needed the skills," Nelson explained. "But here at Pixar, Ed wanted that education to be broadly offered across the entire company. Why are we teaching filmmaking to accountants? Well, if you treat accountants like accountants, they're going to act like accountants. But the potential exists that if you treat everyone in the studio as filmmakers, they have a better chance of acting as filmmakers, which helps everyone understand each other and communicate better. This education program, offered to every single person, recognizes that we all make a contribution to making these films as good as they can be."

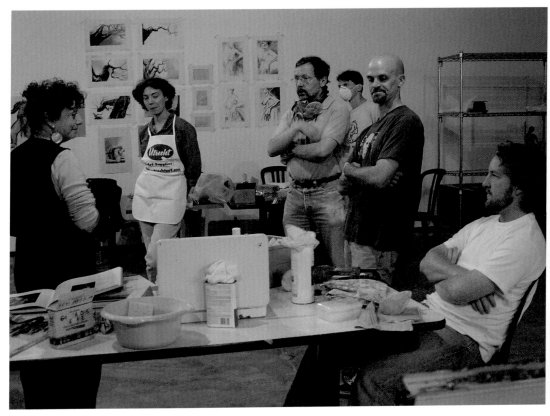

Above: Some of the many classes offered by Pixar University include (clockwise from left) stone carving, ballet, Korean fan dance, and life drawing.
Below: Pixar University's first logo.

Art and filmmaking classes form the core of the P.U. curriculum. Its many offerings have included drawing, painting, sculpting, computer programming, acting, improvisation, live-action filmmaking, yoga, ballet, and bellydancing, plus in-house lectures by speakers from a variety of fields: actors, artists, filmmakers, fish experts, and fashion designers, to name just a few.

"We had started the program to provide training," said Catmull. "But what we eventually discovered was that the social value of the program was the greatest value of all. You're interacting with people that you wouldn't normally see in the studio in a new, interesting way. It's part of the dynamic of the studio."

The fact that classes are almost always made up of students of varying levels of experience—both within the company and within the discipline in question—promotes a relaxed and positive attitude toward their shared goal, shuffling the usual hierarchies and helping people feel more comfortable with learning in front of their peers—being imperfect, making mistakes, and soliciting and sharing advice.

Ultimately, the learning process encourages creativity but also emphasizes the challenge to grow constantly. "Failure is basic

to creative activities, and error recovery is the best definition I have for what effective training is," Nelson noted. "You're really trying to teach people what it's like when everything goes well, but also, how to get back on track when things fall apart. In an innovative business, you want people who have that experience, so that when things are not going well, they have the internal strength to keep going and get to that finished product."

Pixar University sent a clear message that there was a commitment between the company and its people, John Lasseter noted, "We're not a company that disbands its employees after every production. We are committed to our employees for the long term, and we are investing a lot of time and a lot of money to make them better, wider-ranging artists. I always felt Pixar was the perfect blending of Hollywood and Silicon Valley. But because of Pixar University, the dividing line between the art and technology is getting really fuzzy. We're finding some amazing artistic talent from the technical side, and some pretty smart technical people coming from the artistic side."

Chapter 9

Pixar at Home

Over the years, as Pixar has grown and changed, so, too, have the places it has called home. Coincidentally, each of its three homes has corresponded almost perfectly to a different stage of its professional life: hardware/software company, up-and-coming animation company, and full-fledged movie studio.

San Rafael

Even as it established an independent reputation as a leader in computer graphics, Pixar in its early life stayed relatively close to its roots as the Lucasfilm Computer Division—not only figuratively, in its continuing focus on hardware and software, but literally.

When Steve Jobs bought the Computer Division in 1986, Lucasfilm had just begun to move some of its employees from its longtime base of operations, a cluster of buildings on San Rafael's Kerner Boulevard, up to the newly completed Skywalker Ranch. So when faced with the question of where to set up shop, all Pixar had to do was move into one of the spaces recently vacated by their former colleagues. "We simply moved across the parking lot," said Ralph Guggenheim. "The new office wasn't even across the street; we were 30 feet away from the building that we'd all worked in previously."

Pixar's first home, located in Lucasfilm's C building (the buildings were identified by letter), was adjacent to the ILM offices and upstairs from the Lucasfilm Sprocket Systems sound division. The sound group would eventually move up to Skywalker Ranch as well, but Gary Rydstrom remembered being able to just run upstairs for consultations when he was doing the sound for "Luxo Jr."

"It was like a 'crazy aunt in the attic' kind of thing because they were way up on the third floor," he recalled. "Except there would be David D. on the first floor with his early laser printer, and we'd walk by and see red lasers going into the hallway and be afraid to pass."

The group had a long history in the building complex and would have liked to stay. But when Pixar's lease came up in 1990, its landlord refused to renew it, preferring instead to re-lease the space to Lucasfilm for the rapidly expanding ILM. Since Pixar couldn't find

anything affordable in Marin County, they moved to the East Bay, renting space in an office park in Point Richmond, a small town abutting an industrial area, just a couple of miles away from Chevron's oil refineries.

Pixar had left San Rafael reluctantly, but the move to Point Richmond—into a new space that it could truly make its own (the buildings had even been finished to Pixar's specifications)—was an apt symbol for a new period in its life. Months earlier, it had sold its hardware division to another company in order to concentrate on animation and software. Animation had always been the group's true passion, and in finally making it a focus of their business, Pixar was officially declaring its intent to the world.

Point Richmond

When the company first moved into its new space, the animation group, which was just beginning to scratch out a living, could only afford one indulgence—a screening room. They didn't have the money to install theater seats, so John Lasseter, inspired by the living-room décor of the Red Vic movie theater in San Francisco's Haight-Ashbury district, put out a company-wide call for old couches. On the weekends, Lasseter rented a truck and drove around picking up everyone's unwanted furniture. "Before you knew it," Lasseter said, "our screening room was filled with the most ugly collection of '70s couches you've ever seen. But it was great because it was like this eclectic kind of quilt, you know. Right in the middle was this big La-Z-Boy recliner—my director's chair. That room became kind of the soul of Pixar, in a way."

> *"After John brought his son's old scooter into work, Bob Pauley began amassing a small fleet of them. He went to swap meets and yard sales and just got kids' scooters and brought them in, had them all sitting around. And we got into these scooter races—there was a track mapped out, kind of a loop, and we'd time people and write the times on the wall. We all got into a very fierce competition over who could get the best time. I knocked over a couple of people by accident competing in this. But Tom Porter was probably the most competitive of anybody. He had the top record. Late one Saturday night we were in working on something and somebody broke the record. John called him up and said, 'Tom, forty-three seconds.' There was a pause, and then he said 'I'll be right there.' And he drove over from Marin to try to break the record. He went around the track and returned with a bloody knee…but in forty-two seconds."* —PETE DOCTER

Right: A hallway in Pixar's Point Richmond offices, lined with storyboards.

As its animation business expanded, Pixar found itself straining at the seams of its existing space. When the company next door moved out in 1997, Pixar leased the vacated space and broke down the dividing wall to connect themselves to what would become the new animation "pit." Lasseter suggested that they furnish the new area with simple wood-frame cubicles instead of elaborate and expensive office furniture systems, predicting that every animator would inevitably treat his or her space as an "empty canvas" anyway.

Sure enough, the animation department quickly became the most spectacularly decorated part of the company. Mark Walsh made his cube into a tiki hut. John Kahrs began transforming his into a cardboard pagoda. Tasha Wedeen installed a bunk bed. A parachute was fashioned into a circus tent, covering four adjacent cubicles. Before long, the architectural highlights would include, among others, a saloon, a 1960s den, and a park—complete with plants, a fountain, and a little park bench. People started bringing in weird furniture for the communal spaces—a U-shaped restaurant booth, a barber's chair, a pair of hair-dryer chairs from a beauty salon.

Over the next few years, Pixar gradually expanded to occupy most of the initial office complex and a significant chunk of the office park across the street (dubbed "Frogtown" for the marsh on which it had been built). The sprawling two-part warren was like a maze of interconnected dorm rooms, with each section customized to the taste of the locals—who were also sometimes the only people who could successfully navigate the area.

> *"It was a place where you could go and draw on the wall or make a hole in the wall and not feel bad about it and just, you know, make weird cardboard structures or build giant trees in the lobby or whatever. That was kind of fun. It felt a little bit like being a student again."*
> —PETE DOCTER

After *Toy Story* was released in 1995, Pixar, reassured by the film's success, had begun to look for a long-term home. In Emeryville, fifteen minutes south of Point Richmond near Berkeley, they found and purchased a sixteen-acre lot—the onetime home of the Oakland Oaks baseball team and, at the time, the site of an abandoned Del Monte fruit cocktail factory. It was one of the few parcels of its size left in the metropolitan Bay Area.

As they planned the new building, two goals were paramount. The first—the primary reason they had started looking for a new home to begin with—was to renew the sense of community that had begun to dissipate in the company's piecemeal expansion. After *Toy Story 2*, the

Top: Two of the many personalized offices in the animation department in Pixar's new Emeryville building.

studio had made sure that all members of a department worked in the same place, regardless of the production they were on. But the departments were still separated from one another.

"We were in five buildings," explained Steve Jobs. "There was a road between a few of them, and so you'd run into people that had worked at Pixar for a year that you'd never met. Our business depends not only upon collaboration but upon unplanned collaboration, and we were just too spread out. The groups were developing their own styles. We were growing into several divisions instead of one company."

The second, equally important goal was to make sure that the new space wouldn't inadvertently kill the intangible "rough and tumble magic" that flourished in Point Richmond—the feeling of spontaneity, creativity, and total ease.

Ed Catmull said, "There was some worry that if we built this great building, it might be such an edifice that it would take away from what we had in our scrappy Point Richmond buildings. The space there had this feeling of being slapped together, but there was also a really good spirit." As Jobs put it, "We all felt if you came up to our new building and said, 'This is the best corporate headquarters in the world,' we would have failed." The new studio had to be Pixar's home, not just its headquarters.

"Steve's Movie"

When giving tours of Pixar, Pixar University dean Randy Nelson sometimes describes the Emeryville campus as "Steve's movie." In its duration, magnitude, and ambition, the five-year project of creating Pixar's new home was comparable to the making of one of the company's films, and Jobs was intimately involved with every aspect of the project, from the big-picture design of the building right down to the selection of the doorknobs.

"Steve had this firm belief that the right kind of building can do great things for a culture, if you do it right," said Catmull.

Jobs explained, "Peter Bohlin, our architect, and Tom Carlisle, Pixar's director of facilities, and I all kind of designed the building together. We wanted to put everybody under one roof, and we wanted to encourage unplanned collaborations. And the way we did it was to take everything that took you out of your office over the course of a day and put it in an atrium in the center of the building: the doors to get in, the main stairs, the café, the conference rooms, the screening rooms, the bathrooms. And so ten times a day every employee comes to the center of the building, and they mix it up with people that normally they wouldn't see all day long."

"What we'd really wanted was an old factory that we could rehab," said Jobs. "Since we couldn't find one, we built one. We wanted it to be handmade because that's how we make our films. We may have the most powerful pencils in the world, but all our films are made by hand, and we wanted the building to reflect that. Every brick on this building was laid by hand; we had the best brickmasons on the West Coast here for three months. The steel on this building is all bolted together, not welded, like no building since the '30s has been made—we sandblasted the steel and clear-coated it, so you can actually see what the steel's like. When the steelworkers were putting up the steel for this building, they would bring their families on the weekend to show them what they were capable of if someone would just let them, as we did."

The new building was characteristically Pixar not only in its attention to craft, but in that it was continually being improved. "The normal process is you design your building, you do your construction drawings, you put it out to bid, and then you build it," said Carlisle. "Well, our design process *never* stopped. We were designing things almost up to the point when we moved in." As a result, Pixar sent the plans to the contractors in stages—first the foundation, then the structure, then the interiors, then the roof. "It's a very difficult way to build a building, but I think that part of the Pixar process is that we were defining what we wanted as we were going along."

For example, the success of *A Bug's Life* made it possible for the new building to be exactly what they wanted it to be: they could have their ideal screening rooms, their ideal theater, their ideal recording studio. On the other hand, sometimes the changes were a matter of correcting problems discovered en route. "If, as we were in the process, there were things that were anything less than great, we would change them," said Carlisle. "It's a rare opportunity to be able to work for somebody who is so committed to excellence."

Emeryville

Pixar moved to the new building during the Thanksgiving week of 2000—right in the middle of the production home stretch for *Monsters, Inc.* The facilities, systems, and construction crews were working full tilt right until the very last day, but when employees began arriving the next Monday, they were welcomed with open arms—and, most important, working Ethernet connections. The systems team had pulled off an almost entirely seamless move, with employees turning off their computers in Point Richmond and picking up where they left off in Emeryville.

> *"I don't think unveiling the building was any different than when we first put our movies out to our first audience, whether it's opening day or even a sneak preview. I know our directors are nervous as heck about what the audience reaction is gonna be. But that first day, the audience reaction was very, very good, and so I know Steve was pleased."*
> —TOM CARLISLE

Top: Interior shots of Pixar's Emeryville building.

As it so happened, this second move had, again, coincided with a period of transition at Pixar. *Monsters, Inc.*, directed by Pete Docter, would be the first in a series of films not directed by John Lasseter. Thus, Pixar was moving into a beautiful new building, a true studio facility, at the same time the community of directors John Lasseter had envisioned was beginning to come to fruition.

Said Tom Carlisle, "I think the new building told the world, as well as ourselves, that we were a real studio, a viable company that had put down stakes and intended to be around for a long time." Even though it had several films under its belt by then, Pixar had been so accustomed to thinking of itself as a small company—an animation shop run out of an office park—that moving into a gorgeous new home, complete with its name over the gate, took a little bit of getting used to.

"When we first moved in, there was some concern that the place wasn't *us*, that it was somehow too nice for us," said Lee Unkrich. "That first day everyone just kind of wandered around in awe of this beautiful building, which was in such stark contrast to the rented office space we'd been in for years. But the very next day we got back to business as usual, focusing on creating *Monsters, Inc.* And the moment that the animators started bringing their stuff in and making the offices their own, it was pretty clear that things weren't going to change that much."

Above: Pixar's atrium was designed to act as the company's town square—a place where employees from different parts of the studio can meet and interact. Here, employees gather for a company meeting.

The building, said Lasseter, gave them the best of both worlds. "The day that we moved in, I was running into people I hadn't seen in two years at the other building," he continued. And, as he had maintained during the planning process, the freewheeling notion of office-as-canvas survived the transplant to Emeryville intact. "I kept saying, 'Steve, you can make an elegantly cool minimalist design, but as soon as the animators are in there, they're going

to be pounding up old garbage cans they got for 80 percent off at Kmart.'" This turned out to be no joke: soon after they moved in, a local Kmart held a going-out-of-business sale, liquidating their inventory at 90 percent off—a bonanza for the many people who had immediately set themselves to redecorating.

The Love Lounge

It wasn't long before the new building began to reveal the idiosyncrasies that would help give it its own unique character. When animator Andrew Gordon moved into his new office, one of the first things he noticed was a small door with a key in it, built into the wall at floor level. "It turned out to be a sort of a vent shaft, an air-conditioning access room," he said. "You had to crawl through the door to get in, but inside it was actually quite big, almost like a train compartment." Though it was nothing but concrete and dust at the time—"clearly a part of the building you weren't supposed to see"—Gordon was fascinated. Given carte blanche to fix the space up (as long as the air-conditioning valves weren't covered), he cleaned out the dust and strung up some Christmas lights. The enthusiastic response of his first visitors inspired him to make more and more improvements: animal-print upholstery, cushioned seating, soft lighting, even a bar.

"For a while," Gordon recalled, "the Love Lounge really was a secret. It was a place for animators to come and have a drink and kind of hide…we even installed a camera so that we could see when people were coming." As word got out, invitations became a coveted commodity, and the space became a regular stop for visiting notables, whose signatures cover the walls.

Top, clockwise from top left: The sign indicating the door to the Love Lounge; Andrew Gordon and Pete Docter inside Pixar's most famous "secret" space; Steve Jobs pouring John Lasseter a drink as Jane Eisner looks on.

Actor Tim Allen recalled his first visit with amusement: "So, here is John Lasseter, Steve Jobs, and myself, and Steve goes, 'Let's go to the Love Lounge.' We had to crawl on all fours, three grown men, butt-to-nose, through this little hole in the wall. And there's lava lamps and pictures of Doris Day and stuff."

When the animation department shifted to a different part of the building, Gordon had to leave the Love Lounge office. But, at Lasseter's urging, he was given an office that connected to another secret space: a much bigger room that Gordon decided to convert into a casino he dubbed the "Lucky 7." If the Love Lounge was Gordon's Point Richmond ("like my first restaurant or something," he joked), the Lucky 7 is his Emeryville: bigger, better funded, and more polished. The Love Lounge required its visitors to enter in somewhat undignified hands-and-knees fashion, but guests of the Lucky 7 enter in style—through a secret door hidden in a set of custom-built bookshelves. Inside, red velvet banquettes surround a blackjack table, with old photos of various animators' ancestors giving the new space the appropriate sense of history.

Gordon explained that he was inspired to create the Love Lounge, and later the Lucky 7, by his respect for the great animation studios of the past. His appreciation of the camaraderie shared by Pixar's animation department made him want the studio to have its own special places, inside secrets, and "family traditions."

"I got to meet a lot of famous people because of the Love Lounge, which was pretty cool," he said. "But for me, the really cool thing is that people have been inspired by the Love Lounge to find and create other secret spaces in the building."

At Home

Four films after first moving in, Pixar has grown to the point where, as at Point Richmond, it has had to expand into other buildings. But the studio's main building continues to connect employees no matter where they work, exerting a gravitational force on the activities of the studio as a whole.

"I'll admit, I was skeptical coming into it," said Catmull, "but the building turned out to be the most remarkable that I have ever worked in. You can feel the energy when you walk in the front door."

Peter Bohlin, the building's architect, said, "I've probably done two dozen buildings in my life that I feel very good about. And quite a few others that I feel pretty good about. But this is one of the special ones. I think that it's a powerful building, but one where people can still be comfortable."

Lasseter agreed. He said, "What's fun is the public areas of the studio are so beautiful and elegant, but once you get back in the offices and pods, it's fantastic. It belongs to the people."

Opposite page, top: The west side of the atrium contains the Luxo Café on the first floor and conference rooms on the second floor. Opposite page, bottom: The building's atrium (illuminated) is both the literal and the figurative center of the studio's activities.

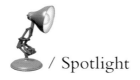 / Spotlight

Voices

Pixar's approach to casting voices is of a piece with its philosophy toward moviemaking in general: everything has to support the story. "The most important thing is that an actor's voice qualities fit with the character," said John Lasseter. "We want people to get caught up with the character and the story and, ideally, not even think about who did the voice, because that pops people out of the movie; it ruins the suspension of disbelief. So we very seldom ask people to put on voices. We want people to be themselves, so their dialogue has a really natural, believable quality."

That Pixar looks for actors with great chops—and particularly top-notch comic skills—goes without saying. The recording sessions are taped for the animators' reference, but the vocal performance has to work independent of body language or facial expression. The actor must also be able to be "on" for hours, doing take after take without the benefit of sets, costumes, or even other actors. (After recording the dialogue for *Toy Story*, both Tom Hanks and Tim Allen said it was the hardest they'd ever worked.)

But Pixar also seeks actors who can improvise. "It usually takes about four years to create an animated film, and every tiny little thing has to be planned in advance," said Lasseter. "We agonize over everything—not just every frame, but every pixel of every frame. So the one place where we have the opportunity to incorporate something spontaneous into the final product is in the recording session."

Lasseter cites Tom Hanks as a particularly inspired improv actor, especially when given a prop to use. When recording the dialogue for the scene in *Toy Story* where Woody tries to use Buzz's arm as a stand-in for the despondent Space Ranger, Lasseter brought along a fake arm (the sort used for Halloween gags) for Hanks to work with.

"He just took off," Lasseter remembered. "He came up with the funniest stuff. I was laughing so hard, I almost ruined the take—I had to leave the room and go into the recording booth with the sound engineer. It was so fresh and so distinctive; I knew the audience would laugh the way we were laughing. Ever since then, we have really looked for actors who can ad-lib and make the part their own."

"We realized that with these ensemble films, most characters don't have monologues, they have one line. Well, John Ratzenberger would kill with the one line every time. We didn't start out planning to have him in every movie, but we

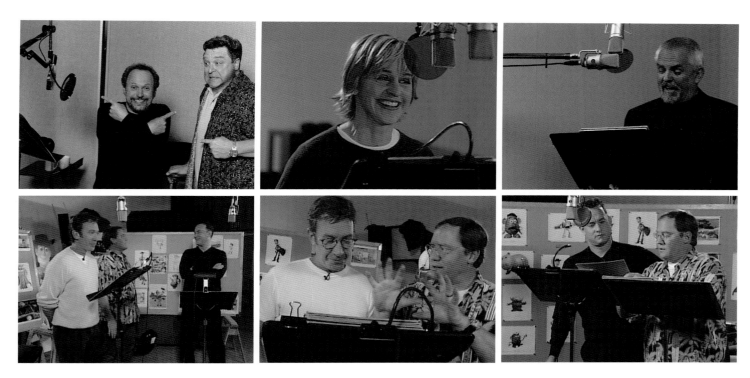

Top row, from left: Billy Crystal and John Goodman (Mike and Sulley from Monsters, Inc.*); Ellen DeGeneres (Dory from* Finding Nemo*); Pixar regular John Ratzenberger.*
Bottom row: John Lasseter at a Toy Story *recording session with Tim Allen and Tom Hanks.*

kept finding parts that were perfect for him, and now he's become our unofficial good luck charm."
—JOHN LASSETER

For Pixar's first films, recording production dialogue with the film's voice actors was always done in the actor's city. Usually this meant Los Angeles, where Pixar had a home-away-from-home at Disney's Sound Stage B, but they also often traveled to New York or Chicago. Pixar's very first voice recording session, in fact, was done in Detroit with Tim Allen.

However, as the studio began to plan its new campus in Emeryville, a recording studio of its own was high on the wish list. A professional recording studio would not only make it much easier to record scratch dialogue (the temporary voice track for the earliest versions of the story reels, usually done by Pixar amateurs), it would also make it possible for Pixar to invite actors to record their dialogue at the studio itself. The idea was that recording dialogue on-site where possible would help save time during hectic production crunches.

But they soon found an unexpected benefit to being able to host actors at the studio that turned out to be even more important. "Directors, key story people, producers—we kind

of get the best of both worlds," said Lasseter. "We get to go down and work with the voice actors and come back up and work with everybody at Pixar. But no one else at Pixar got to see the voice actors at all. They'd see the video recordings we did of them at the recording sessions, and that was it. In turn, the recording sessions for the actors are spread out over a two-year period, a few hours here and there. It's a very different experience of the film than living with it for four years."

"So it's really fun to bring the actors to Pixar when we can, have them record here and then eat lunch at Luxo Café with everybody else. We can walk them through all the different departments and have them meet the people working on the film and see the work in process. It really helps the actors feel more a part of the film, both for the actors themselves and for the crew."

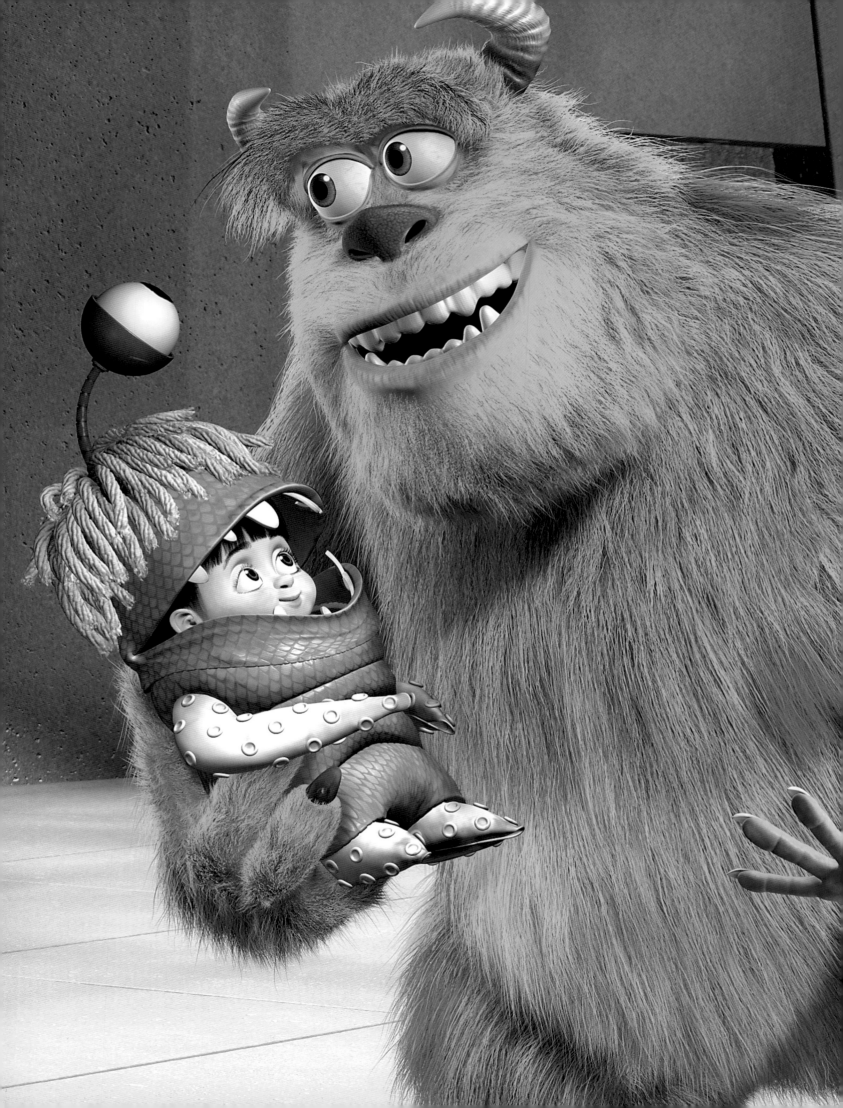

Chapter 10

Monsters, Inc.

"John is brilliant in many ways. But the thing that most impresses me about him is that he realized right from the start that in addition to making his own films, he wanted to grow a generation of directors around him. He's hired well; he hired these young gems who've worked around him for a decade. And he has grown an entire team of creative leaders at the studio." —STEVE JOBS

Production was barely under way on *Toy Story* when John Lasseter began to think about how best to spread the studio's core creative talent over the (hopefully) multiple films to come. He had started by having Andrew Stanton skip production on *Toy Story* to take the lead on the development of *A Bug's Life*. Once *A Bug's Life* began production in earnest, Lasseter asked Stanton to continue on the project as co-director.

But since Pete Docter had gone through the whole moviemaking process on *Toy Story*—and hadn't really worked on *A Bug's Life* yet—Lasseter had him leapfrog *A Bug's Life* to start developing ideas for a new feature, one Docter would direct himself.

Producing films led by different directors was a natural part of Pixar's evolution as a studio, but there was still a great deal of significance to actually crossing this threshold. Lasseter's work had done much to develop computer animation as a medium, and as the only direc-tor at the studio for the past decade, his name had become almost synonymous with Pixar's.

But people within the studio were curious and excited to see what a Pete Docter movie would look like. As Ed Catmull observed, "When you get to a certain level of talent, all these people are unique. A lot of people don't actually understand that; they don't realize that you can't treat directors as interchangeable with one another. There isn't another director like John Lasseter. They're all different, and the difference is the whole point."

The Self-Effacing Showman

Over the years there have surely been many animators whose choice of profession has made them the odd one out in their family, but Pete Docter may be the only one who swam against the current by not becoming a *musician*. Growing up in Bloomington,

Above: Mike Wazowski at work. Rendered character pose.
Opposite page, top: Residential home. Tia W. Kratter, acrylic.
Opposite page, bottom: Early concept art of Sullivan and Boo. Geefwee Boedoe, mixed media.
Previous spread: Boo, Sulley, and Mike. Rendered film image.

Minnesota, with parents who taught music and sisters who would become professional musicians, Docter learned to play the violin, the string bass, the mandolin, the ukelele, and the concertina. While he enjoyed playing music, he didn't care for all the practicing, so a career as an instrumentalist was clearly out. He does, however, credit music with indirectly setting him on the path to animation. "I was dragged to a *lot* of concerts," he said. "I'd get bored, so I'd doodle in the programs. That's where my first cartoons came from."

From an early age, Docter's imagination was fired by stories of alternate worlds, of realities totally separate from our own. "Growing up, all the books I just obsessed over were ones that took you into a whole other world, like *The Lion, the Witch, and the Wardrobe*, or *The Wizard of Oz*. I spent most of my childhood somewhere other than where my body actually was," he recalled.

But Docter, who had a tinkerer's bent, a hands-on curiosity about the world, was fascinated by the way that even relatively clumsy material art forms could provoke a similar suspension of disbelief.

> *"You know there's always that kid in your class—and every class has one—the kid who draws all the time and is really good? That was not me. I was a lousy draftsman. But as soon as I figured out that I could make things come alive, like using the corners of my math book to make flipbooks, I was hooked. It was the same thing with puppets—taking something that you knew was not alive and making it look like it was. I love the idea that half your brain knows that's fake, that it's just pretend, but that if it's done right, the other half is completely willing to accept it and go with it."* —PETE DOCTER

The Muppet Show, Disney animation, and especially Disneyland (the glorious side benefit of his family's annual trips West to see grandparents)—all these scratched the same itch, and he fantasized about someday working with the Muppets, or designing attractions at Disneyland.

"I was pretty socially awkward as a kid, which is a common thread among animators," Docter said, laughing. "You have this need to connect with the rest of the world, but as

Top: Miscellaneous monsters. Geefwee Boedoe, mixed media.

soon as you do so in person you feel totally awkward and abnormal. And so to relate to the world, you sit and draw. I'd spend hours alone in my room making stuff. I made my whole room into a tiki room, sort of patterned on the Disneyland one, but it had a stage with a curtain that I could work by remote control, and all these puppet characters I could trigger. So I had this showman impulse; I wanted to entertain people and interact, but the whole idea was that I wouldn't have to be up there in front of people myself."

In high school, a job-shadowing experience at a local animation studio pointed him toward animation and CalArts. The three student films Docter made while enrolled there— "Winter," "Palm Springs," and the Student Academy Award–winning "Next Door"—drew the attention of an enviable list of would-be employers, including *The Simpsons*, Disney Feature Animation, and Walt Disney Imagineering. "To this day I think Pete's student films are some of the best student films that have ever been made at CalArts," said Lasseter.

But Docter had his heart set on what any outsider would have considered an inexplicable choice: a hardware company with a tiny animation group planning to expand from short films into commercials.

"Looking back, I had all this opportunity for things I had dreamt of my whole life, but the weird thing is, I just *knew* I had to go to Pixar," said Docter. "And I don't really know why. At the time, it was pretty off the track—not something you'd even consider as a job possibility. But John and the rest of the guys had done these great short films. I really fell in love with the short film as a genre at school, and theirs were so cool that I think in the back of my head I was hoping maybe I would get to do some stuff like that. Of course, I got to do commercials instead, and then eventually a feature film, which was even better."

What Makes a Monster?

Docter had been charged with developing and presenting several ideas at once, but given his early affinity for alternate worlds, it was perhaps not surprising that one idea in particular quickly broke from the pack.

Upper top: Character lineup. Ricky Nierva, marker and pencil.
Lower top: Simple shape vocabulary. Ricky Nierva, pencil.

Top row, from left: Concept pastel for "Downtown Monstropolis," Dominique Louis, layout by Albert Lozano; master lighting pastels for "Day Shift" (center left and right); and "Disguise Boo," Dominique Louis.
Bottom Row: Master lighting pastels for "Sushi" (left three) and "Himalayas" (right), Dominique Louis.

It began as a story about a thirty-year-old man whose childhood drawings of monsters come to life and start plaguing his existence. "Nobody can see them except for him, so everybody else thinks he's gone crazy," explained Docter. "It turns out that these monsters represent fears that he had never dealt with as a kid. They help him overcome those fears, and as they do, they disappear. But by that time, they have become really good friends, so it was this bittersweet ending."

Elements of that version would remain in the finished film, but the part of the story that really resonated, the idea that sold everyone, was the idea that the monster world was real. The story soon transformed into one focusing on the monster world on the other side of the closet door. That, in turn, naturally suggested a story about the relationship between a monster and a child.

Said Lasseter, "It was such a brilliant notion to take and explore the idea of, 'What if kids are telling the truth, and there really are monsters in their closets?' It's a truth children know, just like they know that their toys come alive when there's no one else in the room."

Everyone had loved the initial idea for the story and the mind-bending possibilities of inventing a monster world. But having such a wide-open canvas created its own problems. "It was almost like there were too many possibilities. Everybody knows what toys are like. But monsters could be anything, anything in the world...or outside the world! It was almost too much freedom," said Docter with a laugh.

Because Lasseter was up to his ears in *Toy Story 2* at the time, Andrew Stanton came over in his stead to be the project's creative sounding board. "Andrew is so amazing at story structure," said Docter. "The word 'structure' kind of makes it sound boring, but what he has is a really incredible understanding of character, and of how to put things together so that events escalate in a very satisfying fashion. He was really good at stepping back

Top: Background monster chart. Bob Pauley, mixed media.
Above: Boo and Sullivan. Harley Jessup, mixed media.

and looking at all the individual parts that were or were not accelerating coherently, and analyzing all those things in a very thoughtful way that allowed us to construct a story that was engaging to people."

The *Monsters* creative team found their path to the world of their film by using the same methods that had clarified the vision of *Toy Story*—establishing the core rules of the story and asking themselves what followed logically from there. "Andrew came up with the idea of scream power fueling Monster City, which was a watershed concept that helped us structure the world and its relationships," said Bob Peterson, the film's story supervisor. From there, it seemed natural that the scream factory's aesthetic would be drawn from the baby boomer years of the 1950s and 1960s, when both children and their screams were plentiful. The notion also came with a practically ready-made trigger for the film's events: a power shortage resulting from increasingly jaded and hard-to-scare kids.

"Having Monsters, Inc. be a power company created that common, gettable environment of an office and freed the story team and screenwriters up to concentrate on the characters and their relationships," said Peterson. The emotional core of the story had always been the parental love that the protagonist, Sullivan, develops for the human child he calls Boo, but "Sulley" himself had been the hardest thing about the story to pin down. After many iterations of both design and personality, he had been established as an insecure ex-Scarer who wore thick glasses to avoid having to return to his job, where he had witnessed the traumatic effects of a scare on a child. This version of the character seemed to be the solution they had been looking for, and the film was put into full production.

The Disney reviews were going well, and production was chugging along nicely. But the Pixar team was getting the unsettling feeling that the story just wasn't working properly. Finally, they couldn't ignore their consciences any longer. Though they had just conducted a successful screening at Disney, the *Monsters* team decided to stop production and rework

Top: Boo sketches. Dan Lee, pencil.

the story, returning Sullivan to his original incarnation as a top Scarer, the star quarterback of Monsters, Inc. Stopping the train this far along was a daunting prospect—especially with *Toy Story 2* so fresh in the studio's memory—but the change helped all the pieces finally fall into the right places.

"When we decided to do a major reset on *Monsters,* we knew it was going to cause immense turmoil, but I came away from that meeting feeling really proud," said Catmull. "We had a group of people who valued quality enough to initiate a crisis even though they didn't have to."

"*Monsters* was Pete's first movie," observed Joe Ranft, who did storyboard work for *Monsters* and provided the scratch voice for Sullivan. "I've worked for a lot of first-time directors. Working for John on *Toy Story* was different than working for John today. On *Toy Story,* John was discovering how the whole thing worked. He was figuring out what he needed to have happen, how to make a board work and stuff like that.

"Working with Pete was similar to working with John on the early versions of *Toy Story.* It takes everyone a little bit of exploring at first; the directors have to find their own style that's them. And on top of that there's a little bit of figuring out what direction the story is taking. Sometimes you go a little east, you go a little west, you go southwest. Until you're like boom—this is the course we're plotting. Because finding the story's direction is also about correction, about knowing when you're off course."

Balancing Multiple Movies

In addition to the problems every filmmaker faces in wrestling a vision into existence, Docter was facing a web of pressures highly unusual for a first-time director.

To begin with, *Monsters* entered full production at a time when Pixar was becoming increasingly aware of itself as a studio—as an entity that had priorities separate from the immediate needs of the movie at bat. Pixar had always planned with an eye to developing parallel production in the long term; *Monsters,* for example, would overlap production with both *Toy Story 2* and *Finding Nemo.* But the company's resources had been concentrated in effectively serial fashion through *Toy Story 2,* with the studio doing anything and everything necessary to make the movie of the moment.

Top: Background monster textures and colors. Tia W. Kratter, acrylic.
Opposite page, top: Story sketch. Ricky Nierva, marker. This was the very first drawing of Mike Wazowski.
Opposite page, bottom: Monsters, Inc. logo brainstorming. Tia W. Kratter, marker.

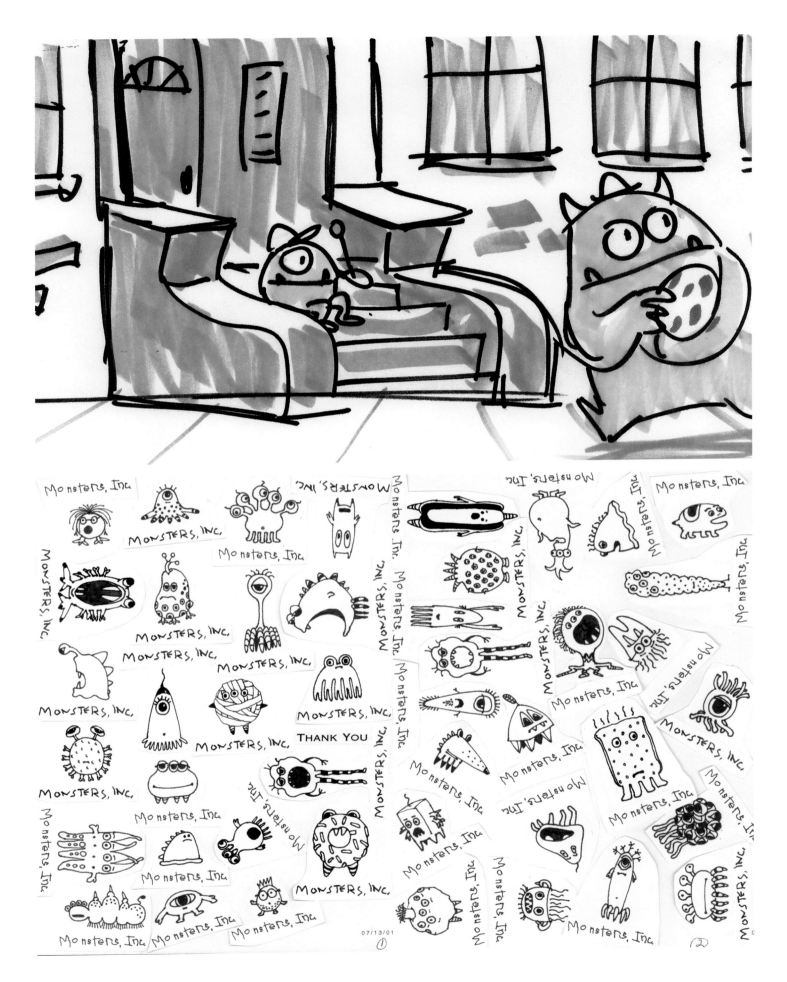

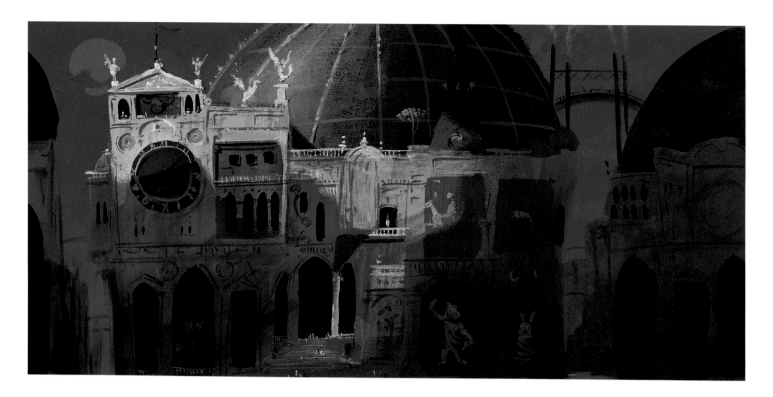

Having a marquee project not directed by Lasseter meant that the company had to confront head-on the practical implications of running parallel tracks at the studio—an issue that brought with it the notion of balancing the interests of one movie against another, as well as against the interests of the studio as a whole.

In the past, making every movie great had meant that the studio threw all its resources behind a film. That was not only impossible to do with multiple productions, but impractical over the long term given the level of resources the studio now had at its disposal. The question had become, what *should* the company be spending on a movie? "Budgetarily we tried to keep ourselves on something of a diet, relatively speaking," said Darla Anderson, who had come over to produce *Monsters* after finishing on *A Bug's Life*. "We didn't want to let ourselves get too hefty."

Furthermore, with the recent epidemic of repetitive stress injuries on *Toy Story 2*, the studio decided it had to make a concerted effort to reduce the amount of overtime on its films. "At first I thought, how are we going to make a movie without overtime?" recalled Anderson. "It was really hard for us to get into that mindset initially because we've been working overtime our entire professional careers to get where we are. But after *Toy Story 2* everybody kind of said, okay, we need to solve this problem because we want to keep our employees healthy. We want them to be happy here and keep them for long careers, and we don't want them to be dropping like flies. It's something we're always mindful of and trying to improve on."

But trying to move closer to an "ideal" production model was not the only hurdle for the production to clear. *Monsters* was also trying to break a trail for a new creative model at the studio—making a film not directed by John Lasseter.

"A Lot of Pressure for Any Artist"

Pete Docter was only twenty-eight years old when he started developing the project that would become *Monsters, Inc.* Though he would pitch in on story for *A Bug's Life*, and of course join the all-hands-on-deck revamp of *Toy Story 2*, at that point, his only production experi-

Top: Monstropolis. Dominique Louis, layout by Harley Jessup, acrylic. Above: Boo. Dan Lee, pencil.

ence was on *Toy Story*—his very first feature gig. More than a few people questioned whether the relatively inexperienced animator was up to making his directorial debut on a big-budget holiday "tentpole" film.

"I was not convinced that he could hold up this weight without John," recalled Tom Schumacher. "He hadn't done it before. He hadn't been an associate director before, he hadn't been a 'number two,' he hadn't been a co-director before. It was really throwing him into the lion's den. Plus, think of the burden—he was following up on some pretty gigantic success, and that's painful. It's much easier to be the most successful guy in the least successful class; it's hard to be the most successful guy in the most successful class."

As Anderson put it, "Here's this sweet kid in charge of this huge thing that is going to be the one product that Pixar puts out for eighteen months—it's a lot of pressure for any artist, let alone a new director."

Docter was partially sheltered from outside skepticism by Pixar's increasing creative autonomy. On *Toy Story* and *A Bug's Life*, each sequence had to be approved by Disney before it could be put into production. On *Toy Story 2*, however, Pixar had run independently out of sheer necessity due to the speed of production. On *Monsters*, while the studio still took reels to Disney for review and helpful feedback, by the end of production, immediate creative oversight had been brought in-house to Lasseter. From that point forward, the go-ahead to put sequences into production would come from Lasseter instead of Disney.

But that close external scrutiny had been replaced with other pressures—most significantly, the tacit sense that *Monsters* was a test case for Pixar's viability as a studio. There had always been pressure associated with being the first person other than John Lasseter to direct a Pixar production, but after the failure of *Toy Story 2* (which had received a battlefield promotion to full-fledged feature) the pressure became white-hot.

"Maybe we forget now," said longtime Pixar sound designer Gary Rydstrom, "but in retrospect it's clear that it was a big deal to have a movie come out of this place that wasn't directed by John. So Pete taking that film, everyone worried, not because they had doubts about Pete, but maybe the secret was everything had to be directed by John."

As people looked back at the studio's successes, it was clear that all had relied on a proven combination: Lasseter's directorial vision, supported by the talents of the group jokingly

Top left and middle two: Miscellaneous monsters. Dominique Louis, pastel.
Top right: Miscellaneous monster. Geefwee Boedoe, mixed media.
Above: Boo. Rendered character pose.

Above: Mike and Sulley, scared. Rendered film image.

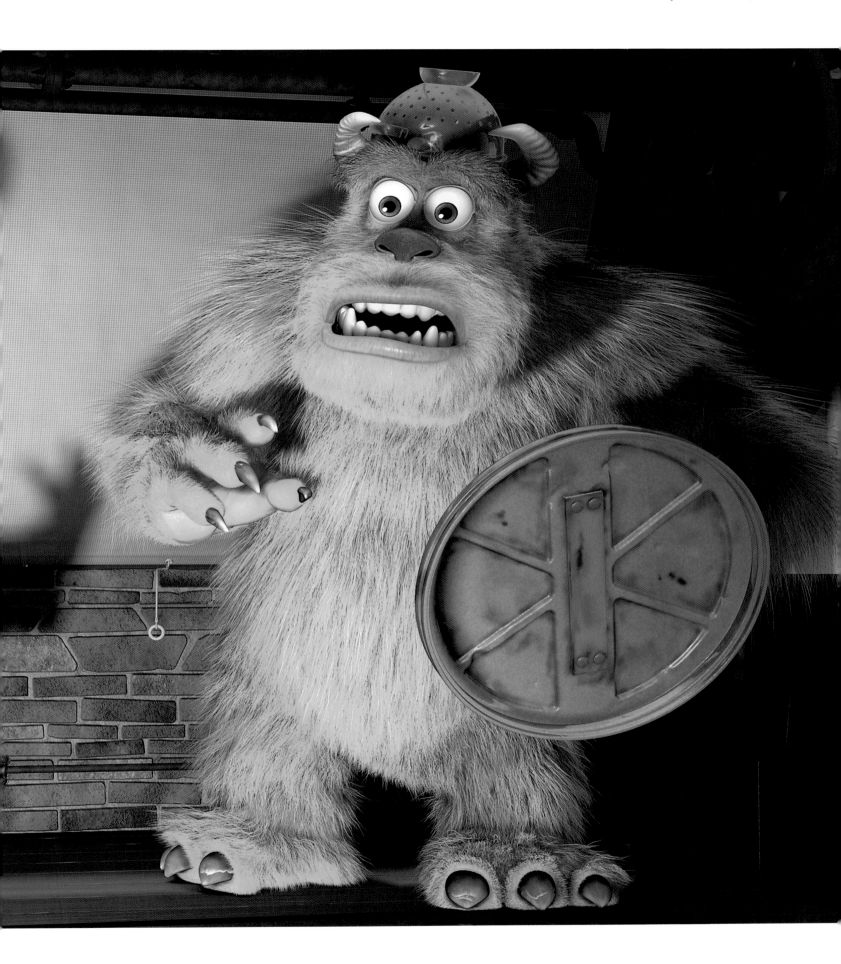

referred to as the "brain trust:" Andrew Stanton, Pete Docter, Joe Ranft, and Lee Unkrich. *Toy Story 2* had admittedly been sent off on the wrong foot, but the fact remained that it had faltered without Lasseter at the helm and had flourished once he took charge. Yet Pixar *had* to show it could be successful under a different director in order to have any hope of surviving over the long term. Could it pass the directorial baton this time?

Lasseter was confident it could. He believed in Docter and was determined not to let *Monsters* fall victim to the same mistakes that had damaged *Toy Story 2*. "We had not set up *Toy Story 2* for success," he said. "I realized we had to set up *Monsters* for success."

This meant making sure Docter had at his disposal all the same resources that Lasseter himself had benefited from, most significantly those of the "brain trust." The group had often likened their chemistry to that of a band. When it came time for them to "split up" in order to produce separate films, the unavoidable metaphor was that of a band dissolving for its members to produce solo projects. But as Lasseter put it, what they discovered was that they didn't have to divide their strengths. Rather, their relationship could be more like a band in which everyone did a stint as the lead singer and songwriter.

As with any paradigm shift, trial and error was part of the deal as the team resettled and tuned itself to the new relationship: the looser collaboration of *A Bug's Life* or *Toy Story 2*, but this time with a different director in charge. They knew finding their rhythm might take time.

"I think there were growing pains all around," said Stanton. "We knew that there had to be a sweet spot somewhere, and that there wasn't a right or a wrong. Sometimes it was messy getting there, but we survived."

In one way or another, everyone lent a hand to the project. Lasseter and Stanton had been offering regular creative feedback from the start, and Stanton, of course, joined the film early on to help write the script. Ranft did a spell in the story department. And Lee Unkrich eventually came onto the project as co-director, joining existing co-director David Silverman.

"We all knew *Monsters* was going to be the first movie not directed by John, and there was added pressure as a result," said Unkrich. "But it was also the first film where we couldn't all work together like we had on all the other movies. So I was brought in to bolster Pete, to be there for him and help him make the best possible movie he could."

Regular meetings, in which they would all review the state of the project and offer critiques and suggestions, preserved the heart of what they valued most about their early days on *Toy Story*—the open and honest exchange.

"We always had faith in each other's abilities," said Lasseter, "and our experiences on *Toy Story, A Bug's Life,* and *Toy Story 2* really gave us confidence that no matter what problem might arise, we collectively could get together and talk it through and argue and discuss things and solve the problem. It may take a few times or trials through, but we will solve the problem. There is no question that that relationship has always made every single one of our films better."

> *"I always had this idea in my head that Walt just sat up one night in bed and said 'Dumbo!' And then they just went ahead and made that movie that was already in his head, fully formed. But it's the furthest thing from that. Somebody has an idea, and then somebody else changes it, and then you turn it around backward, and then you throw it out because there's this other thing.... It's very organic. You can't hold on to anything too tight, but you have to hold it tight enough so that it doesn't drift away from you. It's kind of a weird process of giving and listening." —PETE DOCTER*

Above: Mike. Ricky Nierva, marker.
Opposite page, top: Monsters, Inc.
Harley Jessup, acrylic.
Opposite page, bottom: Monstropolis. Lou Romano, layout by Harley Jessup, gouache. The original code name for Monsters, Inc. *was "Hidden City"—the name of Pete Docter's favorite restaurant in Point Richmond.*

"Our movie traveled a long road of changes and corrections, especially to our main character," said Peterson. "But Pete really held up under this pressure and allowed the movie to teach us what it needed to be."

"I give Pete a world of credit, because it couldn't have been easy," said Kathleen Gavin, Pixar's production liaison at Disney. "But Pete was always poised, always composed. He was always willing to listen to what people had to say—he was never defensive when people gave notes—and yet he stayed true to the core of his movie. It was his vision of the movie that kept it going forward. That is really a remarkable thing."

As might be expected, Docter had delighted in figuring out the details of the monster world—the idiosyncrasies of behavior in this parallel reality—but the heart of the movie came from the truth of his own experience. "Sulley's arc was definitely something I was living at the same time that we were crafting the story," Docter said. Before getting married, he remembered, he had been absolutely certain that his work would always be his first priority. "But then I got married, and then my son was born just as I started developing the story for *Monsters*. So as the story developed, I experienced firsthand what Sulley was going through, which was the shift from 'Okay, it's all about work!' to realizing that there is so much more to life, and that you need to find that balance."

Lasseter knew Docter would handle the material with a deft touch. "Pete is so unique," Lasseter said. "More than anybody else I know, he has kept a strong hold of the childlike wonder of things. His sense of character, his sense of story, and his sense of humor all kind of come from this place in him that has grown into the responsibilities of being a husband and a parent without forgetting what it was like to be young. His films see things with the clarity of a child's imagination, yet at the same time they have a cleverness and worldliness that you have to be an adult to fully appreciate."

Top: Concept art by Harley Jessup. Clockwise from top left, Sullivan and Boo in Monstropolis, mixed media; Harryhausen's sushi restaurant exterior, watercolor and ink; Sullivan and Mike's living room, marker and ink; Waternoose's office, marker.

Rolling Up Your Sleeves

"Once *Monsters* got into production, Pete was just amazing," Lasseter observed. "He's so great with the animators, and he just gets in there and digs around with the technology."

"The whole reason I do it is because I love making the movies," said Docter. "To me, making the film is almost more fun than watching it. You know, rolling up your sleeves and figuring out how it's going to work. That includes everything—not only story, which is really hard, but also just the craft of 'how are we going to get the computers to do this thing that seems impossible right now.'

"Both John and Pete have this highly intelligent and insatiable curiosity. They both under-stand the basics of code, they both understand the technical side of the films, and they both keep asking questions. They want to know what their limitations are. Pete has this little pad of paper he takes with him everywhere all the time, and he writes down all these little things on the pad of paper and never forgets anything." —DARLA ANDERSON

"I was really fortunate that on *Toy Story* John was very giving in terms of bringing Andrew and Joe and me along to everything," Docter said. "So while I was supervising animator, and I worked on story, I also got to see lighting and shading and rendering and recording sessions and everything. I really got a good sense of the whole process.

"Once the story comes together, the actual production is really fun. And there are so many amazing people here that bring their greatness to the film. In a way it's unfair, because in the end, the director gets a lot of credit for stuff that we don't even do. It's really the great people here that are primarily responsible for making it possible for these films to look as good as they do."

Top: The door vault. Tia W. Kratter, layout by Bob Pauley, acrylic.
Above: George Sanderson. Ricky Nierva, marker.

"Probably one of the things that I miss the most in my job now is animating. I think every director that's come from animation has wished he or she could animate at least one scene in their film. Pete actually did it on his; he animated that amazing last shot of Sulley looking through the door at Boo. I give him tremendous credit for insisting on doing that and carving out the time for it."—JOHN LASSETER

"Can CG Be Cuddly?"

Being the supervising technical director of a feature requires one to be part gambler, part general, and part juggler. Tom Porter, the supe TD for *Monsters*, described it as follows: "You get a set of problems, and you need to put a stake in the ground for what you think the 120 TDs on the show can accomplish three and a half years from now. You don't want to shoot too low, because then you don't bring as great a film to the screen as you should. But you don't want to shoot too high, because if you don't deliver, the movie doesn't get finished. Fortunately we have the luxury of relying on clever people to do something great."

At the time Pixar made *Toy Story*, every single motion on screen had to be created by an animator. Though extremely tedious, this was relatively manageable for a film that dealt mostly with plastic or hard surfaces. But *Monsters* posed two significant new challenges in the form of Boo's T-shirt and Sullivan's long, fluid fur.

Because it would have been ridiculous to ask the animators to realistically animate every wrinkle on Boo's T-shirt, or the individual hairs of Sulley's shaggy coat, the technical team had to figure out how to get the computer to simulate, or automatically generate, the necessary movement. Pixar had made limited use of simulation in previous films—to create the snow in the snow globe featured in "Knick Knack," and the water and gently waving plants in *A Bug's Life*—but *Monsters* would be the first feature to employ simulation for its main characters.

Top: Boo's costume shader packet drawing. Tia W. Kratter, pencil; underlying model packet drawing by Jason Deamer, pencil.

In the early stages of the project, Docter had also envisioned Boo as having long, loose black hair. But as work progressed and it became clear that figuring out how to do the

hair would be a substantial theoretical problem, Docter compromised on pigtails, which could be articulated and animated by hand. Deciding the technical priorities of a film, he said, is like going to the store to buy candy. "You only have $3; you can't buy everything in the store. So what are you going to spend the $3 on? You have to educate yourself about what's hard and why, so that you can make the right calls for what the story needs." For Docter, great fur for Sullivan and realistic cloth for Boo's T-shirt were more important than Boo's long hair, which was a cute design element but not essential to her character.

Coincidentally, the problem of fur was one that Porter was dying to see solved. Years before, when he had shown a friend some of the early images from *Toy Story*, the friend had doubted that his daughters would be interested in it because the toys were plastic and not cuddly. "As proud as I was of *Toy Story* and as delighted as I was to see how much audiences appreciated it, that remark about 'cuddly' stuck with me. Could computer graphics be cuddly?"

Simulating dynamic (realistically moving) cloth and hair was tricky enough to begin with. But the problem was complicated by the fact that Pixar needed the dynamics to be both realistic and "directable." If Boo's T-shirt was draping in an aesthetically unappealing way, or Sulley's fur was sticking up in an unattractive but technically accurate cowlick, the system had to afford the director and animators sufficient control to adjust the final image as needed—to redrape the T-shirt, or "comb" the fur flat, even if such behavior contradicted the rules of the simulation.

To this end, Pixar recruited researchers Andy Witkin and David Baraff to help overhaul its existing dynamics system. "A lot of the software we build, and a lot of the production structure we build up, is in the service of allowing the director the latest possible decision point for a lot of stuff," said Porter. "You have to start building the world while the story is still moving and its requirements are changing, and you have to put hooks in the system that allow the director to make adjustments, like combing down a cowlick, very late in the game. It's extremely difficult, but we want to accord the director the respect of giving them that fine control." Without it, the filmmakers would be, as Docter put it, "rolling the dice" on the final image—leaving final say to the computer and risking that strange-looking fur or cloth might distract the viewer from what was happening in the scene.

In the end, said Porter, "it all paid off." Boo's long T-shirt creased and wrinkled marvelously. And Sulley's fur not only looked beautiful, it behaved in gratifyingly realistic fashion, even collecting snowflakes on its tips in one shot. The wonderfully soft-looking coat entirely justified Boo's nickname for Sulley—"Kitty"—and proved beyond a doubt that CG could indeed be cuddly.

Top: From left, Early Waternoose; Yeti; Miscellaneous monster. Jerome Ranft, cast urethane resin.

"Where Does What We're Doing Fit into the World Right Now?"

Monsters was in the middle of sound mixing when the terrorist attacks of September 11, 2001, occurred. The studio immediately decided to change one of the film's scenes to drop imagery now laden with unintended associations—instead of being exploded, a sushi bar "contaminated" by a child's presence would be sterilized by a blue energy field. But, as was true for many at the time, they momentarily struggled with the larger question of the relevance of their work.

"We didn't know what to do at first," said Anderson. "We wondered, where does what we're doing fit into the world right now?"

"I remember none of us wanted to keep working on it," said Unkrich. "It just felt so completely trivial to be making a movie in the middle of all that. But as everybody else did, we eventually picked up and tried to get back to some normalcy. And as we started talking to people and talking to families, we came to realize that no, we're not curing cancer, but we are doing something worthy. There's real value in entertaining people and giving them an escape from reality."

Watching audiences react to the film was something special even for a showbiz veteran like actor Billy Crystal, who voiced Sulley's best friend Mike Wazowski. "I had heard it and seen it in different versions," he said, "but when I saw the final film at the screening they had for us, I was just astounded. Then I saw it with the audience I should see it with—families and kids. When you see it digitally projected, it is pretty extraordinary, and the image of it was just amazing. And the laughter and the crying and the warmth, and I saw kids snuggle up to their parents, and I saw the parents put their arms around

their kids, and I saw the parents with a little moist eye with the reflection from the screen.... You went, 'I'm—I'm in a gift.'"

Docter was thrilled—and relieved—by the enthusiastic reception given to the film. "From beginning to end, *Monsters* took five years to make," he reflected. "That's a long time. At that point it was a sixth of my life. So it was a cathartic experience finishing up. Throughout the film I worried that this was going to be the one: the first Pixar film that starts the downward trend. You know, we'd gone from *Toy Story* to *Bugs* to *Toy Story 2*, with each film making a bigger and bigger splash. And I thought okay, *Monsters* is going to start going back down. And the fact that it did even better was just—I still can't quite believe it. It was just a surreal experience, the whole thing. Your head just kind of swims."

> *"It's like you run into this dark tunnel, trusting that somewhere there's another end to it where you're going to come out. And there's a point in the middle where it's just dark. There's no light from where you came in and there's no light at the other end; all you can do is keep running. And then you start to see a little light, and a little more light, and then, bam! You're out in the sun."* —PETE DOCTER

Even Tom Schumacher, who had originally doubted the wisdom of Lasseter's choice of director, was convinced and moved. "It was a wild ride," he said, "because it was such a complex movie. And it didn't find its center for a very long time. And then when it did, its center was so good, people went nuts for it. Pete emerged as a remarkably sensitive, smart, really great director. And he owns this movie."

Top: Pete Docter (center) at a recording session for Monsters, Inc. *Story supervisor Bob Peterson (left) provided the voice of Roz,* Monsters, Inc.'s *paperwork-obsessed dispatcher.*
Above: Sulley. Rendered character pose.

 / Spotlight

"For the Birds"

After Pixar successfully rekindled its shorts division with "Geri's Game," John Lasseter decided to throw the door open to the studio for the next short. "I wanted to give everyone a chance to submit an idea," he said. "It just seemed like the right thing to do."

Two pitches, by Ralph Eggleston and Bud Luckey, stood out right away, and Eggleston's project, "For the Birds"—about a goofy, lanky bird who tries to befriend a clique of smaller birds—was chosen to go first.

Ralph Eggleston had joined Pixar in 1993 to head up the art department on *Toy Story*. He had been recruited by Andrew Stanton. "When we got the green light for *Toy Story* and it became clear that we were really going to make the film," said Stanton, "I started calling everybody I knew, saying, 'You know how we used to always say there's got to be a better way to make an animated movie? Well, we're going to do it; come on up!' But I think for many of them it was too much of a leap to make; CG was still too new and unfamiliar. Over the years, all the people I called eventually made their way up here one way or another. But the only person out of all those people I called that said yes right away was Ralph Eggleston, who came in to be our production designer. And

thank goodness, because he really became a cornerstone of the look of our films."

Eggleston had come up with the basic premise of "For the Birds" while still a student at CalArts. "It was based on a design project in Bob Winquist's class. I had storyboarded most of it, but I couldn't think of an ending. I also didn't want to have to draw all those little birds by hand." He thought briefly about making the film in cut-out animation, but eventually put the project away.

Eggleston revisited the idea when the open call for shorts came out, and his new version—which featured a more anonymous, cartoony blue bird instead of the original flamingo—immediately caught Lasseter's imagination. The project went through the same creative process as a feature, receiving input not only from Lasseter but from many of the usual suspects in feature development: Joe Ranft, Andrew Stanton, and Jeff Pidgeon, as well as senior story artists like Rob Gibbs. Most of the focus was on tightening the story and action so that it moved at the appropriately zippy pace.

"While I loved the process of designing and planning the film," said Eggleston, "I think I loved the actual production of it

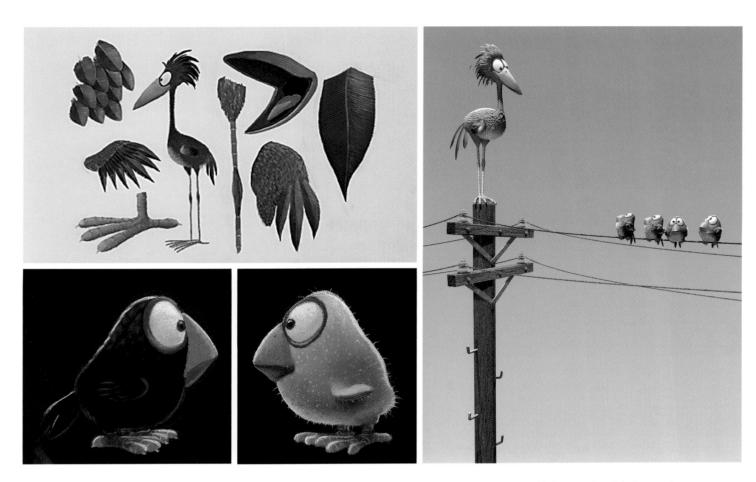

Above, clockwise from top left: Tall bird ("Leo") details, gouache; rendered film image; small bird ("Norm") without feathers, pastel; small bird ("Norm") with feathers, pastel. Concept art by Ralph Eggleston.

even more. It wasn't a film that really went far out of its way to explore the technology; it was just a funny little cartoon, but it was great to work with the amazing Bill Wise, our supervising TD, who carried everything through beautifully."

"For the Birds" was not the technical research lab that "Geri's Game" had been, but it did provide its crew with the opportunity to work on two smaller problems: simulation of feathers (a precursor problem to Sulley's fur simulation) and volume intersection. Since two objects could not "recognize" each other in the computer, the technical crew applied "contact pads" to the birds' sides, so that they could realistically squish up against each other instead of intersecting with one another like ghosts.

Eggleston and his friend Jory Prum recorded the sound effects at Prum's San Rafael studio, using toys from Jeff Pidgeon's collection to create the voices for the little birds. Though Eggleston said he must have boarded ten different endings for the short—"I boarded the thing to death; every little thing was thought through"—one would never guess it from watching the film itself: a graceful, effortless confection with a jaunty Riders in the Sky soundtrack.

"For the Birds" was released in theaters with *Monsters, Inc.*— a pairing that matched the last project completed at Pixar's old home in Point Richmond with its first completed at its new home in Emeryville.

"You never know how an audience will react to your work," said Eggleston, "so it was a really big high to see and hear audiences getting our little film. The scene where the little birds start making fun of the big bird always gets a laugh. But what makes me really happy is that the moment afterward, where the little birds go across the wire and start whispering to each other about the big bird, always gets an even bigger laugh, the biggest in the film. It's a relatively subtle moment, so the fact that everybody responds to it like that is just amazing. Jim Murphy and his team did a fantastic job directing the animation."

"I love being around Ralph because he has such a terrific spirit to him," said Lasseter. "'For the Birds' made me laugh from the moment Ralph pitched it—and makes me laugh to this day— because it really captures his cleverness and energy."

Chapter 11

Finding Nemo

"I think one of Pixar's strengths is that it has a director-driven aesthetic, meaning whoever's got the big dream can, to a certain extent, customize the approach to making a film. Each story has its own demands, and what works great for Toy Story *may not work for* Nemo.*"*
—BRAD BIRD

If *Monsters, Inc.* had been Pixar's opportunity to prove it could be successful under a new director, its next project, *Finding Nemo*, was the occasion for it to explore more fully what it might mean to adapt its filmmaking process to a director's particular talents and inclinations.

"It's natural in any organization to say okay, we've done this enough, let's come up with a template," said Ed Catmull. "And it is reasonable to have a template, but you want it to be a starting point, not an instruction manual that you follow to the letter. So it's good for each production crew to come up with different methods that acknowledge the uniqueness of the individuals working on the project."

Andrew Stanton, *Nemo*'s director, had co-directed *A Bug's Life* and had either written or been a major part of writing the screenplays for all four of Pixar's previous films. Stanton was known within the studio not only for his laser focus and meticulous preparation but for his tendency to shake up story sessions with big "what ifs"—unexpected and sweeping suggestions that turned existing ideas on their ears. So it wasn't surprising that Stanton approached his directorial debut with his own set of ideas on how to tackle the gigantic task of making a movie.

Acting on Paper

Lasseter and Docter had grown up channeling their imaginations through the things they created—drawings, puppets, flipbooks. Stanton grew up expressing his imagination through performance. "I was just your typical nerdy, hyper, spastic kid," he said. "Loved comics, loved Warner Bros. cartoons, and just was always running around, imagining things and pretending. My brothers were five years younger, so I was always volunteering them against their will to do whatever I needed to do, be my audience, be the guy who was going to get shot or whatever."

Though he had always had the reputation of being "the kid who could draw," the dominant interest of Stanton's youth was actually the performing arts. Theater, Super 8 video productions, radio plays, even music—"I just ate it all up. I could not get enough of it," he said.

But as he approached high school graduation, and saw older friends struggle to make it as professional actors, he decided to switch his career aspirations to a field to which he was less emotionally attached. "My logic—I remember it very clearly—was that: I enjoy acting so much that I never want it to let me down, so I won't pursue it as a profession. That way I'll always like it, it'll always be special, it'll never take on a bad connotation. But drawing— I could do that for money!"

This dispassionate attitude toward a career in art lasted about as long as it took for Stanton to peruse the guidance counselor's collection of art school catalogs. In a sea of near-identical brochures and binders, the neon orange CalArts catalog stuck out like a sore thumb. "That was the minute I found out there was a school where you could be taught how to animate, which before then I had thought was an antiquated profession that nobody did anymore, like cobbling. When I found out there was a place you could go to learn this, and that it was founded by Walt Disney, I was like, 'Where do I sign?' And then I was a dog with a bone."

Stanton went on to enroll at CalArts, and as he got deeper into his studies, he realized not only that there was more to animation than he had anticipated, but that in a way, he hadn't left acting at all. "My big epiphany, once I got to start making a short film," he said, "was that all the things I loved were wrapped up in animation. Filmmaking, music, rhythm, acting, posing, drawing, all this stuff—I didn't have to give any of it up to do it. And I suddenly went, 'Aha!' It was a huge 'Aha!'"

"When I was at CalArts, Bob McCrea and Hal Ambro would do monthly walk-throughs of everybody's cubicle areas, and look at everyone's work. In my second year I had the storyboards for my film up there, and they sort of chuckled and said, 'You'd make a good story man,' and they walked out. And damned if that didn't come true, but I don't think I neces-

Top: Sharks. Simón Vladimir Varela, charcoal.

sarily wanted it to be. I wanted to be as good as everybody else was at the really sexy stuff, which was animation, the stuff that everybody was oohing and ahhing about."
—ANDREW STANTON

Though Stanton resisted the idea of being a story artist while at school, his experiences after joining Pixar in 1990 helped change his mind. The thrill of being "in the room"— first for *Tin Toy Christmas*, and then for the early stages of *Toy Story*—had hooked him on the idea of helping to create a story, of participating in the decisions of what would happen to the characters. That work connected with the same storytelling impulse that had so informed his childhood. So when *Toy Story* got the green light from Disney and it came time to choose roles on the film—"it was almost like playing house," he recalled—he signed up for story.

Stanton had never been a board artist for a director before, but that, he said was part of the production's unique energy—the feeling that you could go out and make your own opportunities. "I was so excited to get a chance to make a movie when we did *Toy Story*, and that I was in the right place at the right time, just at the start, that John was going to let Pete and me be part of the think tank. And I knew that at any minute, somebody better than me could come along and get hired. So I just killed myself trying to be as good at everything as I could, trying to make myself indispensable so I could stay in that inner circle and see how a movie was made."

Stanton had been so inspired by Joss Whedon's script work on *Toy Story* that when the crew found itself in need of someone to write more pages, he decided to make himself into that someone. "Andrew really trained himself in an amazing way," remembered Docter. "He got really into it and just started doing all this work. Reading everything he could get his hands on about screenwriting and structure and formatting, everything. Every week he was reading these books, he was listening to directors' commentary, he was just constantly honing the craft and learning and absorbing as much as he could. And he really became the writer of the studio. That was pretty cool to watch."

Top: The drop off. Simón Vladimir Varela, charcoal.

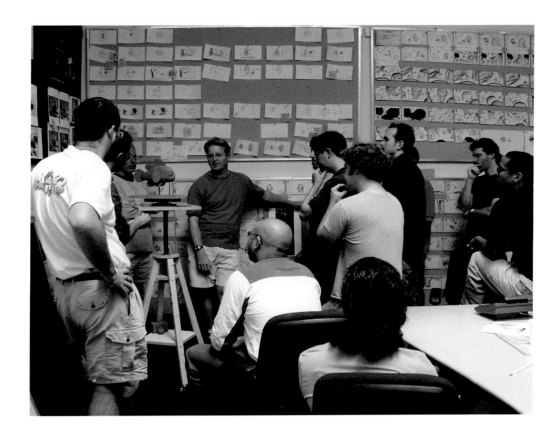

Stanton had originally jumped in to fill a hole while the production looked for a new screenwriter (Whedon had moved on to develop the *Buffy the Vampire Slayer* TV series), but as time went on, it became clear that hiring an outside writer would be unnecessary. Stanton's single-minded focus and drive—the same qualities he'd brought to shaping himself into a screenwriter—made him an exceptional story architect, capable of systematically breaking down a story to figure out what parts were achieving their dramatic goals, what parts were slowing down or thwarting the forward motion of the whole, and what had to be done to get everything working in harmony. "Andrew talks about it as seeing what he wants and figuring out what he needs to do to get there," said Docter. "'I'm gonna need to learn how to mountain-climb, and rappel, and ford a river, and....'"

"Andrew is probably one of the greatest story minds I've ever known," said Lasseter. "The guy is so organized and so intelligent, and the depth of his storytelling is just remarkable." Once *Toy Story* was well in hand, Stanton was a natural choice to lead the advance party on *A Bug's Life*, and then to co-direct the film with Lasseter. The experience, Stanton said, was absolutely essential. "I think if I had directed any sooner than those two features, I would've failed miserably. I think it took those two pictures for me to feel like I had enough confidence and know-how to possibly do it on my own."

The experiences had taught Stanton a crucial lesson about the need to have the emotional core of a story firmly in hand before beginning to write. On *Toy Story*, Woody's visceral fear of being replaced by a newer toy had always been there to power the film through the inevitable rough patches of story development. By contrast, *A Bug's Life* had been set in motion on the strength of little more than an interesting concept. The team had to come up with the film's emotional engine along the way, which made the story process especially long and painful. So when the film wrapped and Stanton began work on his own film, he knew he had to base it on something he felt strongly about, something that would serve as a compass when things got tough.

Top: Director Andrew Stanton (in green shirt) leads a Finding Nemo *art review meeting.*
Above: Darla. Teddy Newton, marker.
Opposite page, top: Marlin and Nemo. Ralph Eggleston, pastel.
Opposite page, middle: Eggs. Ralph Eggleston, pastel.
Opposite page, bottom: Marlin and Nemo. Ralph Eggleston, pastel.

Above and opposite page: "Initiation"
sequence pastels. Ralph Eggleston.

Finding *Nemo*

Stanton first had the idea of doing an underwater story in 1992, when work was just beginning on *Toy Story*. "I was at Marine World, and they had this shark exhibit where you walk through a glass tunnel and the sharks swim over you. I remember thinking then, 'We could make this world. CG would be perfect for this world. You could capture it so well.'" After coming up with the additional idea of a fish trying to escape a tank, he started looking for the emotional root of the story. "I loved the world, and I loved the possible plotting of it, but I didn't have an idea that I cared about that strongly yet. So I knew I didn't quite have enough yet, but I could tell I was close."

The missing pieces didn't fall into place until almost five years later, after *A Bug's Life* wrapped. "My son was about five and a half," Stanton said, "and I had been so busy on *A Bug's Life*, I just felt like I hadn't seen him at all. One weekend I finally had an afternoon free, and I said, 'Let's go take a walk to the park.' But I spent so much time making sure he didn't wander into the street or hurt himself that I just ruined it. I spent the whole walk just going: stay by the curb, don't touch, that's too sharp. Or, that's dirty, put that down. I remember just watching myself do this, and saying to myself, you're completely missing the point of this walk. That ultimately led me to the premise that fear can deny even a good father from being one.

"Then I started to think about, wow, I don't think I've ever seen an animated film that takes a parent-child relationship and tells it from the parent's point of view. Can you do that in a way that will allow kids to relate to it? That kind of made the whole story start to slowly come together. From a brain-stewing standpoint, it took years to develop, but then once I had all the pieces, it was about maybe a year and a half of writing till we got into production."

> *"I wanted something more emotional and dramatic that could carry the film and didn't have to rely on gags and social commentary to make it entertaining. I just felt animation had never gone for that brass ring of sincere drama and depth, just gone straight for it. I wanted to make it so that by the end of the movie, every male in the audience would have no choice but to cry."* —ANDREW STANTON

Top left: "Near miss" sequence pastel.
Ralph Eggleston.
Top right: "Pelicans" sequence pastel.
Ralph Eggleston.
Above: Seagulls. Andrew Stanton, marker.

Lasseter vividly remembers hearing Stanton's pitch. It was a brilliant, intricate story with every detail worked out. Stanton had used natural truths to inform the development of the story world and its characters—Marlin, the fearful and overprotective father, became a clownfish, taking refuge from the dangers of the outside world in the stinging tendrils of an anemone. But Stanton had also tweaked rules to good effect, inventing sharks that aspired

to vegetarianism, and basing the forgetfulness of Dory, the optimistic blue tang, on the evocative (if unscientific) conceit that goldfish have memories of only about three seconds.

When he finished, Lasseter said, "You had me at the word 'fish.'" Lasseter, a longtime scuba diver, was excited by the thought of doing an underwater story. "I thought, man, this is absolutely perfect for our medium. I knew it would be just fantastic."

After the stressful experience of remaking *Toy Story 2*, the studio had resolved to avoid such problems in the future by locking in the story before beginning production. Stanton had helped shape all of Pixar's previous scripts, so with him at the helm and a universally approved script in hand, it looked like smooth sailing.

"It was a wonderful story," said Catmull. "It all fit. It flowed from the first time. We knew it worked before we were going to make it. But it didn't make a bit of difference. We made just as many changes. When you actually get it down and start to put it all out there, you still find things that aren't working."

"It proved to us that creating original stories for these films is just really hard no matter what," said Lasseter. "It helps tremendously to have someone like Andrew who can navigate through the storytelling as well as he does; he's so gifted that way."

The first version of the script had been a much darker and more complicated story. It used a series of flashbacks to tell the backstory of Nemo's parents over the course of the movie, and it set up Gill as a more conflicted character. But as the reels developed, the story was simplified to focus more heavily on Nemo's arc of gaining the courage to attempt escape, and the Tank Gang evolved into a more straightforwardly comic part of the story. Stanton ended up going with a "brain trust" suggestion to eliminate the flashbacks and tell Marlin's story up front, making it easier for the audience to understand and empathize with the character's anxious personality.

Becoming a Director

Stanton, despite all his experience at the studio, found the filmmaking experience to be quite different as a director.

"When I look back, co-directing, being 'number two,' is a nice position," he said. "You get the best of both worlds. You get to be in all the massive creative decisions that make a big influence on the film, but you don't have to go to all the meetings and be the point man

Top left: "Pelicans" sequence pastel.
Ralph Eggleston.
Top right: "Pelicans" sequence pastel.
Ralph Eggleston.
Above: Seagulls. Andrew Stanton, marker.

Above: Concept pastel (top) and early colorscripts.
Ralph Eggleston, pastel.
Opposite page: Miscellaneous fish detail. Chris
Bernardi, Bert Berry, Jamie Frye, Yvonne Herbst,
Laura Phillips, Belinda Van Valkenburg, digital.

MiscChloe.4.tif · MiscChloe.5.tif · MiscCooter.1.tif · MiscCooter.3.tif · MiscDaisyDuke.1.tif · MiscDaisyDuke.2.tif · MiscDaisyDuke.3.tif

Graham.3.tif · Graham.4.tif · Graham.5.tif · MiscBernadette.1.tif · MiscBernadette.2.tif · MiscBernadette.3.tif · MiscBernadette.4.tif

MiscBernadette.7.tif · MiscBoDuke.1.tif · MiscBoDuke.2.tif · MiscBoDuke.3.tif · MiscBoDuke.4.tif · MiscBoDuke.5.tif · MiscChloe.1.tif

MiscDaisyDuke.6.tif · MiscDaisyDukeKid.2.tif · MiscGilligan.1.tif · MiscGilligan.3.tif · MiscGilligan.5.tif · MiscGilligan.6.tif · MiscGilligan.7.tif

MiscGinger.3.tif · MiscGinger.4.tif · MiscGinger.5.tif · MiscGinger.6.tif · MiscGingerKid_01.tif · MiscHutch.1.tif · MiscHutch.3.tif

MiscJosh.1.tif · MiscJosh.2.tif · MiscJosh.4.tif · MiscJosh.5.tif · MiscJoshKid.2.tif · MiscLukeDuke.0.tif · MiscLukeDuke.3.tif

MiscLukeDuke.7.tif · MiscMaryAnn.1.tif · MiscMaryAnn.2.tif · MiscMaryAnn.3.tif · MiscMaryAnn.5.tif · MiscMaryAnn.6.tif · MiscMrHowell.10.tif

MiscPheobe.1.tif · MiscPheobe.2.tif · MiscProfessor.5.tif · MiscProfessor.7.tif · MiscScooby.3.tif · MiscScooby.4.tif · MiscSkipper.5.tif

MiscStarski.2.tif · MiscStarski.3.tif · MiscUncleJesse.11.tif · MiscUncleJesse.13.tif · MiscUncleJesse.18.tif · MiscUncleJesse.19.tif · MiscUncleJesse.9.tif

*Upper top, left and right: "Haiku" sequence
pastels. Ralph Eggleston.
Lower top, left: "Sharks" sequence pastel.
Ralph Eggleston.
Lower top, right: "Jellyfish" sequence pastel.
Ralph Eggleston.
Above: Andrew Stanton's director approval
stamp.*

on everything. You can still slip in as one of the guys in the trenches and really get the
scoop on what's going on, but you can also pull the authority card when you need to. So
what I wasn't prepared for was that when you're actually helming it yourself, you can't hide
in the shadows anymore. You are out there, and you are the bull's-eye for every good or
bad thing that goes on."

In Stanton's work as a writer, long-range planning and problem-solving had frequently
been a solo effort. He had shaped himself into a screenwriter by reading countless books
in his off-hours and cranking out pages on his own. On *A Bug's Life*, he had written an
entire alternate screenplay on the side, just to make sure a new idea worked, before he
presented the idea to Lasseter and the rest of the crew. And he had written the script for
Nemo in solitude, waiting until he had a finished draft before he pitched it to Lasseter.
But being the studio's first writer/director meant that Stanton was a one-stop shop for
the film's vision and execution. He was still getting regular feedback from the "brain
trust," but as *Nemo* progressed, he realized that he missed the energy and added perspective
of collaborating with others on a daily basis.

"When I was in theater," Stanton said, "I think I loved the rehearsals more than I did the
plays. I was never the class clown—I was the guy that sat next to the class clown and knew
how to instigate it and advance it, maybe improve upon it, which should've told me right
then I was director material. Being an island doesn't work nearly as well for me. I'm twice
as funny, I'm twice as smart, I'm twice as whatever when I'm around other people that
challenge me. So I brought on Bob Peterson to help me write when I was at a real tough
point writing on *Nemo,* and then, once I got into production, I brought on Lee Unkrich
as co-director, and then it was just, night and day, you know.

"When you're 'number two,' you can get a good dose of honesty about how people think
the film's going. When you're 'number one,' they're gonna tell you it's going well no matter
what. So that made me really, really see the value of what I had done for John in the other

movies—of being that guy that could just say, you know, I know you're feeling vulnerable, and I know you think everybody thinks the movie sucks, but they don't. Or, I know everybody's telling you that it's great, but it's not. It's not such a lonely position when you've got confidants like that, and you make much better and faster decisions, because you've got that person you really trust to bounce ideas off of."

"I came to *Nemo* when Andrew needed a 'creative friend,'" said Bob Peterson, "someone he could trust enough to complain to, to brainstorm with, even to fight with from time to time. I was there to chum the waters with new ideas. It is so easy to get lost in the crazy millions of decisions a director has to make. Fresh horses on a project bring a new eye and a new perspective, and Andrew really encouraged me to explore any creative tributary I wanted. Mostly we laughed a lot, and found the funny in the characters—things like Crush the sea turtle, or Dory speaking whale."

As for Unkrich, he had been waiting for Stanton's call. "I had loved Andrew's script from the very beginning," he said. "From the moment he pitched it I knew it was going to be a very special movie, and I really wanted to be a part of it."

> *"It was really great to see Pete and Andrew, who I had worked with for years and years, coming into their own and stepping up to bat. They both had their good days and bad days on their movies, but they were learning because they had to. They were flying by the seats of their pants, but using the skills that they had honed for years." —LEE UNKRICH*

As Unkrich settled in as co-director on *Nemo*, he was particularly impressed by how quickly Stanton had schooled himself in the disciplines of his new job. "When we were making *A Bug's Life* and Andrew was co-directing," he said, "I remember there were a lot of things that he just didn't seem to be interested in, like the camerawork and the editing. There were a lot of times when he'd just zone out, and he'd finally say, 'I'm out of here, I've got some things to work on.' He'd disappear, and I'd just work with John. But when

Top left: Gill. Ralph Eggleston, pastel.
Top right: "Jellyfish" sequence pastel.
Ralph Eggleston.

he started making *Nemo*, he was a sponge. He met with anyone and everyone, and he just absorbed information. I was impressed that he stepped up to the plate so fully, committed so fully. But I wasn't surprised, because that's Andrew. Andrew never does anything halfway. There's no grass growing under his feet."

Inventing an Ocean

> *"Andrew hates waste. He hates wasting time, he hates wasting dialogue, he hates wasting frames. It's not impatience—it's just that inefficiency offends him on principle. When he's watching a movie, if he sees a scene that goes on too long, it kills him. He'll be like, 'If that had been two frames shorter, it would've worked brilliantly.'"* —RALPH EGGLESTON

Stanton's supervising technical director, Oren Jacob, and producer, Graham Walters, were well matched to his personality. Like Stanton himself, both were seasoned Pixar veterans assuming lead roles for the first time on the film— Jacob after serving as the associate supervising TD on *Toy Story 2*, and Walters after production managing the same film. All three were energized by the prospect of figuring out their own solutions to the challenges the project posed.

Technically speaking, the story was expensive, both quantitatively, with its many locations and characters, and qualitatively, since the watery setting would require almost every shot to include some sort of simulation.

"The animation system we were getting from *Monsters* was a pretty cool one that could do clothing and hair, but it really didn't have any water in it," said Jacob. "Clearly we were going to have to develop some things. So we broke the water problem into its smaller parts—particulate matter, surge and swell, the surface of the water, the caustic lighting effects on the floor, murk, and the fog beams through the water itself—and figured out how to create and control all of those components. At that point, we thought that we might have a toolkit that could make the film. But after we identically replicated four reference clips of actual ocean footage, we knew we were ready to go." And since all these effects made for extremely long render times, Jacob set up a "speed team" devoted exclusively to figuring out how to make each frame easier and "lighter" to render.

> *"We had been working for a long time on an anemone you controlled by hand, but it looked kind of dumb. Then one day the dynamics guys walked in and said, 'Hey, why don't you take this hairy tennis ball, turn gravity upside down, wiggle it back and forth, and you can make an anemone!' I was like, 'Holy crap, that's the coolest thing I've ever seen.'"* —OREN JACOB

What turned out to be the real killer was, as Stanton put it, "perfecting the recipe" for the realistic-but-caricatured look of being underwater. As with *A Bug's Life*, the art team had been careful not to hew too closely to reality when designing *Nemo*'s underwater world. Production designer Ralph Eggleston and director of photography Sharon Calahan wanted to give the simplified shapes of their stylized environment the soft-edged look of classic Technicolor films. So once the creative team knew they were capable of sufficient complexity to mimic reality, the next step was figuring out how exactly to tweak what elements in order to achieve the look they were aiming for.

"It was really tough to dial all the different ingredients just right," Stanton said. "It was like trying to invent a recipe from scratch. You have all the right ingredients, but you have no cookbook to guide you through."

Opposite page, top: Bruce, Dory, and Marlin. Rendered film image.
Opposite page, bottom: Dory, Marlin, and jellyfish. Rendered film image.

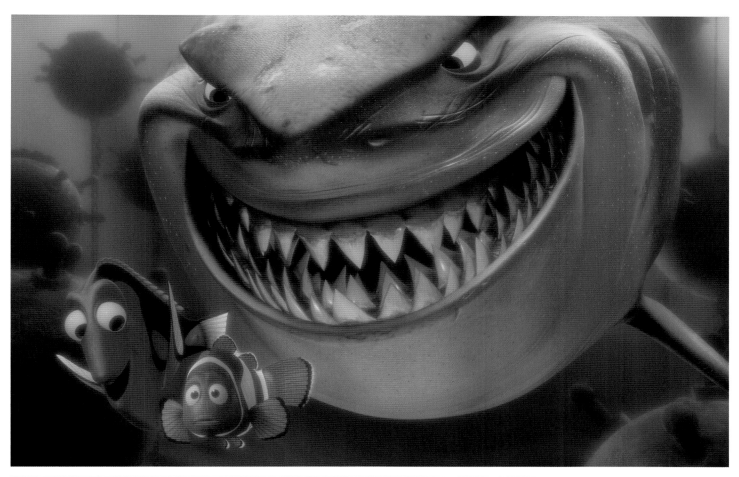

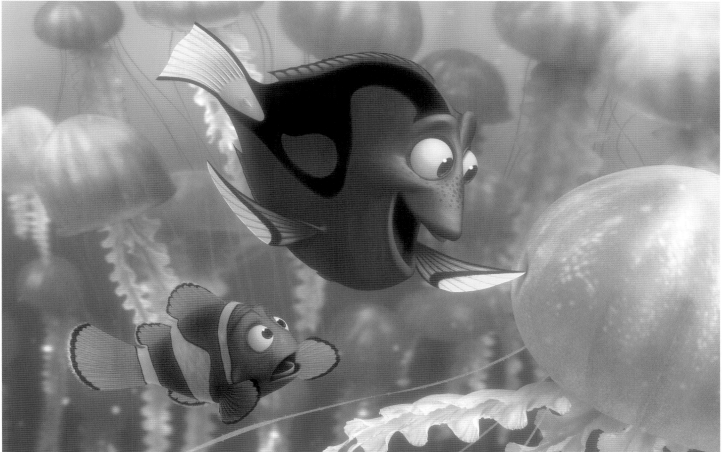

Ultimately, they hit it right on the nose. "I would check in every week, and I would see shots being finished, or even while they were working on it," said Lasseter. "And every week I was so blown away. It was just gorgeous."

"What was cool about *Nemo* was that we could be more restrained and more subtle with the camera work and with the acting, because the world was so rich," said Unkrich. "Even just a plain old shot of the ocean is an amazing thing to look at, with the water rippling on the surface and the light beams streaking down, the particulate matter floating around. There's this multitude of visual elements that make every single shot in the film really, really rich without us having to do anything showy on top of it."

"It was a tough thing to pull off, but they really knocked it out of the ballpark. Nemo *is an astonishing-looking film."* —ED CATMULL

Pixar's films had customarily been released just before the Thanksgiving holiday, but since *Finding Nemo*'s dazzling and colorful world seemed better suited to the summer movie-going season, Pixar and Disney agreed early on to move the film from November 2002 to May 2003. The *Nemo* team was excited to be the first Pixar project given the prime summer slot, but since the shift extended the production by six months without increasing its budget, it also posed a substantial logistical challenge.

As Sarah McArthur, Pixar's head of production at the time, described it, Walters saw the challenge as an opportunity. "Graham said, 'Okay, Andrew works differently anyway, so let's take a look at how Andrew wants to work and let's think of a new way to structure our production pipeline so that we can actually get some man-weeks [the unit of measurement for Pixar's production budgets] out of it and have it be a less-expensive film. They ended up designing a new pipeline tailored to Andrew's working style that helped keep them on budget. They really rose to the occasion with flying colors."

Traditionally, Pixar reviewed film elements independently of one another—for instance, a bare room would be submitted for directorial approval one day, and its furnishings reviewed one at a time in subsequent days. This practice had arisen out of necessity in the company's early days when "compute time" was expensive, and it was cheaper to show the parts separately. But Stanton found that he worked best when he could look at things fitted together, in their film context.

Thus, the new production was roughly arranged by location—Reef, Tank, Ocean, Sharks/Sydney, Schooling/Flocking, and Character—instead of by department. This allowed Stanton to review material in context and helped the crew focus on how their work affected the end result in the film, not on the task as an end in itself. As Walters described it, "We put these interdisciplinary teams together and gave them big chunks of the movie to work on. That removed some of the bottlenecks from the standard pipeline and had the effect of squeezing an awful lot of inefficiency out of the system. It was a little stressful, because, as we learned, some of those inefficiencies were beneficial, but ultimately it got really high-quality work up on the screen. Those savings paid for a lot of extra characters that we never planned for, and for the movie being eighteen minutes longer than we originally planned it to be, and other stuff like that."

Stanton acknowledged, "Without meaning to, I sort of made this epic journey that takes you all over the ocean, and that meant every set piece had to be different and unique. I mean, it pays off. That's one of the nice things about watching the movie. But man, you know, I think if I'd known that's what I was gonna be signing up for, and everybody else, I don't think anybody would have done it."

Above: Darla. Teddy Newton, marker.
Opposite page, top: "Sharks" sequence pastel.
Ralph Eggleston.
Opposite page, bottom: "First day" sequence
pastel. Ralph Eggleston.

Above: Marlin and Nemo. Rendered film image.

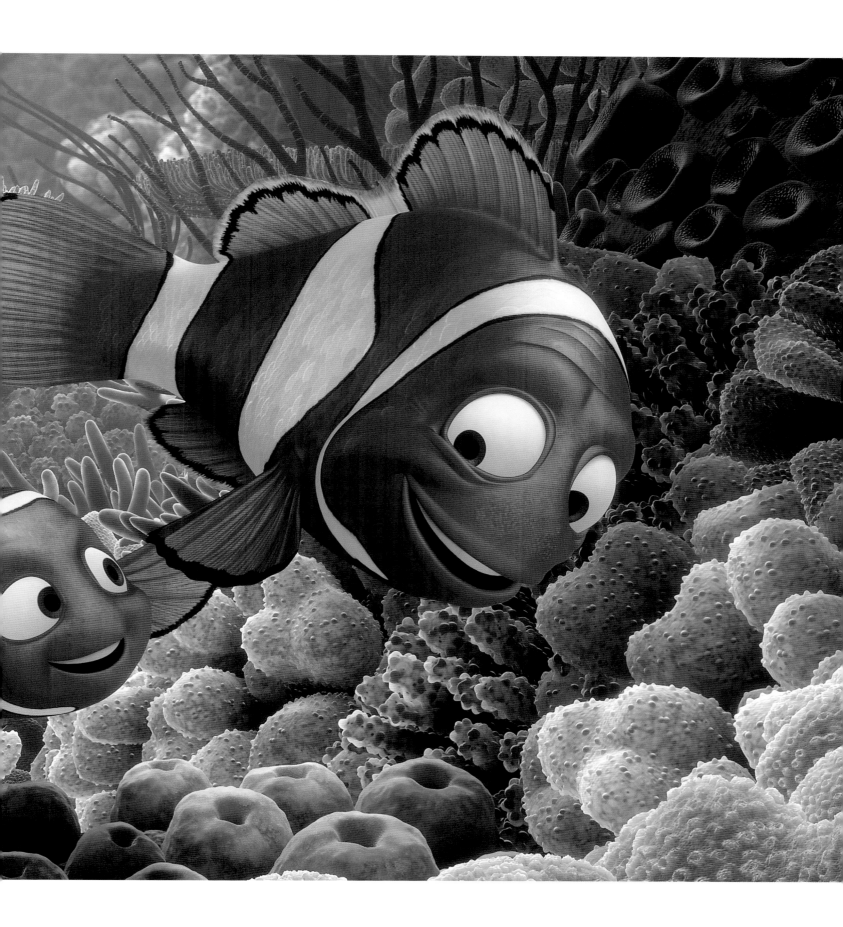

"It's the thing we've come to laugh about," said Walters. "Every director starts off saying, 'This is a sweet little movie with a couple of characters, and I don't want it to be a big deal.' Then the next thing you know we're traveling the ocean and meeting a whole new cast of characters in every scene."

Beta Testing the Studio

"The insurance, the upside when you go with somebody new as a director is that you're going to get something different and unique," said Stanton. "But the flipside is that it's an unknown quantity. I think we're learning with every director."

Stanton compared the process of bringing in different directors—and allowing them to experiment with production methods—to beta testing software: bringing in people to test a newly developed program by using it in different ways.

"I feel like in a weird way we're beta testing Pixar the studio," he said. "The studio definitely works, but as we add every director, we're finding out what it is that makes Pixar work under these new and different circumstances. So with each director you find out what you need to do differently to capitalize on him or her. It's a gamble; I think we all understand the risk every time we put another director into the driver's seat, but it's worth the risk. It's worth finding out because you're only going to hone and sharpen the studio that makes these pictures. You're only going to come out a leaner, meaner studio."

Top: The reef. Rendered film image.

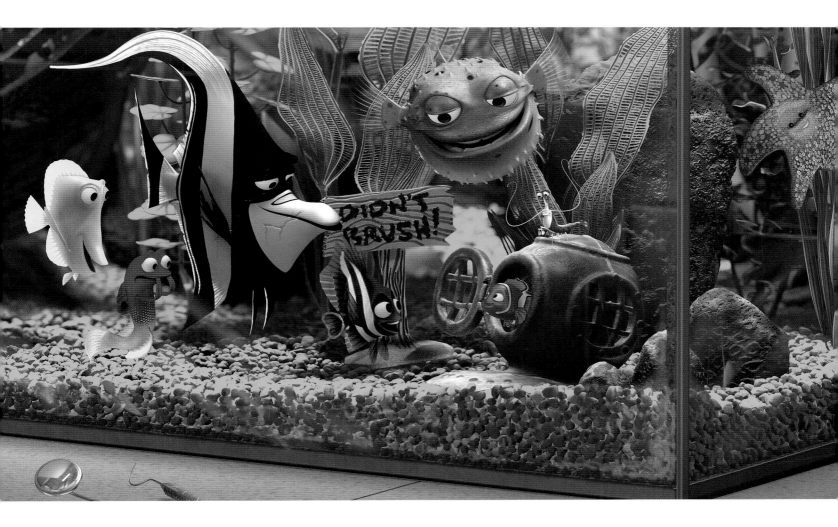

For Catmull, such variation is actually essential to Pixar's long-term health, not just benefi-
cial. "My view is that we have a theory about how we should do things, and at any given
point 70 percent of this theory is correct and 30 percent is way off the mark," he said. "But
starting off, we don't know which is which. So we have to keep evaluating what we're doing,
and doing things in different ways so we can avoid falling into the trap of complacency."

Institutional questions aside, *Finding Nemo* also answered a much more personal ques-
tion for Stanton. "Every time I look at *Toy Story*," he said, "I see how strongly it shows
the stamp of John's personality, but there are also these little moments where I go, that's
Lee, that's Pete, that's Joe, that's me. I knew Pixar was this thing that came together with
all of us. The great chemistry was that we knew how to be a group that forwarded John's
vision. And so I was always fascinated by the idea of, well, what would happen if you just
shifted and said okay, the same group of people, we're all going to focus on and support
Pete, or me, or Lee? In my mind, *Nemo*'s very cohesive with the other films because it
was born from the same group. But it's a real big billboard of, 'This is what you get when
I drive.' It was a great ride."

Top: Nemo and the Tank Gang. Rendered film image.

 / Spotlight

RenderMan

To most of the general public, Pixar is known only as an animation company. But within the computer graphics industry, Pixar retains a dual identity. Here, the company makes announcements not only with the release of each new film but with the release of each new version of RenderMan, Pixar's rendering software. The term "RenderMan" actually refers to two different things: the renderer itself (also known as "PRMan," short for "Photorealistic RenderMan") and the interface that digital artists use to feed information to the renderer.

A renderer is a piece of software that takes the hundreds, even thousands, of individual instructions that tell the computer what is going on in a given picture—what the digital models look like, how they are shaded, how they are lit, and how they are positioned—and follows those instructions to generate the pixels that make up the final image. RenderMan has its roots in the REYES algorithm developed by Loren Carpenter, Ed Catmull, and Rob Cook at Lucasfilm in 1982. True to its name ("Renders Everything You Ever Saw"), REYES was used to render every project produced by the group until 1988, when an early version of the new RenderMan renderer was used in the making of "Tin Toy."

The RenderMan interface, designed in 1987 by Pat Hanrahan (now a computer science professor at Stanford and one of the leading academics in computer graphics), is a sort of "language" for talking about the problem of rendering—a way

for digital artists to break down the components of a scene into layers of instructions that are simple for the renderer to execute. As Ed Catmull described it, "Just like a car's user interface—the steering wheel, gear shift, accelerator, and brake—lets you use a car without having to know how the much more complicated engine inside works, the RenderMan interface lets you use the renderer without having to know the details of how it operates." Pixar was the first to create a comprehensive language for this task—indeed, the RenderMan Interface Specification is still the most sophisticated standard available to the public—and Hanrahan thought carefully about how best to design its "grammar" in a way that could handle increasingly complex tasks over time.

The first commercial version of RenderMan, PRMan 3.0, was released in 1989—part of Pixar's effort to make money by any means possible. In fact, at the time, it was the company's most promising line of business—the writing was on the wall for the hardware division, and there was, of course, no money in short animated films.

In the 1990s, under the leadership of Tony Apodaca, RenderMan underwent further development and refinement, making its first great strides in becoming a tool that could both handle a project of feature-film scale and offer the quality, artistic control, and technical reach that its filmmakers required. "We spent a lot

Above: A few of the films that have used Pixar's RenderMan software. Clockwise from top, Jurassic Park, Star Wars Episode I, The Abyss, *and* Terminator 2.

of time talking to our customers, and worked pretty hard to try to keep ahead of what they needed," said Apodaca. "Our goals were to make sure all the features in our public version were rock solid, to stay on the cutting edge, and to stay conceptually compatible with our past versions."

That attention to consistency paid off. Though some computer animation studios and effects houses continue to use their own proprietary renderers, RenderMan has become the renderer of choice in much of the CG world. A list of films using Render-Man software reads like a who's who of CG effects: *The Abyss, Terminator 2, Jurassic Park, Titanic, Star Wars 1-3, The Matrix,* the *Spider-Man* trilogy, the *Harry Potter* series, the *Lord of the Rings* trilogy, and the *Pirates of the Caribbean* trilogy, to name just a few. The software has been used for every film nominated for a Visual Effects Oscar between 1996 and 2007.

> *"RenderMan has been so valuable to the industry. One of the great things that came out of Pixar for us [at ILM] is that we had the early versions of it, and we could use it to make our renders look absolutely fabulous. Those guys would always be showing us stuff and asking what we needed, and it was great to be able to get in there and request what would help RenderMan work for movies. It's really what separated our work from everybody else's for so long, and it's become standard." —DENNIS MUREN*

Up until 2001, the wall between the studio and the Render-Man group was a porous one. All versions of RenderMan came in two flavors—the commercially available one, and the custom Pixar build, with extra features for internal studio use. Even the makeup of the group itself was customizable—RenderMan-designated engineers were on occasion impressed into filmmaking service when the studio needed all hands on deck. But in 2001, the decision was made to split the Render-Man group off into a self-contained unit, allowing it to behave as an independent software company-within-a-company, instead of a de facto studio tool.

"Movie production is a black hole," said Dana Batali, who has headed up the group since it went solo, "and in the heat of production it is natural to go for quicker, more hacky solutions to your problems. Being able to defend the needs of our software separate from the needs of our films let us take a more long-term point of view for the software. Developing an elegant solution takes a little extra pain up front, but sometimes those more elegant designs solve problems better."

By making the extra investment in RenderMan as a standalone product, Batali observed, Pixar actually ended up with a much better and more thoroughly tested piece of software than they would have as the sole user of a proprietary version. "In the end," he said, "we were sort of able to eat our cake and have it, too."

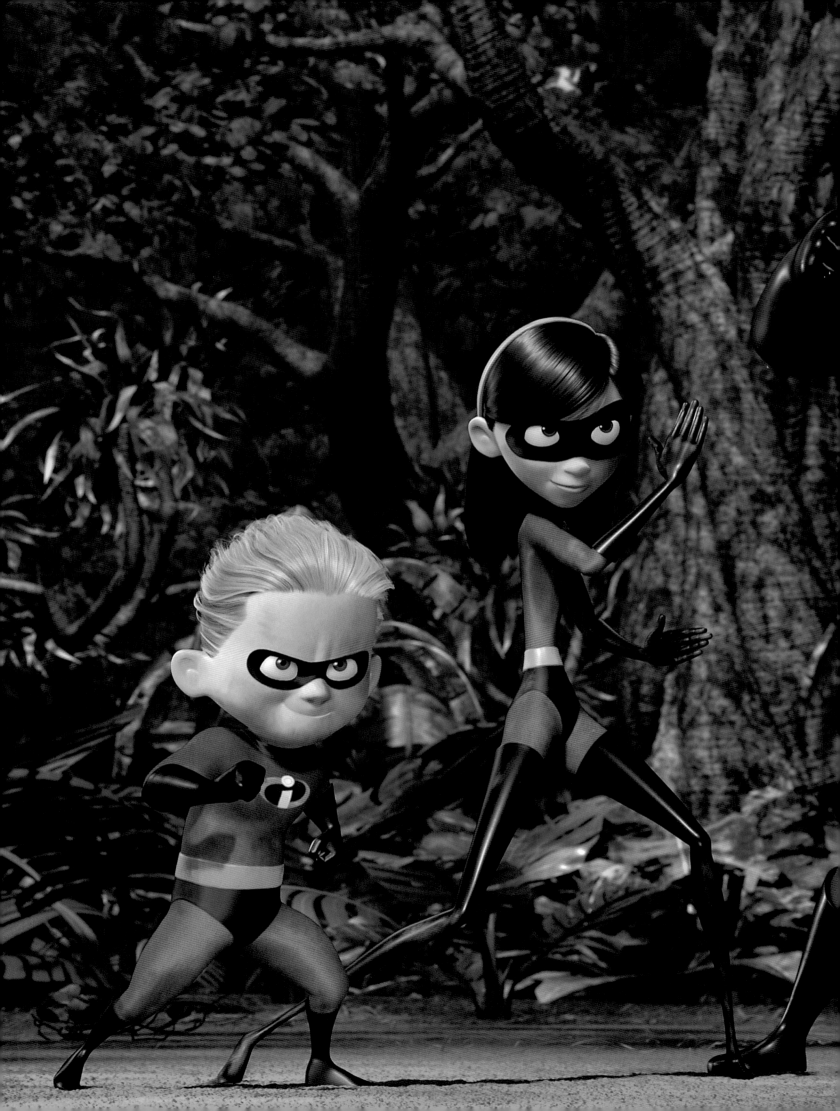

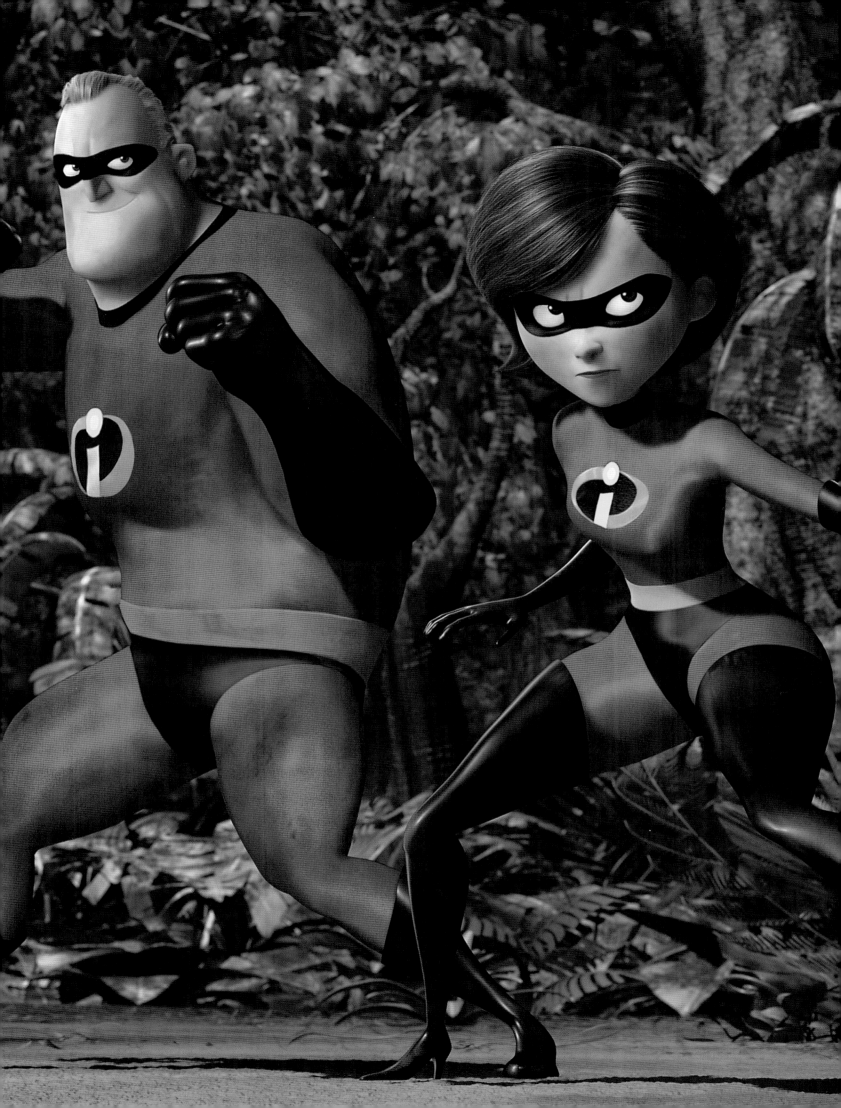

Chapter 12

The Incredibles

Monsters, Inc. was in its last year of production and *Finding Nemo* was just beginning full production when Brad Bird came to Pixar in May 2000 to make *The Incredibles*. Pixar had been courting Bird ever since *A Bug's Life*, from the moment they had first begun planning for multiple directors at the studio.

John Lasseter said, "I always kept an eye out for people who I thought were great visionaries in the medium. And absolutely the best person I could think of, the top of my list, was my old friend and classmate from CalArts, Brad Bird."

Both Tortoise and Hare

Bird did not emerge from the womb flipping pages, but he came pretty close; his first drawings, at the age of three, depicted sequential action. His parents, realizing that Corvallis, Oregon, was not the most fertile soil in which to develop an interest in filmmaking, did everything they could to encourage him.

"I had been out of town when the reissue of *Snow White* had passed through," he recalled, "which killed me because I'd been studying animation, and it was constantly referred to as a milestone. A couple of years later, when I found out it was playing at a theater near Portland, my mom drove me through the rain, two hours each way, so I could see it. It was playing in this dingy, microscopic little theater, but I was just enthralled." Later on, when he developed an interest in live action, a Christmas subscription to *American Cinematographer* became a monthly link to that distant world where people actually worked on films for a living. "My parents, God bless 'em, they just kept throwing logs on that fire," he remembered.

At the age of eleven, Bird began work on his magnum opus, "The Tortoise and the Hare," a fifteen-minute short film that he produced entirely by himself, finishing just before his fourteenth birthday. He entered it in a few contests and, heeding his parents' advice to "start at the top and work your way down," also sent a copy to the Walt Disney Studios. Impressed by Bird's talent and industriousness, the studio wrote back to the teenage filmmaker, inviting him to come by the studio whenever he wanted. For about a year, Bird traveled to Southern California at every opportunity, staying with family friends and visiting the studio daily for what amounted to an unofficial apprenticeship with his idol Milt Kahl.

Above: Mr. Incredible. Rendered character pose.
Opposite page, top: The Incredible family. Tony Fucile and Teddy Newton, ink and paint by Linda Lynch, cel vinyl.
Opposite page, bottom: Tiki Bar. Lou Romano, gouache.
Previous spread: The Incredibles. Rendered film image.

"Getting access to Disney at that time, getting to know Milt Kahl, Frank and Ollie, Marc Davis—for me, it was like being into acting and getting to study with Brando, or being into football and training with Joe Montana. I was completely freaking out, but I was trying to be cool about it on the outside. It was amazing. Unfortunately, while I was unbelievably impressed by all this, I couldn't talk about it with any of my friends, because they didn't know these guys from Adam." —BRAD BIRD

When he was fifteen, Bird started work on his second short, which was to be a much more ambitious (and full-color!) affair called "Ecology American Style." When Disney saw the first forty-five seconds, they liked it so much that they sent him an animation desk to use, along with supplies and a draft version of Don Graham's still unfinished book *Composing Pictures.* But after working on the film for a few more months, Bird said, "I suddenly realized I was missing out on my regular teenage life. I couldn't talk about anything but animation, which would only hold my friends' interest for about a minute and a half before they were ready to move on. And I knew that if I started another film, it would be another three or four years of not having any other experiences besides going to school and working on the film."

So Bird, with Disney's blessing, put away the short and threw himself into other activities—the school paper, football, photography, and drama. In fact, when it came time to go to college, Bird briefly found himself hesitating between CalArts, where Disney had offered him a scholarship to the animation program, and the acting program at Ashland, home of the famous Oregon Shakespearean festival.

"My mother said, 'If you go into acting, you're going to have to wait tables or have some other job to support yourself anyway,'" he remembered. "'So if you're going to be doing something else while you're going to auditions, shouldn't it be something you love?' And I thought, that makes sense. So I went to CalArts, and of course I fell right back into animation and remembered all the things I loved about it—with the added bonus of, for the first time in my life, being around other people my age who were into it, too."

Bird left CalArts early to work at Disney, but like many of his peers to follow, soon found himself suffocating in the bureaucratic atmosphere of the studio at the time. Bird already had a well-established reputation as an agitator for quality and, like Lasseter after him, was eventually fired—effectively for rocking the boat. Deciding that plush production values were no substitute for exciting work, Bird struck out for other shores. He made an auspicious debut as the writer/director of the "Family Dog" episode of Steven Spielberg's *Amazing Stories* in 1985, and he did some work in live-action screenwriting. Then he found a niche in television, becoming one of the key creative forces behind the first eight seasons of

Top: Edna Mode (a.k.a. "E"). Lou Romano, marker.

Opposite page: Colorscript. Lou Romano, digital.

Above: The Jumper. Teddy Newton, collage.

The Simpsons, as well as *King of the Hill*—the two longest-running animated shows on television. But he never gave up on feature film, continuing to develop and shop around projects on the side.

When *Toy Story* came out, Bird called up Lasseter to congratulate him: "I told him it was the best thing I'd seen since Walt died." Lasseter, for his part, was delighted to be back in touch with his old friend and eager to bring him to Pixar. But by the time the studio was able to make its first official overtures to Bird in 1997, he had already committed to making a feature for Warner Bros. Bird's 1999 film *The Iron Giant* was rapturously received by critics, but, unaccompanied by the typical studio promotional push, it faltered at the box office.

"*The Iron Giant* is, I think, one of the best animated films in probably the last twenty years," said Lasseter. "I just loved it. I was stunned that Warner Bros. didn't do more with it. But because of that, we were able to get Brad here."

Bird said, "One of the things that impressed me was that the top guys at Pixar invited me here to bring in new ways of doing things. That had never happened to me before. When I arrived, they had just had three huge hits in a row, and in the Hollywood I had just come from, any studio with three hits in a row wouldn't be open to changing *anything*. The typical Hollywood executive would just put more *Toy Story* and *Bug's Life* films into production. This place was the opposite. The attitude was, 'We're in danger of repeating ourselves or getting too satisfied.' I found it tremendously refreshing and amazing that they always needed to be reinventing themselves and looking down the road.

"Some of my friends in traditional animation thought I was going to Pixar to surf this new wave of technology, but I came to Pixar because I knew they'd protect and nurture the most important thing I had—my story. What I loved about *Toy Story* was that it was a new idea, with new characters, done in a new way. I love Bugs Bunny, but I don't want to do Bugs Bunny. He's already been done by the guys who invented him, and I can't top those guys. But I can sure as hell do the best *Incredibles* around."

Art Imitates Life

The Incredibles, about a family of superheroes living undercover as ordinary citizens, was a movie Bird had been wanting to make for years.

"I fell in love with it right away," said Lasseter. "I love the whole superhero genre, and I knew that in Brad's hands the movie would be amazing. But the thing I love about it the most is the story of this family. It's got so much heart to it."

Bird had been tinkering with the idea for well over a decade. But it wasn't until someone at Pixar asked him how he'd come up with the idea that Bird backtracked to think about where it had come from. Remembering that he'd named the baby in the story after his middle son, Jack, who had been a baby at the time, he asked himself what had been going on in his life then. "I realized I was kind of like Bob. I wanted to get a chance to do the thing I loved: make films. I had all these great projects stuck in various levels of development hell at different studios all over Hollywood, but the studios would never make them. An executive would get fired and his or her replacement wouldn't want something that their predecessor had approved, or my project would get axed because another project vaguely similar to the one I was developing would fail at the box office, or something mundane and frustrating like that. I felt like Bob working at Insuricare. At the same time

Above: Edna Mode (a.k.a. "E"). Teddy Newton, collage. Recalled John Lasseter, "It took a lot of convincing to get Brad to keep his voice in as E. He said, 'No, no, I just do scratch.' Finally I just had to go to him and say, 'Brad, I'm sorry—you're doing it.' It's one of the rare times I stepped in!"

I had a new family that was demanding more of my attention. I was conflicted, afraid that if I did what was necessary to get a chance to make a movie I'd be a lousy husband and father, and if I really focused on the needs of my family, I would never get a chance to make a movie. I wanted to succeed at both. I think that anxiety kind of crept into and fueled the story. Consciously, this was just a funny movie about superheroes. But I think that what was going on in my life definitely filtered into the movie."

"I would have been happy to start making features a lot earlier than I did, but since I had to wait, I think having kids probably helped me be a better director. It's very hard to make a good film without struggle because movies have so many aspects to them, and creative collaborators that all want to go in different directions. So there's a patience you learn in being a parent that comes in handy as a director." —BRAD BIRD

From Hand-Drawn to CG

"Brad is one of the greatest filmmakers working today in any medium. He has such a passion for filmmaking. He never settles for anything other than the best it could possibly be, and he instills that in everybody around him. And I tell you, once we brought Brad and his team to Pixar, we all were learning again. That's what I love about bringing these great people into Pixar—they make you better." —JOHN LASSETER

At Pixar's urging, Bird invited up a group of people he wanted as the nucleus of his new team. All were veterans of Bird's *Iron Giant* crew, and the influx of talent added a new sense of dynamism to the already-bustling studio.

"The infusion of energy from Brad and his whole group was fantastic," recalled Joe Ranft. "The vibe was like the early days of *Toy Story*. They were looking to make their mark,

Top: Mr. Incredible battling the Omnidroid. Rendered film image.
Above: Edna Mode (a.k.a. "E"). Rendered character pose.

thinking, 'Why do we have to do it the same way? Let's challenge this. Let's experiment.' They already had *Iron Giant* under their belt, so they came in really strong." Over the years Pixar had hired many people with primarily 2-D backgrounds, but everyone was curious to see what would happen when an entire creative team, grounded in hand-drawn animation, put their sensibilities and experience into making a CG movie.

For the crew greeting Bird, an unexpected but welcome piece of common ground turned out to be Bird's keen interest in live-action film. "Brad is an amazing animation director, but he's also very familiar with the process of live-action filmmaking," observed Rick Sayre, the film's supervising technical director. "And I think that translates very well, indirectly, to 3-D animation."

Computer animation allows one to use the tools of live-action filmmaking—experimenting with camera angles, using different camera lenses, playing with lighting and editing, being able to reiterate at relatively low cost—while gaining even finer control over performance. "I really appreciate the level of nuance that you can put into CG animation," said Bird. "In hand-drawn animation you get to a point where the activity of the line, the natural 'wobble' of a hand-drawn line, is greater than the movement you're depicting. But in CG you can do really infinitesimally tiny movements, like eye darts, and have them be clean and easy to read on the screen."

But getting used to the CG production process required Bird and his team to make a paradigm shift in the way they evaluated the progress of work. Ralph Eggleston, who had worked with Bird on "Family Dog," jumped onto the moving train of *The Incredibles* straight off of production on *Finding Nemo* to help get the show's gears turning as the team acclimated itself.

In hand-drawn animation, the work of a scene is divided into easily discernible layers. Because each layer in a given scene is usually handled by a single person, each layer makes serial progress. This makes it much easier to observe or visualize the overall progress of both individual scenes and the film as a whole. But in computer animation, work proceeds in a much more parallel fashion. The overall progress of a scene can't easily be observed along the way; it must be assembled in the mind's eye as individual components are reviewed and approved—usually separately and out of their proper context.

Top left: Bob at work. Lou Romano, marker and pencil.
Top right: Bob at work. Rendered film image.
Above: Gilbert Huph. Peter Sohn, marker and pen.

As Bird described it, "You have this wonderful, versatile, flexible machine, but in order to get it to the point where it can be wonderfully versatile, you have to dump so much information into it that it feels like you're working for years and you're not making one inch of

Dennis Lola Earl Edward Dawn Bob Gilbert Huph Lisa Harley Conway Cece Fred

progress. That's what it *feels* like. It's not the actual truth. What CG films feel like is that you are having meeting after meeting, answering thousands of questions every day and nothing is happening, people are just pretending to make a movie. Right about the time that you're ready to give up in despair that you're trapped in some *Waiting for Godot* world of film-making, suddenly the film seems to be coming out at hyperspeed. Shots are completed and coming out of nowhere faster than you can imagine, and you're going 'When did this happen?' Well, each shot had, say, 150 elements, but it only had 149 of them until last night at 12:03 A.M., when that last element got delivered and the whole thing was finally ready to render. Making a movie in hand-drawn animation is like accelerating in a car that doesn't have a lot of horsepower. You might end up going fast eventually, but you got there in a very gradual, nonjarring way. With CG, it's like moss is growing over you, and then suddenly you're being catapulted toward Mars."

Flooring the Rolls-Royce

After years of making do with limited resources in exchange for creative freedom, Bird had grown accustomed to, in his own words, "an underdog mentality." In his new environment, that feeling gradually dissolved—at the film's wrap party, Steve Jobs jokingly recounted the feeling of triumph the executive team felt the first time Bird talked about Pixar as "we" and not "you guys"—but it was not in Bird's nature to abandon that fighting spirit. As he put it, in coming to Pixar to make *The Incredibles*, he took a Rolls-Royce and used it to jump a canyon.

Bird said, "Even though this was a really well-designed, beautifully thought-out studio filled with talented people, and there was plenty of time and money, I was bringing in this project that was absolutely going to push them to the wall."

The Incredibles was far and away the biggest, most elaborate, and most complicated project the studio had ever taken on. Fifteen minutes longer than any Pixar film to date, it ultimately called for more than twice the usual number of sets and over 2,200 different shots—over 600 more than *A Bug's Life*, the studio's previous record-holder. Since the goal was to make the film with the same resources allotted to the standard ninety-minute Pixar film, some clever planning and budget-extending tricks would clearly be necessary to bring a film of this scale to the screen.

The first was a new approach to story reels. Over the years, Bird had begun to favor story-boards that were more cinematically specific than those done in the Disney style that was

Top: Insuricare Co-workers. Albert Lozano, marker and pencil.
Above: Gilbert Huph. Rendered character pose.

Above: Bob and Helen Parr. Rendered film image.

standard in the industry. This grew out of his innate interest in the nuts and bolts of the filmmaking process, and it was later reinforced by the tight schedules on *The Simpsons*. Since the TV show's animation was outsourced, if you wanted something unusual in the final product, it had to be in the boards. Faced with a tight budget and an even tighter schedule on *The Iron Giant*, Bird took the idea of working out the filmmaking in the boards (the cheapest part of the pipeline) a step farther, using Adobe After Effects to add motion and occasionally elaborate camera moves to the already precise storyboards.

This process, implemented in full on *The Incredibles*, produced extremely detailed, cinematically sophisticated reels that made it easy for the viewer to see how the final footage would play. "Their work in story and story reels was just phenomenal, so impressive and so inspiring," said Ranft. They also served a practical purpose. "Those very specific, live-action-style storyboards made all the difference in the world to the technical and production crews," said Sayre. "Because it meant there was an immediate level of communication. Even if what he was asking for seemed impossible, we knew *what* he was asking for."

The second major change involved rethinking Pixar's existing approach to sets. The studio's filmmaking modus operandi had been to build and furnish a complete virtual world, then film in it as if on location. This method, which prizes internal consistency, is perhaps not surprising for a movie studio that started as a software company. Though expensive, it allows complete flexibility in terms of cinematography—one of the great assets of the medium. But spreading their crew over the huge number of locations and effects called for by the script required Bird and his team to take a page from the 2-D manual, locking in their camera angles early on so that they could save money by building the sets only "to camera" and no farther.

As careful as their planning was, it ultimately proved impossible to make the film as envisioned with the standard pool of resources. At 100 minutes, *Finding Nemo* had been eight minutes longer than *Monsters, Inc.*, and it had only just squeaked by; *The Incredibles* was fifteen minutes longer than *Finding Nemo*.

Bird and his producer, John Walker, had agreed on two significant compromises in order to stay within their budget: holding back Dash's and Violet's introductory scenes from production so they could cut them if necessary, and skimping on the quality of the secondary characters. "If it means being a responsible filmmaker and hitting the numbers that we've agreed upon," said Bird, "I'll grit my teeth and compromise on some of the stuff that I feel is less important in order to allow the more important stuff to reach its full potential."

Lasseter moved to preserve the kids' introductory scenes almost immediately. Remembered Walker, "John made a great call, saying that if you don't have the Dash and Violet scenes, the movie becomes too much about Bob—that you lose the family early on and it costs you in the end." But Lasseter also, late in the game, turned on the funding to improve the film's secondary characters, feeling that to do otherwise would compromise the standard that had been set in the rest of the film.

"One of the blessings of this place is that it's run not by executives but by filmmakers with executive power," said Bird. "So it's all storytellers. And you feel very safe and protected in that environment."

"Pixar will never make a film where we have to make an excuse," said Lasseter. "Because you will live with the finished product for the rest of your life, and that mistake, that shortcut, that compromise, will eat at you afterward. So why do it? We have four years to make each one of these films, so let's do it right. As long as I'm in charge creatively, I'll never let something go out of the door that we're not 100 percent proud of."

Above: Omnidroid. Rendered character pose.
Opposite page, top: Nomanisan Dining Room. Lou Romano, gouache.
Opposite page, middle: Nomanisan Lagoon. Geefwee Boedoe, gouache.
Opposite page, bottom: Mr. Incredible vs. Omnidroid. Lou Romano, layout by Don Shank, gouache.

Inventing a Parachute On the Way Out of the Plane

The computer likes the geometric; the perfect; the spare and clean. It has much more diffi-
culty with the organic; the messy; the subtly complex and irregular. So in the looking-glass
world of the computer, where it is easier to blow up a planet than to have one character
grab another by the shirt, believable humans have long been considered the most difficult
thing to do—especially since the human eye is the most experienced and picky of judges.

Though it was a point of pride for the studio that they had never allowed their stories
to be limited by what was technically difficult, their stories to date *had* attempted to
make the most of what the medium did well—plastic toys, hard-shelled bugs, the floaty
underwater world.

It was understood from the start that *The Incredibles*, with its all-human cast, was going to
require the studio to make a technical leap. Because Pixar had never done a movie with a
human as a central character, its infrastructure for dealing with humans had not kept pace
with the part of the graphics field that had been focusing on humans for years. "There
were CG humans out there that people had become used to looking at that were visually
superior to what we were capable of doing," said Rick Sayre, the film's supervising technical
director. Though the goal was to create stylized caricatures that *felt* human, rather than *looked*
human, there was no avoiding technical hurdles like muscles, skin, hair, and clothing, and the
need for the models to be capable of sophisticated and subtle movement and expression.

But it wasn't long before they realized that most of what would make the movie so
technically daunting was its sheer scale. Bird had developed and fleshed out the story
without having any idea of the medium's typical concerns—and had come up with a
movie that was filled pretty much wall-to-wall with all of the most difficult things to
do in computer graphics.

Crossover: Lighting thumbnails by Lou Romano.
Clockwise from top left, Wedding; Suspicious Bob;
Battling Syndrome; New Bob montage; Helen
finds Bob; 100 Mile Dash. Missile Lock; Prologue.
Digital.
Above: Mirage. Teddy Newton, marker and pencil.

"*To quote Rick Sayre, our brilliant technical guru on the film, 'the single most difficult*
thing about The Incredibles *was that there was no single, most difficult thing.' There*
was just a laundry list. If you named the ten most difficult things to do in CG animation,
we had them all, and large amounts of them all. Humans, hair, fabric—hair and fabric

underwater, hair and fabric blowing through the air, different hairstyles, long hair, thinning hair. Lots of changes in costume. The fact that the characters aged and gained weight and had different bodies—Bob has three different body types during the film. This was also the first Pixar film that's needed a separate effects department. Fire, water, smoke, ice…and so many sets. Now we're in outer space. Now we're on an island. We're in an office building. We're on the ocean, in a city, underwater, on a jet, in their home, in a cave, at a hospital, in a secret base. It was just endless." —BRAD BIRD

"We basically had to take a triage approach to figuring out how to get everything done," said Sayre. "There was a fair amount of improvisation involved." Ultimately, getting *The Incredibles* to the finish line required the benefit of every trick in the book, from a complete revision in the way characters were animated to the development of new, powerful tools (which allowed the crew to work at the speeds necessary to meet deadlines) to bona fide technical breakthroughs—all the way down to faster computers.

The first item to tackle was, of course, the issue of how to animate humans. Up until *The Incredibles*, Pixar's character models were controlled with point-weight based rigging, which has the animator manipulate the model by moving points, or collections of points, on the model's surface—like a marionette controlled by hundreds of tiny strings that can be pulled in any direction. This method affords extremely fine control, and it had worked very well on Pixar's previous characters, who had for the most part required little in the way of fleshly deformation (a notable exception being the gelatinous body of *A Bug's Life*'s Heimlich the caterpillar).

But human muscles visibly change shape when they change position. Adjusting every point in Mr. Incredible's bicep every time he moved his arm would have led swiftly to budget overruns and animator insanity (not necessarily in that order). So the technical team decided to move to a different rigging system that was, as Sayre put it, "more of a physical metaphor." Instead of moving the skin of the character in a way that suggested the existence of underlying bones and muscles, animators would move a base skeleton, and the computer would calculate the motion of the muscles and skin on top of it. A new technology called "goo" made for beautiful, high-quality simulation of the interaction between muscle, fat, and skin. This "armature" approach was common in the visual-effects industry, but it

Above: Mirage. Rendered character pose.

required Pixar to change the way it built, rigged, and controlled its characters—and to alter its animation software to accommodate the changes.

For example, usually only skeleton rigs are "light" enough for the computer to manipulate in real time—when muscles, fat, and skin are added on, the rig slows to a barely perceptible crawl. But the animators needed to be able to see the motions and silhouettes of the complete body in order to do their best work. One of the most important advances in the film was a tool that allowed animators to move the full rig (bones, muscles, skin, and all) in real time.

The development of such breakthrough facilitating tools—another one made it possible to light multiple shots simultaneously and in real time—was key to the project's ultimate success. They were accompanied, said Sayre, by many other developments that, though much humbler and lower profile, were just as essential. "You couldn't publish a SIGGRAPH paper about developments like those, but they made a huge difference in everyone's daily life. Without them, we probably wouldn't have been able to finish the film, no matter how smart we were, and no matter how different we were in the way that we worked."

Realistic movement was just one issue. Human characters also needed the right skin, clothing, and hair, and all these things required new technologies.

Bird wanted the characters' skin to be simple—no pores or follicles—but not plastic-looking. The cornerstone of the look was a technique called subsurface scattering, which gave the skin the desired translucency. As had been the case with the water in *Finding Nemo*, the key was figuring how to dial everything just right to produce the desired effect.

Before *The Incredibles,* Pixar had done only two genuinely dynamic (simulated) pieces of clothing, each of which had represented a significant technical advance: Geri's jacket in "Geri's Game" and Boo's T-shirt in *Monsters, Inc.* Because *The Incredibles* called for so many pieces of clothing—over 150 different garments, each of which had to be specially designed and tailored—the cloth research team decided it would be impractical to force the computer to calculate the correct look from scratch in each frame. Instead, they came up with a way to "teach" each character's clothing how to react to specific poses or motions, so the right look could be generated automatically.

Top: Incredibles *composer Michael Giacchino with the film's writer-director, Brad Bird.*
Opposite page, top: Edna Mode (a.k.a. "E") at home. Teddy Newton, collage.
Opposite page, middle: Miscellaneous adults. Teddy Newton, collage.
Opposite page, bottom: Edna Mode (a.k.a. "E") living room. Teddy Newton, collage.

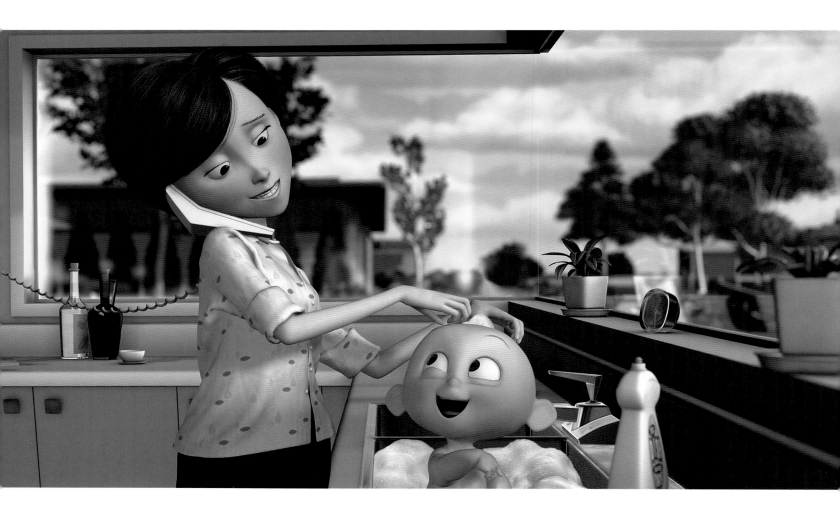

Finally, Pixar had to deal with an issue they had managed to avoid on previous films, and which they knew would be the single most harrowing technical problem of the film: Violet's long hair.

"Long hair was impossible when we started," said Sayre. "There was literally no one in the world who had figured out how to do it well yet. But there was no way we were going to change her hairstyle, because it was key that her character be able to hide behind her hair. So we jumped out of the airplane with the plan of inventing a parachute on the way down. Ultimately we did it, and it was an amazing accomplishment, but it was a white-knuckle ride."

In the end, Sayre believed, the film was an energizing experience and "a very healthy kick in the behind" for Pixar. Over the past few films, the studio's technical advances had been significant, but still incremental. In meeting the demands of a story that hadn't given technical feasibility a single thought, the studio had proven to itself that it was still capable of making quantum technical leaps—that it could take on any challenge that might come its way.

On the way, it leapt a hurdle it hadn't even had in its sights to begin with. Richard Hollander, currently a producer at Pixar, was president of the film division of CG house Rhythm & Hues in 2004. He recalled *The Incredibles* as, for him, an inflection point in the previously parallel trajectories of CG used for animated effects versus CG used for live-action effects. "For me, quite frankly, *The Incredibles* was when I started to feel that animated films should be considered alongside live-action films when it came time to evaluate the best effects work of the year. Their effects weren't supposed to look real; they were supposed to have an appropriately caricatured look, but I felt like they were spending as much time on achieving that look as we do on matching reality. And their work was really good.

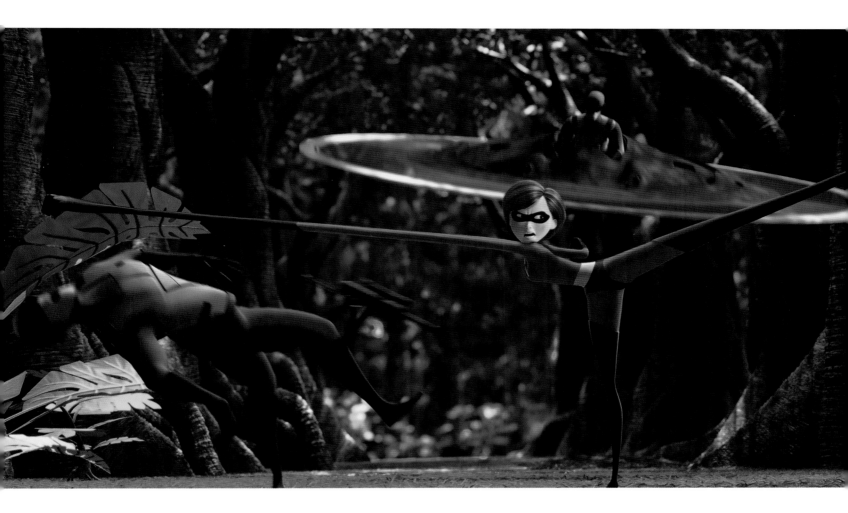

So I couldn't make any more distinction between the two. I felt that everything was now free game."

Pixar to Bird: Merry Christmas

As hoped, when *The Incredibles* hit theaters in the late fall of 2004, it helped change audiences' ideas of what a "Pixar movie" was. The studio's first PG-rated film was an action-adventure that merged high energy, high tension, and a certain atmospheric moodiness, marrying the stylized visuals of hand-drawn animation with the vivid realism of the three-dimensional computer world.

Though absolutely harmonious with the studio's overall filmmaking values, it was quite unlike the movies Pixar had made before—and that, as Catmull explained, was exactly the point. "We need to have variability, and we need to have people with different ideas. You can't keep repeating the old things. By definition, creativity means that you try something new."

For Bird, who had been hardened by years in Hollywood, the endeavor restored his faith in what a studio moviemaking experience could be.

"Early in my career," he remembered, "I tried to come up to the Bay Area and get a project made: an animated adaptation of Will Eisner's comic *The Spirit*. I spent several years trying to make it happen because I wanted to be part of the small number of handmade, high-quality films that were coming out of the Bay Area—*The Black Stallion*, and *Apocalypse Now*, and *Star Wars* of course, and *Raiders of the Lost Ark*, and *Amadeus*, and *The Right Stuff*—all this stuff that I loved.

Top: Elastigirl. Rendered film image. Elastigirl was a particular challenge to build as a computer model—she ultimately required three different rigs and a special program, written just for her, that allowed animators to change her shape as needed.

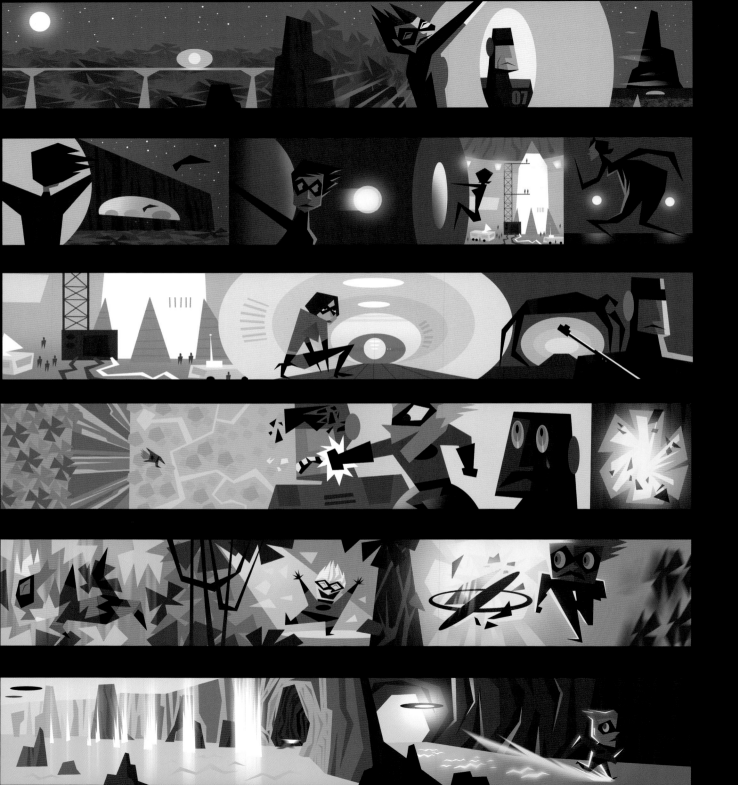

"When it didn't work out for me, and I had to go back down to L.A. to get my career going, I kept my stuff in storage up here. I paid the storage fee every month, basically for the hope that I was just down there temporarily. But years passed, I met my wife, we got married and had kids, and after a while she got tired of writing the monthly check to store stuff that I hadn't touched in ten years. And so she said, 'Face it, you're living down here.' And I said, 'No, this is temporary!' And she said, 'No, you're living in L.A.' So I got the stuff out of storage and moved it down. Almost exactly a year later, I got the offer from Pixar. So I'm very happy to be up here at last.

"Pixar is in many ways true to the spirit of the Bay Area film community that I wanted to join back then, because it is technically advanced, but it is telling unpredictable stories— original stories—and it's always trying to do something new. The collaboration, the feed-back from other directors, is very healthy, because while they push you to make the best possible version of your movie, they are never trying to impose a vision on you. The notes I got on *The Incredibles* were always trying to strengthen the movie that I was trying to make rather than make it like one of the other Pixar movies."

As producer John Walker observed, "If we had made this movie at a different studio, I think we would've had to spend much more time defending it than making it. We didn't have to do that here. We spent time making the film and making it better.

"It was tough to get the film past Disney at first," he recalled. "They did not want to make the film. They felt it should be a live-action movie if anything; they didn't see what made it 'an animated movie.' But John [Lasseter] stood up for the project when we had nothing but a shoeshine and a smile. He really fought for it, and it's because of him that *The Incredibles* got made."

Said Bird, "I could not have asked any more of this studio than I did, and they could not have given me any more than they gave. The animation department's crew T-shirt says it all. It has a picture of a tube of toothpaste with a little *Incredibles* logo on it. And it is wad-ded up and squeezed completely dry; you cannot get one more microbe of toothpaste out of it. That's exactly what the crew was like at the end of this movie.

"I'm shocked when I look back on it, really. Basically, I came into a wonderful studio, frightened a lot of people with how many presents I wanted for Christmas, and then got almost everything I asked for."

Top: Jack-Jack's transformation. Lou Romano, digital.
Above: Jack-Jack. Rendered character pose.
Left: Bob jump study. Angus MacLane, pencil.

 / Spotlight

"Boundin'"

"Boundin'," Pixar's first short film to feature talking characters, was the brainchild of story artist and character designer Bud Luckey.

Luckey grew up in Billings, Montana. "I drew from the get-go," he said. "I don't remember not drawing; I used to draw with red brick on the sidewalk." Appropriately enough, his first movie was *Snow White and the Seven Dwarfs*. "The next movie I saw was a live-action one, and I didn't understand it at all, because I could just walk out my door and see real-live people," he said. After high school, Luckey spent four years in the Air Force before enrolling in CalArts' predecessor school, the Chouinard Art Institute. There, he took classes from legendary Disney figures like Don Graham, Marc Davis, and T. Hee. "Bud is from the same background as those of us who went to CalArts, but a generation earlier," said Lasseter.

Luckey did some work in Los Angeles after graduation, including a stint as an in-betweener for former Disney animator Art Babbitt, but soon moved up to San Francisco, where he worked in advertising and did freelance television work. It was during this period that, along with writing partner Don Hadley, he created and animated his gently whimsical song-stories for *Sesame Street*, including "Ladybugs' Picnic," "Infinity" ("That's About the Size of It"), and "Ten Tiny Turtles on the Telephone."

Luckey's path crossed with Pixar's by way of Colossal Pictures—the company that marketed Pixar's services to the advertising world. "I remember seeing him at Colossal and being wowed by his drawings," said Pete Docter. "When I heard that he was the guy who did 'The Old Lady Who Lived in a Nine,' 'Alligator King,' and especially the two snakes who demonstrate 'here' and 'there,' I was star-struck."

Luckey and the Pixar folks hit it off right away, and Luckey became a full-time Pixar employee in 1992—part of the "second wave" of creative hires at the company that included story artist Jeff Pidgeon and animator Rich Quade.

"I basically was a 2-D animator for almost thirty, forty years," said Luckey. "But when I first saw 'Red's Dream,' I knew that was it. I loved it. When I heard that they were gonna do a feature, I said 'include me in.'" Luckey would go on to play an important role in the development of *Toy Story*—most notably, suggesting Woody be changed from a ventriloquist dummy to a cowboy doll. "Bud has had such an impact on all of our films," said Lasseter. "Being able to make his short was a gift for all of us."

Above, clockwise from top left: Lamb, rendered film image; Prairie dogs storyboard, Bud Luckey, pencil; Naked lamb, Bud Luckey, pencil; Prairie dog sculpt, Jerome Ranft, oil-based clay; Jackalope and lamb, rendered film image.

"Boundin'" had come out of the same studio-wide call for ideas that had yielded Ralph Eggleston's short "For the Birds." "Bud came in with his banjo and told this story and sang this song, and I just fell in love with it," Lasseter remembered. "His drawings and designs have a wonderful joy to them, and the story is just quintessentially Bud—so unaffected and wise."

The song-story format of "Boundin'" harkened back to his *Sesame Street* pieces, but the story drew upon elements of Luckey's childhood: "A lot of it comes from the mountain area where I grew up in Montana, a lot of sagebrush. I wanted to have a character that was kind of pathetic and sympathetic, and I remembered, as a kid, seeing newly shorn sheep standing out in the rain and how pathetic they looked. So I started with that, and then I brought in a jackalope, who's kind of the mythical hero, or the one who sets everything straight. The prairie dogs were sort of your schoolyard brats who pick on each other."

Osnat Shurer, the film's producer, recalled that the story's aesthetic required a different style of animation. "Bud wanted the animation for 'Boundin'' to have the looseness of traditional animation. It was a very hard thing to express, except for sending us back to looking at some traditional animation work, but

finally we found the right phrase for the kind of animation he wanted: 'baggy pants animation.' And that became our theme throughout the film." The fact that "Boundin'" was a short and not a feature, she said, made it easier for them to play with the animation style in this manner.

Lasseter said that many people at the studio expected "Boundin'" to be released with *Cars*. "But 'Boundin'' was done a lot earlier than *Cars*, so we put it out with *The Incredibles*; we just release shorts and features together as they are finished. And to me, that actually turned out to be an even better combination. Pairing the beautiful cowboy wisdom of Bud Luckey's short film with Brad Bird's amazing superhero action adventure really shows the diversity of Pixar—the terrific range of ideas that come out of the studio."

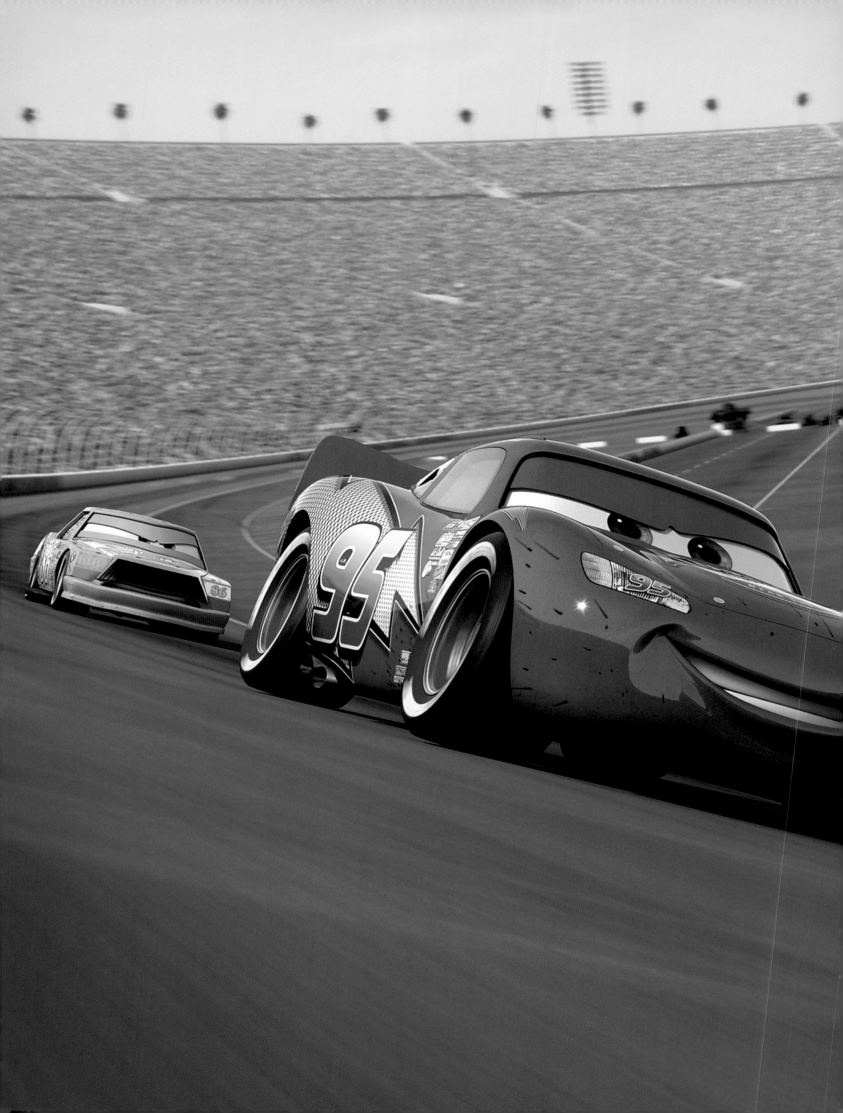

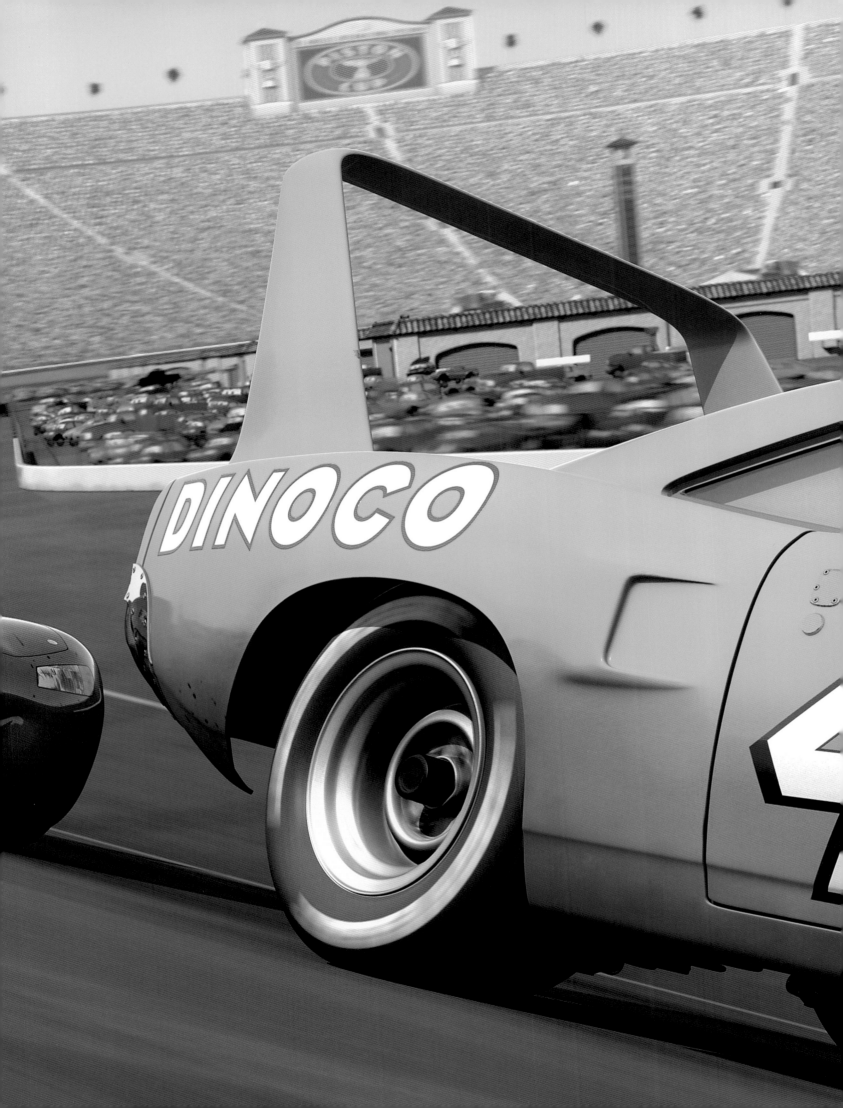

Chapter 13

Cars

Above: Lightning McQueen. Rendered character pose.
Opposite page, top: Ornament Valley. Tia W. Kratter, acrylic.
Opposite page, bottom: John Lasseter in a lighting review meeting for Cars.
Previous spread: Lightning McQueen racing. Rendered film image.

"Slice open one of my veins and cartoons will pour out; open another vein and you'll get a flood of motor oil." —JOHN LASSETER

If John Lasseter's love of the arts came from his mother, Jewell, a high school art teacher for thirty-eight years, his love of cars surely came from his father, Paul, the parts manager at the local Chevrolet dealership. As a kid, Lasseter would dust the parts bins; when he got his driver's license, he started working there as a stock boy and delivering car parts. Growing up in Southern California in the '60s and '70s only reinforced the passion for cars that Lasseter picked up from his dad. Whittier Boulevard was one of *the* cruising streets in all of Southern California—there was a beautiful Bob's Big Boy Drive-In Restaurant, and a drive-in theater where Lasseter would go see movies with his high school friends. "I grew up in L.A., in this car-crazy culture," he said. "Lowriders, muscle cars, the surfer/beach community—there were all these different car cultures, and I loved them all."

So it was no surprise to anyone that Lasseter would one day merge two of his longest-running passions.

The idea of a car movie had been percolating in Lasseter's mind since *Toy Story*. Lasseter's carpool buddy, character designer Bob Pauley, was a fellow second-generation car fanatic (Pauley's dad had been an engineer for Ford), and the two invariably filled the long commute with car talk. Recalled production designer Bill Cone, "I still remember Bob and John coming to the office after riding to work together. John would say, 'Cars, Bob. One of these days we're going to make a movie with cars.'"

The spark that ignited that particular engine was a conversation with Jorgen Klubien, a longtime Pixar story artist and Lasseter's roommate from his days at Disney. "Jorgen had lunch with me during *A Bug's Life* and he said, 'You know, we've done something with toys, we've done something with bugs; it would be great to do something with cars as characters'—because he and I both *loved* 'Suzie, the Little Blue Coupe.' After all those conversations with Bob, I thought that was a great idea."

After Klubien wrapped on *A Bug's Life*, Lasseter sent him off to develop a story with cars as the main characters. Klubien returned with "Yellow Car," an ugly duckling tale about a

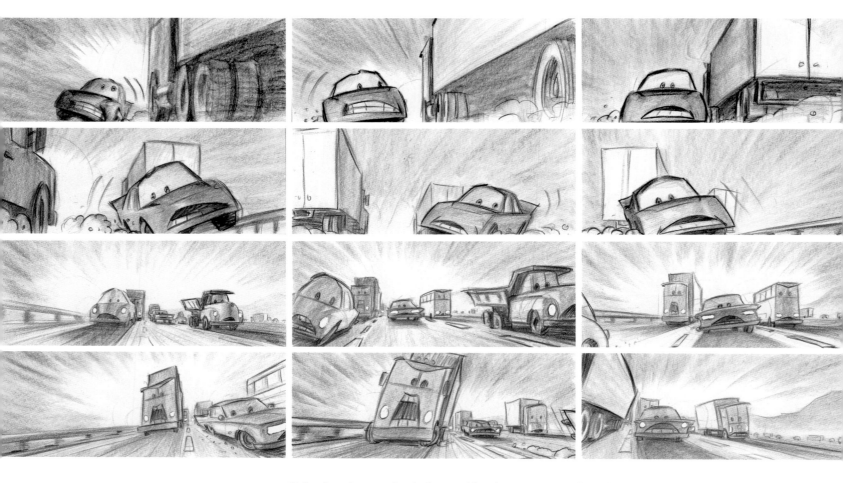

little electric car who is shunned by the gas-powered residents of a small town. The story would serve as the jumping-off point for Lasseter's next project—*Cars*.

The Journey Is the Reward

Lasseter, like many Pixar veterans, had worked long production hours more or less continuously through the 1990s, directing the overlapping productions of *Toy Story*, *A Bug's Life*, and *Toy Story 2* back to back. When he had jumped in to rescue *Toy Story 2*, his wife, Nancy, had agreed to postpone their extended family vacation for yet another year on the condition he adopt a saner working schedule (regular hours, healthful meals, and exercise). But, she warned him, time wasn't standing still; their five sons were growing up quickly. "'Be careful,'" Lasseter remembered her saying. "'One day you're going to wake up and the boys will have all gone off to college, and you will have missed it.'"

"That really stuck with me," he said. "So after *Toy Story 2*, I decided I was going to take the entire summer off to be with the family." That summer, the Lasseters finally took their extended vacation—a two-month road trip across America in an RV. They started off by putting their feet in the Pacific Ocean, just north of the Golden Gate Bridge, and headed east with no plan except to put their feet in the Atlantic before turning around and coming back. The trip, said Lasseter, was transformative.

Top: Storyboards for "Lost." Garett Sheldrew, pencil.
Above: Boost. Jay Shuster, marker and pen.

"It was the first time in my life that I was living every day to its fullest and not worrying about tomorrow," he said. "I reconnected with my family in a way I hadn't been able to do

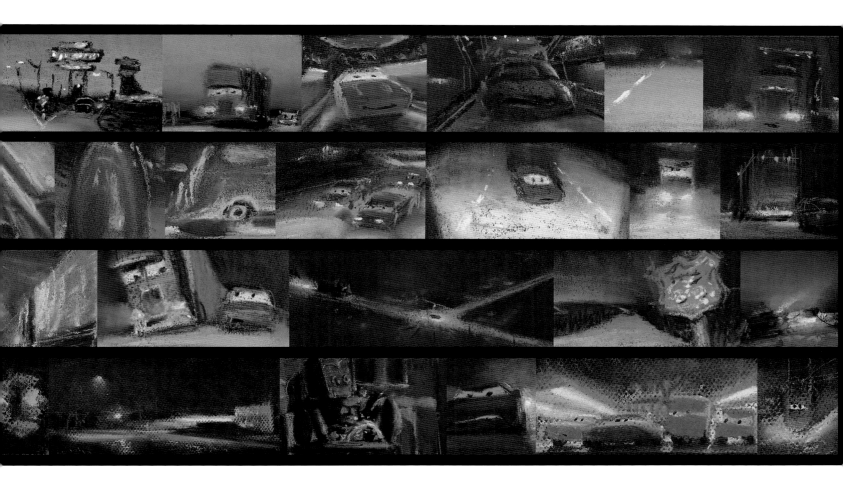

for a long time. Being on the road together with them, having this great adventure driving the small highways and going where the wind blew us, made me realize that the journey truly is the reward."

After the release of *Toy Story 2*, Lasseter and his longtime head of story Joe Ranft had begun to research their subject, going on field trips, reading books, and watching every car-related documentary they could get their hands on. By the time Lasseter left for his family vacation, they had found two major sources of inspiration. The first was the world of racing, which Lasseter had discovered and fallen in love with a few years earlier through the local Infineon Raceway in Sonoma. The second was *Divided Highways*, a documentary that examined the interstate highway system's effect on American culture.

Lasseter returned from his trip that fall with the idea for his new movie: a race car gets stranded in one of the small Route 66 towns that have been bypassed by the interstate. "It was the perfect situation—taking a race car, which is built for the sole purpose of going as fast as possible—and putting it in the world of the old highway. Because I felt like that race car. My life was just going faster and faster and faster. There's an interesting parallel between the modern superhighway and what's happening to our lives in a world where everything is getting faster and life is getting busier. Life has become all about the destination, not the journey."

Lasseter wanted his movie to be about a fast car that learns to slow down. But he also realized that he wanted the movie itself to be one that could slow down. Lasseter wanted to make a film that took the time to enjoy its characters, and he knew there was no one better for it, no one who would understand this goal more, than his friend Joe Ranft.

Top: Colorscript. Bill Cone, pastel.
Above: Boost. Rendered character pose.

Drawings that Live

"Our characters are not real. It's an illusion that they are alive, but even though we are the ones who create them, it feels like they have something inside them that's motivating them and driving them. I'm very curious about what makes people tick—I'm always trying to figure out what makes me tick!—so I'm never bored when I'm trying to crack what's going on with a character. I love trying to figure them out." —JOE RANFT

Lasseter and Ranft met at CalArts in 1978, when Lasseter was a senior and Ranft was a freshman, but they didn't really connect until they were both working at Disney a couple of years later. "We were all part of the same group of friends," Lasseter remembered. "Joe was just always hilarious. He could do magic tricks, and he was always willing to go all out for whatever we were doing. He went on to take some improvisational comedy classes from The Groundlings, and he was so good that he was invited to stay on and go to the next level because they thought he was so talented that he could have been one of their lead guys on stage." Ranft never sought the spotlight, but once there, he was a natural performer. A longtime member of the Magic Castle's Academy of Magical Arts, he had been admitted to its selective Junior Magicians Group as a teenager.

Like Lasseter, Ranft grew up in Whittier, California. Jerome, his youngest brother and a sculptor at Pixar, remembers that, as a kid, Joe had a lot in common with Sid from *Toy Story*. Jerome said, "He was your typical older brother—constant teasing. He'd have séances and try to scare the crap out of us, or pretend to be a zombie when he was babysitting us. And there was always that bit of Sid in Joe. But when he got to college and fell in love with story, I think he found a way to take that energy and focus it into what he loved—into being the person he decided he was going to be."

"I was always interested in telling stories, or in ideas," Ranft remembered. "Ken O'Connor, who was my drawing perspective teacher, would bring in original artwork from the archives at Disney, and one day he brought in all these storyboards done by Bill Peet for the film *Song of the South*. They were simple, but they really had a lot of energy. Really alive, living drawings. The bell went off for me there. I just went 'I want to learn how to do that.' I was like, God, I would love to learn how to make drawings that are that expressive, that show so much character. It was all just expressed so simply and graphically and just popped off the page."

Ranft had many gifts, but drawing did not come easily to him. "Joe was not naturally a good draftsman," said Lasseter. "He became a good draftsman almost through brute force, through pure work and practice and taking drawing classes and working and working and working harder. He was always taking classes, always trying to elevate his talent and make himself better."

Like a magic trick rehearsed for hours, until the unfamiliar moves become muscle memory, Ranft gradually transformed his pencil into a medium sufficient to channel his tremendous gifts for character and storytelling onto paper. "Joe's drawings were not as polished and finished as some," recalled Pete Docter, who was in the very first story class Ranft taught

Top: Doc Hudson model packet drawings. Bob Pauley, pencil.
Above: Doc Hudson. Rendered character pose.
Opposite page, top: Doc racing. Bill Cone, pastel.
Opposite page, bottom: Doc Hudson sculpt. Jerome Ranft, oil-based clay.

at CalArts. "And yet I don't think there's been a better story guy in the business. He knew how to make things read like gangbusters; his sense of character and story and staging and just the whole economy of the form was so strong."

> *"We were all trained in the Disney style of storyboarding and pitching, where you pin your drawings on a four-by-eight board in front of a room full of people and you pitch your board with a pointer and act it out. Joe's such a brilliant actor that you just lived for his pitches because they were so fun to watch. But he also really understood the art of storyboarding. His rule was that a storyboard drawing had to read from across the room; it had to be so clear that you could tell what was going on even from a distance."* —JOHN LASSETER

Ranft's ability to put his finger on the pulse of a moment or an idea was a talent that scaled to address every aspect of a film's story. He could dash off a drawing that communicated a feeling at a glance, choose just the right sequence of images to convey a crucial story point, and come up with personality details that breathed vivid life into even the smallest of characters. Under his hands, seemingly ordinary ideas sprang to life and revealed themselves in his storyboards to capture the essence of what was fun about a project.

As Lasseter recounted, "On just about every single movie he started, he would see some nugget in the script or in the story—just a vague concept, a rough idea— say, 'that's kind of neat, there's some possibility in there,' and take it away to storyboard it. It'd be the first thing he would storyboard for the movie, and inevitably, that sequence would always stay pretty much intact through the making of the film, no matter how much the rest of the story changed." On *Toy Story*, it was the opening scene of little green army men staking out a birthday party; on *A Bug's Life*, it was the kids' play that tipped the circus bugs off to the fact that they were expected to be great warriors.

What made Ranft a great story artist was his ability to empathize with his characters—to find the angles and details that made a character not only unique but human. Ranft had a sharp eye and an even sharper wit, but he was always more interested in finding a way to laugh with a character than to laugh at it. He could be devilish, but his humor was never mean or nasty. "I think one of Joe's greatest talents was that, not only was he one of the funniest people

I've ever met, the humor always came out of the character," said Lasseter. "It was never just a generically 'funny' line; it was always something that told you something new about the character's personality."

Story artist and director Brenda Chapman, a longtime friend of Ranft's from their days together at Disney, remembers how Ranft convinced her to leave L.A. and come to Pixar to work on *Cars*. She said, "I grew up in a small town near Route 66 in Illinois, so it already spoke to me on that level, but it was the way that he was describing those characters to me over the phone that won me over. He knew each one of them intimately; it was like he'd put a little bit of himself into each one."

McQ

The main character of *Cars*, Lightning McQueen, was named in memory of one of Pixar's most distinctive personalities—animator Glenn McQueen. McQueen, a longtime car connoisseur, had been among the first leads to join Lasseter's project, but passed away before the film moved into full production.

"It was a huge loss," said Lasseter. "Glenn's sense of humor, his satirical look on things, and his absolute dedication to this place and his crew was just beyond anybody else. He always took care of the animators and the whole animation department. On *Toy Story*, some of the animators hadn't even finished college when they started working here, and Glenn not only helped them become better animators, he helped them adjust to working life. He taught them how to do their laundry, gave them dating advice, you name it. He helped so many of them in every way; everybody looked up to him."

Animator Jim Murphy, one of McQueen's closest friends at the studio, agreed. "Glenn was always the spokesman for the department. He was kind of curmudgeonly and sardonic—in a nice way—but he also had a velvet touch, and really had a great relationship with each person in the department. As a supervising animator, not only are you managing people on the film, you're also overseeing to make sure that the department is taken care of as a group

Top: Animator Glenn McQueen inspired the name of the film's main character. Above: Lightning McQueen. Bob Pauley, mixed media.

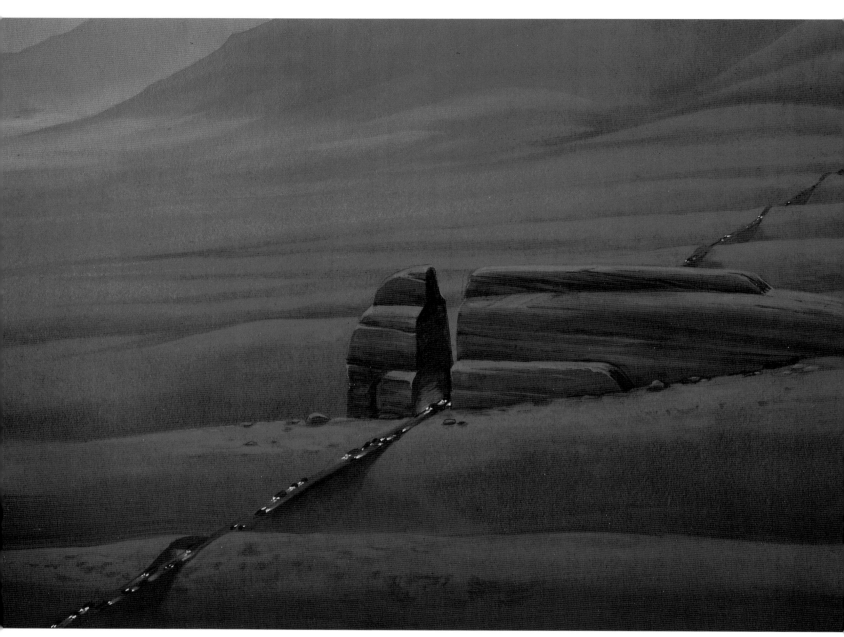

Above: Clockwise from top left, Interstate Study, Tia W. Kratter, acrylic; Ornament Valley, Jerome Ranft (sculpt), Bill Cone (overlay), Gary Schulz and Suzanne Slatcher (model), sculpt/overlay/pencil; Ornament Valley, Jerome Ranft (sculpt), Bill Cone (overlay), sculpt/overlay/pencil; Ornament Valley, Nat McLaughlin, pencil.

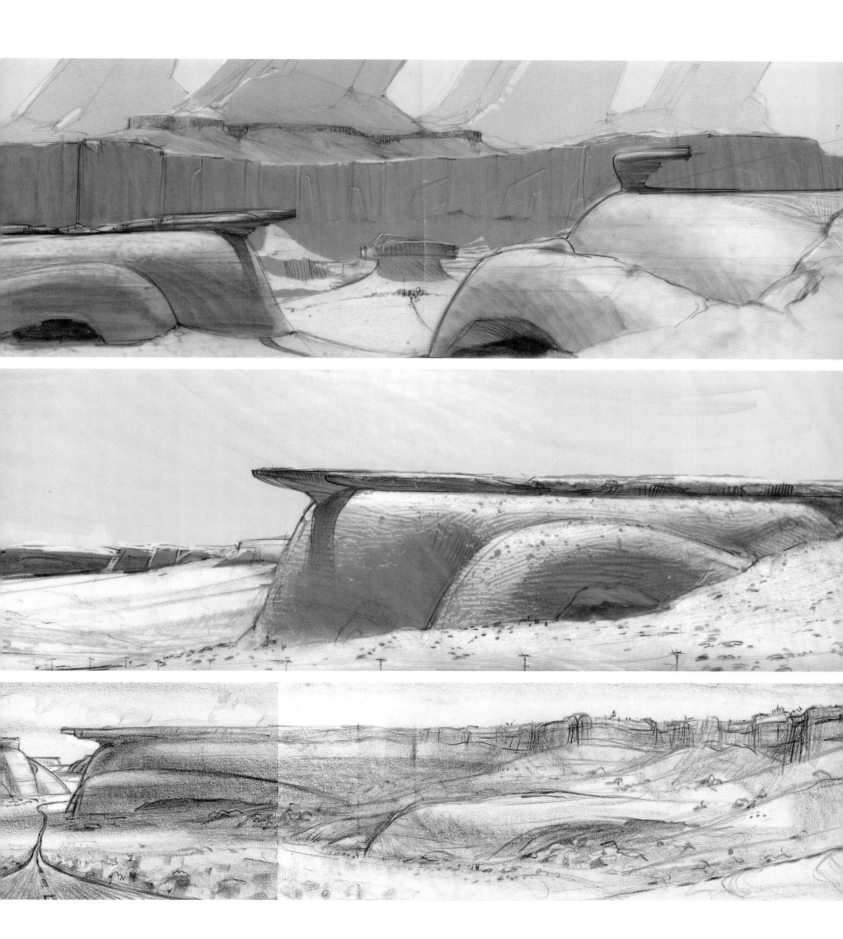

and staying together as a group. And that responsibility was something that he took very seriously. He worked very hard to protect the environment in animation and make sure it stayed vibrant."

Creating the World of *Cars*

"There are three things you need to do to make a movie that is successful, a movie that truly entertains your audience," said Lasseter. "First, you've got to tell a compelling story that keeps people on the edge of their seats, so they can't wait to see what happens next. Second, you have to populate that story with really memorable, appealing characters, even the bad guys, because those characters will live beyond the boundary of the film if you do it right. And third, you need to put that story and those characters in a believable world."

The world Lasseter sought to create for *Cars* was something new for him—one akin to, but not part of, our own—and he was eager to investigate its possibilities. As a child, he had always been fascinated by created worlds, from the story universe of his first drawings to the dioramas at local museums. "The more detailed and accurate they were, the more I loved them," he said. Part of what drew Lasseter to computer animation was the promise it held to create worlds of unprecedented detail—seamless and immersive, yet with all the weight of our own rule-bound world.

When it came to creating Pixar's story worlds, Lasseter was always a stickler for research. Research provided the details that would help make the worlds believable, that would ballast their flights of fancy and provide the basis for the audience's suspension of disbelief. "We are cartoonists," said Lasseter. "We are animators from beginning to end. The audience knows it was not photographed with a real camera. But if you can make them look at it and go, 'I know it's not real, but boy it sure feels real!'—to me, that's the goal of a Pixar film. Feeling like you can reach up and touch something even though you know it's not real—that's part of the entertainment."

Top left: Sally. Dave Deal, pencil.
Top right: Sheriff. Dave Deal, pencil.
Above: The King. Bob Pauley, marker and pencil.

"One thing I discovered about the automotive world," said Lasseter, "the racing world, the classic cars world, or any auto subculture—is that these people are tremendously passionate. Cars are their life. Racing is their life. So I really wanted us to be able to get the details right for them. How many times have we gone to see a movie about a subject we know and love and got the feeling like the filmmakers did not do their homework? Too many times people take creative license with things to the

point where the film stops being believable. Our philosophy was that if we can get it right for even the real aficionados, it'll be that much more believable for everyone else as well."

The more research the team did, Lasseter discovered, the better he understood exactly what *Cars* needed to be. Field trips to huge speedways gave them firsthand experience of the sensory overload of a stock car race—the deafening noise from engines rumbling the air, the blinding floodlights, the smell of exhaust and burned rubber, the seas of screaming fans. A trip to Detroit conveyed the sweep of automotive history in America, taking in both the highlight of the domestic car industry's year—the annual North American International Auto Show—and the mile-long ruins of the once-mighty Packard Motor Car plant.

But the production's most important research was done on Route 66, the iconic highway almost done in by the interstate highway system built in the 1960s and 1970s. Michael Wallis, a "Mother Road" expert, led two different Pixar road trips of Route 66 in 2001— one for Lasseter, Ranft, and other senior members of the crew, and one put together by Ranft for the *Cars* story team.

"We really fell in love with that piece of America," remembered production manager Jonas Rivera. "We found a grace and charm to these towns that none of us had ever experienced before. I remember Joe saying, 'If we can just capture 10 percent of what we found out there and get it into this movie, it'll be really cool.'"

"All the myriad wonderful people and personalities and characters that we met on those trips definitely touched us," said Ranft. "That's the story of the Mother Road; that's our inspiration. *Cars* starts out as a modern film and then becomes a more heartfelt, old-fashioned movie about character relationships, kind of like a Frank Capra film."

Lasseter said that meeting people who remembered what life was like in the heyday of Route 66—people like Angel Delgadillo, one of the founders of the Historic Route 66 Association—was especially moving. "Before the interstate opened, people on Route 66 were really excited about it, because they thought it was going to bring more people, and visitors were the lifeblood of these towns. But the day that the ribbon was cut on the new interstate, their entire livelihood was taken from them. These wonderful little highway towns were basically told they were obsolete. It was amazing to hear how they struggled to survive; how they did everything they could to tell the world, 'we're still here. We're not gone.'"

Top left: The King. Dave Deal, pencil.
Top right: Ramone. Dave Deal, pencil.
Above: The King. Rendered character pose.

History at a Glance

Pixar always prided itself on sweating the details of its worlds, but *Cars* took this endeavor to new heights. This time, it wasn't just a matter of principle. The details were essential to the believability of the world and to the believability of the story.

"When we drove Route 66, the biggest thing I came away with was the importance of capturing its patina, its unique texture and detail," said Lasseter. "In one glance at any of the abandoned towns along the Mother Road, you can see its long history combined with the sadness that they're no longer in use because there's no need for them anymore. There's so much visual history—you can immediately see through the peeling paint to the life that once was. Even the grass between the cracks in the concrete is important—it says that no one drives here any more. I realized we would need a level of visual detail that we'd never done before."

> *"John is involved in every detail of the picture, from the first page on paper to the credits scrolling at the end. He has this amazing vision. But he won't just direct the details; he'll explain exactly why he wants those details. I think that's one of the cool things about working with him; you never feel like you're doing anything just to do it. There's always a real story-driven reason why something is being done." —JONAS RIVERA*

Patina, of course, is directly contrary to the preferences of the computer for the simple and the perfect. "It takes so much effort," said Lasseter. "The design, the thought, the planning, the implementation, the art—every step until you get to the final screen. You're just battling with the computer the whole way to make things less perfect. The eye is so comfortable with the organic world—the moment that something isn't done to that level, it pops you out of the film. It ruins the suspension of disbelief."

"I actually found John's ambition for the film's level of detail very exciting," said Eben Ostby, who had signed on as *Cars'* supervising technical director. "One of the things I was most attracted to was the desert look of the film." Since the Radiator Springs setting was inspired by the desert of the American Southwest, Ostby took a field trip with the art directors to get a better sense of what they'd be trying to do. "We drove into the desert, to see the hills and cliffs and figure out how we could capture their essence and make it work in the film. We also took a lot of pictures of the way dirt piles up near roads, and the way paint peels off buildings, all these things that give the sense of an old, somewhat down-at-the-heels town. Bill Cone was so interested in the beautiful desert light; that came together with the town to create something really unlike anything anyone's ever done in CG before."

Top: Luigi motion study. Bob Pauley, pencil.
Above: Guido and Luigi. Bob Pauley, marker and pencil.

Another unexpected wrinkle of the subject matter was the sheer size of the sets it required. Since a race car covers considerably more ground than a cowboy doll (even one running at top speed), the sets had to be scaled up accordingly. The film's setting would naturally call for majestic vista shots, but the relative lack of large plants or buildings to "wall off" scenes meant even short scenes required the computer to render vast and detailed backgrounds (the Radiator Springs set, for example, contains half a million sagebrush plants).

But the biggest technical challenge of *Cars* was the decision to use ray tracing to render the film. Ray tracing is essentially sophisticated light simulation. Instead of making the computer-generated light obey just one or two basic rules, like illuminating a surface or creating a simple shadow, it forces it to follow the more complex rules of real light, like reflection and refraction. Though it is extremely compute-intensive, it gives you better lighting effects—soft shadows, distortions of light through glass, and, most important for a world populated by metallic cars, true reflections.

Jean-Claude Kalache, the film's director of photography for lighting, said that the subtle but unmistakable effects of ray tracing were essential in a film that set a high standard for detail. "Working with ray tracing was much more expensive than traditional approaches, and mistakes were very costly—both in terms of render time and the time of our lighters. But without this technology, we would not have been able to achieve the look John wanted to capture. If we didn't have ray-traced reflections, our cars would not look right; they wouldn't look like metal. If we didn't have occlusion, then our world, our desert, our buildings, our cars would have a floaty quality; they would not have the contact shadows that make them feel grounded. If we didn't have the soft shadows, it wouldn't have been true to what we experienced on those desert roads and towns. And finally, without irradiance, the most subtle of all the effects, we would not have been able to fully respect the true nature of the cars' metal surface."

Top left: Luigi's Tire Shop. Rendered film image.
Top right: Luigi's Tire Shop model packet detail. Jay Shuster, marker and pen.
Above: Guido and Luigi. Rendered character poses.

In anticipation of the massive computational demands of rendering the film, Ostby set up a speed team to optimize and streamline the rendering process. The studio also made significant improvements to the Renderfarm, making it larger and more powerful than ever. "I bet we have more compute power than NASA right now," joked producer Darla

Above: Lightning McQueen and the Radiator
Springs gang in front of Flo's. Rendered film image.

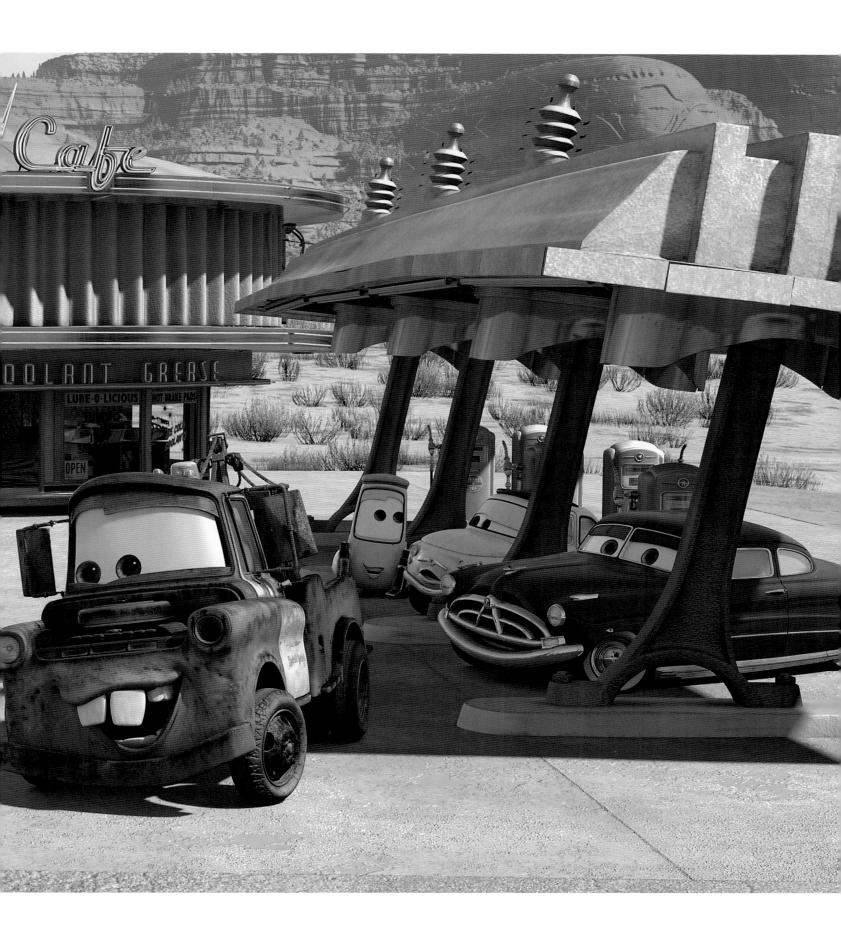

Anderson, while the show was under full steam. "The renders are huge. But it's all worth it. The images are beautiful, just gorgeous—people are going to feel like they are *in* the world as the story is taking place."

In the spring of 2005, Pixar decided to move *Cars* from the fall of that year to the summer of 2006. The decision to move the studio's future films from their traditional holiday release dates to a summer release date had been in the works for some time, but the studio decided to implement the change early because *Cars* was judged to be such a quintessentially *summer* film. "Getting in the car and going on a road trip is a very traditionally American way to spend a vacation," observed Anderson. "It's that feeling of visiting national parks, cruising, being out in the car, freedom."

"Two-and-a-Half Jobs"

While Lasseter had always been the creative head of the studio, the role had demanded much more of his time after the release of *Toy Story 2*, his last directorial effort. Through that film Pixar had effectively been in serial production, with the studio focusing the bulk of its resources on one movie at a time. As the addition of other directors made truly parallel feature production a reality, Lasseter's studio responsibilities began to multiply. Pixar formalized Andrew Stanton's previously unofficial role as Lasseter's creative second-in-command, which helped to balance some of the supervisory load involved with overseeing and coaching projects in development, but Lasseter's responsibilities remained considerable.

At the time, Lee Unkrich observed, "If you were to take *Cars* out of the picture, John would still have a very difficult full-time job staying on top of all the different movies and making sure they stay on track. But to do all that *and* make his own movie…. John basically has two-and-a-half full-time jobs."

Top: Evolution of the cow-to-tractor. Jay Shuster, pencil.
Above: Tractor. Rendered character pose.
Opposite page, top: Frank the combine. Jay Shuster, pencil.
Opposite page, bottom: Frank the combine. Rendered film image.

As a result, *Cars* took longer than usual to make—about six years. In their earliest days, *Cars* and *The Incredibles* were actually at the same stage of development at the same time, but because of Lasseter's additional obligations, *The Incredibles* was sent ahead in order to

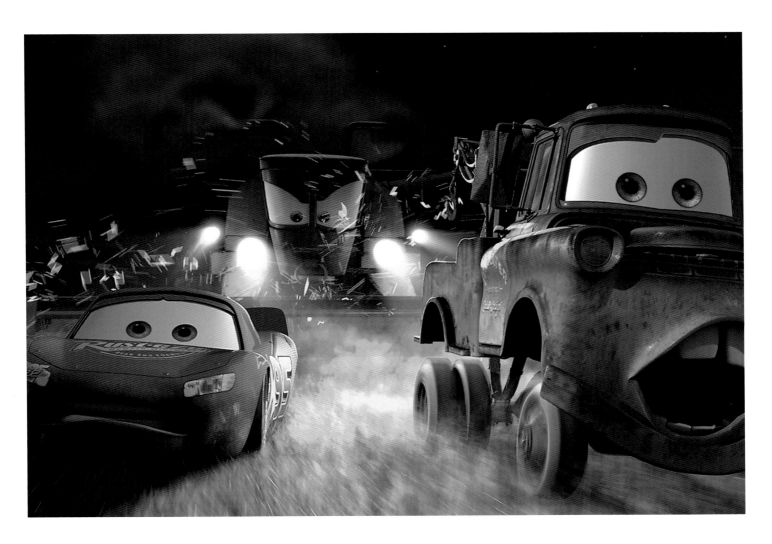

Top: The Wheel Well Motel. Rendered film image.
Above: Sally model packet drawing. Bob Pauley, pencil.

give *Cars* the extra time. "It can be hard sometimes," admitted Lasseter, "but really, it's hardest on the people around me, who have to deal with my schedule."

Heather Feng, Lasseter's assistant, has worked with Lasseter for more than a decade, and she marvels at his energy. "What makes it possible to make everything work is his amazing ability to focus," she said. "When he goes into a review, even if he's just come out of a crazy meeting, he can give whatever's in front of him his complete attention. If he is talking to you, you are the only person in his world at that moment. And you feel that."

Anderson agreed. "John has so many things going on, but he remembers everything and is always able to give amazing feedback. It's kind of scary sometimes," she said, laughing.

Anderson also observed that experience—both Lasseter's and his team's—was invaluable to *Cars*. "This movie could not have been done without somebody with John's level of experience," said Anderson. "He knows where to delegate, he knows what battles to pick, he knows where the eye's going to go to on the screen. That experience, that confidence, helped us sail through things that would have overwhelmed a more junior director, or even a younger John.

"Not only was our crew in general very remarkable, very professional, but the leads on this film had worked with John on several movies. So the relationships that had built up over the years made it possible for everyone to really trust each other and get things

done quickly, because everyone knew how everyone else works. For me personally, being here for so long and being so plugged in to what's happening at the studio made it much easier to strategize and collaborate with everybody to make sure everything got done."

Joe

It had been a long haul, but by the summer of 2005, the movie was shaping up nicely; the story had been locked and the studio had settled into its familiar rhythms of production. After the longer-than-usual tour in story, Ranft was glad of the chance to take his customary post-film break and work on the curriculum for new story artists that he'd been planning to introduce at Pixar. There was a lot he wanted to do.

But on August 16, 2005, Joe Ranft died in an automobile accident on the Mendocino coast of Northern California. He was a passenger in the car, which was en route to a retreat where Ranft volunteered as a mentor for men who were trying to turn their lives around.

The news reverberated throughout the animation world; Ranft, one of the most respected figures in the industry, had a vast network of friends and colleagues. At the public memorial service held at Pixar, the crowd filled the huge atrium.

Top: Cruising at night in Radiator Springs.
Rendered film image.
Above: Sally. Rendered character pose.

Top: The character of Mater was inspired by a broken-down truck the Cars crew encountered in Galena, Kansas. Joe Ranft was immediately intrigued by its possibilities. Above: Mater's junkyard model packet detail. Nat McLaughlin, pencil.

For months, the studio was numbed by the loss. The *Cars* crew in particular was staggered by the blow. But with months of production still to go, they steeled themselves, determined to honor Ranft's memory by doing their utmost to bring his last movie to life.

What makes a wrap party special is the unique experience of seeing the finished film for the first time with the people who have worked so hard to make it. Nine months later, at the *Cars* wrap party, it was bittersweet for Ranft's friends and co-workers to see him so vividly present in the film when his absence in their lives was still so palpable. "We were sad because we missed him terribly," said Lasseter, "but in a way, it was also reassuring—Joe will live on in the film for as long as *Cars* exists."

For Lasseter, the part of *Cars* that most reminds him of his friend is, of course, the sequence Ranft had identified as the film's "diamond in the rough." In "Best Friends," Mater the rusty tow truck, whom McQueen the hotshot race car had written off as a naïve simpleton, surprises the out-of-towner with his unexpected genius for backward driving—and with an equally unexpected declaration of friendship.

If Lasseter's experiences had informed McQueen's realization that life is worth slowing down for, a few of Ranft's personality traits had definitely rubbed off on Mater. Obviously Ranft was far more cosmopolitan than the unsophisticated tow truck; he had spent decades in the up-and-down animation business and was nobody's fool. But somehow experience had tempered Ranft without hardening him; it had given him perspective without taking away his optimism, idealism, and faith in others.

"Trust the process" was Ranft's mantra, and he led by example with his serene acceptance of the Sisyphean lot of the story artist (he often referred to storyboarding as "story re-boarding").

"Joe was always the most positive person," said Lasseter. "You would have a disastrous pitch or screening, where everything got ripped apart and you didn't know where to go from there, and Joe was always the voice of optimism: 'We got some great ideas. We got some great notes.' He was always the one to just roll up his sleeves and get back to work."

> *"Our mom was an army ER nurse stationed in Europe during the Korean war. She was always best in a crisis, and I think Joe was the same way. The tougher it would get, the more focused he'd get on how to solve the problem."* —JEROME RANFT

"Joe was put on this earth to help other people," said Lasseter. "Not only through his art but through his life outside the studio, with his family and friends and all the charities he worked with. He was there for everybody. And a part of him is still here. He's so much a part of this place, the heart, the soul, the spirit of this place, the characters…everything."

Top: Storyboards for "Best Friends."
Joe Ranft, marker.
Above: Mater. Rendered character pose.

 / Spotlight

"One Man Band"

"One Man Band," the short making its debut with *Cars*, was the first project at Pixar to be made under the supervision of a pair of directors. Story supervisor Mark Andrews and digital artist and director of photography Andy Jimenez, the film's creators, had come to Pixar with Brad Bird to work on *The Incredibles*.

"Mark is about the force of an idea, and Andy is about finessing it onto the screen," said Bird. "Beyond their love of movies, they have three things in common. One, they are excellent at their jobs. Two, they have great respect for each other. Three, they drive each other crazy."

Jimenez said that when he and Andrews were offered the opportunity to pitch three ideas for a short, their biggest challenge was to come up with an idea that they could get behind as a team. "Some of the experiences we had in the past at other studios under dual directors were absolutely miserable, because they didn't share the idea in their hearts; they didn't agree on the vision of the film. So Mark and I knew we really had to come up with an idea we shared ownership of, so we could actually use our differences to an advantage."

"When they finally pitched their three ideas," said Lasseter, "it was the most hilarious thing. One of them was pure high-

energy Mark Andrews, one of them was pure sentimental Andy Jimenez, and the third, 'One Man Band,' was exactly the combination of these two guys."

"We had actually developed all three ideas together," said Mark Andrews. "We structured and wrote them together—we would have been happy to make any of them—but you can definitely see in hindsight, the other two were both 70-30. One was 70-30 me, and the other was 70-30 Andy."

"The great thing about 'One Man Band,'" said Jimenez, "is that it's like we were both on two separate roads going to the same place. We both had a love of music; we were both able to put a piece of ourselves into it."

Because the film's premise—two street musicians competing for a coin—made music such an integral part of the story, Jimenez and Andrews asked to bring a composer onto the project much earlier than usual. "Our initial pitch went great, because we were verbally talking about two themes of music that would become more elaborate, overlap, and become one piece of music. But then when we showed the reels the first time to John, the film wasn't working as well. It fell a little flat because we were grabbing other pieces of music from other movies that didn't really show that escalation of two themes becoming one.

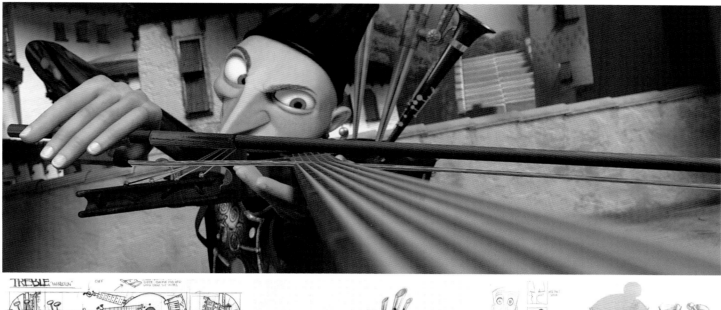

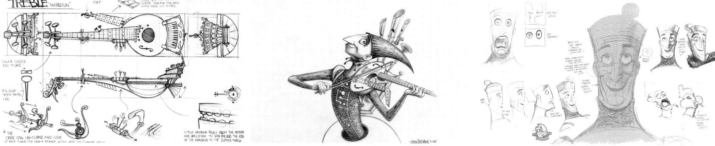

Above, clockwise from top: Treble, rendered film image; Bass model packet drawing, Ronnie del Carmen, pencil and digital; Treble, Jason Deamer, pencil; Mandolin model packet drawing, Jason Deamer, pencil.

So Mark and I realized we needed our composer to come in then, during our story development phase."

The two directors agreed Michael Giacchino, who would later score *The Incredibles*, was the perfect choice. Recalled Andrews, "We brought him up and showed him what we'd done so far, boards and character designs and things like that, and talked about what we wanted in the music. Then he went right back down and sent a sketch up the next day. He's that quick. It was this iterative, very fast back-and-forth between him and us, and we had the themes nailed in like a week or two."

Andrews and Jimenez said that once the story reel was locked, the rest of the production was a pure pleasure. "Bill Polson, our supervising TD, told us, 'Don't worry about the technology. You tell us what you want. It's our job to figure out how to get it for you,'" said Andrews. The two directors told Polson that they wanted to be able to create a city that had a sense of age to it; one that had the varied appearance of a city built up gradually over time. The technical team came back with a program that built varying degrees of deterioration into five basic buildings. Recalled Andrews, "You'd just slide this knob, and the building would get worse or better, or worse or better—it was fabulous! You could control how messed up the roof tiles were, whether the shutters on the windows were open or closed, even the

type of shutters on the windows, just by moving the sliders. So with five buildings, four roofs, and two different kinds of windows, we had this entire city."

Production designer Ronnie del Carmen's playful character designs patterned the looks of the musicians, Bass and Treble, on the directors. While the directors concede that analogies can be made between themselves and their creations, they insist that any similarities to real persons are, on their part at least, entirely unintentional.

"Of course a lot of ourselves ended up in the movie," said Jimenez, "but the film is about two musicians who do the exact same thing and want the exact same thing. Part of why I think the dual director thing worked is that Mark and I have different strengths."

Andrews nodded. "Me and Andy's true-life relationship is much different," said Andrews. "He raises the bar, I raise the bar. Instead of competing against each other, we inspire each other to get better. In that way, our relationship is closer to our original story, which ended up with them collaborating and making this new music and being happy. But we had to have our characters do something different, because collaboration's not funny. Competition is funny."

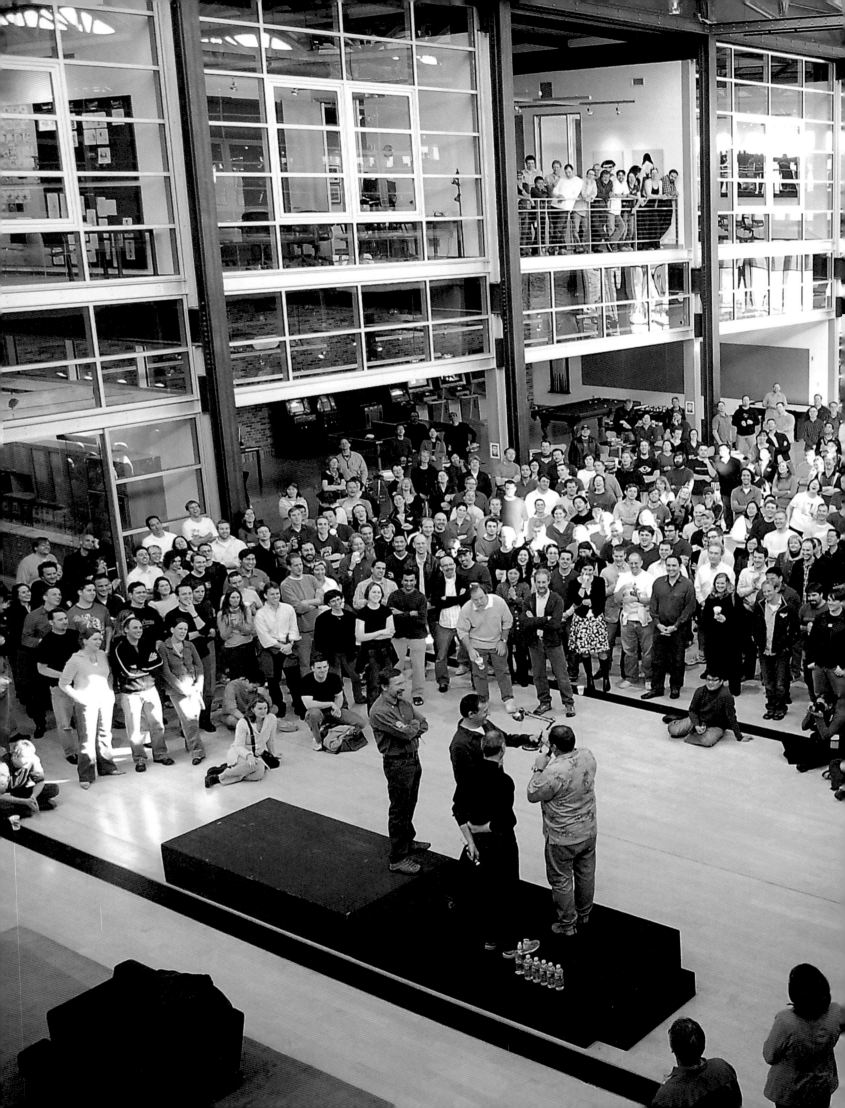

Pixar Joins with Disney

"Pixar's history separates extraordinarily cleanly into decades. The first ten years was going from nothing to Toy Story, becoming a production company and achieving our goal of making the world's first computer-animated feature film. The second goal was to go from a production company making one film every four years to a studio making a film a year without losing one molecule of quality. And the second era of Pixar took ten years, too."

—STEVE JOBS

As Pixar neared the end of its second decade, undoubtedly the biggest question facing the studio was how to proceed after its present distribution deal with Disney had run its course. It was a question Steve Jobs had been mulling over for several years.

Jobs observes that part of what made it possible for him to head up two companies at once for twenty years—NeXT and Pixar from 1986 to 1996; Apple and Pixar from 1997 to 2006—is that the companies are such different environments. At NeXT and then at Apple, he said, he oversees everything in detail, in the same way that a director at Pixar knows every part of his or her movie. At Pixar, however, he leaves the moviemaking to the moviemakers, and he focuses purely on the big picture for the studio: its competitive context and its long-term needs. This means that the pace of his decision-making is also different for each company.

"At Apple," he said, "there are ten *really* important decisions to make every week. It's a transactional company; it's got a lot of new products every month. And if some of those decisions are wrong, maybe you can fix them a few months later. At Pixar, because I'm not directing the movies, there are just a few really important strategic decisions to make every month, maybe even every quarter, but they're really hard to change. Pixar's much slower-paced, but you can't change your mind when you go down these paths."

Picking the right partner for Pixar's films beyond *Cars* would be especially important because of the profound changes that were taking place in the movie business. "The whole industry's in flux now," said Jobs in 2005. "Not just animation. The entire film industry is in for major changes. Home theaters are getting better, but movie theaters haven't even gone digital yet. New distribution methods are opening up. The theater-to-DVD windows are shortening, and there are so many movies that the shelf space for each movie is reduced. The whole business is in a lot of turmoil."

Previous spread: The company meeting at which it was announced Pixar would be bought by Disney.

in 2003. "We've had four pictures to date, and they've all been relatively successful. So, participation in the movies' success in the future," I think Pixar has proven itself," said Jobs effectively producing the movies independently, Pixar felt that it had a fair claim to greater somewhat less than half of the proceeds of every film it made. But considering that it was of the film's profits before the rest was split between the two companies, Pixar took home the studios became 50-50 partners in the films. Since Disney Disney took out a distribution fee out

When Pixar renegotiated its distribution deal with Disney after the release of *Toy Story*, was soon capable of standing on its own both creatively and operationally.

input from many of its collaborators at Disney, like Tom Schumacher and Dick Cook, it had also shown itself to be a quick study. Though it valued and would continue to seek us how to do things on the production side. I give them a lot of credit for that." But Pixar "I'm convinced we would have crashed and burned on *Toy Story* without Disney showing experience had been essential in helping the young studio find its footing. As Jobs put it, from day one, doing its utmost to help every film find its audience, and Disney's production

Disney's marketing and distribution network had given Pixar's films first-class treatment and a healthy balance sheet.

running in the red to a bona fide studio with a bought-and-paid-for production facility the Disney portfolio, and they had transformed Pixar itself from a commercials house today without it. "The Pixar films had consistently been among the best performers in history, and it's been the best thing that ever happened for Pixar. We wouldn't be here partnership with Disney has probably been the most successful partnership in Hollywood

Signing with Disney in 1991 had been a windfall for both companies, Jobs said. "Our

Disney

both now, and through the changes sure to come?

Given the changes that would take place in even the next three to five years, Pixar knew it had to weigh its choice very carefully. Who would be the best company to partner with,

Top: Left to right, Ed Catmull, Steve Jobs,
Bob Iger, and John Lasseter.

we're in a pretty good position as a studio to be able to negotiate a new agreement with Disney or someone else whereby we keep a much greater share of the profits than just the roughly 40 percent we keep now."

Pixar was barred from talking to other studios about a new deal until after it delivered the third of its five films to Disney. Since *Toy Story 2* was not counted as one of the five, it was only after Pixar delivered *Finding Nemo* in the spring of 2003 that it was able to fully investigate its options for a post-*Cars* life.

Clearly, there were a lot of practical reasons to stay with Disney. At the time *Finding Nemo* was delivered, the Pixar-Disney partnership was four-for-four—a track record unprece- dented in the industry. Disney's historic and continuing significance to family entertainment and Pixar's reputation for quality and innovation, combined with the companies' shared roots in animation, complemented one another in a truly unique way. Disney's market- ing and distribution teams were the best in the world at promoting animation, and their network of theme parks was an asset no other studio could match. Furthermore, the two companies would always be connected through their joint ownership of Pixar's first seven films.

With this in mind, and assuming Disney was willing to offer competitive financial terms, it was clearly most logical to stay with Disney—unless there were compelling reasons not to.'"In the early days of our relationship with Disney, we didn't look at the contract," said Catmull. "And it's always a sign of a good relationship when the contract goes in a drawer and you don't look at it. But near the end . . . we started to look at the contract."

Sequels

Given the different personalities and diverging needs of the two companies, as well as their long history together, the question of how best to proceed was a difficult knot to untie. One example of a complicating issue between the two studios was their differing attitudes toward sequels.

Pixar had the right of first refusal in the production of any sequel to its movies, but it could not block Disney from making a sequel if Disney wanted to do so. It was Disney's biggest point of leverage over the younger studio, and predictably, the site of the first notable rift in the relationship—*Toy Story 3*.

When *Toy Story 2* was changed from a direct-to-video release to a theatrical film, Pixar had completed and delivered it without asking to have it count toward the five films of their deal. "We did it because we'd started it and we were going to follow through with it," said Catmull. "Any future sequels, though—including *Toy Story 3*, which Pixar had a great idea for and which both Disney and Pixar wanted to see made—would only be feasible for Pixar if they counted toward the five films they owed Disney. Otherwise, every time Pixar made a film featuring characters it didn't own, and that it would have to split profits on, it was forgoing the opportunity to make a film that they would own, and that they would keep full profits on.

As Catmull said, "We were a public company, and our investors on the outside had built into their plans the fact that we were going to come to the end of the five films for Disney and start making films we owned outright. And we really didn't have the leeway to just throw in another film and not have it count. So we felt that *Toy Story 3* should count, especially since it would clearly be a good deal for both parties."

Executives at Disney, however, felt otherwise, informing Pixar that they would not accept *Toy Story 3* as one of the five movies it owed. In time, they made it clear to Pixar that Disney would eventually make sequels to *all* of the Pixar films, with or without Pixar's participation. As painful as it was to contemplate someone else making *Toy Story 3*, Pixar decided it could not back down on the issue. "They wanted a sequel to every film at a film a year," said Catmull. "That was more than we could handle even if we wanted to do some." If they gave in and made the projects simply to protect their characters, they would be compromising their creative future—they'd have to either fill their plate with sequels, or resort to the "'A team/B team" caste system they had repudiated on *Toy Story 2*.

Changes

In January 2004, Pixar announced that it was breaking off talks with Disney, and that it would begin to explore distribution options with other studios. John Lasseter described the day of the announcement as one of the worst in his life. "Steve Jobs stayed at the negotiating table with Disney about two to three years longer because of me. Because I wanted our characters. These characters are like our children, and it just killed me to think of the people who forced *Cinderella II* into existence making sequels to our films, running our characters into the ground. I fought and fought and fought, but finally got to the point where I realized, we can't do a deal with them." As saddened as Lasseter was at the prospect of leaving the studio's characters behind at Disney, he realized, that to continue in the relationship under the existing circumstances would have compromised the studio's future.

"We were going to go off and create great new characters in the future; it was going to be fine, but it was still really hard. Creating the characters for our films took thirteen years of our lives. We're not like the guys doing the deals; they can close the deal, congratulate each other, and then—they're done. They walk away. We were going to be starting all over again. You reboot the computer and your hard drive's empty. But what else were we going to do? We had no choice—we could not have made a deal with Disney as it was."—JOHN LASSETER

Pixar's future after the current deal expired had been the subject of idle speculation for years, but the announcement that Pixar had officially broken off talks with Disney created a new sense of anticipation within the company. Everyone hated the thought of leaving Pixar's characters behind, but at the same time, the company was clearly about to enter a new era, and people were excited to see what lay over the crest of the hill.

Pixar had begun to meet with other studios, but as the year progressed, it became clear that Disney might soon be under new management. Roy Disney, who had been ousted from the Disney board the preceding year, had begun a grassroots campaign to replace CEO Michael Eisner—reminiscent of the coup he staged in 1984 that had brought Eisner to Disney in the first place. Rumbling dissatisfaction with Eisner seemed to coalesce around this effort, leading to a shareholder meeting in March 2004 where an unprecedented 43 percent of Disney shareholders refused to reelect Eisner to the company's board of directors. The event set off a yearlong tectonic shift at Disney, centered around the question of when a new CEO would be announced, and who that person might be.

After Eisner announced in September 2004 that he would relinquish Disney's top post in two years, the company's board of directors initiated a formal search process for his successor—one that would consider external candidates as well as the company's current president, former ABC head Bob Iger.

In an earnings call in February 2005, Jobs told analysts that since changes at Disney could prompt a game of "musical chairs" at the major studios, Pixar would suspend talks with any studios until changes were announced and the dust settled.

The following month, Michael Eisner announced that he would step down as CEO on September 30, a year early, to be succeeded by Bob Iger. In interviews given after the announcement, Iger, who would begin exercising authority over the company in the interim, said that reopening a dialogue with Pixar was a major priority.

Pixar employees, who had observed with keen interest the occasional groups of visitors in business suits, pricked up their ears. In earlier company meetings, Catmull, Lasseter, and Jobs had said that they hoped to have a distribution partner in place by Summer 2005. Cars had been bumped from a Winter 2005 to a Summer 2006 release, postponing the ultimate deadline for a new deal accordingly, but things were still starting to feel a little close. Ratatouille, Pixar's first wholly self-financed film, was due to come out in Summer 2007, a year after Cars, and marketing campaigns and toy planning usually began at least two years in advance. But summer of 2005 came and went; fall became winter. The possible terms of a new distribution deal had long been fodder for watercooler conversation in the studio, but as news-media chatter speculating on the negotiations grew louder, such hallway conversations grew quieter. Those in the studio wondered, What on earth could be taking so long?

Company Meeting

By January 2006, just about every possible permutation for a Pixar-Disney relationship had been extensively debated in the entertainment business media or on online animation or business chat boards. Comcast's failed bid to acquire Disney in February 2004 had inspired observers to new heights, including "Apple merges with Disney" and, prior to Iger's ascension to CEO, "Jobs leaves Apple for Disney." But in the second week of January, rumors that Disney was about to acquire Pixar broke from the background buzz of speculation and started making their way up the ranks of news outlets, gathering steam (and detail) as they climbed.

Pixar had grown to almost 800 people by then, but it had always prided itself on its ability to keep secrets like a small company—a discipline that had made it possible for information to flow freely inside company walls. Pixar employees, accustomed to getting their studio news straight from the source, didn't quite know what to make of the tidal wave of increasingly likely-sounding gossip that was heading toward them.

"Two more weeks," said Tom Porter to Neftali Alvarez as Alvarez scootered past him in the hallway. "Two weeks until what?" asked Alvarez, braking to a halt. "Two weeks until our twentieth birthday." "Ah, that's right," said Alvarez. "Think we're going to make it?" Porter asked.

On January 24 at 1:06 p.m., Ed Catmull sent an e-mail to Pixar's studio-wide mailing list: "We would like all employees to assemble in the Atrium at 1:15 p.m. Please ask any visitors you may have to leave the building prior to the meeting. Thanks, Ed."

The studio often held company meetings in the atrium. People usually gathered gradually over the course of about 10 minutes, chatting with their co-workers until Catmull or Lasseter stepped up onto the portable platform that was wheeled out for such occasions and asked for everyone's attention.

But this one was different. Seconds after the e-mail went out, people immediately began streaming into the atrium, either silent or whispering in hushed tones. Most of the conversation occurring in the crowd appeared to be taking place in the form of exchanged glances. Even the odd whisper ceased as soon as Catmull, Lasseter, and Jobs walked into the atrium. They stepped up onto the platform, each carrying a hand-held microphone.

Silence lay thick and heavy over the crowd.

"'At this moment,' said Jobs, 'a press release is going out over the wires announcing that Disney will acquire Pixar.'

The three men weren't surprised to see the wave of astonishment that spread over the company at the confirmation of what had once seemed to be an outlandish rumor.

"'Legally, we absolutely could not say a word about the negotiations while they were going on,' said Lasseter. 'So it *killed* us that the news got leaked before we were able to announce it to the rest of Pixar ourselves. Because we knew every single person at this studio had to be in exactly the same place that Ed and I were in three or four months earlier, when Steve first told us that Bob Iger had brought up the notion of Disney buying Pixar. We knew the Eisner Disney was still really fresh in everyone's minds, just as it had been for us back then. But Steve had simply said to us, 'You have to get to know Bob.'"

Something Different

Bob Iger had begun talking with Jobs during the summer of 2005 about a possible renewal of the distribution deal. Iger said, "As I neared the day that I was going to become CEO, and I started to focus more and more on the future of the company, it became clear that for Disney to truly be successful in the future, we had to return to the glory days of animation. Doing that, of course, really begins with finding the right people. And the more I thought about it, the more I realized that Pixar had more of the right people than probably any other place in the world, from an animation perspective. I had to try to figure out a way to either find people of that caliber or stay in business with Pixar in some form to tap into that great talent."

In September, shortly before Iger officially took charge, he went to the ribbon-cutting of Hong Kong Disneyland, where the opening ceremony parade prompted a sobering realization. "It hit me that the characters that were in the parade all came from films that had been made prior to the mid-'90s—except for some of the Pixar characters," he said. "I felt that I needed to think even more out of the box than I had been thinking, and I had a much greater sense of urgency.

"I became CEO on October 1. I called Steve around that time and said I thought we ought to talk; I had some bigger ideas.... That began a long period of discussion, because it was very serious for both sides. Steve really needed to feel comfortable that Pixar was in the right hands—that Disney's approach to managing Pixar, if we owned it, would respect its talent and culture. He was also deeply respectful of John's and Ed's opinions and said at the beginning that this was not something that he would contemplate doing unless they were really supportive."

On Jobs' recommendation, Catmull and Lasseter had separate dinners with Iger. After years of feeling like they were on a different page from Disney management, the two men remember being very pleasantly surprised by how similar their and Iger's values seemed to be.

Top: Steve Jobs announcing Pixar's acquisition by Disney. "The times when it's been best for Pixar have been when we can just focus on making movies and not worry about the other stuff," he said.

But Iger didn't just want Pixar to remain Pixar. He wanted to restore Disney to Disney.

impressed with that."

changing the world," said Catmull, "and he was determined to be ahead of it. I was very Jobs, about the new atmosphere at the company. "Bob recognized that technology was Disney the first studio to endorse the new format spoke volumes to Catmull, as it had to shows available for download on iTunes. Iger's willingness to go out on a limb and make and Jobs had first gotten to know one another in their discussions to make ABC's television Before they had even met, Catmull had been struck by Iger's vision for Disney's future. Iger

the studio and the importance of maintaining its quality."

person than we had been used to dealing with. He understood the value of animation to light-years beyond what they had been expecting. "Bob was a totally, completely different genuinely committed to preserving what was unique about Pixar, was in and of itself The fact that Iger had that experience and perspective," Catmull said, "and that he seemed

make sure it stayed healthy.

went through, he would be paying a lot of money for Pixar, and it was in his interest to on his watch be done in the right way. It went beyond principle, he pointed out: if a deal being absorbed into a larger company, and he was determined that any merger taking place his time with ABC. The experiences had taught him the perils as well as the possibilities of As Iger explained to both Lasseter and Catmull, he had been through two acquisitions in

"Well, I'm different.'"

that they haven't mishandled. How's it going to be different with Pixar? And he said, "I said, 'I'm sorry Bob, but there's not one thing Disney has acquired in the last ten years Lasseter liked the man and appreciated his honesty, but he didn't pull any punches.

been built around it. And, he said, he recognized that the core was broken." animation is to Disney. It's the heart of the entire company; the whole organization has talking, and, you know, I really liked him. He knew from the beginning how important "Bob actually came up to have dinner with me at my home," said Lasseter. "We started

studio's birthright of hand-drawn animation.

Disney had been so influential to both Catmull and Lasseter; as red-blooded animation fans they couldn't help but want to see it get better. If they were to take charge of Disney animation, they could try to help bring it back to what it once had been. They could restore the

Steven Lavine, the president of CalArts, recalled that as the school had begun to move into teaching computer animation a few years earlier, it had consulted with many of its alumni working at Pixar. "It was interesting the extent to which they affirmed the importance of the 2-D curriculum, and that, while it was important to introduce the students to computer skills, the heart of their education should remain the traditional crafts of drawing, design, story-telling, lighting, camera, and the rest. I think we probably would have gone more completely into 3-D, but for Pixar's urging that we not lose the values that are carried by that tradition."

A few years earlier, Disney management had gone so far as to shut down hand-drawn animation at the studio—a shocking development within the industry, and one that had uniformly saddened Pixar employees. As proud as they were of the success of computer animation, they had always seen it as simply a part of a larger tradition that, to be healthy, should rightly encompass many different forms.

Jobs had been right—it definitely was not business as usual with Iger. "I really started believing that this guy is different, believing this guy could do it," said Lasseter. "And then it started going back into that core of me, of how much I love Disney—not the Disney that the company had become over the past decade, but the Disney of Walt Disney. It really pained me to see Disney meaning so much less to families than it used to mean."

"What Bob was proposing went beyond saying, 'Well, we'll buy you guys and let you alone,'" said Catmull. "That's the path they could have taken. And that might have succeeded. But Bob was committed to making fairly dramatic changes to Disney to get it back where it should be. So he didn't want to make a half step. He wanted to make a bold move, and the bold move was to acquire the company and put feature animation under us, and to give John a creative role in the theme parks. He said, 'I want you to help me change animation here. And I will give you the authority to do that.'"

But they weren't making the decision for Disney. They were making the decision for Pixar.

What was best for Pixar?

Protecting Pixar

"Our number-one priority was protecting the culture that we'd built and the way our people work together," said Catmull. "A real creative community is a rare thing, and it is the most important thing for us to hang on to. I mean creative in the broad sense of story, art, production, and technology. Our primary job is to make sure that we keep it alive and healthy."

This community, he explained, had three major parts. There was a group of directors who worked well with one another. Those directors were supported by an entire studio of talented people. And the community at large was one in which honest and critical self-analysis was the norm.

"As a company, one of the great assets we have is a whole group of people who are always consciously trying to improve on what we're doing," Catmull said. "They will look at the work they are doing and say, 'This is our career; we want to keep on doing this. So if what we're doing isn't going to work in two years from now—whether that is our story, or our software tools, or our production habits—then we've got to start changing now.' I just love that about this place."

What made it possible for the whole system to run as it did was that people were able to make the right decision for the long term even when there were strong short-term arguments against it. When the story wasn't good enough, they stopped and fixed it. When the system was working well, they deliberately changed things to see if a different way would work better. It was essential, going forward, for that autonomy to be preserved in order to preserve the culture as a whole.

As Catmull, Lasseter, and Jobs explained to the employees assembled in the atrium, they had come to a fork in the road. Disney could not see its way clear to continue the relation-

Top: John Lasseter explained in further detail the reasoning behind the decision. "We'd reached a point where we couldn't just keep going straight ahead," he said. "We'd reached a 'T.' We had to go left or right."

ship on a distribution-only basis, so Pixar could no longer continue along the path it had been following. Pixar had to make a significant change in direction—a hard left or a hard right—and either join up with Disney or strike out on its own as an independent company. As Catmull explained, each path had its own risks.

The general sentiment at the studio seemed to favor going independent. Alone, Pixar wouldn't have had to worry about the internal currents of a big corporation; it would have been perfectly free to chart its own course. "And there was strong advocacy for that path," said Catmull. But as they looked at the situation, he said, there were obstacles they could see that were not obvious on the surface.

If Pixar were to establish itself as a fully independent entity that simply contracted out for its distribution network, it would have to develop a greater infrastructure to deal with its new marketing and consumer products needs. "All of a sudden there would be another two to three hundred businesspeople in the company, and that would be a risk to the culture," said Catmull. What's more, they would have to scale up these departments quickly. "Building an organization takes a long time. It takes a long time to learn how to do something right, and it also takes a while to get the right people. In fact, one of the reasons Pixar has been successful is that we took our time building it. So now we'd be saying that we have to build these organizations quickly. And that's a high-risk proposition."

Furthermore, even this trade would not necessarily guarantee Pixar's creative autonomy over the long term. In order to be able to make the right creative and organizational decisions for the long term, Pixar needed to have the financial backing to make tough short-term decisions when necessary. At first, Pixar had been protected by Steve Jobs, who funded the company while it was finding its feet. Once Pixar went public, it had been protected by its track record of perfection at the box office, which not only insulated it financially but earned it the latitude from its shareholders to make decisions as it saw fit. But in the expensive and often fickle movie business, it's dangerous to be in a place where you have to rely on perfection to keep your head above water. Realizing this, and antici- pating a day when it might need to strike out on its own, Pixar had saved as much money as it could, and kept it liquid. Its billion-dollar bank account was a sizable nest egg by any

Top: Disney CEO Bob Iger was the last person to take the stage at the meeting. Iger spoke about animation's central role to Disney, saying, "To have Pixar come in is really important."

Chapter 14: Pixar Joins with Disney

standard. But while it surely had enough to weather one flop, there was no guarantee it could weather a spell of bad luck.

In the short term, going independent would have meant assuming greater financial risk (funding 100 percent of their films) in exchange for what would hopefully be smaller cultural risks (no interference from a parent company). But in time, those financial risks had the potential to become significant cultural risks themselves. In the fall of 2005, Pixar's stock was, as its board of directors put it, "priced to perfection." In other words, the current share price reflected an expectation by the market that the company would produce nothing but hits for the next five to ten years. "Therefore," said Lasseter, "the stock wasn't going to go up just by us continuing to do what we were doing. And at a certain point," the directors said, the shareholders would have begun to demand growth. So if we were all on our own, we would've had to start doing something more than just making one great movie a year—for financial rather than creative reasons. We'd need to start making more movies a year, doing TV, doing live action, doing something to make the company's business grow. And that, Ed and I felt strongly, would really change the culture."

Pixar had been willing to accept these substantial risks because, in their opinion, they still posed less risk to the heart of the company than joining with Disney in the company's previous incarnation would have.

"If we joined up with another company, we could have been changed by that company," Lasseter said. "With Disney, we would have been a little company coming into a much bigger one, and the culture of the larger corporation could have overwhelmed us." Before they had met Bob Iger, this had seemed a virtual certainty, which is why over the past few years the studio had been quietly preparing itself for the possibility it would need to go independent.

But Bob Iger was promising Pixar autonomy at Disney, and backing up his words with actions—offering Catmull and Lasseter authority over Disney animation as a whole, not just Pixar. And when they compared the independent path with this new alternative, they decided that joining this Disney was the best way to protect what they valued most about the company they had worked so hard to build.

Catmull, Lasseter, and Jobs realized that if they could set the right protective measures in place, allowing Pixar to be acquired by a Disney they could trust would actually allow Pixar to remain closer to "itself" than being independent would have. They would be able to keep their characters and ensure they were taken care of. As a subsidiary of a larger company with many different businesses, Pixar could stay focused on producing great movies, without being pressured to expand into different arenas or come up with new sources of growth. There would be no need to build up a marketing infrastructure alongside the creative infrastructure.

Protecting Change

Said Catmull, "When we announced that Pixar was being sold to Disney, the rest of the company was extremely surprised because they couldn't figure out why we would do this. So we met individually with each of the groups in the company, and we went through the whole logic of why this was the right thing to do. By the end of that, everybody understood the decision, and we didn't lose a single person in the process. It was really amazing, but once they got it and they realized what the opportunity was for all of us, they got completely behind us.

"Outside, a single film could have taken us down. We had no stability. There were all kinds of things that could go wrong. But we felt like, if we did it right, and we had confidence in this new management, then we'd actually be able to protect the kind of change that we went through. Not protect things to be the same, but protect the way we change things. Can we protect it forever? It's too hard to say, because nothing ever stays the same.

"But I think we've got the right spirit, which is why we're taking on the challenges. It's a spirit of doing something different every time. And I feel like we are in the best place to do that. We've got the best kind of support here."

Over the years of failed negotiations, said Catmull, Disney and Pixar had found themselves going down different paths. "Suddenly there was this twist of fate and the right things fell into place at the right time. The things that had been driving us apart suddenly all got taken care of, and it worked out great for both parties. Which is not always the outcome of mergers. Even though it's an unexpected turn of events, it feels like this is the true culmination of the building of Pixar and this amazing company into something that will continue to make waves on into the future."

"Pixar's had this wonderful way of always making everything be at a beginning, with great promise. Just when it looks like maybe things would be going stale, it's back to a great, fantastic beginning with incredible potential all over again. That is so important to something that's going to continue to prosper and grow." —RAY FEENEY

Top: February 2006, Pixar's 20th anniversary company photo.

Conclusion

"A story is something you can make, but the soul cannot be made. Pixar is still a young studio. In producing more films, its style may change or its stories may change. But as long as it keeps its soul and heart, the studio will be able to survive." —HAYAO MIYAZAKI

Said Lee Unkrich, "I think the thing that has allowed Pixar to be successful is that all the creative and management decisions, from the top down, have been about trying to make the best films possible. There are obviously people here who worry about money and budgets, as they should, but for Steve and John and Ed, it's always about trying to make really great films, and that filters down through the entire company and every level of management. These are long-term investments that we're talking about—no one is willing to make a creative decision to solve a short term problem that will hobble the film and make it less special in the long run."

Pete Docter agreed. "There are people I've worked with in other places who are every bit as talented as the people here, but it seems like the thing that makes Pixar different is the opportunity and the will to do something over and over and over until it's right."

"We've pioneered the whole medium of computer animation, but John once said—and this really stuck with me—'No amount of technology will turn a bad story into a good story.' I think one of the unique things about Pixar is that we've been willing to stop the train when we know it's not great. That train's a very expensive train every day you stop it. There's the best people in the world sitting there twiddling their thumbs, while the story is being fixed. But to a greater or lesser degree, we've done that on every film we have made. And that's one of the things I'm most proud of this studio for, because I think that courage is something that really sets Pixar apart. That dedication to quality is really ingrained in the culture of this studio." —STEVE JOBS

The Whole Is Greater Than the Parts

Pixar's biggest asset in the pursuit of its goal of making great films has consistently been its collaborative approach to problem-solving. Said Ed Catmull, "Everything successful that I've ever been involved with has worked because there was a core group of people about whom you could really say that the whole was greater than the sum of the parts. Pixar, on

every level, has always been a joint effort with a group of people who spark on each other, who rely on each other and build on each other's strengths, and together make things happen that wouldn't happen otherwise.

On a corporate leadership level, Catmull, Lasseter, and Jobs have used their complementary skills to build a studio that regards every part of the company as essential to its larger goal. "We've always looked at the studio as having four legs to it," said Jobs. "The creative leg, the technical leg, the production management leg, and the business leg. And the heads of all these parts of the company work together as a team, to make sure that we're building the best studio in the world."

Jobs credited Catmull in particular with setting the egalitarian tone of the studio. "Pixar did an impossible thing," said Jobs. "It blended two cultures together to make its own culture. It blended the creative culture of Hollywood with the high-tech culture of Silicon Valley. These cultures do not understand each other at all. Silicon Valley thinks the creative process is a bunch of young guys sitting around drinking beer, thinking up one-liners. It couldn't be farther from the truth. You know, I've seen it with my own eyes; the creative process is as hard and as disciplined as any engineering process.

"The opposite is true as well. Hollywood thinks the technology is something you can just go write a check for and buy—that there's no creativity involved at all. And that couldn't be farther from the truth either. The best scientists and engineers are just as creative as the best storytellers, just in a different way. You can't go buy technology like we have. Pixar's had to invent this all and we don't sell it.

"The Pixar culture, which respects both, treats both as equals. There are no second-class citizens here, and that really has been Ed's vision. Another thing that Ed's always said is we have to hire people smarter than ourselves. And Pixar's done that. The talent at this company is unbelievable. It's the densest group of really brilliant people that I've ever seen in my life. It's amazing."

The Best Idea Wins

"I go in to work every day knowing that probably 90 percent of everything I create, draw, or think of will be thrown away—by choice. That's just as it should be to make a fine film. Only the best ideas can survive. That turnover keeps the movie in constant flux: You start by telling the film what you would like it to be, and then eventually the film tells you what it must be." —BOB PETERSON

On a creative leadership level, Pixar's institutionalized practice of peer review—each project is collectively reviewed by all of the directors at the studio on a regular basis—has created an unusual creative community in which the directors of the different films constantly support, critique, and learn from one another. Said Gary Rydstrom, Pixar's longtime sound designer and now a director at the studio. "I've worked on enough movies to know that the way they are made nowadays can be very disconnected. People and parts of the process don't see each other, don't talk to each other, work in different cities. So making a movie can be a very lonely thing; you and your crew just make your movie in your own world. What I like about this company is that it's the kind of place where even if you're not on someone else's project, you're asked at some level to be involved. It's not moviemaking by committee: there is always the singular vision of the director making the film, but the project is open to comments and ideas from people not even on their team. That collaboration across projects is great. It makes you feel like you're part of the studio, not just doing a film

and using the studio as a way to accomplish it. It feels very communal that way, and creativity thrives in that kind of atmosphere."

These review sessions are not for the faint of heart. As Lasseter said, "When you set foot in this building, you have to be able to check your ego at the door. We're honest with each other; we'll tell people when it's not good. And sometimes you don't want to hear it. It happens to me the same as everybody else. But if they're right, you have to be able to take their note."

Brad Bird, one of the few directors at Pixar to have spent the majority of his career elsewhere, finds the atmosphere uniquely inspiring. "I think that the idealism that I've had about filmmaking, an idealism that reality oftentimes tried to knock out of me, has been allowed not only to come back but to flourish at Pixar. People here love film so much that we can't imagine doing anything else, and because we love it, we don't let each other off the hook; we challenge each other. And I think that is a really healthy atmosphere in which to do good work. If you're always questioning, and allowing yourself to be humble enough to take your licks, and accept the idea that your work can always be improved, then you're much more inclined to learn from other people's projects and become better."

Fellow director Brenda Chapman, another veteran of the Hollywood studio system, agreed, pointing out that the peer review format is a safety net as much as a gauntlet. "You have every opportunity to succeed here," she said. "All the notes always come from a place of, 'How can we make this better and help this director succeed?'—which is kind of amazing, if you know anything about the way Hollywood usually works. Even if at some point or another someone doesn't like your film very much, there are always other people who are trying really hard to help you make it work, to make everything click so that that person can get on board."

The notion that "the best idea wins, no matter who it comes from" applies not only between directors but within the studio as well. Once a film has reached a certain level of progress, it is screened for the entire company, and all employees are encouraged to submit their thoughts. For although the director's vision is the engine that powers the whole machine, he or she relies on a host of others in order to bring the best film possible to the screen.

As Lasseter put it, "From top to bottom, this studio is about the people. I'm good as a director only because of the people around me. I love being inspired by them, and being able to inspire them in return. There's nothing better than being able to give someone an idea they hadn't thought of and having that idea come back a hundred times better than you'd imagined."

Making Movies to Be Proud Of

On paper and in person, today's Pixar Animation Studios is very different from Pixar the hardware-software-animation company of 1986. The success of Pixar's feature films, from *Toy Story* to *Cars*, has given the studio resources it could never have dreamed of twenty years earlier, and it has helped take computer animation from a novelty to a mainstream art form. "*Toy Story* was a milestone in the history of animation," said filmmaker and animation scholar John Canemaker. "It made a tremendous impression on audiences around the world and it has spawned an industry of people trying to emulate that success."

"I remember seeing the very first bits of 3-D animation and thinking ahead to all of the amazing things that the medium could do," says John Lasseter. "I love that we've been able to be a part of making that come to reality."

But Pixar's first ten years are what make Carmull, Lasseter, and Jobs take the success of its second ten years with a grain of salt. "Luck plays a significant part in these things," said Carmull. "Perseverance and picking the right people, these things do matter. But if something had gone just a little differently somewhere along the way, ours could've been a very different story, and no one would be hearing about us. You can't let these things go to your head."

As a result, the studio is much more concerned with its health as a company than with always aiming to outdo itself at the box office.

"If you get into the trap of focusing on box office, there's almost no result that's satisfying. If you make the most money of all time, you wonder, 'Why didn't I make $10 more?' From my point of view it's just great to make something that I wanted to make, and have it be profitable so I can make another one—to have the people who took a risk with me be rewarded for taking that risk. That's quite enough for me. I just want another chance at bat."

—BRAD BIRD

Said Lasseter, "I've always said to Ed, 'If we can do three things, we're going to have a successful studio. One, give people jobs that they can be creatively satisfied in—give them creative oversight in their work, and make great movies they can be proud of for the rest of their lives. Two, pay them a fair wage so they can buy a house and live a good life and send the kids to good colleges. And three, have fun, because it ends up on the screen.'

"I met a family that lives in Sonoma, where I live, and the little girl's grandmother was an 'ink and painter' on *Snow White*. To this day, she talks of what her grandmother did with such pride; you just know that story is going to be handed down to her children, and to her children's children. And I always said to myself, that's the level of quality we have to aspire to at Pixar. We devote so much of our lives to making these films—let's make films that our families can be proud of for the rest of their lives."

Every Day Is the Beginning

Having slowly but successfully achieved its goals of becoming first a production company, then a studio, Pixar marked the beginning of its third decade by throwing its lot in with Disney—a move that, for a company proud of its built-from-scratch roots, at first seemed like a distinct break with its past. But one year after the merger, said Ed Carmull, things are working out beautifully. "Disney made certain promises to us. Now we're a year into it, and they've lived up to all their promises. They've supported us, they want us to be healthy, and so we're still the same company, except for the normal sort of variation and changes any group goes through. In fact, now that Pixar is a part of Disney, we are starting to see opportunities that we never would have seen if we had simply remained their partner. It's gone better than we ever could have dreamed."

Carmull, Lasseter, and Jobs all have considerably different roles now—Carmull and Lasseter oversee both Pixar and Disney Animation, and Jobs, in addition to his duties as part of the six-person Pixar and Disney Animation oversight committee, sits on the Disney board. But

as far as the daily life of the studio goes, in terms of the way decisions are made for the films, "very little has changed," Pete Docter said. "The way we make films today is more or less the same way we've done it from the start."

And that, of course, means that the studio constantly finds itself at the beginning of its story, straining to see what the future will hold. Because for the people who work at Pixar, every new movie starts from a blank slate.

"When I first came to Pixar," recalled Andrew Stanton, "animation was such a small group. We were sort of like kids who could get away with anything because no one was watching. What amazes me is everybody's watching now, and we still get that same artistic freedom. That really makes you want to not screw that up. Getting to make a movie is such a massive privilege; so few people get the opportunity to do it to begin with, and the number of people who get to do it again is even smaller. So every time you get that chance, you should be doing everything in your power to make it the best damn thing you possibly can."

"The films never get easier," said Catmull. "The reason they never get easier is that we're trying to push the boundaries every time and put something up on the screen that has never been seen before. I hope we never miss, but to some extent, if we're taking risks, we're bound to miss some, and if we aren't taking risks, we'll die. So for us, it's about maintaining a spirit of innovation that will continue on for many years."

"These films take a long time to make. People often ask, 'How can you possibly work on something creatively for four years and still be into it?' But I know that every day coming into Pixar, I'm going to laugh at least once as hard as I can. Every day I'm going to see something I've never seen before in my life. So every day I walk into work excited to see what the day will bring."—JOHN LASSETER

Academy of Motion Picture Arts and Sciences Awards

1986

Nominee, Best Animated Short Film
"Luxo Jr." – John Lasseter, William Reeves

1988

Best Animated Short Film
"Tin Toy" – John Lasseter, William Reeves

1991

Scientific and Engineering Award
Computer-Assisted Production System – The CAPS Development Team: Randy Cartwright (Disney), David B. Coons (Disney), Lem Davis (Disney), Thomas Hahn, James Houston (Disney), Mark Kimball (Disney), Dylan W. Kohler (Disney), Peter Nye (Disney), Michael Shantzis (Disney), David F Wolf (Disney), the Walt Disney Feature Animation Department

1992

Scientific and Engineering Award
RenderMan – The RenderMan Development Team: Loren Carpenter, Rob Cook, Ed Catmull, Tom Porter, Pat Hanrahan, Tony Apodaca, Darwyn Peachey

1994

Scientific and Engineering Award
Film Input Scanning – Gary Demos and Dan Cameron (Information International), David DiFrancesco and Gary Starkweather, Scott Squires (Industrial Light & Magic)

1995

Special Achievement Award (Oscar)
Toy Story – John Lasseter
"For his inspired leadership of the Pixar Toy Story team, resulting in the first feature-length computer-animated film."

Nominee, Best Screenplay Written Directly for the Screen
Toy Story – Screenplay by Joss Whedon, Andrew Stanton, Joel Cohen, Alec Sokolow; Story by John Lasseter, Peter Docter, Andrew Stanton, Joe Ranft

Nominee, Best Original Musical or Comedy Score
Toy Story – Randy Newman

Nominee, Best Original Song
"You've Got a Friend in Me" (Toy Story) – Randy Newman

Scientific and Engineering Award
Digital Image Compositing – Alvy Ray Smith, Ed Catmull, Thomas Porter, Tom Duff

1996

Scientific and Engineering Award
Particle Systems – William Reeves

Technical Achievement Award
Direct Input Device – Brian Knep (Industrial Light & Magic), Craig Hayes (Tippett), Rick Sayre, Thomas Williams (Industrial Light & Magic)

1997

Best Animated Short Film
"Geri's Game" – Jan Pinkava

Scientific and Engineering Award
Marionette 3-D Animation Systems [Menv] – Eben Ostby, William Reeves, Samuel J. Leffler, Tom Duff

Scientific and Engineering Award
Digital Painting – Richard Shoup (Xerox PARC), Alvy Ray Smith, Thomas Porter

1998

Nominee, Best Original Musical or Comedy Score
A Bug's Life – Randy Newman

Technical Achievement Award
Laser Film Recording – David DiFrancesco, Bala S. Manian (Digital Optics), Thomas L. Noggle

1999

Nominee, Best Original Song
"When She Loved Me" (Toy Story 2) – Randy Newman

2001

Nominee, Best Animated Feature Film
Monsters, Inc. – Pete Docter, John Lasseter

Nominee, Best Original Score
Monsters, Inc. – Randy Newman

Best Original Song
"If I Didn't Have You" (Monsters, Inc.) – Randy Newman

Nominee, Best Sound Editing
Monsters, Inc. – Gary Rydstrom, Michael Silvers

Best Animated Short Film
"For the Birds" – Ralph Eggleston

Academy Award of Merit (Oscar) – Rob Cook, Loren Carpenter, Ed Catmull
"For significant advances in the field of motion picture rendering as exemplified in Pixar's RenderMan."

2002

Nominee, Best Animated Short Film
"Mike's New Car" – Pete Docter, Roger Gould

2003

Best Animated Feature Film
Finding Nemo – Andrew Stanton

Nominee, Best Original Screenplay
Finding Nemo – Screenplay by Andrew Stanton, Bob Peterson, David Reynolds; Original Story by Andrew Stanton

Nominee, Best Sound Editing
Finding Nemo – Gary Rydstrom, Michael Silvers

Nominee, Best Music Score
Finding Nemo – Thomas Newman

2004

Nominee, Best Animated Short Film
"Boundin'" – Bud Luckey

Best Animated Feature Film
The Incredibles – Brad Bird

Nominee, Best Original Screenplay
The Incredibles – Brad Bird

Best Sound Editing
The Incredibles – Michael Silvers, Randy Thom

Nominee, Best Sound Mixing
The Incredibles – Randy Thom, Gary A. Rizzo, Doc Kane

2005

Technical Achievement Award
Subdivision Surfaces – Ed Catmull, Tony DeRose, Jos Stam (Alias)

Scientific and Engineering Award
Cloth Simulation – David Baraff, Michael Kass, Andy Witkin

2006

Nominee, Best Animated Feature Film
Cars – John Lasseter

Nominee, Best Animated Short Film
"One Man Band" – Mark Andrews, Andrew Jimenez

Nominee, Best Original Song
"Our Town" (Cars) – Randy Newman

Nominee, Best Animated Short Film
"Lifted" – Gary Rydstrom

Acknowledgments

Without a doubt, the greatest pleasure of working on this project was talking to the many, many people who so kindly took the time to speak with me, and who shared their memories and thoughts so candidly. I am equally indebted to those who made their resources available for use in this book, especially Leslie Iwerks, whose interviews and image research provided such an invaluable foundation. Thank you, too, to Mark Vaz, who helped this project take its first steps. Hats off to the people who have helped to build Pixar's and Disney's fantastic libraries of interviews, particularly the Pixar Nonfiction Unit, and to the sharp eyes of Christine Freeman, Pixar's intrepid lead archivist. I would also like to thank the many people who so willingly gave feedback on this project in all its forms, and/or helped with fact-checking and corrections—especially Loren Carpenter, David DiFrancesco, Craig Good, and Tom Porter.

We are lucky to have such wonderful friends at Chronicle Books. Sincere thanks to Sarah Malarkey, Matt Robinson, Vanessa Dina, Tera Killip, Doug Ogan, and Jeff Campbell, who poured their considerable talents into making the best book possible. Thank you to the team at Tolleson Design—Steve Tolleson, Craig Clark, Boramee Seo, René Rosso, Kelly Ongpin, and Holly Hudson—for making everything look beautiful.

This book could not have been completed without the many people at Pixar who helped push, pull, and generally power this project to completion—in particular, Mary Beech, Kat Chanover, Mary Coslin, Andy Dreyfus, Liz Gazzano, and Krista Sheffler. Thanks also to Angie Bliss, Kelly Bonbright, Amy Gary, Rosaleen O'Byrne, Kerry Phelan, Elisabetta Quaroni, Lori Richardson, Michele Spane-Rivera, and John Walker.

Thank you to the Pixar Creative Services team (including Leeann Alameda, Bobby Podesta, and Desiree Mourad for their work on the cover), Juliet Greenberg and Peggy Tran-Le of the Pixar Living Archives, and Heather Feng, Wendy Tanzillo, Joan Smalley, and Cassandra Anderson. We also greatly appreciate the kind assistance of our friends at the University of Utah, CalArts, New York Tech, LucasFilm, Apple, and Disney.

And as always, special thanks to Pixar's executive team: Ed Catmull, Steve Jobs, John Lasseter, Jim Morris, Ali Rowghani, and Lois Scali.

On a personal note, I would like to thank Mary Coleman, Kiel Murray, Kevin Reher, and the rest of the Development family at Pixar for supporting my work on this project. I am grateful to Yvonne Paik, Tae Paik, Kevin Paik, Christopher Paik, and Michael Benveniste for their unfailing support and encouragement.

And finally, I would like to thank Ed Catmull and John Lasseter for trusting me to tell this story.

–Karen Paik

When John Lasseter and Ed Catmull invited me to embark on Pixar's first major history project in 2001, I was honored to be asked to document the company's amazing genesis. What began as a year-long research foray and feature documentary turned out to be six wonderfully fun years of witnessing and partaking in some of the most historic events and successes in the company's evolution. I want to thank the many people I interviewed who gave me their time and trust, sharing their heartfelt accounts of the challenges, trepidations, and excitement of being at the forefront of such groundbreaking history. The greatest challenge of shaping the hundred-plus interviews and thousands of powerful images and stories into not only a book but a feature documentary film was just living up to the brilliant subject matter.

I want to thank my family of friends at Pixar who were formidable in the making of this book, including Christine Freeman, Juliet Greenberg and the Pixar Living Archives team, Steven Argula, Krista Sheffler and the Pixar marketing team, Mark Vaz for laying its foundation, Karen Paik for shaping it beautifully, and at Chronicle books I salute and thank Sarah Malarkey and Matt Robinson for their guidance and patience in making this the best book it could be.

On a personal note, I would like to thank John and Ed, whose friendship and support throughout this journey was the greatest gift of all.

And congratulations to Pixar, for inspiring countless generations to come . . . to infinity and beyond!

–Leslie Iwerks

Index

Italics indicate pages with photographs and illustrations.

A

The Abyss, 227
Academy of Motion Picture Arts and Sciences Awards, 105, 299
Adobe, 15
"The Adventures of André & Wally B.," 42–44, 62, 72, 73
Aladdin, 142
Allen, Tim, 87, 154, 172, 175
Alvarez, Neftali, 286
Amazing Stories, 233
Ambro, Hal, 206
Anderson, Darla
 A Bug's Life and, 131
 Cars and, 269, 272, 274
 commercials and, 96, 138
 Monsters, Inc. and, 188, 189, 195, 198
 photo of, 118
 Toy Story and, 104
Andrews, Mark, 278–79
Antz, 134
Apodaca, Tony, 226–27
Apple Computer, 49–50, 63, 116, 282, 286
Arnold, Bonnie, 80, 93
ARPA (Advanced Research Projects Agency), 13–14

B

Babbitt, Art, 252
Baraff, David, 197
Barak, Dana, 227
Beauty and the Beast, 57–58, 69, 106
Bird, Brad, 30, 32–35, 60, 64, 230, 233, 236–39, 243, 245, 246, 249, 251, 278, 296, 297
Blanchard, Malcolm, 14, 17, 21
Blinn, Jim, 17, 58, 60
Bluth, Don, 34
Bohlin, Peter, 168
"Boundin'", 252, 253
Brannon, Ash, 149
The Brave Little Toaster, 38, 39–40, 45
Brown, Treg, 73
Buck, Chris, 32
A Bug's Life
 concept art for, 117–19, 122–31, 134–36
 on DVD, 137
 image quality of, 137
 inspiration for, 116
 production of, 118–19, 129–31, 134
 release of, 134
 rendered film images and character poses for, 114–16, 120–21, 132–34
 research for, 124–25
 story of, 118, 119, 124
 voices in, 134
Burton, Tim, 31, 34, 69, 83
Burtt, Ben, 72, 73

C

Callahan, Sharon, 119, 125, 218
CalArts, 30–34, 67, 181, 206, 233
Canemaker, John, 296
CAPS (Computer Animation Production System), 56–58, 68
Carlisle, Tom, 168, 169, 170
Carpenter, Loren, 21, 22, 23, 24, 25, 26, 44, 226
Cars
 concept art for, 258–69, 272–74, 276, 277
 inspiration for, 256, 258–59
 main character of, 263, 266
 postponed release for, 272, 286
 production of, 268–69, 272, 274–75
 rendered film images and character poses for, 254–56, 259, 261, 267, 269–75, 277
 world created for, 266–67
 wrap party for, 276
Catmull, Ed. See also individual films
 childhood of, 12–13
 early animation by, 14–15, 16
 at Lucasfilm, 18, 19–27, 41
 at New York Tech, 17–19
 photos of, 15, 18, 47, 283, 289
 REYES and, 226
 role of, 8, 9, 17, 112, 295, 297
 at the University of Utah, 12, 13–14, 15
Chan, Albert, 103–4
Chapman, Brenda, 263, 296
Chouinard Art Institute, 31, 252
Clark, Jim, 15, 17
Clark, Les, 32, 35
Clements, Ron, 32, 69
Cohen, Ephraim, 17
Collins, Lindsey, 204
Colossal Pictures, 64, 69, 252
Comcast, 286
Computer animation
 hand-drawn animation vs., 80, 102, 238–39
 three-dimensional, 38
Cone, Bill, 256, 268
Conway, Don, 71
Cook, Dick, 23, 283
Cook, Rob, 22, 25, 26, 59, 226
Crystal, Billy, 175, 198

D

Dahl, Roald, 69, 70
Davis, Lem, 57
Davis, Marc, 32, 35, 252
Debney, John, 39
Decker, Spike, 74, 139
DeGeneres, Ellen, 175
Del Carmen, Ronnie, 279
Delgadillo, Angel, 267
DeRose, Tony, 139
DiFrancesco, David, 17, 20, 21, 44, 137
Digital Effects, 38
Dinosaur Bob, 70
Disch, Thomas, 39
Disney. See also individual films
 animation department at, 33, 34–37
 archives of, 30–31
 atmosphere of, 233
 attitude of, toward sequels, 142, 284–85
 buys Pixar, 282–93, 297
 CAPS and, 56–58, 68
 co-branding with, 110
 contract renegotiation with, 110, 283–84
 management changes at, 56, 285–86
 music in films of, 106
 Nine Old Men of, 32, 34–35
 original contract with, 70–71, 109, 283
 partnering with other studios, 69–71
Disney, Roy, 56–57, 102, 285
Disney, Walt, 13, 30, 37, 56, 112, 142, 162
Disneyland, 32–33
Divided Highways, 259
Docter, Pete
 A Bug's Life and, 116
 childhood of, 178, 180–81
 commercials and, 67
 Finding Nemo and, 204, 207, 209
 hiring of, 64, 67
 Monsters, Inc. and, 170, 178, 181, 184, 186, 188–89, 193–97, 199

photos of, 71, 112, 171, 199
on Pixar's company culture, 294, 298
on Point Richmond building complex, 166, 167
Toy Story 2 and, 83, 92, 97, 104, 116
Toy Story and, 83, 92, 97, 104, 141, 149, 161
DreamWorks Animation, 131, 134, 145
DroidWorks, 46
Duff, Tom, 21, 75

E

"Ecology American Style," 233
EDS, 51
EditDroid, 21, 23, 43, 46
Eggleston, Ralph, 19, 93, 200–201, 218, 238, 253
Einstein, Albert, 13
Eisner, Jane, 171
Eisner, Michael, 56, 285–86
Eisner, Will, 249
Emeryville building complex, 164, 165, 167, 168, 169–71, 172, 173
The Empire Strikes Back, 21, 22, 23
Evans, Chris, 24
Evans, David, 14–15, 17
Evans & Sutherland Computer Corporation, 14, 17

F

Feeney, Ray, 158, 293
Feng, Heather, 274
Finding Nemo
 concept art for, 205–17, 220–21
 inspiration for, 212
 production of, 218, 221, 224
 release of, 221
 rendered film images and character poses for, 202–4, 219, 222–25
 sound in, 73
 story of, 212–13
 voices in, 175, 204
"For the Birds," 200, 201
The Fox and the Hound, 32, 36
Futureworld, 14

G

Gavin, Kathleen, 57, 68, 194
General Motors, 50–51
"Geri's Game," 134, 138, 139
Giacchino, Michael, 246, 279
Gibbs, Rob, 200
Good, Craig, 71, 92
Goodman, John, 175
Gordon, Andrew, 171, 172
Gordon, Bob, 97
Graham, Don, 162, 233, 252
Gribble, Mike, 74
Guggenheim, Ralph, 20, 21, 43, 64, 67–68, 70, 71, 80, 92, 93, 96, 164

H

Hadley, Don, 252
Hahn, Don, 34
Hahn, Tom, 57
Hanks, Tom, 86–87, 89–90, 154, 175
Hannah, Jack, 30, 31
Hanrahan, Pat, 17, 226
Hansen, Ed, 30, 40
Harry Potter series, 227
Haskett, Dan, 34
Hee, T., 31, 34, 252
Hollander, Richard, 248
Humans, animating, 244, 245–46, 248–49

I

Iger, Bob, 283, 285, 286, 287–89, 291

The Illusion of Life, 35

The Incredibles
concept art for, 231–36, 238–39, 242, 244–45, 247
creative team for, 237–38
inspiration for, 236–37
production of, 239, 243–46, 248–49
release of, 249
rendered film images and character poses for, 228–30, 237–41, 243, 245, 248–49, 251
wrap party for, 239

Indiana Jones, 73

Industrial Light & Magic (ILM), 19, 22–23, 24, 26, 164

The Iron Giant, 236, 237, 243

Iwerks, Ub, 37, 42

J

Jackson, Karen Robert, 149
Jackson, Peter, 101
Jacob, Oren, 218
James and the Giant Peach, 69, 70
Jeup, Dan, 155
Jimenez, Andy, 278–79
Jobs, Steve
childhood of, 48
Apple Computer and, 49–50
contract negotiations and, 70–71
in the early days of Pixar, 62–63
Emeryville building and, 168
in the Love Lounge, 171, 172
NeXT and, 50, 51
photos of, 49, 53, 171, 283, 288
on Pixar's acquisition by Disney, 282, 287
Pixar's IPO and, 109–10
purchases Pixar, 50–53
at Reed College, 48–49
role of, 9, 108, 112, 282, 295, 297
on second-product syndrome, 116
Toy Story 2 and, 149, 156, 157
Johnson, Ollie, 32, 34, 35
Jones, Chuck, 73, 76
Joyce, William, 70
Jurassic Park, 92, 227

K

Kahl, Milt, 32, 230
Kahrs, John, 167
Kalache, Jean-Claude, 269
Kass, Michael, 139
Katzenberg, Jeffrey, 56, 68–71, 87, 89, 90, 131, 145
Kay, Alan, 50
Keane, Glen, 31, 34, 36, 38–39
Kimball, Mark, 57
Kimball, Ward, 32, 35
King of the Hill, 256
Klubien, Jorgen, 256
"Knick Knack," 62, 69, 76, 77
Kroyer, Bill, 34, 38

L

"Lady and the Lamp," 31, 34
Lang, Larry, 48
Larson, Eric, 32, 35
Lasseter, John. *See also individual films*
childhood of, 28, 29
at Disneyland, 32–33
at CalArts, 30, 31, 32–34
at Disney Studios, 34–40, 261
joins Lucasfilm, 40–46
in the Love Lounge, 171, 172
passion for cars of, 256
photos of, 29, 30, 31, 32, 36, 45, 71, 105, 118, 171, 257, 283, 290
on Pixar's IPO, 110
on Pixar's relationship to Disney, 285, 286–87
research of, 266–67
role of, 8–9, 112, 272, 295, 297
work habits of, 59
Lasseter, Nancy, 258
Lavine, Steven, 291
Leffler, Sam, 58, 75
Levinson, Barry, 45
Levinthal, Adam, 44
Levy, Lawrence, 108
Lion King, 145
Life Savers "Conga" commercial, 66, 67
Listerine "Boxer" commercial, 66, 67
The Little Mermaid, 57, 69, 106
Lord of the Rings trilogy, 227
Lounsbery, John, 32, 35
Love Lounge, 171, 172
Lucas, George, 19–22, 25, 26, 28, 44, 52–53
Lucasfilm Computer Division
becomes Pixar, 9, 46–47, 52
employees of, 19, 20, 21–22
founding of, 19–20
work of, 22–27
Luckey, Bud, 86, 200, 252–53
Lucky, 7, 172
Luxo Café, 172, 173, 175
"Luxo Jr.," 54–56, 58–60, 62, 72, 142

M

MacLane, Angus, 152
MAGI/Synthavision, 38
Malin, Leonard, 37, 62, 156
The Matrix, 227
McArthur, Sarah, 57, 91, 130–31, 147, 149, 157, 221
McCaffrey, Mike, 110
McCrea, Bob, 206
McEntee, Brian, 39
McQueen, Glenn, 98, 147, 263
Merv, 75, 129
Miller, Diane Disney, 34
Miller, Ron, 34, 40
Milo, Yael, 71
Miyazaki, Hayao, 294
Monsters, Inc.
concept art for, 179–89, 192–98
inspiration for, 181, 184
production of, 186, 188–89, 193–98
rendered film images and character poses for, 176–78,
190–91, 199
story of, 184–86
voices in, 175
Montan, Chris, 106, 107
Moore, Bill, 31
Moorer, Andy, 20, 21, 43
Morris, Jim, 26
Motion blur, 18, 25–26, 27
Motion Doctor, 75
Murch, Walter, 73
Muren, Dennis, 45, 46, 227
Murphy, Jim, 155, 201, 263
Music, 106–7
Musker, John, 30, 31, 34, 36, 40, 69
Muybridge, Edweard, 60
My Dinner with Andre, 42, 43

N

Nelson, Randy, 162, 163, 168
Netscape, 15
Newman, Randy, 80, 89, 106, 107
New York Institute of Technology (NYIT), 16, 17, 18
NeXT, 50, 51, 63, 282
The Nightmare Before Christmas, 69
Nye, Peter, 57

O

O'Connor, Ken, 31, 261
Oftedal, Mark, 98
101 Dalmatians, 37
"One Man Band," 278, 279
Oscar Mayer Weinermobile, 105
Osby, Eben, 41, 58, 62, 71, 74–76, 99, 101, 104, 268

P

Pacific Data Images (PDI), 131, 134
Pauley, Bob, 166, 256
Peachey, Darwyn, 129
Peet, Bill, 261
"Pencil Test," 64
Perot, Ross, 51
Peterson, Bob, 185, 194, 216, 217, 295
Philips, 50–51
Philips, Flip, 71
Pidgeon, Jeff, 103, 200, 201, 252
Pinkava, Jan, 138–39
Pirates of the Caribbean trilogy, 227
Pixar. *See also individual films*
attitude of, toward sequels, 284–85
commercials of, 64, 65, 66, 67–68, 93, 96, 138
company culture of, 290–92, 294–98
directorial talent at, 111–13, 178, 193, 224–25, 230
early days of, 56–71, 83
employees of, 62, 113, 280–81, 286, 293
future of, 282–83, 297–98
growth of, 9, 108, 111–12, 162, 282, 286
IPO of, 109–10
joins Disney, 282–93, 297
locations for, 164–72
logo of, 111
origins of name, 44
short films of, 58–62, 74–77, 138–39, 200–201, 252–53,
278–79
stock certificate of, 109
success of, 189, 193, 296–97
Pixar Image Computer, 44, 46–47, 51, 56, 57, 62, 68
Pixar University, 162, 163
PixarVision, 137
Plotkin, Helene, 149
Plummer, Elmer, 31
Point Richmond building complex, 164, 165, 166, 167–68
Polson, Bill, 279
Porter, Tom, 22, 23–26, 44, 45, 58, 99, 101, 166, 196, 197, 286
Prum, Jory, 201

Q

Quade, Rich, 252

R

Random point sampling, 26
Ranft, Jerome, 261, 277
Ranft, Joe
A Bug's Life and, 116, 119, 134
at CalArts, 67
Cars and, 259, 267
childhood of, 261
death of, 275–76
at Disney, 39

"For the Birds" and, 200
The Incredibles and, 237, 243
Monsters, Inc. and, 186, 193
personality of, 261–63, 277
Toy Story and, 70, 83, 87, 89, 90, 97
Toy Story 2 and, 149, 155
Ratatouille, 286
Ratzenberger, John, 174, *175*
Ray tracing, 269
"Red's Dream," 62, 74, *75*
Reed College, 48–49
Rees, Jerry, 34, 38
Reeves, Bill, 21, 24, 41, 43, 45, 58, 59, 62, 71, 75, 99, 101, 130
Reher, Kevin, *118*, 119, 131
Reitherman, Woolie, *32*, 35
Renderer, definition of, 226
Renderfarm, 269
RenderMan, 25, 75, 226–27
The Rescuers Down Under, 57, 142
The Return of Jafar, 142
REYES, 25, 226
Rivera, Jonas, 267, 268
"The Road to Point Reyes," *10–11*, 12, 43
Robertson Stevens, 110
Route 66, 267, 268
Rydstrom, Gary, 72, 73, 189, 295

S
Sagan, Carl, 21
Salesin, David, 59
Saludos Amigos, 142
San Rafael building complex, 164, 166
Sarafian, Katherine, 154
Sayre, Rick, 125, 238, 244–45, 246
Schneider, Peter, 68–69, 70, 89
Schumacher, Tom, 70, 80, 87, 89, 90, 92, 102, 104, 147, 155, 189, 199, 283
Schure, Alexander, 17, 19, 21
Second-product syndrome, 116
Self-shadowing, 59
Selick, Henry, 32, 34, 83
Sendak, Maurice, 39
Servais, Raoul, 58
Sesame Street, 252, 253
Shantzis, Michael, 57
Shurer, Osnat, 253
SIGGRAPH, 18, 22, 44–45, 58, 60, 61, 134
Silicon Graphics, 15
Silverman, David, 193
The Simpsons, 236, 243
Skywalker Ranch, 164
Smith, Alvy Ray, 17, 18, *20*, 21, 24–25, 27, *47*, 50, 56, 62–63, 71
Snow White, 230, 297
Solomon, Charles, 37
Song of the South, 261
Sound design, 72–73
SoundDroid, 21, 23, 43, 46
Spider-Man trilogy, 227
Spielberg, Steven, 25, 233
Spike and Mike's Festival of Animation, 64, 74, 139
Sprocket Systems, 72
Stanford Research Institute, 14
Stanton, Andrew
 A Bug's Life and, 116, 118, 119, 178
 at CalArts, 206–7
 Finding Nemo and, 204, 212–13, 216–18, 221, 224–25
 hiring of, 64, 67
 Monsters, Inc. and, 184–85, 193
 photos of, *71*, *112*, *118*, *209*
 on Pixar's company culture, 298

role of, 272
Toy Story and, 70, 83, 84, 89, 90, 91–92, 116, 200
Toy Story 2 and, 149, 156
Star Trek II: The Wrath of Khan, *24*, 25, 38
Star Wars, 19, 32
Star Wars Episode I, 227
Stern, Garland, 17, 18
Stock, Rodney, 26, 44
Stockham, Tom, 14
Stop-motion animation, 38
Subdivision surfaces, 15, 139
Subsurface scattering, 246
Susman, Galyn, 145, 156
Sutherland, Ivan, 14–15
Sweetland, Doug, 98

T
Tague, Nancy, 64
Taylor, Bill, 99
Terminator 2, 227
Texture mapping, 15
Thinkway Toys, 103–4
Thomas, Bob, 29
Thomas, Frank, *32*, 34, *35*, 39
The Three Caballeros, 142
"Tin Toy," 62, 70, 72–73, 74–75, 76
Tin Toy Christmas, 70
Titanic, 227
"The Tortoise and the Hare," 230
Toy Story
 concept art for, *81–90*, *92–95*, *102–3*
 contract for, 70–71, 80, 109
 inspiration for, 70
 music in, 106–7
 preview screenings of, 102
 production of, 80, 89–90, 92–93, 97–99, 101
 release of, 105
 rendered film images and character poses for, *78–80*, *91*, *98*, *100*, *103*
 sound in, 73
 story of, 84–86, 87, 89–92
 success of, 105, 296
 team for, 82–84
 toys based on, 103–4
 voices in, 86–87, 174, 175
 wrap party for, 104
Toy Story 2
 concept art for, *143–52*, *154–56*, *158–59*, *161*
 inspiration for, 142, 144
 lessons learned from, 157, 158–59, 161
 production of, 145–47, 152, 155–56
 rendered film images and character poses for, *140–42*, *144*, *147*, *153*, *156–57*, *160–61*
 sound in, 73
 story of, 142, 144, 149, 152, 154
 wrap party for, 157
Toy Story 3, 284–85
Trident gum commercial, 64, 65
Tron, 37–39
Tropicana orange juice "Wake Up" commercial, 64, *65*
Tubby the Tuba, 18

U
University of California
 Los Angeles, 14
 Santa Barbara, 14
University of Utah, 13–15
Unkrich, Lee
 A Bug's Life and, 119, 125
 Cars and, 272
 on Emeryville building, 170

Finding Nemo and, 216, 217–18, 221
Monsters, Inc. and, 193, 198
photo of, *96*
on Pixar's company culture, 294
Toy Story and, 96–97, 101
Toy Story 2 and, 146, 149, 156

V
Van Allsburg, Chris, 69
Vicom, 68
Voices, 174–75. *See also individual films*
"Vol Libre," 21, 22

W
Walker, John, 243, 251
Wallis, Michael, 267
Walsh, Mark, 167
Walters, Graham, 149, 218, 221, 224
Warin, Deirdre, 59, *71*, 76
Warner Bros., 73, 76, 236
Warnock, John, 15
Wedeen, Tasha, 167
Wedge, Chris, 39, 41, 80
Wells, Frank, 56
Whedon, Joss, 91–92, 207, 209
Where the Wild Things Are, 39, 40
Wilhite, Tom, 39, 40, 45
Williams, Lance, 17
Winquist, Bob, 200
Wise, Bill, 201
Witkin, Andy, 197
Wozniak, Steve, 49

X
Xerox PARC, 17

Y
Young, Michael, 15
Young Sherlock Holmes, *45*, 46

Z
Z-buffer, 15

Author Biographies

Karen Paik joined Pixar's Creative Development team in 2000. She works with directors, providing research on characters and environments and giving feedback on each stage of story development. She is also the author of *The Art of Ratatouille*. Ms. Paik grew up in the San Francisco Bay Area, and received her bachelor degree in history and literature from Harvard University. An animation fan since childhood, she first encountered Pixar's work in a computer animation course she took while in high school. She still has the promotional Listerine postcard that was handed out to the class by the Pixar guest lecturer.

Leslie Iwerks is an Academy Award–nominated director and award-winning author. Her previous documentary films include *The Pixar Story*, *Recycled Life*, *The Ride/The Day,* and *The Hand Behind the Mouse: The Ub Iwerks Story*, which chronicles the life of her grandfather, the original designer of Mickey Mouse and an Academy Award–winning motion picture pioneer. Her accompanying biography of the same title won the 2001 E.G. Lutz Award for top animation book of the year. A graduate of the USC School of Cinema-Television, Ms. Iwerks directs, produces, and writes documentaries, television, and feature film projects often related to social and humanitarian issues and historical subjects. She resides in Santa Monica, California.

Ed Catmull is co-founder of Pixar Animation Studios and president of Pixar and Disney Animation Studios. Previously, he was vice president of the Computer Division of Lucasfilm, Ltd., where he managed four development efforts in the areas of computer graphics, video editing, video games, and digital audio. Dr. Catmull has been honored with three Scientific and Technical Engineering Awards, including an Oscar, from the Academy of Motion Picture Arts and Sciences. He has also won the Steven A. Coons Award, the highest achievement in the computer graphics field, for his lifetime contributions, and was awarded the animation industry's Ub Iwerks Award, given to individuals for technical advancements that make a significant impact on the art or industry of animation. He lives in Northern California.

John Lasseter is chief creative officer of Pixar and Disney Animation Studios and principal creative advisor, Walt Disney Imagineering. He is a two-time Academy Award–winning director and oversees all Pixar and Disney films and associated projects. Mr. Lasseter directed the groundbreaking and critically acclaimed films *Toy Story, A Bug's Life*, and *Toy Story 2*. Additionally, he executive produced *Monsters, Inc.*; *Finding Nemo*; and *The Incredibles*. Mr. Lasseter returned to the director's chair in 2006 with the release of the Disney/Pixar film *Cars*. His very first award came at the age of five when he won $15.00 from the Model Grocery Market in Whittier, California, for a crayon drawing of the Headless Horseman. He lives in Northern California.

Steve Jobs is co-founder and CEO of Pixar Animation Studios, which has won twenty Academy Awards, and whose films have grossed more than $3.2 billion at the worldwide box office to date. Pixar merged with The Walt Disney Company in 2006 and he now serves on their board of directors. Mr. Jobs grew up in the apricot orchards that later became known as Silicon Valley, and still lives there with his wife and three children.